The Second Life of Art

THE
SECOND LIFE
OF ART

SELECTED ESSAYS

OF *Eugenio Montale*

EDITED AND

TRANSLATED BY

JONATHAN GALASSI

The Ecco Press

NEW YORK

1982

The translator's acknowledgments which appear on page 339
constitute an extension of this copyright.
First published by The Ecco Press in 1982
18 West 30th Street, New York, N.Y. 10001
Published simultaneously in Canada by
George J. McLeod Limited, Toronto
Printed in the United States of America
Designed by Cynthia Krupat
Published by arrangement with Arnoldo Mondadori Editore
and Il Saggiatore.
Publication of this book was made possible in part by a
grant from the National Endowment for the Arts.
First Edition

Library of Congress Cataloging in Publication Data
Montale, Eugenio, 1896–1981 / The second life of art.
Bibliography: p. 341
Includes index.
 1. Arts—Addresses, essays, lectures.
 I. Galassi, Jonathan. II. Title.
 NX65.M65 700 81-9861
 ISBN 0-912946-84-9
 ISBN 0-912946-85-7 (pbk.)

Grateful acknowledgment is made to the following publications where these translations first appeared: *Antaeus* / "W. H. Auden", "The Cinque Terre", "The Intellectual", "The Poet", "Voluntary Exile in Italy"; *The Bennington Review* / "Man in the Microgroove"; *Canto* / "Dante, Yesterday and Today"; *The Georgia Review* / "Style and Tradition"; *La Fusta* / "The Fortunes of Pascoli"; *Montemora 4* / "Aesthetics and Criticism", "Eugenio Montale: An Interview"; *New England Review* / "On the Trail of Stravinsky", "Uncle Ez"; *The New York Review of Books* / "The Second Life of Art"; *The Paris Review* / "A Visit to Braque"; *Pequod* / "Intentions (Imaginary Interview)"; *Ploughshares* / "Words and Music"; *Salmagundi* / "Poetry and Society"; *The Threepenny Review* / "Malraux"; *TriQuarterly* / "Seven Questions About Poetry for Eugenio Montale".

Contents

On Other Writers

Observations & Encounters

Tributes

Interviews & Self-Criticism

Introduction

I

This book brings together a selection of writings on art— primarily but not exclusively the art of poetry—by one of the great artistic sensibilities of our time. Eugenio Montale has been widely acknowledged as the greatest Italian poet since Leopardi and his work has won an admiring readership throughout the world. His seven books of poems have, for thousands of readers, expressed something essential about our age.

Yet the poet's artistic interests extended far beyond poetry itself. Following his own prescription for what he called in an important early essay "a superior dilettantism, rich in human and artistic experience," Montale immersed himself in most of the recognized arts of our civilization and distinguished himself in many of them: as a literary and social critic and as a writer of short fiction; as a singer and student of the opera and as a music reviewer; even as a painter and draftsman. An aesthetic personality *par excellence*, he clearly approached experience in terms of how it has been and can be expressed. An appreciator as well as a creator by nature, he had the unusual capacity, thanks to the breadth of his artistic expertise, to understand the innate but often tenuous relations that exist among the various arts, and, perhaps more important, he appreciated more profoundly than most art's necessary relationship to the rest of life, its communicative function. Art, as he writes in the title essay in this collection, lives first in the moment in which it is made, but its second, larger life occurs at the moment in which it is made use of, is understood or misunderstood by an audience. In our culture, with its predilection for intense specialization, the arts tend to play a compartmentalized, removed, and relatively insignificant role in everyday life. Montale, by con-

trast, saw and lived artistic experience as having a direct if complex relationship to common experience. Art for him was at once deeply personal and ultimately social; though the artist obeys private impulses in creating his work, it becomes useful to others to the extent that it communicates something about life in general, that it reflects reality. "The ultimate possibility of social significance which an art born of life always has" is "to return to life, to serve man, to say something for him."

Montale wrote widely and incisively about all the arts that interested him. A 1977 bibliography of his work, in fact, lists more than 1800 essays and critical articles written between 1916 and 1976, the majority of them dating from the poet's years on the *Corriere della Sera.* This book can do no more than provide a sampling of Montale's various attainments as an essayist and critic, though an attempt has been made to give some idea of the extent and relative emphasis of his interests. The main focus here is of necessity on literature and particularly on poetry, for the book has been conceived as a companion volume for readers of Montale's poems who want to learn something of the background, beliefs, and frame of mind of this astringent, musical, pessimistic and profoundly humane writer. American readers in particular may feel ill equipped, as the present writer did, to understand the intellectual and cultural tradition out of which Montale's work arose; as he himself has noted, modern Italian culture for clear economic and historical reasons has had a more limited currency abroad than the other major European brands of civilization, and, much as Montale played an important part in bringing modern Italian letters into the international mainstream, the tradition out of which he wrote is familiar to few non-Italians.

This book aims, then, at providing the rudiments of a context in which to view Montale's greatest work, his poetry, by presenting selections from his writings on the role of culture in modern society; on the literature and thought of his own country, especially those writers who have influenced him most significantly; on writers of other cultures in whom he is particularly interested (and on whom his views are particularly interesting to us); on the other arts; and on himself and his relationship to his own society.

In a sense then, this book can be seen as selections from an un-written intellectual autobiography.

The essays, which are organized chronologically within each thematic section, span a period of fifty years, from "Style and Tradition" of 1925 to the Nobel Prize address. Notes are provided to elucidate obscure references within the text. Book titles have been translated where necessary, but not most individual poem titles.

II

Eugenio Montale was born in Genoa on Columbus Day, 1896, the youngest of the five children of Domingo Montale, a well-to-do manufacturer of marine products, and his wife Giuseppina Ricci. The poet told his biographer Giulio Nascimbeni that the Montale family came originally from Parma and was called Montali; a great-grandfather, a general in the army of King Carlo Alberto of Piedmont and Sardinia, Frenchified the name according to the bourgeois fashion of the time, pronouncing it Montal.

Domingo Montale, who gave his name the conventional Italian pronunciation, was himself a native of Monterosso, a town on the mountainous stretch of Ligurian coast above La Spezia known as the Cinque Terre; there, in 1905, he built a villa, where Montale was to spend summers until he was thirty. The "rocky and austere" Ligurian shore, beautifully evoked in the essay "The Cinque Terre," was to provide the objective correlative, so to speak, for the interior existential landscape which was to be the primary subject matter of Montale's early poetry.

Montale's career as a student was curtailed by delicate health, and he was largely educated at home, partly by his sister Marianna. In his late teens, he decided to be an opera singer, training with the baritone Ernesto Sivori, who considered him "a great promise for the opera," but after Sivori's death he abandoned this ambition, "also because I was suffering from unrelieved insomnia," as he tells us in "Intentions (Imaginary Interview)." The next year, in 1916, Montale wrote the first of his poems to survive, the famous *"Meri-ggiare pallido e assorto,"* later collected in *Ossi di seppia.*

He was drafted in 1917, and trained at an officer's school at the Palazzo della Pilotta in Parma, where he formed his first literary

friendships, most significantly with the critic and poet Sergio Solmi. Montale was commissioned a lieutenant and served at Vallarsa in the Trentino, later commanding an outpost near Valmorbia on the River Leno.

Cashiered in July 1919, he returned to his family in Genoa. He read widely in the city library and began to meet other writers at the Caffé Diana, the gathering-place of the anti-D'Annunzian intellectuals, among them Angelo Barile, Adriano Grande, Pierangelo Baratono, and, most important, Camillo Sbarbaro, the Ligurian "crepuscular" or "twilight" poet, who was to have a strong influence on Montale's work (see "Recollections of Sbarbaro" and "Intentions (Imaginary Interview)" for discussion of these poets and other early influences on Montale's poetry). Montale began writing reviews and critical essays and looked without success for a position on a literary magazine or paper, being, as Nascimbeni puts it, "constitutionally unadapted to any form of precarious bohemianism." His first published poems, the "*Accordi—sensi e fantasmi di un'adolescente*," appeared in 1922 in the Turin journal *Primo Tempo*, edited by Giacomo Debenedetti and Solmi.

Montale's first book of poems, *Ossi di seppia*, was published early in 1925 by the young anti-Fascist intellectual Piero Gobetti, editor of the Turin review *Il Baretti*, to which Montale was now contributing. Though the critical response was not immediate, the book would establish Montale within a few years as the leading Italian poet of his generation, a generation now confronting the reality of the Fascist usurpation of power. Fascist henchmen had murdered the Socialist deputy Matteotti in June 1924, and Mussolini's speech to Parliament assuming extralegal authority was delivered on January 3, 1925, at the same time that Gobetti was preparing to print *Ossi di seppia*. Curbs on political parties and the press soon followed, and Gobetti went into exile in Paris the next year, where he would soon die. 1925 was also the year of Giovanni Gentile's "Manifesto of Fascist Intellectuals" and of Benedetto Croce's opposing anti-Fascist manifesto, to which Montale contributed his signature. (See "Fascism and Literature" for a discussion of the intellectual climate of these years).

In the November–December 1925 issue of *L'Esame*, Montale published his first article on the novels of Italo Svevo, who up until

then had gone virtually unrecognized in the serious literary press. Montale described Svevo as the most important Italian novelist since Verga (an opinion confirmed by the French critic Benjamin Crémieux in an article in *Le Navire d'Argent* for February 1926), thus initiating a critical re-evaluation—or evaluation—which led to worldwide fame for Svevo in the last years of his life. Montale was to meet Svevo in Milan in 1926, and their friendship, described touchingly in "Poetry and Society" and elsewhere, was to last until Svevo's death in 1928. Svevo, who in real life was the Triestine manufacturer of marine paints Ettore Schmitz, had had business dealings with Montale's father—Montale wrote that "there was always an odor of turpentine about our relationship, which I never succeeded in carrying very far on the literary plane"—and he was responsible for introducing Montale in Florence to his future wife, Drusilla Tanzi, known as La Mosca, who was then married to the art critic Matteo Marangoni. Svevo took a paternal interest in Montale's talent and hoped to convert him from poetry, which frankly bored him, to fiction. "I await anxiously," he wrote Montale in December 1926, "for you to move on from poetry to the more reasonable mode of self-expression."[1]

> I sense that you are much afflicted by the poems of others, [Montale replied] and probably by Saba's. I shall continue to write poems for several years, because it is the one form that I feel is possible for me today. Don't be surprised that there can be a temperament directed toward the lyric and literary criticism: from Baudelaire to Eliot and Valéry, how many have experienced the same fate?
>
> And besides, with my experience of life, all of it exclusively internal, what could I contribute in the field of narrative? I am a tree that has long been burned by the *scirocco*, and everything that I could give in the way of stifled cries and starts is all in *Ossi di seppia*, a book of which Saba did not understand one syllable.[2]

1. *Carteggio Svevo-Montale*, p. 37.
2. *Ibid.*, 39–40. For information on Saba see "For Lina Saba."

Montale had come to know the poet Umberto Saba, as he had come to know Svevo's novels, through the agency of the Triestine Bobi Bazlen, a cultural gadfly who played an important role in enlarging Montale's cultural horizons (See "In Memory of Roberto Bazlen"). Trieste, the half-Hapsburg and thus "continental" locale of Svevo's novels—and the home of a number of other innovative writers including Saba and Svevo's friend James Joyce, who lived here from 1905 to 1915—became a kind of adopted home for Montale in these years. He was to describe the Trieste of Svevo's work, in an article written on the occasion of the novelist's death, as "the haven of modern man, given over to every contradiction and slave to his own implacable lucidity," and the city and its artists crop up frequently in the present volume, attesting to their powerful influence on his own outlook.

Montale moved to Florence in March 1927, having at last found work in the publishing house of Bemporad. After a little more than a year he was let go when the publisher reduced his staff, but in January of 1929 was appointed director of the Gabinetto Vieusseux, a noted Florentine library and literary institution frequented in the previous century by Leopardi. Montale's arrival in Florence coincided with the flourishing of the review *Solaria* (1926–1934), edited principally by Alberto Carocci until it was eventually closed down by the Fascists. Picking up where Gobetti's *Il Baretti* had left off, *Solaria* promoted a broad internationalist viewpoint and was to be a gathering-point for "the best of bourgeois culture" in these years. As Vittorini wrote in his famous *Diario in pubblico*, " 'Solarian' was a word which in the literary circles of those times meant anti-Fascist, europeanist, universalist, anti-traditionalist." Among the Italian writers published in the magazine— and many foreign voices were featured—were Vittorini, Carlo Emilio Gadda, Cesare Pavese, Salvatore Quasimodo, Cesare Zavattini, Gianna Manzini, Guido Piovene, Pier Antonio Quarantotti Gambini, and of course Montale. (His "Report on the Cinema" was written for a special film number of the review.)

"The poet of negation, in a period when one could only exist by negation," Montale was perhaps the central inspiration for the group of Solarians and others who gathered daily at the famous caffé *Le Giubbe Rosse*. During his years in Florence he befriended

many of the writers mentioned above—as well as Mario Praz, Renato Poggioli, Arturo Loria, Lea Ferrero and others; he visited Bernard Berenson at *I Tatti* nearby, and also came to know a whole generation of young writers, many of them members of the "hermetic" movement from which Montale always dissociated himself (see "Let's Talk About Hermeticism"), but who looked to him as a model.

The poems which were to make up Montale's second book, *Le occasioni*, were written in this period. A group of them were awarded the Premio dell' Antico Fattore in 1931 and published by Vallecchi in the chapbook *La casa dei doganieri e altri versi* in the following year, but *Le occasioni* as a whole was not to appear until 1939, when it was greeted with widespread critical acclaim. Montale was also removed from his post at the Gabinetto Vieusseux in 1939 because he was not a member of the Fascist party. Forced to earn his living solely from literary work, he wrote for a number of reviews, including *Letteratura, Campo di Marte, Pan, Primato,* and *Prospettive*, and began working as a translator, primarily from the English. Among the authors he rendered into Italian were Melville (*Billy Budd*), Steinbeck (*In Dubious Battle* and *To a God Unknown*), Fitzgerald, Hawthorne, Hemingway, Faulkner, Dorothy Parker, Marlowe (*Doctor Faustus*), Corneille (*Le Cid*), as well as some intermezzos of Cervantes and five plays of Shakespeare: *Hamlet, The Winter's Tale, The Comedy of Errors, Timon of Athens,* and *Julius Caesar*. A selection of his lyric translations, *Quaderno di traduzioni*, including poems by Shakespeare, Blake, Emily Dickinson, Hopkins, Hardy, Yeats, Eliot, Pound, Guillén, Dylan Thomas and others was published in 1948.

In 1942 Gianfranco Contini, who was then teaching in Switzerland, smuggled the manuscript of Montale's chapbook *Finisterre* into Lugano, where it was published in 1943, as Montale considered it unpublishable in Italy for political reasons. (The tense atmosphere in Florence during the occupation is movingly evoked in Montale's obituary for Lina Saba). With the liberation came great hopes for political and cultural rebirth in Italy. Montale joined the liberal *Partito d'Azione*, a continuation of the wartime anti-Fascist *Giustizia e Libertà* movement, but the party was destined to split in the radical left-right polarization of postwar Italian

politics. After the war, Montale wrote for the Florentine daily *La Nazione* and helped found the cultural review *Il Mondo*. In 1946 he began contributing to the Milanese *Corriere della Sera* and in 1948 moved to Milan to become its principal literary critic. In the summer of that year, he and La Mosca, who was recuperating from an illness, spent several months at Forte dei Marmi on the coast north of Viareggio. It was here that Montale began painting, and Forte dei Marmi became his habitual summer residence.

Montale's move to Milan to work on the *Corriere* seemed to mark an important shift in his relationship to Italian culture at large. "The poet of negation," who, writing from "outside," had represented the humanistic values and aspirations of an oppressed generation, now found himself in a position of public authority and prestige, from which he continued to express his own personal, and largely pessimistic views. This was at a time when other intellectuals were adopting more narrowly committed positions; Vittorini, for example, had joined the Communist party and was editing the Communist review *Il Politecnico* in Milan. Suddenly, to some, Montale's detachment and independence appeared "hermetic" and elitist. Montale consistently defended his personal stance, arguing that "art isn't made with opinions," and warning against an overly narrow conception of *engagement*, as he has spoken elsewhere against excessive devotion to isms of all kinds. Nevertheless, in the rigidly politicized atmosphere of postwar Italian society, his private brand of liberalism appeared outmoded and even reactionary to a part of the younger generation.

Fully ninety percent of Montale's critical writing was done during his years on the *Corriere della Sera*, and during the fifties and sixties his articles appeared several times a week, leaving him little time to write poems. Many of the themes and qualities that are to be found in his poetry, however, can be seen in the whimsical autobiographical sketches written for the paper and later collected in *Farfalla di Dinard* (first published in 1956), as well as in the travel pieces published in *Fuori di casa* (1969). Most of the cultural criticism published in *Auto da Fé* (1966), a brilliant portrayal of the predicament of humanistic culture threatened by mass society, was also written for the *Corriere*, for which Montale had also become chief music as well as literary critic in 1955.

Montale's third, and for many his greatest book of poems, *La bufera e altro*, including the work in *Finisterre*, was published in a limited edition in 1956. In the following year, Mondadori, who now became his principal publisher, issued a regular trade edition of the work. In 1961 he was awarded honorary degrees by the universities of Rome, Milan, and Cambridge, and won the Premio Feltrinelli of the Accademia dei Lincei, Italy's most distinguished learned body, in 1962. On October 20, 1963, La Mosca died after a long illness.

Montale's reputation by this point was extensive in the international literary community as well, and translations of his work were now appearing in many countries. In 1965 New Directions issued a *Selected Poems*, edited by Glauco Cambon, and the next year in Paris Gallimard published all three of Montale's volumes with a translation *en face* by Patrice Angelini. The Italian review *Letteratura* devoted a special issue entirely to his work in 1966, republished in an expanded version as *Omaggio a Montale* by Mondadori. The Svevo-Montale correspondence, with Montale's writings on Svevo, also appeared in this year, as did the first of the *Xenia* poems, written in memory of his wife, which were to signal the beginning of a new stage in Montale's poetic career.

In 1967 Montale was named Senator for life, an honor occasionally bestowed on artists of great distinction by the President of the Italian Republic. *Satura*, his fourth collection, including all the 26 poems of *Xenia*, appeared in 1971. The flatter, more prosaic style of much of the work in *Satura* was continued in the metaphysical observations of *Diario del '71 e del '72*, published in 1973, and of the *Quaderno di quattro anni* (1977).

Montale retired as an editor of the *Corriere della Sera* in 1973, though he continued to write for the paper. On October 23, 1975, he was awarded the Nobel Prize for Literature. His address to the Swedish Academy, "Is Poetry Still Possible?", is included in this volume. *Sulla poesia*, a collection of his writings on poets and poetry, from which this book is largely drawn, was published in 1976, and in 1978 a collected edition of his poetry, *Tutte le Poesie*, including several previously uncollected poems, appeared. Einandi published a complete poems, *L'opera in versi*, with bibliographical annotations by Rosanna Bettarini and Gianfranco Contini, in 1980. *Altri versi*, which includes the work of Montale's last years as well

as uncollected poems from throughout his career, was published by Mondadori in 1981, as was *Prime alla Scala*, an edition of his music criticism. In press as of this writing is *Sulla prosa*, an anthology of his criticism of prose writers, and a collection of his writings on art is reportedly also planned.

Montale died on Saturday, September 12, 1981, one month before his eighty-fifth birthday. After a state funeral in the Cathedral of Milan, he was buried near Florence, next to his wife.

III

"Montale completed his apprenticeship with Lemaître, Taine, the philosophers of contingency, the *Essais de psychologie contemporaine*; he followed [Croce's] *La Critica*, the reviews of Boine and Cecchi, subscribed to *La Ronda*." Thus Giorgio Zampa, the editor of Montale's *Sulla poesia*, describes the intellectual background out of which Montale the critic emerged.[3] It is a classic forward-looking bourgeois amateur's formation, oriented toward France and the ideas of "decadent" modernism, but influenced too by the rigorous *italianità* of *La Voce* and *La Ronda*,[4] whose editors were trying to effect a rejuvenation of literary culture on native grounds. The most pervasive influence on the young Montale, however, as we see in "Style and Tradition" and elsewhere, was the idealist philosophy of Benedetto Croce, which could be called the forming spirit of liberal Italian intellectual life in the first part of the twentieth century.

Yet Montale soon declared his critical independence from these sometimes contradictory influences, showing, as Zampa says,

3. *Sulla poesia*, p. 609.
4. *La Voce* was a weekly cultural review concerned with contemporary moral, political, and philosophical issues, founded in Florence in 1908 by Giuseppe Prezzolini. After the departure of the futurists Papini and Soffici, who were to found *Lacerba*, *La Voce*, under the editorship of Giuseppe De Robertis, was an entirely literary review, concentrating on close reading of texts. Poets published in this period (December 1914–December 1916) include Jahier, Cardarelli, Onofri, Ungaretti, Sbarbaro, Apollinaire. *La Ronda* was a literary review (1919–1922) edited principally by Vincenzo Cardarelli, who advocated a severe classicist call-to-order in reaction to the immediacy and spontaneity of much contemporary Italian writing. Strongly nationalist, *La Ronda* favored a complex prose-poetry (its model was Leopardi's dialogues, the *Operette morali*) over verse as the vehicle for its proposed rejuvenation of *italianità*.

"the will and the capacity to confront the chosen or given subject directly, without screens, premises, or doctrinal bases." Though drawn to general ideas, he was clearly diffident about them, and in his criticism he tended to eschew theoretical formulations and to concentrate, as have his distinguished contemporaries Giacomo Debenedetti and Sergio Solmi, on a direct appraisal of the literary thing in itself. American readers will no doubt be reminded of the outlook of the New Critics who appeared at about the same time in American and English universities.

The direct, non-programmatic confrontation of the text is in keeping with the nature of Montale's prose style, which is one of great flexibility and concentration, and at the same time of apparent simplicity and ease. Italian, the most baroque of the Romance languages, had become weighed down in its critical as in its poetic discourse by a highly elaborate, etiolated rhetoric. Montale's radical renovation of Italian poetry was motivated by a desire to "come closer" to his own experience than the prevailing poetic language allowed him. As he writes in his famous 1946 self-analysis, "Intentions (Imaginary Interview)":

> "I seemed to be living under a bell jar, and yet I felt I was close to something essential. A subtle veil, a thread, barely separated me from the definitive *quid.* Absolute expression would have meant breaking that veil, that thread: an explosion, the end of the illusion of the world as representation. But this remained an unreachable goal. And my wish to come close remained musical, instinctive, unprogrammatic. I wanted to wring the neck of the eloquence of our old aulic language, even at the risk of a counter-eloquence."

A similar desire to "come closer" to "something essential" could be said to motivate the new critical directness achieved by Montale and his peers. Even in translation one can sense something of how quickly Montale sloughed off the excessive formality of the then-prevailing critical language to develop what Zampa rightly calls his "ideal spoken tone": a supple, allusive idiom rich in the momentary *aperçus* that often contain his most interesting ideas.

And this tone, once developed, has remained close to constant

through fifty years of writing. Though Montale's work as a journalist at a comparatively late point in his career encouraged him to write with even greater informality and fluency than previously, there was no real change in quality or method of thought or expression. His use of the brief, colorful *terza pagina* or page-three "feature" piece to express often far-from-popular opinions is brilliant, and entirely consistent with the "superior dilettantism" he espoused from the beginning of his career. A piece such as "A Visit to Braque," for example, tells us as much in its own elegant, idiosyncratic way about its writer's views on modern painting and the French cultural establishment as a more frontal essay might.

Montale's early critical work stuck close to the conventional subject matter of the professional poet-critic. With the exception of his "Report on the Cinema," which prefigures his ideas about the relationship of serious art to mass culture that he was to develop more fully in pieces for the *Corriere della Sera* in the fifties and sixties, the early essays deal primarily with Italian and French writers. A 1930 interview, "On Contemporary Poetry," shows Montale trying to communicate his own complex and creative approach to the problems of tradition and innovation, an issue central to his achievement as a poet and to his overall contribution as a man of letters. Most significant treatment of this theme, however, is "Style and Tradition" (1925), an early manifesto arguing for a revivification of the Italian poetic tradition from within, strongly influenced by Croce and comparable in some ways to Eliot's "Tradition and the Individual Talent" of 1919. As Arshi Pipa notes in his admirable study, *Montale and Dante*, "so perfect is the correspondence between [Montale's] objective and his own work that one is tempted to consider his youthful article as a literary profession of faith which he constantly stood by."[5]

Montale calls here for "the creation of a tone of voice, of a language of understanding that will bring us together with the crowd for whom we work unheeded, which will permit the use of implication and allusion and the hope of cooperation; the creation of a center of resonance which will allow poetry to become once

5. Arshi Pipa, *Montale and Dante*, p. 140.

more the pride and boast of our country. . . ." This will be accomplished through "concern[ing] oneself with concrete facts":

> We would prefer not to accept any mythology; but instead of the new ones which some would impose on us we would decidedly prefer those of the past which have a justification and a history. We would certainly take the splendor of Catholicism over a frenzied relativism and actualism. Instead of seeking frontiers too vast and horizons too distant, we would set our sights on the boundaries of our own country, the language of our people.

"Style and Tradition," with its acute awareness of the historical content of language, provides a context for viewing not only Montale's poetry but also his criticism, and indeed everything he has achieved in the arts. "The language of a poet is an historicized language, a relationship," he would write in "Intentions." "It is valid to the degree that it opposes or differentiates itself from other languages." Where many modern artists were to concentrate their whole efforts on opposing the art of the past, on creating something entirely "new," Montale was constantly aware of the further implications of what Walter Jackson Bate has called "the principcal dilemma facing the artist generally from the Renaissance to the present day."[6] Montale's solution to the problem of tradition, certainly one of the most successful solutions achieved by a poet in our century, involved an innovative appropriation of the Italian literary past to serve his own very personal contemporary purposes. To Pipa, who sees Montale's relationship to Dante as the central issue in understanding this aspect of Montale's achievement in renewing Italian literature, "he has continued tradition in poetry by recreating it, and this he has done by going back to its origin, where he has established contact with one who may well be called the father of the nation."[7]

For someone like Montale, working—and succeeding to an

6. Walter Jackson Bate, *The Burden of the Past and the English Poet.* Cambridge, Massachusetts: Harvard University Press, 1970, p. vii.
7. Pipa, p. 140.

astonishing degree—to redirect Italian literature toward what might be seen as a new classicism, the cataclysms of modern history as he experienced it through two wars and the Fascist regime could only appear profoundly destructive. "Substantially agnostic and with no political ideas to defend other than vague and old-fashioned liberal ones," as Pipa puts it,[8] Montale was in some ways an ideal citizen of the "liberal" prewar Italy of Giolitti, i.e., the Italy of the poet's youth. But the culture he describes in "Is There an Italian Decadence?" (1946)

> a culture like ours, in which history, and events, have always entered into the life of art indirectly, and only insofar as they have found the individual who knew how to give them a definitive form

had effectively disintegrated in the Second World War, to be replaced by a radically politicized society dominated by the struggle between the "red and black," Communist and Christian Democrat, clerisies. The role foreseen for culture on either side was, in Montale's view, excessively narrow if not perverse, and in fact ran counter to his understanding of the artistic function. "A Wish" of 1944, along with "Fascism and Literature" of the following year, had outlined what he hoped had been learned in the experience of Fascism and his dream for a cultural and spiritual renewal in Italian life. His disillusionment with and detachment from the postwar taking of political sides and his insistence on a broader understanding of the "relevance" of art were in keeping with his own bitter political education, and beyond that with his conviction that as a poet he suffered from or was equipped with "an inadaptability, a psychological and moral maladjustment which is part and parcel of every basically introspective personality, i.e., of every poetic personality." In the end, as an artist, his revolution was necessarily personal, not narrowly programmatic:

> Since from birth I have felt a total disharmony with the reality that surrounded me, the material of my inspiration could only

8. *Ibid.*

be *that* disharmony. . . . I *did* choose as a man; but as a poet I soon realized that the battle was taking place on another front, where great events that were then unfolding mattered little.[9]

The relationship between art and its social context was an important preoccupation for Montale the critic, particularly during the late forties when he began writing regularly for the *Corriere della Sera.* "Poetry and Society" discusses the relationship of art to the place that produces it, in this case the city of Trieste; while "The Cinque Terre" evokes the landscape of Montale's early poetry. Both of these essays are notable too for their uniquely Montalian blending of personal and general themes, while "Two Artists of Yesteryear" is interesting for its evocation of the aesthetic atmosphere in which the young Montale grew up. "The Second Life of Art" is a genial brief against the needless obscurity of much modernist work, and as such can be seen as an implicit defense against the charge of hermeticism sometimes directed against the author. "Two Jackals on a Leash," on the other hand, deals with critical blindness to true originality in art with a devastating ironic wit, the case in point being certain misreadings of two of Montale's *Mottetti.* The tone of this piece is echoed in "The Poet" and "The Intellectual," two examples of a series of brilliant send-ups of cultural types published in the summer of 1951.

Also dating from this period are a number of important essays on contemporary foreign poets, most importantly Montale's considerations of Eliot and Pound. After the modern French tradition, about which he has unfortunately written relatively little, Montale was most familiar with and influenced by English and, to a lesser extent, American poets, and his to us often unconventional views of our own poetic heritage are highly instructive. Browning, whose fusion of the prosaic with verse Montale has cited as an achievement to which all modern poets are indebted; Whitman; Hopkins; Dickinson; Hardy, whose poems on the death of his wife influenced Montale in the writing of the *Xenia*; Lawrence; and Auden are among the modern English language poets who have interested

9. See "Eugenio Montale: An Interview."

Montale deeply, and in fact in "The Way of the New Poetry," a review of an anthology of modern English poems in Italian translation, Montale declares that "These dismantlers of the spirit and language of a great literature, these poets of the contemporary crisis, are without a doubt, along with a few others from other countries and other languages, the only lyric poets of today."

Predictably, Eliot was of primary importance in our tradition for Montale.[10] Comparison between the two poets is inevitable, for both turn to a re-evaluation of tradition in their search for an authentic means of giving voice to the existential anxiousness of twentieth-century man. Both also share a similar, though independently developed, poetic method, in which an external fact or situation in the poem serves as the "objective correlative," in Eliot's words, for an emotional message. There are important differences between them, however, for Montale unlike Eliot could not find a resolution of his existential anomie in the acceptance of religious orthodoxy. Montale's skepticism is more pessimistic, as perhaps his humanism is less programmatic, gentler, and more broad-minded. Still, the two essays on Eliot in this volume attest to the English poet's significance for Montale as a renovator of tradition. He writes in "Eliot and Ourselves" that "Eliot, like Valéry before him has contributed, at least in Italy, to our contact with the great European tradition which has been lost for many years. They have recalled Italian readers to a less superficial familiarity with their poetic heritage, a more intimate sense of their classicism." Yet Montale has written elsewhere with a certain condescension toward Eliot's and Pound's "accelerated, night-school" course in European culture, and he has disputed what he sees, perhaps inevitably, as Eliot's superficial appreciation of Dante. The fact is that the European tradition to which Eliot turned for comfort was for Montale not a conscious acquisition but an inescapable inheritance. It was not only an immense—and immensely challenging—resource, but a problem, largely played-out and in need of renewal. In a sense,

10. Eliot had published Mario Praz's translation of Montale's *"Arsenio"* in *The Criterion* (VII), June 1928; while Montale's translation of "A Song for Simeon" appeared in *Solaria* (V, 2), in December 1929. It was republished in *Circoli* (III, 6), November–December 1933, along with Montale's versions of "La Figlia che Piange" and "Animula."

Eliot's problem, the need for roots, was the opposite of Montale's, and Montale's was undoubtedly the greater of the two, although his solution was related to Eliot's in that it involved radically re-accepting and reabsorbing his tradition instead of rejecting it. So, though their work shows some similarities, which led Eliot to call Montale "a kindred spirit," their kinship was limited by their different temperaments and by the different situations in which they were writing.

Montale's relationship to Pound was at once more familiar and less complicated, for he had met Pound at Rapallo in 1926 and saw him socially from time to time throughout the thirties. As the essays included here indicate, Montale found Pound's *Cantos* beautiful in parts but lacking in overall intellectual structure and perhaps in intellectual maturity as well. (The political differences between the two are obvious.) Montale doesn't seem to take Pound entirely seriously, because of what he sees as Pound's excessive subjectivity and the superficiality of his approach to the past. Nor did Pound's forays into Italian culture, such as his ill-fated edition of Cavalcanti, not to mention the "fluent incorrectness" of his Italian, improve Montale's opinion of him. Yet Pound's intimate relationship with Italy and Montale's personal association with him drew Montale to him almost in spite of himself, and there are more writings on Pound in *Sulla poesia* than on any other writer.

Montale traveled extensively for the *Corriere* in the fifties and sixties, visiting New York very briefly in 1950, and even accompanying Pope Paul VI on his trip to the Holy Land in 1962. In May of 1952 Montale delivered a noted address on the isolation of the contemporary artist, "The Artist's Solitude," at the International Congress for Cultural Freedom in Paris. An interview conducted with André Malraux on the same trip is revealing of Montale's somewhat grudging admiration for the French bourgeois cultural tradition, as is his "Visit to Braque" of the following year, while his portrait of Brancusi, whose lack of *urbanità* deeply offended Montale, is one of the few truly corrosive performances he has permitted himself.

A few appreciations of major Italian poets written in the forties and fifties are included in this volume, along with some im-

portant cultural essays, particularly "A Second Profession," which argues against government patronage of artists. Two interviews from the early sixties, in which Montale defends himself against charges of aloofness from contemporary society, are also highly significant. The most important contributions of the sixties, however, are considerations of three of the commanding figures in Montale's life as an artist. "Itàlo Svevo in the Centenary of His Birth" is Montale's most extensive and complete consideration of the Triestine novelist, and for that reason is presented here instead of the early, historically significant essays. "Aesthetics and Criticism," an address delivered at a celebration honoring the memory of Benedetto Croce in 1962, underscores the philosopher's importance for Montale's generation both as an intellectual influence and as a symbol of integrity and moral courage in a dark period. Though he takes exception to certain aspects of Croce's understanding of the creative act, the philosopher's profound humanism is clearly an important source for Montale's own moral attitudes. As he writes, Croce's

> faith in man, his certainty that the forces of reason will never be definitively vanquished, will never find us indifferent. Even more than his aesthetic . . . it is his incitement to moral responsibility, to paying one's own way, which today, beyond any political or religious conviction, makes us feel the force of his presence.

Finally, in 1965, Montale turned his attention to the fundamental formative influence on his own poetry in a speech closing a celebration in Florence of the 700th anniversary of Dante's birth. The address is an attempt to come to terms with the meaning of Dante's work for a modern writer, not a poet, for, as Montale puts it, "compared with Dante there are no poets." Montale criticizes Eliot's simplistic approach to the problem of belief in the *Divine Comedy* for a modern reader, but does not directly discuss his own relationship to its author. Yet Montale's clear familiarity with and reverence for Dante attest to a depth of attention different from anything else in his criticism, and the reader cannot fail to

infer Dante's overwhelming importance to Montale's views of the artist and his relation to his society.

The final selections from the late sixties and seventies include a number of memoirs and tributes for friends and fellow poets: Bobi Bazlen, Camillo Sbarbaro, Ungaretti, and Pound. Last of all comes the Nobel Prize address, which reiterates Montale's views on the predicament of art in mass society.

Montale stands, in this writer's view, as one of the great modern continuators of our humanist tradition. He succeeded in his poetry in reviving the oldest European lyric tradition through a radical, creative appropriation of its fundamental resources, transforming them to suit his own needs and the needs of his own time. Similarly, in his work as a critic Montale sought to carry out what he described in "The Magnificent Destinies" as the duty of the intellectual: "to see that some of the best of the past survives into the future." His profound familiarity with his tradition has been coupled with a critical intuition of what within that tradition can speak to contemporary man, can be useful to him. "The second life of art, its obscure pilgrimage through the conscience and memory of men, its entire flowing back into the very life from which the art itself took its first nourishment" was what interested him as a critic. Montale's classical sense of the necessity of the past, of knowing it and making it a part of the present, coupled with his awareness of the critical nature of his own moment, provided him with one of the most profound perspectives on modern culture that any writer has given us. Anyone concerned with the role of individual expression in organizational society will recognize him as an indispensable spokesman for the odd, uncooperative single man who insists on bearing witness to his own peculiar vision, whatever the consequences.

Oppression has always fostered art; in fact, as Montale himself suggested, it may be that the discouragement provided by adverse conditions can give rise to the need and even to the capacity for expression that is more than merely personal, that speaks to man at large. We need only mention names such as Mandelstam, Akhmatova, Celan, and Milosz to be reminded what totalitarianism

has contributed to the poetry of our century. Montale's work, too, might be seen, from one point of view, in this light. As he himself makes clear, however, this is only part of the story. The writer's quarrel with the world is always fundamentally personal; if it is profound enough, it may also be universal. It is his complex understanding of what the personal and the social, of what the historical and contemporary truly are, that lies at the heart of Montale's vision and of his lesson for us.

<div align="right">

—*Jonathan Galassi*

</div>

On Culture & Society

Style and Tradition

[Published in *Il Baretti* (II, 1), January 1925. This essay, which may be seen as the artistic credo of the young Montale, was written when he was twenty-eight and strongly under the influence of Benedetto Croce's idealist, historically-grounded philosophical and literary program. (See "Aesthetics and Criticism" for a consideration of Croce's importance for Montale's generation.) Piero Gobetti's review *Il Baretti*, published in Turin from 1924 to 1928, followed his earlier *Rivoluzione liberale* (1922–1925). Gobetti (1901–1926) was a leading liberal, anti-Fascist intellectual and the publisher of Montale's first book of poems, *Ossi di seppia*, which appeared shortly after the publication of "Style and Tradition." *Il Baretti* was named for Giuseppe Baretti, the most important Italian critic of the mid-eighteenth century. His review, *La frusta letteraria (The* Literary Whip), was published in Venice from late 1763 to early 1765, when it was suppressed, with the express intention of "applying the whip to the backs of all these modern boors and evildoers, who spend every day scribbling." Baretti used the pen name Aristarco Scannabue in *La frusta letteraria*. Gobetti was exiled to France in 1926 and died in Paris soon thereafter, a victim of Fascist persecution. (See also "Intentions: Imaginary Interview" and "Introduction to a Swedish Translation of His Poems.")]

I have been very pleased to note that in the first number of this review, the director of *Il Baretti*, along with words of condemnation (both his own and others') for our recent spiritual and literary past, has made mention of rare spirits and original individuals with whom there is no doubt that we must join forces; and that he has also noted his wish to maintain, recover, and discover allies. If it is inevitable that the writers in the new reviews assume an attitude of polemic and condemnation in regard to the bad habits of the past, as men of letters and, at the same time, believers in new faiths and new hopes, it is equally certain that in such proceedings and indictments it is difficult to maintain proportion and not give in to rashness or imprecision.

All of us are aware of the problematic and programmatic writings that have often lighted our vigil; the ideological, or even barely verbal, scuffles—*verba sesquipedalia*—which have often distracted and deluded us on our way. To avoid the imprecise, to set ourselves limits and concrete plans, even if they be modest—this is the great difficulty which a literary review faces, today more than yesterday; particularly a review like this one, which has not been afraid to follow explicitly the teachings of that master of clarity, Croce. When we think of him and of the still uncertain and controversial fruits of his teaching, which in many ways we accept for our own, it is difficult indeed to resist the temptation to make ourselves into historians and judges, if not executioners, of the present.

The problem of tradition is the problem common to all of us, and to pose it clearly is in itself a difficult undertaking, which would bring us halfway toward a solution. But we are a long way from this.

How much reality and how much illusion are there in our tendency to make ourselves critics and judges of our time? Lack of perspective, personal emotions and experiences, present us with obstacles on all sides. We do not know how much is caprice and how much is truth in our cultural stock-takings and judgments, in the impulses which drive us to make our most uncontrollable whims into laws and imperatives. The concept of tradition which guides us, the aims of clarity and concreteness which we draw from Croce's teaching, for example, are very clear and, for us, definitive, as far as the problems of culture and criticism and the program of work for the future involving them are concerned. There is work enough here for more than one generation; and yet there is already talk, around and about, of casting aside the certain in favor of the uncertain. If the poets have lost faith in language, the critics, who do not want to do less, are giving themselves up either to Providence or to Freud and contingency; in all of them there is a great disdain for art and a clear desire to fish in troubled waters.

A first duty then could lie in the search for simplicity and clarity, at the cost of appearing impoverished. In Italy there is practically no literature that is civilized, refined, and popular at the same time, and there never may be; it is lacking precisely because a

median society, a familiarity with non-vulgar attitudes, a habit of them, is lacking: i.e., a widespread intellectual well-being and easiness without great heights or vast depths. One must therefore work in solitude, and for a few: beyond, there is only coarseness, and not only bourgeois coarseness, but the other kind, varnished over with culture and self-satisfaction.

The widespread and barely concealed disrepute in which the man of letters and the intellectual are held in our country cannot be the ultimate cause of the great desire which our rising writers evince to align themselves with profound philosophers, above the fray. But in reality there is no better way of demonstrating one's philosophical cultivation today than to forget it and to concern oneself with concrete facts. We would prefer not to accept any mythology; but instead of the new ones that some would impose on us we would decidedly prefer those of the past which have a justification and a history. We would certainly take the splendor of Catholicism over a frenzied relativism and actualism. Instead of seeking frontiers too vast and horizons too distant, we would set our sights on the boundaries of our own country, the language of our people. Too much work is left to be done today for these leaps in the dark to tempt us; though—apart from the well-defined larger historical tasks which Croce's example has set us—it is thankless work, dark and joyless: the creation of a tone of voice, of a language of understanding that will bring us together with the crowd for whom we work unheeded, which will permit us the use of implication and allusion and the hope of cooperation; the creation of a center of resonance which will allow poetry to become once more the pride and boast of our country, no longer a solitary individual shame.

In all of this, which can certainly form the basis of agreement for a prolonged activity which we shall certainly not see finished, it is clear that we are still within the realm of criticism and culture. As far as poetry, the secret and constant preoccupation of so many, is concerned, there is much less light, for in the end the concept of tradition that is being invoked, and with justification, on many sides is less helpful to us here. Where tradition is understood not as a dead weight of forms, of extrinsic rules and customs, but as an inner spirit, a genius of the race, a consonance with the most endur-

ing spirits that our country has produced, then it becomes somewhat difficult to suggest an external model for it or draw a precise lesson from it. Tradition is continued not by those who want to do so, but by those who can, sometimes by those who are least aware of doing so. Programs and good intentions are of little help in this regard.

We maintain that our era has begun in some ways to find its own voice and to express itself, and we believe we can assert that the best writers of today will one day be best seen within the context of our country's history; which does not exclude them from their place as citizens of Europe. Meanwhile, however, this day-to-day existence has seemed too precarious to some. That is, it has been noted that the problem of style understood as something organic and absolute, as the supreme moment of literary creation, still remains at the point where Manzoni and Leopardi left it; and that since them there has seemingly been only debasement, compromise, dialect, and falsetto.

It cannot be denied that there is some truth in this discouraging picture; just as it is clear that the exaggeration of its significance has led to incredibly out-of-date and vague results.

It has not been kept sufficiently in mind that Manzoni marked the point of arrival of a secular branch of Catholic culture; that Leopardi himself would be incomprehensible if we did not know the exceptional humanist and rationalist elements in his education; and that, before them, the Foscolo who translated Sterne and composed the *Grazie* was already close in spirit to a certain superior dilettantism[1] of today.

Since not even men like these were able to remain long on the summits they conquered, how dangerous it should seem to us to isolate and idolize a few crystalline unrepeatable moments of their art, considered in the abstract and apart from the body of work which they crowned and justified.

If, having reached these heights, it was necessary for them to return to the plain, this is not a valid reason to deny significance to the writers who followed. We have seen contemporary poetry make

1. Montale's use of *dilettantismo* is not pejorative, but refers to a modest, private devotion to an art, in contrast to the grandiosity of the public, quasi-"official" turn-of-the-century artist.

use of a more communal tone, with undeniable, concrete results; and one after another we have seen the failure of the bolder *trovatori*, who sing in universals and ingenuously repeat the formulae of the past which they have taken for extrinsic realities valid in themselves. More than these, who make use only of the externals of traditional style—and nothing else is possible in this respect unless new historical conditions give rise to new beliefs—more than these, we say, those who seem to us to be within the tradition are those who, reflecting in their work the characteristics of our complex and difficult age, tend to a superior dilettantism, rich in human and artistic experience.

In Italy—as others have already observed—few understand what a first-class dilettante can be; and this, too, can be blamed on our scant degree of culture—and not only in literature. For our part, we would consider ourselves lucky if in our work we could contribute to the development of a cordial atmosphere of allusion and understanding in which a mode of artistic expression, albeit modest, could develop without misinterpretation. Instead, we are still waiting for the Messiah, who will not come.

The truth is otherwise; and it is that, whether or not the new art will develop out of our current critical torment, it will not be *ours* if it does not respond to the most pressing needs that have arisen in us. Its simplicity will have to be rich and vast; for he who does not feel that his faith in ingenuous prophets is on the wane is credulous indeed. Today we may be detained by condemnations and accusations, but no one, without feeling impoverished, could imagine giving up certain notes in the air which represent entirely whatever small wealth we have accumulated.

Style, the famous total style which the poets of the last illustrious triad[2] did not give us, sick as they were with Jacobin rages, Supermanism, Messianism, and other wasting diseases; style perhaps will come to us from the sensible and shrewd disenchanted, who are conscious of the limits of their art and prefer

2. A received notion of nineteenth-century Italian poetry was that great poets came in threes. "The last illustrious triad" referred to by Montale is Carducci, Pascoli, and D'Annunzio. Before them there had been Foscolo, Leopardi, and Manzoni. The most recent triad in Italian letters is generally considered to include Ungaretti, Saba, and Montale.

loving it in humility to reforming humanity. In times which seem marked by the immediate utilization of culture, by polemicism and diatribe, our salvation perhaps lies in useless and unobserved labor: our style will come from good usage.

If it has been said that genius is one long patience, we should like to add that it is also conscience and honesty. A work born with these characteristics does not need much more to reach to the most distant of ages, like Vigny's *bouteille à la mer*.

It is clear that we must do everything we can to safeguard what has been realized up to now, the three or four points of understanding which are in danger of being erased and cast aside. In this common minimum of a program there is work for our entire generation: we have no time for dissension, outrageous positions, or cabals.

Certainly the reincarnated Aristarco-Baretti will leave these luxuries to the writers of tomorrow, more fortunate than ourselves. As for now: "Happy New Year, Scannabue."

A Wish

[Published in *La Nazione del Popolo*, Florence, September 19–20, 1944.]

This is a wish, not a manifesto; or perhaps it is an invitation. We would like to see Italian art and science, within their own particular and very different limits, abandon every suspect agnosticism, give up for good the habit of tying the dog where the master of the moment wants it, and begin again to serve freely those irrepressible moral and material, economic and ethical forces which finally, sooner or later, will make our continent into a united federation of free workers' free States.

Note that we mean "serve" in the sense of being useful, not of enslavement; and being useful freely, that is, without sacrificing that measure of luck, serendipity, and contingency which puts a human stamp on art and science. Certainly, it is not difficult for anyone to understand that art and science, though they are different and perhaps even opposite by nature, are united in the final analysis by a common principle of formal, rhythmic, stylistic order. But it is hard to determine theoretically how to activate this principle in which necessity and gratuitousness, the face of history and the face of man, seem to be ensnared and compromised in turn, thus confirming what a truly exceptional thing is the universal activity of the single man, the infinity of the limited individual. There is an art which comes to life with the heat and immediacy of a document; only later does posterity manage to decant it, denude it, and take its "style" from it; but there is also an art which is born already sealed, embalmed, perfected—an art in which it is possible to recognize a human aspect only after many years.

The way of the sciences is no less strange, especially the physical and mathematical sciences (so closely resembling poetry) in

which genius and routine, the creative spark and its material, utilitarian application, blend and condition each other, alternating unpredictably. But doubts or verifications of this sort—as perhaps it is pointless to mention—can limit the activity of the artist or scientist little, if at all; as they can hardly make us doubt our direct experience of the fact that art and science today are worthwhile to the extent that a force superior to ourselves is expressed in and through them. This force is no longer the dark irrationalism, the fury of activity which Nazism-Fascism and its pseudo-cultural manifestations (a degeneration of idealism in philosophy) hoped to make into a justification and a standard. It is simply the old battle of good and evil, the struggle of the divine forces fighting in us against the unchained forces of bestial man, the dark forces of Ahriman. Thus in us and through us a divinity is brought into being, earthly at first, and perhaps celestial and incomprehensible to our senses, which without us could not develop or become cognizant of itself. And because of this, we must simply say no to every exploitation of man by man, to every lie of a reaction cloaked in the cult of order and the return to the antique, to all the too-easy one-dimensional certainties prompted by immediate advantage. We must simply say no: we must act so that a betrayal by the intellectuals will no longer be possible on a vast scale. Do you remember the famous manifesto that was signed, almost twenty years ago, by an impressive number of Italian scholars and artists?[1] After a few years, precious few of them still kept the faith, still honored their signatures. The others—the majority—*turned*, the way bad wine does in the fall.

This must never happen again in Italy. Until every danger has been averted, intellectuals must not relax an intransigence which we could wish were Manichean, even, in respect to moral values; and an attitude in the realm of art which we would hope was realistic in its method and its forms, but of an essential and even existential significance in the ultimate and higher sense. Only when we have attained this attitude and not before, will it be possible for us to rebuild, to broaden ourselves, to go in new directions, to forget the incubus if we can. In the war which may be about to

1. See Note 12 to "Fascism and Literature."

cease—at least its great battles if not its spirit, which is the spirit of a revolutionary, civil, intercontinental war—it was relatively easy for us Italians to orient ourselves from the beginning. Even against our apparent interest, it was easy to intuit that the war would be lost *by those who were in the wrong*; that is, by the side on which our country was then fighting. But imagine a war of the worlds for our children or grandchildren in which that kind of certainty was lacking; imagine a war devoid of every orienting light due to a vast betrayal on the part of the intelligentsia, a war which seemed like nothing more than a toss of the dice on the green table of history. This must not occur, at least not through any fault of ours. Otherwise, the many wounds that have defaced and defiled our country may well not be the last nor the worst.

Fascism and

Literature

[Speech delivered in Florence, March 15, 1945. Published in *Il Mondo*, Florence, April 7, 1945.]

The question of the relationship of Fascism to our literature was debated in Italy almost two years ago, in the memorable period of Saturnalia that followed the 25th of July, 1943.[1] Had Fascism left its mark in this field? Did Italian writers deserve freedom? And how would they use it tomorrow? There were opinions and counter-opinions, condemnations and absolutions, cries of hosanna and crucifixion, and the idle argument, which has now begun again, went on until the 10th of September that year, when it was swallowed up in a sequence of tragic events, not just a sea of gossip. One could have reminded those who posed the problem in such summary terms then of one obvious fact: that just as our language has been the slowest to evolve among the great literary languages of Europe, so our literature has been, and probably will remain even after Fascism, the most static, the most indifferent to the contingencies of life, the least faithful interpreter of the times in which it is written. And once we have admitted that this is its nature, without trying to explain or justify it (in this respect), if anyone asks us whether Fascism succeeded in leaving a deep imprint on our literature or in changing its course, its sense and direction, we can only answer no. Fascism has left no positive mark on our literature, no notable book or author, though it tried to create—

1. Mussolini's resignation was accepted by the King of Italy on this date. On September 10th, the Allies invaded the South.

or destroy—something, in fact a great deal. Mussolini, a yellow journalist and failed serial novelist (as his *Amante del cardinale*[2] reveals), but also a man who had read widely and diversely, was all too aware that the new political order he had proclaimed would be less than nothing if a truly original and significant literature did not arise to support it, to speak from the heart of its origins, *raison d'être*, and importance, and not only polemically. Fascism had to mean a new life in the arts and literature, too, or it would have no concrete spiritual significance. What was needed, then, was a literature in step with the new times; but what should it be like? Since Italian writers, who have always been inclined to shut themselves up in their ivory towers, were not thinking about it, and not all—or even many—of them seemed inclined to regale us with a series of biographies of our *condottiero*, the Providential Man was obliged to think about it himself, dictating themes, organizing panels, awarding prizes and stipends to the well-behaved, and reporting those who allowed themselves an exaggerated independence of sensibility and judgment to the "appropriate authorities" for disciplinary action. One had to be "in line"; in the line indicated first by the Printing Office, then by the Ministry of Propaganda, which later became the Ministry of Popular Culture, and finally, but with great selectivity, by that institution created by Fascism to keep the poor Italian man of letters on the hook, the Italian Royal Academy.[3] But the "line," in spite of so much effort and expense and racking of brains, was hard to make out. What, officially, was the duty of the Italian, i.e., the Fascist, writer? It's hard to remember, for "planning" of subject matter, as the Soviet RAPP[4] did, could not and did not occur in Italy: Fascism had to have an heroic

2. Mussolini's anticlerical novel *Claudia Particella, l'amante del cardinale* was serialized in *La Vita Trentina* in 1909.
3. Founded 1926 on the model of the Académie Française, inaugurated 1929. Originally intended as a new body to oppose the existing Italian academies, it absorbed the Accademia dei Lincei in 1939. It was suppressed in 1944 and the Accademia dei Lincei was reconstituted. The Italian Academy's presidents included Marconi (1930–1937), D'Annunzio (1937–1938), and Giovanni Gentile (1944).
4. *Rossijskaya Associacia Proletarskich Pisatelej*, Russian Association of Proletarian Writers, 1925–1932. Political-literary organization designed to combat bourgeois ideology in letters. It was suppressed by the Central Committee in 1932.

morale, it had to "explode" and expand the narrow limits of the little Italy of Umberto and Giolitti[5] in both time and space. What was needed, therefore, was a constructive, Roman, imperial litera- ture, which would stamp the mark of the era of Mussolini in bronze. Who could provide it? D'Annunzio had put away his bus- kins and trumpet years ago; his Corrado Brando,[6] his songs from across the sea,[7] belonged precisely to the period of Giolitti's deprecated liberal, bourgeois Italy, and were not at all representa- tive of the best of his art. The Comandante lived privately as a prisoner at Gardone, collecting fabulous subsidies and only rarely threatening some show of independence. A servant of the new master, how could he have rebelled? He paid his tribute in a few harangues, a few oratorical passages, a few rare missives to his big brother Benito; and then he was silent. And no one, certainly not the much-discredited Marinetti,[8] could take his place as the poet- *vates*, the incarnated spirit of imperial Fascism. The attempt was then made to suggest other themes for Fascist writers: the battle for grain, maternal fertility, Italian workers abroad; there were competitions for colonial novels, for poems with a social rather than individualist or introspective impetus. But it was all in vain: no notable writer emerged, not one memorable page came to light. To be called a Fascist writer, then, one had only to be openly loyal to the regime, or better yet, openly flatter its founder. One woman alone was admitted to the Italian Academy; she had described the beautiful hands of Il Duce at length in the *Corriere*! A playwright of widespread fame who was anything but in line in his essential

5. Umberto I was King of Italy from 1878–1900. Giovanni Giolitti (1842– 1928). Five times prime minister in the period 1892–1921, Giolitti was widely acknowledged, by Croce among others, as the leading architect of liberal democracy in Italy before World War I. Salvemini, however, denounced him as *il ministro della mala vita* [The minister of the underworld] (1910) for his authoritarian and cynical governing methods.
6. Protagonist of D'Annunzio's 1906 tragedy, *Più che l'amore* [*More Than Love*]. A personification of the Superman, Brando is an African explorer who does not hesitate to commit crimes in order to obtain funds for his mission.
7. *Canzoni della gesta d'oltremare*, oratorical, patriotic poems published by D'Annunzio in 1912.
8. Filippo Tommaso Marinetti (1876–1944). Poet, leader of the futurist move- ment, an early exponent and celebrant of Fascism. Member of the Italian Academy.

inspiration, Luigi Pirandello,[9] associated openly with the regime after the murder of Matteotti[10] (and he later came to regret it); and because of his gesture he was among the first to be made a member of the Academy. But the academicians themselves, once they were safely in under the shadow of the *feluca*,[11] didn't try very hard to keep in line as desired: they continued to be intimist or crepuscular or elegiac—they collected their stipends and maintained privately that art was "something else," that politics had nothing to do with it. They were academics or generals in the militia—or both—and wrote books called *Short Pants, The Paradise of My Sadness, The Smell of Good Herbs. . . .* A veritable scandal! So that it was soon allowed that Fascist writers (the only writers who could win literary prizes, for example) were card-carrying writers, and anti-Fascist or non-Fascist writers the few others who had kept out of the party. There was a census of the two groups in 1925, when Gentile[12] issued his rash proclamation, which found a small number of adherents, and Croce answered him with a manifesto signed by hundreds of intellectuals and writers. But from a, shall we say, statistical viewpoint, the usefulness of this lineup was short-lived, for there were rapid conversions from one camp to another, changes of heart and desertions, and only a few, particularly among the "artistic" writers, maintained a consistent, coherent attitude. Fascism had been unable to create a truth of its own, but it had seriously undermined the enduring truth, the truth hidden in

9. (1867–1936). The playwright was elected to the Academy in 1929. He won the Nobel Prize for Literature in 1934.

10. Giacomo Matteotti (1885–1924). Elected Secretary General of the Socialist Party in 1924, he was one of the most outspoken opponents of Fascism. After a powerful speech in Parliament (30 May 1924) he was kidnapped along the Lungotevere in Rome on June 10th. His body was discovered on August 15th of that year.

11. The cocked hat worn by the Fascists.

12. Giovanni Gentile (1875–1944). Philosopher and educator. Originally a collaborator of Croce's, he later became a leader in establishing an intellectual basis for Fascism, to which his interest in the shoring up of family values drew him. His "Manifesto of Fascist Intellectuals" was published in April 1925 and was signed by 250 intellectuals, including Pirandello, Ungaretti, Soffici, Panzini, etc. On May 1, the "Manifesto of Anti-Fascist Intellectuals" organized by Croce was published, with the signatures of several hundred artists and intellectuals and a far more distinguished list of adherents.

the hearts of everyone which waits to be rediscovered from generation to generation. It had covered the walls with idiotic inscriptions and sown nothing but skepticism, moral indifference, and base opportunism. The few endowed with the true second sight of art, which is always discriminating and cannot do without the sense of good and evil, remained immune from it; as did others, not artists in the strict sense, who because of their origins, education, or background—and Croce and Salvemini[13] were their principal masters—had been called upon to act, struggle, and suffer for all, that the thread of truth not be broken and the true, profound history of our country not suffer interruption. We are grateful today to men like Amendola and Gobetti, Gramsci and Rosselli[14] (to mention only those who are no longer with us), engaged writers rather than artists, who by their work and example were able to show us the path that a universal Italian, a citizen of the enduring Italy, must follow in times of darkness and error. Their teaching was not in vain, for today there is already quite a long list of young and not-so-young men—from Ginzburg to Pintor and from Colorni to Labò[15]—who, in facing torture and the extreme sacrifice, cast an heroic light on the field of our literature and culture.

The literature of the "artist," of the man who confronts his own destiny and the human condition, clearly was capable of reflecting

13. Gaetano Salvemini (1873–1957). A leading radical and hence anti-Fascist historian and writer on politics, he went into exile in 1925. Salvemini was Professor of History at Harvard from 1933 until 1948, when he returned to the chair of history at the University of Florence.

14. Giovanni Amendola (1886–1926): Liberal politician, murdered by the Fascists. Piero Gobetti: See introductory note to "Style and Tradition." Antonio Gramsci (1891–1937): Italian Communist Party leader, author of the famous Letters from Prison. Condemned to twenty years in prison in 1924, he died in 1937. Carlo Rosselli (1895–1937): Socialist writer and editor and a leading anti-Fascist collaborator. A student of Salvemini, he became a leader in Giustizia e Libertà [Justice and Liberty], a clandestine anti-Fascist organization founded in 1929 with Ernesto Rossi. Rosselli and his brother Nello, an historian and politician, were assassinated in France in 1937.

15. Leone Ginzburg (1909–1944): Russian-born writer, editor, and participant in Giustizia e Libertà. Arrested in 1943, he died in prison. His wife, Natalia, is a noted writer. Giaime Pintor (1919–1943): Writer and translator. An active anti-Fascist partisan, he was killed in combat, aged twenty-four. Eugenio Colorni (1909–1944): Teacher of philosophy in Trieste and Socialist Party leader, murdered in 1944. Giorgio Labò (1914–1944): Architect and partisan, shot by the Germans in Rome.

the times to a lesser extent. If we had a political dictator in Mus-
solini, and a still-powerful orientator in the field of aesthetic
thought in Benedetto Croce, we did not have a dictator in poetry
who could at the same time both guide and control our spirits.
Even though they could rarely confront the Fascist fury in any
direct way, novelists and poets were free in a sense, in that they did
not suffer excessive impositions; they were less free, slaves even, if
one thinks of how much of themselves they had to suffocate and of
the limitations they had to impose on themselves so as not to incur
excommunication and be deprived of any possibility of earning a
living. In essence, one could put the plaint of adolescence or one's
grandfather's slippers into prose or verse, or confabulate some long
drawn-out nineteenth-century story; one could converse with one's
own transcendent ego in the convoluted style of the new *trobar
clus*;[16] but in no way was it permitted to react directly to one's own
time, to criticize it, denounce its ways, deride its defects. Or rather
it was permitted only in a softened form, to the spoiled children of
the Fascist Superstate. And therefore it was a time of intimist prose
writers, exquisite essayists, ascetic, fakiresque poets—who were
sometimes also sincere, but more often echoed other experiences.
We cannot judge them, particularly not here. A few names, cer-
tainly, go beyond the limitations I have indicated. These are artists
whom Fascism found already developed and mature, who because
of their capricious temperament and solitary ways of life were not
easy targets. It was impossible to shoot at the man of smoke,
Perelà,[17] though he turned out to be not precisely "in line" as
desired; it was hard to raise questions about the tendencies of a
Pea's[18] Versilian feasts and rhapsodies; while the racial laws were
enough to remove the resurrected novels of Italo Svevo, which
were not of the Fascist period, from circulation.

And the poets were even more elusive. Where does orthodoxy
end and the impermissible begin in the lyrics of two poets as politi-

16. Provençal expression meaning "to poetize in a closed fashion," used to
characterize the intentionally difficult style of certain Provençal poets, e.g.
Arnaut Daniel.
17. Protagonist of the novel *Il codice* [*The Codex*] *di Perelà* (1911) by Aldo
Palazzeschi, later reissued (1954) as *Perelà uomo di fumo* [*Man of Smoke*].
18. Enrico Pea (1891–1958). Narrative poet and dramatist, influenced by
D'Annunzio. He wrote in the Versilian dialect.

cally different, and opposite, as Ungaretti and Saba? The "Printing Office" didn't have spectroscopes suited to this kind of analysis. And since few men of the Fascist era didn't have to read so much as act and live dangerously, they came to the conclusion that literature was a thing of the past; it was Oriani and D'Annunzio, it was Beltramelli and the early Pascarella, and even the early Panzini; and, perhaps, for reasons of prestige (where the Nobel Prize was concerned) even Pirandello and Deledda;[19] but today it was a dead thing and no one felt the need for it any more. Fascism, thus, was an unfavorable climate for poetry and creative literature. Only from its exiles could we have expected a notable contribution, but Silone[20] remains an isolated case, and, with the exception of a few political writers, the boundaries of our literature in the last twenty years, even geographically speaking, have been those of Fascist Italy. But does poetry need a favorable climate? Does it need "encouragement"? It seems permissible to doubt this. No regime has encouraged literature (albeit bad literature) as much as the Fascist regime; and the results are there for all to see. We are expecting other and better results from the *discouragement* that these twenty years have forced on the best and worthiest, on those (be they young or grown) who may not yet have said their piece. In these men, or in the few who have lived bitterly the tragedy of the Fascist dictatorship, lie our faith and hope. It is useless to wait for the work of a new generation who will find the way clear after the slate has been wiped clean of the errors that have been made. Experience is personal, it is not communicable through hearsay or the mediation of culture. It is necessary for those who have offered to speak and express for themselves and for us all the drama and the will to rebirth of our time. Only then can Italian literature—

19. Alfredo Oriani (1852–1909): Post-romantic nationalist imperialist novelist, whom Mussolini recognized as his master. Antonio Beltramelli (1879–1930): Fascist novelist, influenced by Oriani and D'Annunzio. Member of the Italian Academy. Cesare Pascarella (1858–1940): Roman dialect poet, a romantic historical writer influenced by Carducci. Elected to the Italian Academy, 1930. Alfredo Panzini (1863–1939): Noted novelist, student of Carducci. Founding member of the Italian Academy. Grazia Deledda (1871–1936): "Decadent" novelist, awarded the Nobel Prize for Literature in 1926.
20. Ignazio Silone (1900–1978). Noted left-wing novelist, author of *Fontamara* (1930), *Pane e vino* [*Bread and Wine*] (1937), and other works. He went into exile in 1928, eventually settling in Switzerland.

which is alive today only in flashes and glimmerings insofar as it reacts to our time and not as it interprets it directly—only then will our fiction, our poetry, our artistic prose, win again in Italy and abroad the recognition which in fact they deserve. Italy is without a doubt the country in which the cult of the irrational, the exasperation of the ego, the theories of art as pure magic, suggestion, and allusion—in a word everything meant by the abused term "decadence"—have done the least damage. Whatever in these theories has entered our house has changed appearance, been tempered, become truer. And Italy has remained more than a humanistic, a human country through its many trials. Her gift to Europe will be great indeed if she can continue in this direction; the prestige that a new democratic Italy could regain throughout the West would be unequaled if she can remember to remain, and remain in her art as well, an ancient country, civilized and Christian, and not aspire to the easy crown of neo-barbarian babble and acrobatics. This time hers could be a conquest truly destined to endure, not a *papier-mâché* empire doomed to collapse at the first opposing breeze.

The Second Life
of Art

[Published in the *Corriere della Sera*, Milan, May 28, 1949, under the title
"*Tornare nella strada*" (Back into the Street).]

The so-called divorce between contemporary art and the public
is not a recent development. Even fifty or a hundred years ago—
and one could go back much further—there was an art for the few,
for initiates. Leopardi and Baudelaire failed to win enthusiastic
recognition in their lifetimes, and Manet had to slap one of his
denigrators to turn him into his devoted servant and patron. Never-
theless, the initiated public in the last century was still a public,
not a crowd of failed artists. Those who approached *Parsifal* and
the *Ring* cycle at the end of the nineteenth century studying pon-
derous "thematic guides" and following the leitmotivs with their
fingers were lawyers, doctors, businessmen, not always failed
musicians or poets.

Today, it is no longer thus. Only the professional (whether he
is failed or not), only someone "in the field" can hope to be, I won't
say entertained, but less frightened by certain forms of art which
refuse categorically to take shape too visibly or perceptibly. Go and
hear Arnold Schönberg's *Ode to Napoleon*: a man recites (bad)
lines of Byron in stentorian tones. His cries succeed—and fail—at
overcoming a sea of intestinal rumbling and dissonance which do
not engender surprise so much as tedium, for the ear quickly be-
comes accustomed to the new tones, the new false notes. The piece
goes on and on, but it does not live during the performance, nor
can it hope to do so afterward, for it does not affect anything that is

truly alive in us. If this example doesn't suffice, try reading an "uninterrupted" poem by Eluard, or worse, by one of his followers: you will find pages composed of strings of adjectives, hundreds of them, without a single noun; you will find poems in which each line moves on its own, has a meaning in and of itself, but is not linked to the others. The syntax is nonexistent, or it is confined to a level that is not only extra-logical but extra-intuitive. At the most, it is sustained by a mechanical association of ideas. The reader has to create the poetry for himself; the author has not chosen for him, has not willed something for him, he has limited himself to providing a possibility for poetry. This is a great deal in itself, but not enough to stay with us after the reading. An art which destroys form while claiming to refine it denies itself its second and larger life: the life of memory and everyday circulation. I will try to explain what this second life of art is so as not to be misunderstood.

It is true: the work of art that is not created, the unwritten book, the masterpiece which could have come into being and did not, are mere abstractions and illusions. A fragment of music or poetry, a page, a picture begin to live in the act of their creation but they complete their existence when they circulate, and it does not matter whether the circulation is vast or restricted; strictly speaking, the public can consist of one person, so long as that person is not the author himself. Everyone is agreed on this point; one must not make the mistake of believing, however, that the appreciation, or consumption, of a particular expressive moment or fragment must necessarily be virtually simultaneous with its presentation to us, in an immediate relationship of cause and effect. If this were so, music would be enjoyed only in the moment in which it is played, and poetry and painting only in the moment when the eye rests on the printed page or the painted canvas. Once the cause, the narcotic, was gone, everything would cease; *si charta cadit*[1] every glimmer of music or poetic feeling would necessarily vanish into nothing.

I do not say that many modern artists consciously make this artistic blunder; but I do want to point out that, whether con-

1. "*Si charta cadit, tota scientia vadit*" [If his paper falls, all his knowledge flees]. Macaronic Latin saying, used to refer to one who is expounding ideas not his own.

sciously or not, a coarse materialization of the artistic act is at the root of many of today's experiments. For this reason the second life of art, its obscure pilgrimage through the conscience and memory of men, its entire flowing back into the very life from which art itself took its first nourishment, is entirely disregarded. I am wholly convinced that a musical arabesque which is not a motif or "idea" because the ear does not perceive it as such, a theme which is not a theme because it will never be recognizable, a line or group of lines, a situation or a character in a novel which can never come back to us, even if changed and contaminated, do not truly belong to the world of form, of expressed art. This second moment, of common consumption and even misunderstanding, is what interests me most in art. Paradoxically, one could say that music, painting, and poetry begin to be understood when they are presented but they do not truly live if they lack the capacity to continue to exercise their powers beyond that moment, freeing themselves, mirroring themselves in that particular situation of life which made them possible. To enjoy a work of art or its moment, in short, is to discover it outside its context; only in that instant does the circle of understanding close and art become one with life as all the romantics dreamed.

I cannot see a line of indifferent mourners[2] at a funeral or feel the Triestine *bora*[3] blow without thinking of Italo Svevo's *Zeno*; or look at certain modern *merveilleuses* without thinking of Modigliani or Matisse; I cannot contemplate certain caretaker's or beggar's children without having the Jewish baby of Medardo Rosso[4] take shape in my mind; and I cannot think of certain strange animals—the zebra or the zebu—but the zoo of Paul Klee opens in me; I cannot meet certain persons—Clizia or Angela or . . . *omissis omissis*—without seeing once again the mysterious faces of Piero and Mantegna or having a line of Manzoni (*"era folgore l'aspetto"*[5]) flash in my memory; nor—on a somewhat less elevated plane—can

2. See "Italo Svevo in the Centenary of His Birth" for a discussion of this famous scene from *La coscienza di Zeno*.
3. A cold, dry northeast or east-northeast wind on the Adriatic.
4. (1858–1928). Impressionist sculptor, forerunner of modern sculpture. Influenced Rodin and the futurists.
5. [his appearance was as lightning] from Manzoni's *"La risurrezione."*

I consider certain episodes in the eternal war between the devil and holy water without hearing in my heart the enveloping feline mewing of the aria of St. Sulpice (as sung by Rosina Storchio).[6]

So far I have given clear but perhaps overly obvious examples of what I mean by the circulation of an expressive moment or of an artist's entire personality, summed up in his attitude; but it is not necessary to think of great names to explain the intensity of the phenomenon. There is no musical or poetic phrase, no painted or narrated character, who has not "taken hold," who has not affected someone's life, altered someone's destiny, eased or aggravated someone's unhappiness. Countless loves have been born in the trills of a vulgar little tune, countless tragedies have been sealed to the beat of a canzonetta, a Negro spiritual, or a line that "nobody else" (maybe not even its author) remembered any more.

Note that I don't say that art, and particularly music and poetry, must be easily mnemonic or memorable. This is an opinion concerning poetry which I have seen attributed to the Hon. Palmiro Togliatti,[7] and when I read it I congratulated myself that I did not figure among the admirers of that aesthete (or that man). If what he said were true, Chiabrera[8] would be worth more than Petrarch, Metastasio[9] would be better than Shakespeare, and the poems in *Alice in Wonderland* would outdo all the odes of John Keats. What I do say is that any expression at all which has had a miraculous, liberating effect on someone—an effect of liberation and of understanding the world—has attained its goal and achieved form.

I repeat that effects of this kind occur at a distance and are unpredictable. From time to time a great artist like Proust, obsessed by the *"petite phrase"* of Vinteuil[10] (is he Franck or Gabriel Fauré?), can construct a whole world out of one memory, organize it, and bring it to its own particular *modus vivendi*; but we do not

6. From Massenet's *Manon*, Act 3. Rosina Storchio (1876–1945): Soprano, one of the greatest interpreters of Massenet and Puccini.
7. (1893–1964). Italian Communist Party leader.
8. Gabriello Chiabrera (1552–1638). Imitative poet in the Ronsardian tradition, a progenitor of the Arcadian school.
9. Hellenized pen name of Pietro Trapassi (1698–1782), Arcadian, Austrian court poet and the most representative Italian poet of the eighteenth century.
10. The composer in Proust's *A la recherche du temps perdu*.

have to go so far for art to intrude on us and continue an absurd, incalculable existence within us. Nor would I say that the second life of art is related to the objective vitality or importance of the art itself. One can face death for a noble cause whistling *"Funiculi funiculà"*; one can remember a line of Catullus entering an austere cathedral or pursue a profane desire associating it with a Handel aria full of religious unction; one can be thunderstruck by a caryatid of the Erechtheion while waiting in line to pay one's taxes, or recall a line of Poliziano[11] even in days of insanity and slaughter. Everything is uncertain, nothing is necessary in the world of artistic refractions; the only necessary thing is that these refractions be made possible, sooner or later.

Modern artists (I don't mean all of them) who, through natural impotence or fear of walking down already-traveled streets or out of a misguided respect for the ineffability of life, refuse to give it a form; those who deliberately exclude every pleasant sound from music, every figurative element from painting, every syntactical progression from the written word, condemn themselves to this: to not circulating, not existing for anyone. Since there is no possibility for a great communion between the public and the artist, they also reject the ultimate possibility of social significance which an art born of life always has: to return to life, to serve man, to say something for him. They work like beavers, gnawing at the visible, driven by an automatic impulse or an obscure need for an outlet or the need to build themselves a dark, ever darker, ever more hidden shelter. But they will never save themselves if they lack the courage to come into the light again and look other men in the eye; they will not save themselves if, coming as they have from the street and not out of the museums, they do not have the courage to speak words that can go back into the street again.

11. Pseudonym of Agnolo Ambrogini (1454–1494) of Montepulciano (whence the name), poet and humanist patronized by Lorenzo de' Medici.

The Artist's Solitude

[Speech delivered in French at the International Congress for Cultural Freedom, Paris, May 21, 1952 on the theme "Isolation and Communication." Published by the *Associazzione italiana per la Liberta della Cultura*, Rome (1952).]

Isolation and communication, the theme that has been proposed to me, are the two poles of a dichotomy which concerns not only the writer or artist. Man, to the extent that he is an individualized being, an empirical individual, is inevitably isolated. Social life is an addition or aggregation, not a unity of individuals. The man who communicates is the transcendental self who is hidden in us and recognizes himself in others. But the transcendental self is a searchlight which illuminates only a very short strip of space in front of us, a light which points us toward a condition which is not individual and therefore not human. Our age has the merit of having discovered or underlined as never before the total character, the dramatic nature of artistic experience. The attempt to fix the ephemeral, to render the phenomenon non-phenomenal, to make the individual self communicate, though it does not do so by definition, in short, the revolt against the human condition (a revolt dictated by a passionate love of life) lies at the heart of the artistic and philosophical quest of our time. Contemporary, i.e., existential, philosophy may even change in the near future, but it does not seem very likely that the artists of tomorrow will differ very much from us in their moral and psychological attitudes.

Can the maximum of isolation and the maximum of *engagement*, in this sense, coincide in the artist, and must they always coincide? No one, in our era, was more isolated than Kafka; yet few found ways of communicating as he did.

If, on the other hand, we put the problem ambiguously and

understand communication to be the material distribution of a work, and isolation the mere fact that an artist lives apart, manifests his own personal political credo, and prefers reserve to the babble of society, then the problem becomes insoluble. In such a case, every best-seller communicates, every writer whose political opinions we agree with becomes *engagé*, and every artist who speaks a personal language of his own not immediately accessible to everyone appears despicably solitary, shut up in his ivory tower.

My premise, then, would be this: that the artist succeeds in communicating only through isolation and that a polemical or propagandistic kind of *engagement* cannot be of interest in this regard.

It can be objected that the distribution of a work of art is not merely a statistical matter and that there is a difference which is not simply quantitative between the communication of a Kafka and, at one time, a Maurice Dékobra.[1] This is an objection with a practical basis but scant theoretical support. There are artists for whom the life of society and the peculiarities of the human comedy exert a strong attraction. They are the so-called realists. There is a realism of Apuleius and Boccaccio, of Rabelais and Maupassant or Courteline,[2] if you will. A hundred years ago realism was called naturalism; today, at least in Italy, it is called neo-realism. In Russia today all art that is not a quasi-photographic reflection of Russian social reality is banned. If those who want artists to communicate mean to prescribe an inquiry of this kind, the least that can be said is that their request is indiscreet and indiscriminate. An artist may accept an invitation which conforms with his own ideas; great musicians and painters have worked to order, on commission. It is also possible for a novelist, responding to a request from his political or spiritual leader, to write a book of propaganda which is at the same time a masterpiece of art. But these are exceptional cases, which cannot be made into a general rule. Generally speaking, an artist's capacity to communicate is not measured by the success, by the physical distribution, of his work.

1. Pen name of the cosmopolitan French novelist Maurice Tessier (b. 1885), popular in the 1920s and '30s.
2. Georges Courteline (1858–1929). French satirical novelist and playwright.

The sonnet of Arvers[3] has doubtless been more widely read than *Le cimetière marin*, but no one would be willing to admit that Arvers "communicates" more than Valéry.

I will stop here because I see that I have gone beyond the terms of my proposed subject and have more than touched on other themes—Revolt and Communion, Diversity and Universality—which must be developed by others. But I have the impression that the three themes are closely interconnected and that other speakers will make the same apparent digression. Sticking closer to the terms proposed, I will say that the artist's isolation, a phenomenon which appears particularly serious in our century, the mistrust of language and the consequent search for new expressive means, are connected to mechanical progress, to the spreading of middle-class culture and the vulgarization (in the original sense of the word) of the arts. The static sense of life has disappeared along with certain universals of classical culture; the meniscus between art and life has been broken and life itself appears as a monstrous work of art, constantly destroyed and constantly renewed. Some believe that the spectacle (the cinematic or theatrical extravaganza) is the true art of our time and that the director who stages it, using themes or works by poets as a starting point, is the true contemporary artist. The ancient arts seem dead, figurative painting seems impossible, tonal music seems to have exhausted its possibilities, lyric poetry is untranslatable and next to incommunicable; only those forms of expression which can be made accessible to vast masses by new technical means (cinema, television, radio) seem truly adapted to the vitalism of our times. And since interpreting or even reading and understanding a work of the past is directing, is performing a creative act, it follows that today we are all more or less great artists. Where everyone is an artist there are no artists; our time has made art so immediate it has destroyed it.

I do not think a reaction to these dangers is imminent, but I do believe that when irrationalist vitalism and the new technology of communications have reached the extremes of their development it will be necessary to return to a different and less materialistic idea

3. Félix Arvers (1806–1850). Poet famous for his sonnet *"Mon âme a son secret, ma vie a son mystère . . ."*

of artistic communication. Art then will be organized on two levels: a utilitarian, almost recreational art for the great masses and a real and true art, not terribly different from the art of the past and not easily reducible to cliché. This optimistic hypothesis presupposes that the intellectual and cultural *clercs*, who are capable of going against the current, will stand their ground and not let themselves be overwhelmed. It is these great isolated personalities who give a meaning to an epoch and their isolation is more illusory than real. Their searching, too, in their imitators, becomes cipher, decoration, spectacle; in short, they too join in the great ballet of art for everyone.

To sum up, I do not believe that the triumph of new technical means is without importance in a world which is moving toward a new, positive, scientific humanism and which is trying to improve the lot of the multitude; but I maintain that tomorrow, too, the most important voices will be the voices of those artists who through their isolated voices give expression to an echo of the fateful isolation of each of us. In this sense only the isolated speak, only the isolated communicate; the rest—the mass communicators —repeat, echo, popularize the words of the poets, which today are not words of faith but perhaps one day may become so again. There are a new man and an old man in conflict inside each of us today; hence the disharmony, the disequilibrium of our times. The advent of the totally new man would mean the advent of the "robot," the mechanical man, and the end of art. The triumph of the old man over the new, which would be an even worse defeat, is still uncertain. And we have not yet been given to know what historical, social, psychological, and economic conditions will make the coexistence of these two men possible and productive in the man of tomorrow.

A Second Profession

[Published in the *Corriere della Sera*, January 27, 1959.]

How many writers manage to live on their earnings from their art without having to take up another profession? Apparently there are many in the so-called People's Republics, but few, very few, in countries where a relative freedom of thought and opinion flourishes. In these countries, an unknown number of literary men make ends meet, sometimes rather brilliantly, working with pen and ink or typewriter composing newspaper articles, film scripts, adaptations of other writers' novels into plays or films, or other kinds of popularizations; but it remains to be shown that these men live on earnings from their art (given that they are truly artists). The truth is that if they are poets they also have a second profession: that of the man of words. Extremely well-known writers, even those who have won the Nobel Prize, live by their pen, not their art. There are some rare exceptions, but even these are illusory. When we see the Complete Works of a famous author on the shelf, we can distinguish at a glance the small number of books which belong to his art from the many products of his other profession as a generator of the printed word.

This is the case in the western hemisphere. Elsewhere, it seems, things are different. Russia, certainly, has several thousand authors who receive a regular stipend from the State, in return for which they are expected to produce creative work, not manipulated pseudo-literary products. Yet one does not have to know very much about what is going on in the Soviet Union to understand that there is no such thing as a State that gives something for nothing. Trustworthy, even unquestionable observers report that in the totalitarian countries the writer who expresses opinions or sen-

timents which do not conform with instructions from on high is accused (and this is the least that can happen to him) of "biting the hand that feeds him"; which, unfortunately, is entirely true. A fanatic could object that personal opinions are not at all necessary for an artist and that freedom does not conflict with a "freely" accepted authority. But who can freely accept a freedom that depends on a stipend? A glance at literary history tells us that Russia had a great revolutionary literature only when her writers did not receive state salaries. Afterwards, it was a virtual desert.

The observations we have made, which are certainly far from original, demonstrate clearly that it is virtually impossible anywhere in the world for a writer to live by his art. The writer who sells his words may occasionally give us some pages of true poetry, even works which are destined to survive, but he will live only by producing inferior stuff. A second profession is forced on all writers, or almost all, which is not to say that the apparently intellectual occupations (teaching, journalism, the cinema, etc.) are the most congenial to that freedom of the spirit which is the true terrain where art arises. It is impossible to imagine a Foscolo or a Leopardi who spent ten hours a day clipping newspaper articles for a service, though it was possible for bankers to write *Giovannin Bongee*[1] and *The Waste Land*.

On the other hand, it is easy to object that *La Comédie Humaine* would never have been written if Balzac had spent his short life in the offices of a savings bank; we would not have *War and Peace* or the *Recherche* if Tolstoy and Proust had not been blessed with considerable "means." And here we come upon the second profession that may be the most propitious for literature, that of landlord. Beyond this there are the honest-to-goodness professions, including that of the producer of books broadly speaking. But we must also recognize the strange situation in which the author of unsold and therefore barely profitable or unprofitable books finds himself. Hundreds, perhaps thousands of painters and sculptors of questionable worth live by selling their work, and their clients al-

1. *Desgrazi e olter desgrazi de Giovannin Bongee* [*Disgraces and Further Disgraces of Giovannin Bongee*], satirical poem by the great Milanese dialect poet Carlo Porta (1776–1821).

most always, directly or indirectly, include the State. Large public grants make the difficult life of music, theater, and film possible. Shutting the ticket windows, or a "strike" by painters, film-makers, or actors, would throw the whole world into consternation. But watch writers cross their arms and tighten their belts and you'll see that no one will notice their protest. The newspapers will continue to publish, and everyone will be convinced that some masterpiece will sooner or later be found at the bottom of a trunk—preferably after the death of its author. In short, the old saw that literature thrives on discouragement persists tenaciously at the heart of our classical culture. I will let the reader decide whether this is an alibi which allows bourgeois society to starve its poets without feeling guilty, or an indirect tribute to the rarity and unpredictability of poetry.

The writer's profession practiced on a broad scale—as it is today—is a fairly recent development, related to the growth of journalism and publishing. If we don't want to go as far back as the early eighteenth century, then Edgar Allan Poe is the prototype of the modern free-lance who lives on what he earns from his articles; and they brought him misfortune. Later, Melville worked as a simple clerk. Nor shall we go back even further and recall the occupations and economic misadventures of a genius like Cervantes. In the heroic ages of poetry, poets were diplomats, chamberlains, ecclesiastics, warriors, merchants, playboys, and sometimes even thieves and assassins, but they never lived on their "royalties." There were also royal poets, court librettists, and hagiographers, but they were special cases; and today, too, there are dramatists (usually mediocre ones) who live by their products. I don't need to repeat that these are usually "products," not works of art. Besides, the theater is a world apart. There have always been men of the theater who were authors, actors, and impresarios at the same time, and who therefore performed different jobs simultaneously; but even this example doesn't invalidate the old axiom that *You can't eat poetry.*

The problem of how poets can earn their keep without wasting the best years of their lives in another profession thus seems more insoluble than ever today. But like all insoluble problems, it has

probably been badly put. To say that a respectable State should distribute purely symbolic posts, sinecures, or the like to its most promising writers, or guarantee the sale of their books by law or decree or even by force, is to prove oneself incurably naive. Maybe an ideal society could help its poets and writers in an entirely secret and indirect way, without offending their dignity and independence; but the old feudal cultures were much better adapted to this end. The new industrial civilization based on money and success offers no guarantees of this sort. In a society like ours only a useful art, a *Gebrauchskunst*, can be transformed into cash. A picture made by punching four holes in a canvas or music obtained by filtering or parceling out a few electronic screeches can become an object which can be sold to private consumers and even to the State, through grants for exhibitions, festivals, etc. It is much more difficult and infinitely less preferable for the State to organize and "plan" the distribution of funds to its poets in order to free them from the shame of a second profession. Who would choose these poets? What nonexistent Academy? And with what assurances of seriousness? And who could prevent the proliferation of so-called poets seeking grants and subsidies?

Poetry (in the broadest sense of the word) is unfortunately the most defenseless of the arts today; for different and perhaps contradictory reasons, neither the totalitarian societies nor those which delude themselves into thinking they are free can do anything to favor or protect its creation. It might even be said that they arose precisely in order to create conditions inimical to its development. But it would be a mistake to think that such notions make the life of the poet or his vocation itself any less honorable. Poetry's constitutional inability to earn poets anything probably means that it has a dignity of its own to which the other arts cannot always aspire. A noted critic presented a group of thirty young Italian painters a while ago under the rubric "Thirty Masters of Tomorrow," without anyone saying a word. But if the thirty had been poets rather than painters, neither their sponsor nor the poets themselves would have escaped ridicule. This means that poetry has not yet descended to the level of merchandise in the public eye, and that the title of master, in itself fairly debased, is intolerable to a writer with any self-respect.

If one can attain this kind of dignity only by practicing a second profession, very well then, let there be second and even third professions. All the ills one blames on them are largely made up for by the fact that through them the art of the word has not yet sunk to the level of the so-called "fine arts," which are certainly more profitable, but at the cost of what compromise?

The Magnificent Destinies

[Published in the *Corriere della Sera*, May 9, 1959.]

It is not necessary to consult the annals of history and the glimmerings of prehistory in order to realize that today for the first time hundreds of millions of persons living in different and distant countries, but all provided with the benefits of compulsory education, find themselves in rapid, often lightning-fast communication through the means which mechanized civilization has discovered—from printing to television, not to mention travel, which is extremely easy today. Unless the end of the world is near, there is nothing to make us think that this paroxysm of pseudo-education has exhausted its possibilities: we are probably at a beginning, not an end. The only end that for the moment seems to preoccupy philosophers, doctors, sociologists, theologians, and other students of *Homo sapiens* is the probable end of man as a distinct being capable of expressing values. Contemporary man has inherited a nervous system which cannot tolerate the current conditions of life; until the man of tomorrow—no longer *sapiens* but simply *faber*—develops, contemporary man reacts to changed conditions not by facing these conflicts, but by becoming a mass, by "massifying." The badger hunted down by dogs makes itself into a ball and rolls down a steep incline; and contemporary man does likewise if he still has a spark of sensitivity. But this happens only to those who try, even passively, to defend themselves, and they are few; the rest simply expunge every trace of personal feeling from themselves

and agree to live like objects in the hope of preserving their mere physical identity as long as possible.

Some philosophers say that contemporary man is alienated. This is a fashionable term, and its meanings are not always clear. If it is intended to refer to man's native dependence on forces greater than himself, then man's alienation begins with his birth and may end—though not for certain—with his death. But this is not the view of dependency which interests those who study man's place in society. According to a very widely held opinion, man's present-day alienation should be seen in relation to the capitalistic phase of industrial civilization. Man, they say, has become a cog in a wheel because the means of production remain in private hands. Once these means truly belong to everyone, man will be the master of his own fate, he will escape massification and brainwashing. To which others reply: the means of production, communication, and information do not achieve their true effectiveness unless they are directed from the top of the social pyramid. In a collectivist society they will fall into the hands of the leaders of the one political party or of the one tyrant. Control over the radio, films, and television, for example, can make a flock of sheep out of millions of minds without their realizing it. A hundred years ago Kierkegaard could write that "numbers are the negation of truth." Today his negation has become an intoxicating collective pseudo-truth.

Being neither philosopher nor sociologist nor scientist, I myself do not have a great deal to say on this subject. I am convinced that there is a natural alienation, but I believe that this can to some extent be compensated for by the will of the individual; and I am just as certain that it will be very difficult indeed to neutralize the bad effects of the development of mechanized civilization (whether regulated from above or below) in an overpopulated world. Yet at the same time, at the risk of contradicting myself, I am not at all unhappy to be living today and I do not mourn the not-so-distant past in which, for a mere difference of opinion, one could end up at the stake. Certainly man has won and lost a great deal over the centuries. But since it is not in our power to modify the conditions in which progress has placed us, our duty as so-called intellectuals is to see that a part of the best of the past survives into the future.

If we confine ourselves to what concerns me most closely, i.e., the field of artistic and literary activity, I already know the objections that can be raised against me. What do writers and artists have to complain about? They have never known a better day. They have an ever more extensive public, their work is sold as never before; and they are even relieved of having to have a technique, a craft, for today individual technique is all that counts. In short, they are virtually free to express themselves as they wish, since their demanding and humiliating protectors and patrons have practically disappeared. True, all of this requires the continuing growth of one "standard" sort of production; but artists can still resist brainwashing by shutting themselves up in their ivory towers.

If only it were so! But the ivory towers have been in use for some time, and from them has issued the theory which makes the work of art into an object to be consumed and discarded. All the isms that have followed one another for at least half a century are the prolongation and exploitation of discoveries made in dark laboratories, the commercialization and massification of the ivory tower. The art that is outstanding is produced by automatons, and no other art seems possible for the moment.

It will be said that more books are being printed today than ever before, that more images which can claim to have some relationship to the world of art are finding their way into homes. And it will be added that today there are no longer composers who can write an opera in three weeks, and that the public who reads or goes to the theater has become more demanding. But demanding in what way? Demanding in that they require obeisance to the recipe of the moment, and want it served up cooked to a T. And as for books, what sells are not books; they are objects enclosed in cardboard cases from which few dare to remove them. They are not read, they are museum pieces. Soon they will be replaced by microfilm. The last classics to find readers were published unbound by Sonzogno,[1] with sharkskin-colored covers, for a lira. The others, bound classics, the complete works, are good only for creasing one's trousers. In everything, literature and theater, what the public de-

1. Popular Milanese publishing house, founded 1818.

mands is the technical perfection of the object, certainly not intrinsic quality.

Undoubtedly, there is a technical scruple which also enters the very heart of the work of art. No one is more scrupulous than the composer who organizes all the possible combinations of his twelve tones with a glacial fanaticism, though the poet who never repeated a consonant before the others had appeared in his rhythmic period would be even more admirable. Fortunately, this is too difficult an undertaking. On reflection, a Donizetti who can make *La Favorita*[2] out of a pre-existing *Angelo di Nisida* in a few days is no less serious than the composer who takes ten years to give us a technically up-to-date miscarriage. There was much more freedom in Donizetti's alienation and enslavement: the capacity of the authentic talent to play with an open hand.

Would we like to suggest a return, then, to the antique in the sphere of the arts? Since it would be a false antique in any case, we have no proposals to make. In no way do we want to regress, even at the cost of contradicting ourselves: if our age offers new possibilities it would be insane to reject them. What matters today is that we not let ourselves be misled by the philistinism of the falsely modern, by the constant mistaking of the means with the end in art, by the materialism of those who would like to put physical sound—noise—in place of the sound that is born in the imagination, the rapid and exciting massage of the raw impression in place of actual poetic communication. Yes, there is a great deal of communication in the world today; but it is the communication of the herd immobilized for hours on end in front of a screen in order to watch the agony of an unfortunate who has to answer absurd questions prepared by committees of so-called "experts." It is culture reduced to a jukebox coin. It is the literature of the surrogate. It is the story or poem which, after barricading itself so that it is accessible to few, goes into combat in the guise of a more-or-less neorealist cartoon. It is painting that produces works which criticism cannot discuss, so difficult is it to distinguish the work of genius from the nonsense of the irresponsible.

2. Donizetti's 1840 opera was based on an earlier work, *L'Angelo di Nisida*.

At this moment mass culture and compulsory education (which for that matter is still inadequate in Italy) have had the effect of producing an art by and for everyone, and for no one. It is probable that the magnificent—and progressive—destinies of humanity had to pass through this phase. And it is hard to see whether or how humanity can get beyond it. Perhaps it is a mistake to look at man from too anthropocentric a viewpoint. It may be that a profound transformation of man is under way and that the perspective we have chosen is entirely inadequate. For that matter, what sense would art have in a world of the non-alienated, or the totally alienated?

Theodor W. Adorno, the philosopher and sociologist who has used the word "alienation" most frequently in recent years, a man with a Freudian and Marxist background, has also written: "Only he who is free of every obligation can contribute to a community that is worthy of men, much more so than he who accepts one that is imposed on him, and, for the most part, seeks his own satisfaction." What concerns us, for the moment, is that the sowing of those men who have kept their eyes open and have not let themselves be flattened into the collective roadbed not be lost. It is not certain that a further decline in classical studies would be a catastrophe. The worst, the absolute abyss, would be if the meaning and the memory of that time which must flow into the time of tomorrow were lost; if that ascent, that stairway of values which the great spirits of the past attempted to build so that man—even alienated man—might make himself another image of his destiny on earth, were halted or cut short.

Man in
the Microgroove

[Published in the *Corriere della Sera*, October 9, 1962.]

The past is the greatest enemy of contemporary man, and not without reason. Its failings, in fact, are many and the worst of them is that it is not with us, is not the present. In times of unrestrained vitalism this is an unpardonable sin. We can expect something good from the future, our physical survival if nothing else; but the past is death already gathered at our back. Must we really recover the past as humanism demanded? It's doubtful that it's worth the trouble, for the past also includes art, another enemy of modern man. Art is by definition tied to the past for the simple reason that we see it in perspective; there is also a contemporary art, of course, but it has different characteristics which we would call "organoleptic," directly perceptible: an odor of fresh varnish or ink which is enough to keep it close to us. When art takes on extra-temporal connotations, when it claims to survive in time, our tolerance is put to a difficult test. It is useless, then, to haunt the archives, libraries, or museums; if we keep in mind that a new humanism has been discovered, in which man is the product of industry and industry is the product of man (and so the circle is closed), what real interest can the humanism of times less advanced than our own hold for us?

We should add that while it is silly and dangerous to detest the present the past can be detested with impunity: it doesn't react or take revenge, it doesn't compromise anyone. We can expect dirty tricks from the future: we need to keep all the windows open so it

won't surprise us. It is with good reason, then, that we speak of "open-ended" works of art, as men's minds are already open and no longer blocked or closed by the rubble of the past. A closed work is a piece of the past which claims to go back in time, an operation destined to fail because time is irreversible. The work of man, and not only the work of art, must be so open that it dies at the very instant of its creation. Practically speaking, the instant will not be a literal flash of lightning, it may last a bit longer; but it is clear that if we produced objects that insisted on a long life they would be harmful to the economy (and to morale).

Contemporary man is like a sailor who must continually throw into the sea a ballast which has become dangerous: a ballast not only of things but of memories and regrets. An insignificant object can become a concentration of the past for us and thus assume a totemic function. For many years I carried with me a rusty metal shoehorn[1] I was so ashamed of that when I stayed in a hotel I'd hide it so the maid wouldn't see it. It was the only thing that had been with me since childhood. One day in Venice I forgot where I had hidden it, or rather forgot the shoehorn itself, and I never had the courage to inquire about it. In all probability it is sleeping today at the bottom of the lagoon. Still, I feel remorse, and when they tell me that a cosmonaut has circled the globe six, ten, or sixty times, I think the greatest discovery would be the one that would bring me back my old rusty shoehorn. I know perfectly well that if the shoehorn were to reappear on my table I would feel more terror than joy. Consciously or not, I rid myself of it. I must therefore accept the assistance of chance and continue to live without that magic, silent, rusty Oliphant,[2] as I must confess that I have dared to replace it with a red plastic model which I now set out in plain view and could lose without regret.

What a cemetery of memories a secondhand store is! If all the junk collected there could speak, if the Paris *marché aux puces* had a voice, we would know the scandal of the past flowing back into the present, an occurrence which history excludes by the very laws

1. This image occurs also in *"Xenia,"* II, 3, in Montale's *Satura* (1971).
2. The hunting horn in the *Chanson de Roland* which Roland blows to recall Charlemagne after the battle of Roncesvalles, bursting his temples.

of its nature. History lists, organizes, and attempts to interpret a few great events of the past, but they are seen in terms of a present which was unpredictable *then*. In short, history uses the past, adapts it to its own ends. History is always the voice of the present, which is why historians will never agree. And the hypothesis that the past contains its own future would be demonstrable only if we agreed to the idea that life is a tape or a record which has already been recorded once and for all. We who exist in the moment in which I write are a mere millimeter of a microgroove on this record: the rest has already been played, another part is yet to play, but we know it exists, even if we are unaware of its dominant themes. Maybe there will be no more themes, maybe they will be replaced by a vertical and "serial" mumbling, organized with pedantic, scholarly asininity by some hidden universal brain.

In such an eventuality, a small blemish might make the needle of the record player jump back and a fraction of the past might re-occur for us in all its objectivity; not to mention the terrifying possibility that the stylus might skip forward and we could thus find ourselves for a time in a distant future, having jumped beyond our immediate future, which is to say, *beyond our own death.*

However, I must honestly confess that things of this sort have never occurred to my knowledge and that consequently a pre-existing recording of human and inhuman events can be considered improbable. Yet it remains within the realm of possibility. What has never happened could happen tomorrow; the sudden breaking of the record could mean the end of the world, the universal flood or an extraordinary geological event could have been a partial breakage. In such a hypothesis it's understood that the providential function that regulates life would not be the record itself but the blemish that makes it skip. In any case, we could say that life is something that does not depend on us, and the flowing of the past into the future is seriously in question. And if we discard the hypothesis of the record or tape as insanity, it remains all the more evident that the past is a tomb and that modern vitalism has good reason to see it as its worst enemy. Its euphoria is the euphoria of a man who has been saved from drowning by a miracle.

What remains to be considered is the much more serious naturalistic hypothesis that the past contains the future in embryo, the

way the seed contains the tree and its fruit. Since nature acts with an incredible prodigality of means and only one seed in a hundred thousand takes root, man could have developed and survived across thousands of centuries by simple chance. In other words, man as he is today was highly improbable at the beginning of biological life.

This is the opposite of the first hypothesis. In the first, the Supreme Being listens, perhaps without surprise, to the work that his one single *fiat* has produced, the work in which we were included once and for all, without any responsibility; in the second, the Being tosses his dice, shuffles his cards, and is curious to see what will happen. The first theory is in line with Calvinist predestination; the second holds that for better or worse man came out of chaos and has created another chaos, which will not last until infinity but which we cannot reject because we have no choice.

Are there no other theories? For the man in the street—and here I mean the simple man—there are certainly others. The man in the street learned centuries ago that good and evil exist and that man, even if he knows virtually nothing about himself, can be the first judge of his own behavior; and he also knows that his judgment of himself qualifies him in his own eyes, makes him different, changes him, and for the better. The man in the street knows that before him came his forebears, who did not have television and the airplane but who penetrated the fabric of the world with faculties which are totally atrophied today. The man in the street knows or at least intuits vaguely that he has very little freedom of thought and action, but he also knows that once in a while he has felt at liberty to make a decision and has been terrified of that void and pulled back, taken the path of easy advantage, and felt shame and remorse. All of this is of little importance in the course of events. The man in the street doesn't produce opinions, found parties, or direct newspapers; he doesn't attend festivals, is not familiar with linguistic criticism or the central problems of the cinema, and lacks the philosophical terminology to define his condition, which is that of a poor devil who works to survive and supposes that it is a worthy thing to live as a reasonable man in a *serraglio* of educated sheep. The man in the street, in short, doesn't make history and even has the vague suspicion that there may be great dignity in not making it.

But go tell the man in the street he is improbable or irresponsible or that he contains within himself the epiphany of a new and different being technologically enmeshed in a universal machine which will be his reason for living and is later supposed to explode without doing any harm after it has served its purpose, but may possibly continue on its own, having devoured all the experts. Go tell him this and more; he won't understand you and will think that books, the "dirty books" that Mirbeau[3] mentioned in a famous play, have turned your head.

And yet the real history, the one that counts and is not to be found in books, is precisely this one, the one made by simple men; and it is the only one that still rules the world. Tomorrow perhaps it too will disappear and then science will be able to record a truly unheard of man, a new zoological specimen whose distinguishing features I fortunately don't know. I am not entirely sure that this portentous individual is not already hidden within the microgrooves of the record.

3. Octave Mirbeau (1848–1917). Progressive French novelist and playwright. His best-known play was *Les affaires sont les affaires* (1903).

In the Flow
of the Current

[Published in the *Corriere della Sera*, February 19, 1963.]

Throughout a great many of the centuries known to history (thirty, perhaps, but with enormous lacunae in time and space) one has the impression that men expressed themselves by proxy. Even without casting votes, they entrusted the duty of representing them in the fields of action, thought, art, and religious faith to a chosen few. The many did not concern themselves individually with all this, and said to the few: You do it. The many, in and of themselves, seem not to have had an individual existence: they were the raw material of history. Still, somehow it was possible to write the history of those times, though with wide margins, by approximation.

Today it is different: one may or may not love the times in which we live (I love them passionately, and precisely for this reason I am aware of their transience), but it cannot be denied that we are almost certainly entering into a prehistory, into the dark prelude to times which the historians will later describe. As for the preliminary period we are living, it does not seem probable to me that it can be offered for historical analysis because there are no more proxies, or those that do exist are too numerous; they sink from view too rapidly and do not serve as directional signals. Today individuals—by the millions and billions—want to represent themselves, to exist, to explode individually. They want to live their own lives on the level that is possible for them, the level of the

emotions and senses. And on this level special proxies are impossible: the average man has the same rights as the exceptional man and can even convince himself that he can bore through the crust of life more authentically than the studious man who is almost always hardened and fossilized by ancient prejudices and stubborn class pride.

But is it really true after all that the atomized man, the man who doesn't make himself a topic of conversation, does not choose his own representatives? They will not be deputies or senators, philosophers or agitators of the people, but movie actors, noisome pop singers, or even criminals at large, or adventurers of all sorts; yet they will always be those in whom the disinherited and those who are dissatisfied with the joy of living can see themselves projected. Are they the worst men, these unappeased hungry ones? It's doubtful. Certainly, the explosion of the individual and sensual egotism builds nothing durable, but it is precisely the idea of duration that is losing credit; not to mention the idea of building, which is not as stable as it is thought to be. Of course building is part of today's activism; but not without its correlative, the *pars destruens*, the need to destroy in order to open up a new space for other activities. Action, therefore, lacks a true objective purpose, and usefulness is not simply one aspect of life.

The opinion that we only live once has put down sturdy roots even in those who believe in an afterlife. There very well may be an afterlife, they say, but since it's impossible that it will be like the here and now, let's be sure that we suck all the juice from the life that is given us. One cannot say that the senses do not have a sense; it is unthinkable that, after having created us, God could wash His hands of us for thousands of centuries, as the venerable Teilhard de Chardin would have us suppose. On the other hand, if the Creator is merciful (and how can we think He is not?) He will understand that during such an endless interval no rational being could live using only half his vital faculties. And so sin and evil no longer frighten anyone, since they represent a necessary moment in the dialectic with good; in fact, good would not even be imaginable without the counterpart of evil. Here, too, representatives have disappeared: at one time the great sinners sinned for us all, they

were representative men, illustrious in their own way. Today everyone supplies this need on his own.

Ministers, senators, deputies, bigwigs, official authorities represent us, and we don't even know their names: we read about them in the newspapers and wonder, Who is he? Very optimistically, we manage to suppose they are honest, worthy persons; in no case do we feel that a part of ourselves, of our will, resides in them. Our representatives, if we have any, are elsewhere. It is not easy to find them, for they are innumerable and changeable, and these representatives of ours do not themselves know they are such. One can say even more: the men who speak for us cease to interest us on the day that they realize they have become important. Look at the example of the men who seem to be most alive: the "beatniks," the "angry young men," the men of the recurrent literary and artistic *nouvelles vagues*. It would be impossible to conceal our sympathy for them at the first moment of their protest. In an age of abject conformism and cunning mystifications their way of sweeping up all the hypocrisies with which we live into a pile and tossing them into the dustbin is for us a positive act. But the moment is short-lived. When protest turns into a profitable career, then the spark is extinguished; our delegate, our chosen man, the man we had entrusted with the courage we lacked is rapidly replaced by another. Still, the existence of a universal protest which does not attack this or that political or social system, but the unnaturalness of our way of life, remains undeniable.

Now, faced with such a problem, none of the conceivable social structures with which the world of the future can provide us helps us to reach a satisfactory solution. We know it now by heart: universal mechanization is not in question, the machine in itself is neither good nor bad and everything depends on the use to which it is put. But there is an objection ready to be made here: to what use different from its current use should we put it? At the most, mechanization can bring us all a short, or very short, work week, three or four working days with the rest of the time devoted to leisure (if it is possible for a mass of men required to enjoy themselves as a duty to society not to become a formidable breeding ground for new "angry young men" . . .).

The shrewdest of the young Marxists (who prefer to call themselves Marxians) know very well that all the answers to the problem are unsatisfactory and prefer to take the bull by the horns. To be unnatural, they say, is precisely man's destiny, for he has left the natural state in order to enter his artificial phase. There was something still natural, something apish, about *Homo sapiens*, which must now be extinguished in the light of a new epiphany. One day we shall have the totally "self-made" man, author of his own destiny, master of his own world if not of the universe. Granted, the job will take centuries, but it is worth the effort to try. In these centuries in the antechamber—supposing that a catastrophe of war or geology does not reduce its survivors to the state of Rousseauian man—the psychoanalysts, psychiatrists, and devotees of "other" art will have much to do: and this will be precisely the time whose history it will be impossible to write. Later, once the idea of nature has finally been excluded from consideration, the social structure will have assumed stable forms, the problem of the individual will no longer be felt, history—the history of structures—will compile reports and statistics, and art itself, understood as a letting off of steam, as the liberation and sublimation of irrepressible primitive instincts, can and must die, with no regrets.

Note that such an hypothesis is one of the most optimistic, for every other involves even eschatological predictions. And at base it is precisely these predictions which lie hidden in the hearts of the angry young of today: while we wait for the deluge let's rid ourselves of every hypocrisy and give free rein to the animal that is hidden within us.

Here the voice of a reader interrupts me and says, "We understand; but if this is the situation how can you claim to love the age in which you live?"

Well, I love the age I was born into because I prefer to live in the flow of the current rather than vegetate in the swamp of an age without time, as the age of our ancestors seems to have been, no doubt through our own error. I prefer to live in an era that knows its own ills rather than in the endless season in which they were patched over with the bandages of hypocrisy. After all, without

denying the infinite deceit that overwhelms us, one has the impression that today men have opened their eyes as never before, not even in the days of Pericles. Yet though their eyes are open, they still see nothing. Perhaps they will have to wait, a long time, but for me and for all of us who are alive time is running out.

Is Poetry
Still Possible?

[Montale was awarded the Nobel Prize for Literature on October 23, 1975. He delivered this address before the Swedish Academy at the Nobel Award ceremony in Stockholm on December 10.]

If I am not mistaken, this marks the seventy-fifth anniversary of the Nobel Prize. But though many scientists and writers have earned this prestigious recognition, very few of them are still alive and working. Some are present today, and to them go my greetings and best wishes. According to widely held opinion, the work of soothsayers who are not always reliable, either this year or in the very near future the whole world (or at least that part of it that can be called civilized) will experience an historical change of colossal proportions. It is obviously not a question of an eschatological development, of the end of man himself, but of the advent of a new social order intimations of which exist only in the vast dominions of Utopia. When it comes, the Nobel Prize will be a hundred years old, and only then will it be possible to make a complete assessment of how much the Nobel Foundation and its award have contributed to the development of a new form of communal life, which may mean either universal Well- or Ill-Being, but will in any case be of such scope as to put an end, at least for many centuries, to the age-old quarrel over the meaning of life. I mean to refer to the life of man and not to the appearance several million years ago of amino acids, the substances which made possible the appearance of man and which even then may have contained the plan for him.

If this is the case, how long is the stride of the *deus absconditus!* But I don't mean to digress, and I wonder whether the conviction which underlies the institution of the Nobel Prize regulations is justified, i.e., that the sciences—though not all of them to the same degree—and works of literature have contributed to spreading or defending new values that are "humanistic" in the broad sense. The answer is certainly in the affirmative. The list of those who have made a contribution to mankind and won the coveted recognition of the Nobel Prize would be long indeed. But infinitely longer and practically impossible to identify is the list, the legion, the army of those who work for humanity in numberless ways, even without knowing it, and who do not aspire to any possible prize because they have not written books, papers, academic treatises, and have never thought of "getting into print," as a widespread commonplace puts it. Clearly, there is an army of pure, immaculate souls, and *it* is the obstacle (though plainly insufficient in itself) to the spreading of that utilitarian spirit which in various guises leads to corruption, crime, and every form of violence and intolerance. The academicians of Stockholm have many times said no to intolerance, cruel fanaticism, and the persecuting spirit which often animates the strong against the weak, the oppressors against the oppressed. This is particularly so in regard to their choice of literary works, which can sometimes be dangerous but never as lethal as the atomic bomb, the ripest fruit of the eternal tree of evil. But I will not dwell on this note as I am neither philosopher nor sociologist nor moralist.

I have written poems, and it is because of them that I have been awarded the prize, but I have also been a librarian, a translator, a literary and music critic, and even unemployed, for what was seen as insufficient loyalty to a regime I could not love. A few days ago a foreign journalist came to see me and asked, How did you parcel out so many different activities? So many hours for poetry, so many for translation, so many for office work, and so many for living? I tried to explain that you can't plan a life like an industrial project. There is a lot of room in the world for what's useless, and in fact one of the dangers of our time is the commer-

cialization of the useless, to which the very young are particularly susceptible.

In any case, I am here because I have written poems, an absolutely useless product, but almost never harmful, and this is one of its claims to nobility. But not the only one, for poetry is an activity or a malady which is absolutely endemic and incurable.

I am here because I have written poems: six volumes, as well as innumerable translations and critical essays. They have called it a slight body of work, supposing perhaps that the poet is a producer of merchandise, and the use of the machinery must always be maximized. Fortunately, poetry is not merchandise. It is an entity about which very little is known, so little that two philosophers as different as the idealist historicist Croce and the Catholic Gilson are both agreed that a history of poetry is impossible. For my part, I consider poetry, materially speaking, to be born of the necessity to connect a vocal sound (the word) with the hammer beat of the earliest tribal music. Only much later could words and music be somehow written down and differentiated. Written poetry appeared, but its common relationship with music made itself felt. Poetry began to emerge in architectonic forms; meters, strophes, the so-called closed forms arose. In the first Nibelung sagas and later in those in the Romance languages, the true material of poetry was still sound. But the Provençal poets soon developed a poetry that appealed to the eye. Slowly poetry became visual because it portrayed images, but it was also musical: it brought two arts together in one. Naturally, formal schemata played a large part in the visibility of poetry. After the invention of printing, poetry became vertical, it didn't fill all the white space, was rich in "new lines" and reprises. Certain blank spaces also had a meaning. Prose, which takes up the entire page and gives no indication of how it is to be spoken, is very different. And at this point, metrical schemes became the ideal tool for narration, i.e., for the novel. Such was the case with the octave, a form that was already a fossil by the early nineteenth century despite the success of Byron's *Don Juan* (a poem he left half-finished). But toward the end of the nineteenth century the closed forms of poetry no longer satisfied the eye or the ear. The same can be said for English blank verse and the "loose" Italian hendecasyllable. And at the same time painting made great

strides toward the disintegration of naturalism, with immediate consequences in pictorial art. Thus, by a process which it would take too long to describe, the conclusion was reached that the truth, or real objects, cannot be reproduced, since in so doing one only creates useless facsimiles; instead, the objects or figures of which Caravaggio or Rembrandt would have presented a facsimile that was a masterpiece, are now exposed *in vitro*, or even *au naturel*. Years ago, a portrait of a mongoloid was shown at the great Venice exposition: it was a *très dégoûtant* subject, but why not? Art can justify anything. Except that on coming closer one realized it was not a portrait, but the unhappy victim in the flesh. The experiment was later halted by the police, but on a strictly theoretical plane it was entirely justified. For years the critics who hold university chairs had been predicting the absolute necessity of the death of art, in preparation for who knows what palingenesis or resurrection of which there are no indications.

What conclusions can be drawn from all this? Clearly, the arts, all the visual arts, are democratizing in the worst sense of the word. Art is the production of objects for consumption, to be used and discarded while we await a new world in which man will succeed in liberating himself from everything, even from his own conscience. The example I have given could extend to the exclusively noisy, undifferentiated music that can be heard in those places where thousands of the young gather together to exorcise the horror of their solitude. But why today more than before has civilized man come to loathe himself?

Obviously, I can see the objections. We must not confuse the issue with social maladies, which may have always existed but were little known because the old means of communication did not allow us to recognize and diagnose the malady. Yet it is remarkable that a sort of general millenarianism is accompanied by an ever more widespread comfort, that well-being (where it exists, i.e., in limited parts of the world) wears the livid features of despair. Against such a dark backdrop of the current culture of well-being, the arts, too, tend to become confused, to lose their identity. Mass communications, radio, and especially television have tried—not

without success—to annihilate every possibility for solitude and reflection. Time is speeding up, works of a few years ago seem "dated," and the artist's need to be heard sooner or later becomes the spasmodic need for the current, the immediate. From this comes the new art of our time: the performance, a display that is not always theatrical, which involves the rudiments of all the arts in effecting a kind of psychic massage on the spectator or listener or reader or whatever. The *deus ex machina* of this new agglomeration is the director. His job is not only to coordinate the staging but to provide intentions for works that do not or did not otherwise have them. There is a great sterility in all this, an immense lack of faith in life. In a landscape of such hysterical exhibitionism what can be the place of poetry, the most discreet of the arts? So-called lyric poetry is the product, the result, of solitude and accumulation. It remains so today, if in very rare cases. More numerous, however, are the cases in which the so-called poet gets in step with the rest of the times. Poetry then becomes acoustical and visual. Words splash in every direction like an exploding grenade, there is no real meaning, only a verbal earthquake with many epicenters. Interpretation isn't necessary, though in many cases the help of a psychoanalyst would be useful. Since its visual aspect is predominant, this poetry is also translatable, and this is a new development in the history of aesthetics. It does not mean that the new poets are schizoid. Some of them can write classically traditional prose and pseudo-verse devoid of all meaning. There is also a kind of poetry written to be shouted in a square in front of an enthusiastic crowd. This arises primarily in countries where authoritarian regimes are in power. And these athletes of poetic vocalism are not always lacking in talent. I will cite one example, and you will forgive me if it is a case that concerns me personally. But the story, if it is true, demonstrates that there are now two poetries that cohabit together; one of these is consumed immediately and dies as soon as it is expressed, while the other may sleep quietly. One day it will awake again, if it has the strength to do so.

True poetry is similar to certain pictures whose owners are unknown and with which only a few initiates are familiar. Yet poetry does not live only in books or school anthologies. The poet does not know—often he will never know—whom he really writes

for. Here is a small personal example. In the archives of the Italian newspapers there are obituaries of persons who are still alive and working. They are called *cocodrilli*, crocodiles. A few years ago at the *Corriere della Sera* I discovered my own *cocodrillo*, written by Taulero Zulberti, critic, translator, and polyglot. He wrote that the great poet Mayakovsky, having read one or more of my poems translated into Russian, is supposed to have said, "Here is a poet I like. I wish I could read him in Italian." It's not impossible that this occurred. My first poems began to circulate in 1925 and Mayakovsky (who traveled as far as America and elsewhere) died a suicide in 1930. Mayakovsky was a poet of the pantograph, of the megaphone. If he did say these words I can say that those poems of mine had reached their destination by a circuitous and unpredictable route.

Don't think, however, that I have a solipsistic idea of poetry. It has never been my idea to write for the so-called "happy few." Actually, art is always for everyone and for no one. But what remains unpredictable is its true "begetter," the person for whom it is written. Art as spectacle, mass art, art which tries to produce a kind of physical-psychic massage on a hypothetical consumer is faced with endless possibilities, since the population of the world is continually growing. But its end point is absolute emptiness. You can frame and show a pair of slippers (I have even seen my own come to this end) but you cannot exhibit a landscape, a lake, or any other great natural spectacle under glass.

Lyric poetry has certainly broken its own boundaries. There is poetry in prose, too, in all great prose that is not merely utilitarian or didactic: there are poets who write in prose or what more or less resembles prose; millions of poets write verses that have no relationship whatsoever to poetry. But this means little or nothing. The world is growing, no one can say what its future will be. But it is impossible to believe that mass culture, thanks to its ephemeral nature and its tendency to decay, will not produce a culture that is also its obstacle and reaction as a natural counterforce. We can all contribute to this future. But the life of man is short, and the life of the world may be almost infinitely long.

I had thought of giving this title to my brief address here: Can poetry survive in the world of mass communications? Many wonder about this, but on serious reflection the answer can only be in the affirmative. If by poetry we mean so-called *belles lettres*, it is clear that worldwide production will continue to increase out of all proportion. If on the other hand we limit ourselves to poetry that rejects with horror the label of product, poetry which arises as if by miracle and seems to fix an entire epoch and an entire linguistic and cultural situation, then it is necessary to say that there is no possibility poetry will die.

It has been said many times that poetic language has a strong whiplash effect on the language of prose. Strangely, Dante's *Commedia* did not produce a prose of such creative greatness or did so only centuries later. But if you study French prose before and after the school of Ronsard, the *Pléiade*, you will notice that French prose lost the flaccidity for which it was considered so inferior to the classical languages and made a veritable leap into maturity. It was a curious result. The *Pléiade* did not produce homogenous collections of poems like those of the Italian *Dolce Stil Nuovo* (which is clearly one of its sources) but from time to time it gave us true "museum pieces" which will become part of a possible imaginary museum of poetry. It was a taste that could be called neo-Greek, and which centuries later the *Parnasse* tried in vain to equal. It proves that great lyric poetry can die, be reborn, and die again, but will always be one of the high points of the human spirit. Let us read together a song by Joachim Du Bellay. This poet, who was born in 1522 and died when he was only thirty, was the nephew of a cardinal with whom he lived for several years in Rome, where he acquired a profound distaste for the corruption of the papal court. Du Bellay wrote a great deal, imitating the poets of the Petrarchan tradition with varying degrees of success. But this poem (which may have been written in Rome) was inspired by the Latin verse of Naugerius[1] and is the fruit of a painful nostalgia for the gentle Loire landscape he had left behind. From Sainte-Beuve to Walter Pater, who wrote a memorable profile of Joachim, the brief *Ode-*

1. Latinized pen name of Andrea Navagero (1483–1529), Venetian politician and author of noted Latin lyrics.

lette des vanneurs de blé has entered the repertory of world poetry.
Let us try to reread it, if we can, though this is a poem where the
eye has a part to play:

> A vous troppe legere,
> qui d'aele passagere
> par le monde volez,
> et d'un sifflant murmure
> l'ombrageuse verdure
> doulcement esbranlez,
>
> j'offre ces violettes,
> ces lis et ces fleurettes,
> et ces roses icy,
> ces vermeillettes roses,
> tout freschement écloses,
> et ces oeilletz aussi.
>
> De vostre doulce halaine
> eventez ceste plaine,
> eventez ce sejour,
> ce pendant que j'ahanne
> a mon blé, que je vanne
> a la chaleur du jour.[2]

2. Andrew Lang's translation of Du Bellay's poem appeared in his *Ballads
and Lyrics of Old France* (1872). It reads as follows:

> To you, troop so fleet,
> That with winged wandering feet,
> Through the wide world pass,
> And with soft murmuring
> Toss the green shades of spring
> In woods and grass,
>
> Lily and violet
> I give, and blossoms wet,
> Roses and dew;
> This branch of blushing roses,
> Whose fresh bud uncloses,
> Wind-flowers too.

I don't know whether this *Odelette* was written in Rome during an interlude in the discharge of burdensome official duties. It owes its survival today to Pater. A poem can find its interpreter across centuries.

But now, in conclusion, I must answer the question that has lent a title to this short address. In today's consumer culture which sees new nations and new languages appearing in history, in the culture of man-as-robot, what can the fate of poetry be? There could be many answers. Poetry is the art that is technically available to everyone: all it takes is a piece of paper and a pencil and the game is up. Only later do problems of printing and distribution arise. A fire in the library at Alexandria destroyed three-quarters of Greek literature; today not even a universal blaze could do away with the torrential production of poetry in our time. But it is precisely that: production, i.e., the manufacture of objects subject to the laws of taste and fashion. That the garden of the Muses may be destroyed by great storms is, more than probable, certain. But it seems just as certain to me that much printed paper and many books of poems must resist the ravages of time.

The question is different if we are considering the spiritual revival of an old poetic text, its modern-day remaking, its being opened up to new interpretations. But in the end it is always doubtful what limits and boundaries apply when we speak of poetry. Much of the poetry of today is written in prose. Much of today's verse is prose—and bad prose. Narrative art, the novel, has produced great works of poetry from Murasaki to Proust. And the theater? Many literary historians do not even concern themselves

Ah, winnow with sweet breath,
Winnow the holt and heath,
 Round this retreat;
Where all the golden morn
We fan the gold o' the corn,
 In the sun's heat.

with it, except for a few geniuses who make up a chapter apart. And beyond that: how do we explain the fact that ancient Chinese poetry survives all translations, while European poetry is chained to its original language? Maybe the phenomenon is explained by the fact that we only believe we are reading Po Chü-i while in fact we are reading that marvelous counterfeiter Arthur Waley? We could multiply the questions, and the only answer would be that not only poetry, but the entire world of artistic expression or so-called expression, has entered a crisis that is closely bound up with the human condition, with our existence as human beings, with our certainty or illusion of being privileged beings, the only ones who believe they are the masters of their fate and repositories of a destiny of which no other living creature can boast. It is useless, therefore, to ask what the fate of the arts will be. It is like asking whether the man of tomorrow, even a very distant tomorrow—if we can still speak of that tomorrow, which may be an endless age—will be able to resolve the tragic contradictions with which we have been struggling since the first day of Creation.

On Italian Writers

On the Poetry
of Campana

[Published in *L'Italia che scrive* (XXV, 9–10), Rome, September–October 1942. Dino Campana, "the wild man" of modern Italian poetry, was born in 1885 in Marradi, near Faenza. In 1913, he brought his *Canti Orfici* (*Orphic Songs*) to Giovanni Papini and Ardengo Soffici at their magazine *Lacerba*, in Florence, but Soffici lost the manuscript. Campana reconstructed the book from memory and it was published in Marradi in 1914. An expanded version edited by the poet's friend Bino Binazzi, appeared in 1928. Campana died in 1932 after a long history of mental illness. Montale's essay was written following the publication of a new, further enlarged edition of the *Canti orfici* and of a volume of Campana's *Inediti* (Unpublished Writings), both of them edited by Enrico Falqui.]

The publication of an entire volume of uncollected writings by Dino Campana and the republication of the *Canti Orfici* in a more accurate edition than the previous (1928) one offers a good pretext in several respects for re-examining the work of a poet who has not been forgotten. Campana's bibliography, which has already been carefully edited by Falqui, will doubtless be added to by numerous writers. Yet, in contributing in our own small way to such an "increase," we soon find that there is not a great deal of uncovered territory. The poet of Marradi was not unappreciated; and if, in his opinion, help and assistance of a more concrete nature did not accompany this appreciation before he was struck by an incurable "spiritual confusion," he was not alone in suffering such a fate. Much is granted to dead poets, little to the living: especially to the living with the troublesome nature of Campana.

Proud, sick, and restless as he was, who could have calmed him and brought him peace? Strictly speaking, we repeat, there was no lack of appreciation. When Campana published in *Riviera Ligure*, between November 1915 and May 1916, the five poems which Binazzi added to the 1928 edition of the *Canti Orfici*, and which the present dedicated editor, Enrico Falqui, has placed among the uncollected poems (with the necessary note, it is true, though for our part we would have preferred a more strict distinction between those poems published by the author and the others), the curiosity that had been aroused by the *Canti Orfici* showed no signs of abating. The book had been praised by De Robertis, Binazzi, Boine, and Cecchi. Campana was then thirty, and in those days reviews were not measured in meters. In 1917 I myself came to know a group of student officers who were confirmed "Campanians" in the barracks of the Palazzo della Pilotta in Parma; the acknowledged leader of the group was Francesco Meriano, already editor of *La Brigata* and a friend of Binazzi. But in 1918 Campana was placed permanently in a sanatorium, and it was then that his myth was born. Since then, articles on the *Canti Orfici* have followed one after another, among the most notable of which for me are those by Solmi, Gargiulo, Contini, and Bo, all of them listed, with many others, in Falqui's bibliography. In these writings one can see plainly the double interpretation of Campana which was already latent in his earliest critics, and which finally attained perfect clarity of expression in Contini's essay. Is Campana a *visual* or a *visionary* poet? A recent rereading of the *Canti Orfici* has convinced me—let me say right off—that the horns of this dilemma are anything but irreconcilable: for it is true that Campana's critics who are least inclined to mysticism and irrationalism concede him "illuminations pushed to the point of myth" (Gargiulo) and deny that in Campana it is possible to speak of simple impressionism (Contini); while on the other hand the most astute interpreter of the poet's "uncontrollable night" (Carlo Bo) has expressed himself in phrases and images ("a poetry that did not have the time to flower, or did so only with the too-early, cruel assistance of its fruits") which reveal at least one limit of this poetry.

The observation, which is easy enough to make even if it were not confirmed by personal recollection, that Campana was soon noticed by the establishment, must not lead one to think that the rumor-mongers of the moment (futurists, Lacerbians,[1] etc.) paid much attention to the author of the *Canti Orfici*. They may have taken him for one of their own, but at a proper distance; and Campana himself did not regard them with great sympathy. Still, the poet did not sprout like a mushroom in an atmosphere unprepared to receive him. One of the interests of the uncollected work just published (about sixty poems, along with various notes, aphorisms, pensées, etc.) is precisely that they allow us to relate Campana better to his times and shed light on his futurist apprenticeship. An apprenticeship about which there had always been explicit and implicit doubts. Today the weakest parts of the *Inediti* [*Unpublished Writings*], and especially of the forty-four poems in the recently discovered notebook, convince us that the poet began and developed anything but precociously, in an atmosphere red-hot with isms. The list of poems that contain striking traces of the work in Marinetti's first anthology of 1912 would not be short. They range from a "tentacular" Marinetti-Buzzi[2] ambience ("*O poesia poesia,*" "*Oh l'anima vivente,*" "*Umanità fervente sulla sprone,*" etc.) to an Art Nouveau–style symbolism, somewhere between Lucini[3] and D'Annunzio ("*Convito romano egizio*" and others). There are also signs of the "loutish" Palazzeschi[4] ("*Prosa fetida*") sometimes combined with the scene-painting of Rosai[5] ("*Notturno*

1. *Lacerba* was a futurist-oriented literary and political review founded by Giovanni Papini and Ardengo Soffici upon their leaving *La Voce* in 1913. The magazine suspended publication in 1915.
2. Paolo Buzzi (b. 1874). Futurist poet and novelist.
3. Gian Pietro Lucini (1867–1914). Poet, novelist, and essayist. A futurist with a sensual, D'Annunzian love of language, he was the author of *Il verso libero* [*Free Verse*] (1908).
4. Aldo Palazzeschi. Pseudonym of Aldo Giurlani (1884–1974). Originally a crepuscular poet, he was briefly a futurist, working on *Lacerba* with Papini and Soffici, and later wrote novels with surrealist overtones.
5. Ottone Rosai (1895–1957). Painter and writer. Originally a futurist, he later painted contemplative realist pictures in the nineteenth-century Tuscan tradition.

teppista"). (We shall mention a different Palazzeschi later on.) But the group also contains poems which will be significant when set next to those of the *Orfici: "Donna genovese," "Il ritorno," "Sulle montagne,"* for example. There is also the typical Campanian musical *Stimmung* a little bit everywhere (*"A un angelo del Costa," "Furibondo," "Une femme qui passe"* . . .) which we shall see later in *La chimera*. As well as that vast Mediterranean sense of space which is typical of certain of Campana's efforts, here, naturally, not without a great deal of D'Annunzio.

Are they juvenile poems? Up to a point. In all probability, the poems in the notebook were written between 1912 and 1914 when the poet was between twenty-seven and twenty-nine. Perhaps they were all transcribed quickly and at once, making use of recent experiences (recollections of his trip to America in March–November 1913) as well as others less recent, so that they wouldn't be lost. It's impossible to know for certain. The most achieved poems of the *Orfici*, the only ones that stay in one's memory, are almost all here; or their musical germ is here. Campana seems to have included them in the *Orfici* without looking at the notebook again. And when we remember that after the manuscript of the *Orfici* was lost Campana rewrote it very speedily, it is possible to conclude that the rewriting-transcribing of the parts of the notebook included in the *Orfici* must also have been rapid: rapid, and followed, if not by a repudiation, then certainly by dissatisfaction and disinterest. Clearly the notebook was put away for what Campana thought would be forever.[6] We know nothing of the manuscript of the *Orfici* that was lost; nor how far the recopied manuscript followed the old one in the prose it contained. But we can conclude that here too Campana had worked *ex novo* and quickly, if it is true that they represent the maturest part, in a stylistic sense as well, of the book. Campana saved only a small part of the earlier poems represented wholly or in part by the notebook—clearly the best part, thus proving himself a perceptive critic of himself. In any case it is clear that—whether from memory or not—Campana took the verse part of the *Orfici* from his notebook. He cut the poems, pruning

6. It was found later. [Author's note.]

and lightening them. The idea of a "European, musical, colorful" poetry was a product of Campana's education as well as an instinct; but it clearly had been accompanied or preceded by an experimentation, still somewhat inert and passive, with the new isms then in the air. Official Futurism, too, like the innovators at the turn of the century, had claimed that it was "breaking the glass," clearing the air. Campana, however, had chosen subtler masters than those followed by his temporary mentors. He instinctively rejected the more mechanical, cataloguing aspect of the free verse that was then fashionable, and went—as the facts confirm—to the truest sources of the movement, from Whitman to Rimbaud. For himself, in art and life, he related an issue of style to an issue of conscience, and he was aware that in his time and place his was a new and different voice. But we should be careful not to attribute too much conscious reflection to a man who, due to the tragic and precarious state of his health, was the poet of a brief, perhaps extemely brief, period. One of the charms of Campana's poetry certainly lies in its obscurity, which was anything but intentional, but which the poet's illness protected and favored. It is a poetry— here I share the opinion of Solmi—"which can hardly be separated from the feverish atmosphere which constitutes its source." Gargiulo seems to feel otherwise; he points out the poet's obscurities and declares that "nothing, on the page, authorizes us to make biographical deductions as to the causes of this defect: on the page we can only attribute it, as in similar cases, to the profundity or 'ineffability' of its inspiration." It is not entirely clear what similar cases Gargiulo has in mind. The reference to ineffability makes one think of Ungaretti; but it is well known that in Ungaretti the danger of obscurity is accepted, even theoretically, as the inevitable counterpart of a risky desire for pure poetry which is much less apparent in Campana. Ungaretti, who has qualities all his own which distinguish him from his epigones and imitators, clearly shares the taste for the fragment understood as a new genre, perhaps the only genre of our time, a legitimate and self-sufficient expression of the lyric *moment*, the product of a poetics which does not wish to mix the necessarily brief and flashing apparitions of poetry with elements of a different, voluntary nature. Up to a point,

Campana shares in this climate: among his obscure intentions one can make out a demiurge, the ritualism of the conjurer of poetry which probably never would have been satisfied on the plane of pure lyric. His is a poetry in flight, which always disintegrates at the point of completion: its development would have been unpredictable, to say the least. For the idea of what would have followed, that is, the idea of a later, *different* Campana is somehow unthinkable to us, and even unlikely. And in fact no one has dared to confront it, very few have considered Campana as a promising poet, cut off by an evil fate.

It has been observed that Campana was in better trim in prose than in poetry. This is an accurate observation, but it cannot be forced. Campana the poet per se lacked time, application, and continuity, i.e., the very conditions which allow a poet, when he is not an *enfant prodigue* (as he was not), to perfect his instrument. Still, Campana's verse, even that part which is most open to classicizing movements, often justifies itself as a type or a variety of his prose. If it is important in a poet to cultivate the point of contact or coincidence between instinct (physiology) and technique, a close examination would permit us to observe the scant difference, which is not always a difference in tone, that lies between these two modes. Nevertheless, it remains true that—whether or not he cultivated them—Campana achieved the conditions of spontaneity in which he was able to express himself more often and more easily in his prose writings: writings which run from the lowest, most diaristic tone, to the most elevated, which is not always his most poetic. It also seems probable, if not certain, that Campana was very unsure of his verse, since when he wrote or rewrote the prose sections of the *Orfici*, though he did not omit the poems in the notebook, he made a strict selection from them, and revised them with great insight. As to the selection itself, we have already seen that, apart from the few exceptions indicated, it was made with extreme clearsightedness; concerning the revisions, it is enough to examine the most conspicuous example, "*Boboli*," which appears this way in the notebook:

Nel giardino spettrale
Dove il lauro reciso
Spande spoglie ghirlande sul passato,
Nella sera autunnale,
Io lento vinto e solo
Ho il tuo profumo biondo rievocato.
Dalle aride pendici
Aspre, arrossate ne l'ultimo sole
Giungevano i rumori
Rauchi già di una lontana vita.
Io sulle spoglie aiuole
Io t'invocavo: o quali le tue voci
Ultime furon, quale il tuo profumo
Più caro, quale il sogno inquieto
Quale il vertiginoso appassionato
Ribelle sguardo d'oro?
S'udiva una fanfara
Straziante salire; il fiume in piena
Portava silenzioso
I riflessi dei fasti d'altri tempi.
Io mi affaccio a un balcone
E mi investe suadente
Tenero e grandioso
Fondo e amaro il profumo dell'alloro:
Ed ella m'è presente
(Tra le statue spettrali nel tramonto).[7]

In the *Canti Orfici*, it becomes the following, with the title "*Giardino autunnale*":

Al giardino spettrale al lauro muto
De le verdi ghirlande
A la terra autunnale

7. In the spectral garden / where the cut laurel / spreads barren garlands on the past, / in the autumn evening / I, slow, defeated, alone, / called up your blond scent again. / From the rough, dry / slopes, red in the last of the sun, / came the now-harsh / noise of a far-off life. / I, in the barren flowerbeds / I invoked you: o what were / your last words, what your favorite / scent, your

Un ultimo saluto!
A l'aride pendici
Aspre arrossate nell'estremo sole
Confusa di rumori
Rauchi grida la lontana vita:
Grida al morente sole
Che insanguigna le aiuole.
S'intende una fanfara
Che straziante sale: il fiume spare
Ne le arene dorate: nel silenzio
Stanno le bianche statue a capo i ponti
Volte: e le cose già non sono più.
E dal fondo silenzioso come un coro
Tenero e grandioso
Sorge ed anela in alto al mio balcone:
E in aroma d'alloro,
In aroma d'alloro acre languente,
Tra le statue immortali nel tramonto
Ella m'appar, presente.[8]

This is the most detached and perfect of Campana's lyrics: but such crystallization is rare for him. More often the poet seems tempted by *Lied*, even if it is a stuttering *Lied*, verging on the inexpressible:

Sorgenti sorgenti abbiam da ascoltare,
Sorgenti, sorgenti che sanno

most disturbed dream / your giddy, passionate / rebellious golden look? / A heartbreaking fanfare / was heard rising: the flooding river / silently carried / the reflection of the splendor of other times. / I come out on a balcony / and persuasive, tender / majestic, deep and bitter / the scent of laurel fills me: / and she is here with me / (among the spectral statues in the sunset). 8. To the spectral gardens, to the silent laurel / with its green garlands, / to the autumn land / a last farewell! / On the dry slopes / Rough, red in the last sun / far-off life / blending in harsh noise / shouts to the dying sun / that bloodies the flowerbeds. / A heartbreaking fanfare / is heard to rise: the river disappears / in the golden sands: in the silence / the white statues atop the bridges / have turned: and things no longer exist. / And from below, silence like a horn / Tender and majestic / rises and reaches toward my balcony: / and in the aroma of laurel, / the bitter, fading aroma of laurel, / among the immortal statues in the sunset / she appears to me, is here.

Sorgenti che sanno che spiriti stanno
Che spirti stanno ad ascoltare . . .[9]

Elsewhere much greater ambitions, compositional as well as musical, prevail: *"La chimera," "Immagini del viaggio e della montagna," "Viaggio a Montivideo," "Genova"*—thematically valuable, but only in places. Nevertheless, these poems show the direction which Campana the poet was consciously planning to take: the path from his most Lacerbian poems (*"Batte botte"*), passing close to the rhythmical experiments of Palazzeschi—with that breath rising to a double alexandrine time which Renato Serra[10] found in the poet of *"Gioco proibito"*—which hoped to arrive at a complete coloristic-musical dissolution of poetic discourse. Campana's interest in a poem of Giaconi's[11] (her *"Dianora,"* which was later attributed to him), and the letter he sent to Novaro[12] (in which he refers to "the neo-Greek sensibility of truly modern Italian poetry"), tell us something about this: Giaconi had been weaned on the English, and in her case the remark was certainly valid. On the path Campana had set out on, prose may have distracted and attracted him through the greater sense of freedom and agility it offered his volubility of expression—prose, certainly, as well as other occasional momentary distractions. In a lyric written after the *Orfici*, one of his last in verse, *"Hai domati i picchi irsuti,"* there are even some choral and popular notes not far from parts of Jahier.[13]

An urgency of content flashed into the uncontrollable night; the energetic will and voluptuousness of a nomad, a "tramp" who knew Whitman and Rimbaud and experimented with his poetry as

9. Springs springs we have to listen, / Springs, springs that know / Springs that know what spirits / what spirits are here to listen . . .

10. (1884–1915). Literary critic, contributor to *La Voce*. Author of *Le lettere*, 1914. He was killed in World War I.

11. Luisa Giaconi (1870–1908). Poet, influenced by Pascoli. Her *Tebaide* was posthumously published in 1909.

12. Mario Novaro (1868–1944). Poet, editor of *Riviera Ligure* 1895–1919. He also edited the works of Boine.

13. Piero Jahier (1884–1966). Autobiographical Genoese writer, a member of the *Voce* group.

an activity that was indivisibly both aesthetic and voluntary, moral; "song of himself"; *"saison en enfer"*; Lacerbian and Vocean free verse and autobiography; diffuse neoclassical echoes—De Robertis has mentioned Carducci, and the idea of a traditional poet destroyed by sickness or bad training has also been suggested here and there—echoes not only of Carducci but of D'Annunzio, which for my part I would not want to separate from the more personal and obscure nature of Campana's "barbarous" message, from that idea of an Orphic poetry which is not confined to the title of his book and cannot be considered irrelevant to his conception of himself as a latter-day Germanic rhapsode, seduced and dazzled by the bright lights of the Mediterranean—all of this appears in flashes in the few pages of the *Canti Orfici.*

Let us pause for a moment at this "Orphism," which Campana's book certainly makes no effort to define. It coincides with the rise of a metaphysical painting in Italy (Carrà, De Chirico) of whose existence and intentions Campana could not have been unaware. Like the early De Chirico, he evokes powerfully the ancient cities of Italy: Bologna, Faenza, Florence, and Genoa shine forth in his poems and inspire some of his greatest moments. Is this barbarous or if you will antique aspect another indication perhaps of his latent Carduccianism, which is even more apparent in the openings of some couplets? Possibly; but it seems to me that Campana's Orphism and his illusion that he was a latter-day *poeta germanicus* lost in the lands of the south coincide in his intentions and even in his achievements. I do not wish to make Campana into a German poet except metaphorically, or into a theoretician of racism, but it was clearly not by chance that he dedicated the first edition of the *Orfici* to the "tragedy of the last German in Italy," and that in his dream of barbarism—which may have been nothing more than his incorrigible conviction that he was an ancient—there was actually a suggestion of an ideological and moral nature. The disparate pensées (*Storie*) published in the recent *Inediti* includes several curious allusions to this: "The creator of French impressionism is the *gaulois*, a scoundrel who has become self-aware through democracy, a slave, incapable of abstract, i.e., aristocratic, ideas. The human odor of the *gaulois* is what makes France uninhabitable for delicate sensibilities.—Nietzsche." Other remarks fol-

low which are also useful in interpreting his poetry: "To flow over life, this would be necessary,[14] this is the only possible art", and there are other references to Nietzsche and Wagner. But there is little, too little for one to make out anything like Campana's "thought." We do not know precisely how much German the poet knew: certainly it must have been among the five languages which he claimed to know well when he wrote to Novaro. He probably knew little or nothing of George, and the Orphic Rilke came after his book; perhaps he had some awareness of Hölderlin's Greece; with Nietzsche he had a secure and often obsessive familiarity. In any case it is obvious that his sense of escape, "that investigation of dimension, that spatial tension" (Contini) was not achieved— at times, it is true—without the help of a language which vies with German in its abstract capacities, an unfocused language, blunt at the edges, capable of halos and iridescences, of an "extremely bloated and never definite" speech (Bo); the one language which could render the *Stimmung* of "*La chimera*," "*Notte*," and many other fragments—at times, even, in the notebook, in fragments of fragments, of a more or less Futurist intonation. Is Campana a *poeta germanicus*, then? And why not, if we remain in the realm of metaphor and admit that Campana instinctively excavated for himself, out of our language, a language entirely his own? I have said "excavated" but actually it is not the notion of an excavation that best describes Campana. We should think instead of actual leaps in the air, of rapid immersions in a different element, unfamiliar to the poet himself.

Dal ponte sopra la città odo le ritmiche cadenze mediterranee. I colli mi appaiono spogli colle loro torri a traverso le sbarre verdi ma laggiù le farfalle innumerevoli della luce riempono il paesaggio di una immobilità di gioia inesauribile. Le grandi case rosee tra i meandri verdi continuano a illudere il crepuscolo. Sulla piazza acciottolata rimbalza un ritmico strido: un fanciullo a sbalzi che sfugge melodiosamente. Un chiarore in fondo al deserto della piazza sale tortuoso dal mare dove vicoli

14. Here Campana is translating from the *Gay Science* of Nietzsche. [Author's note.]

verdi di muffa calano in tranelli d'ombra: in mezzo alla piazza,
mozza la testa guarda senz'occhi sopra la cupoletta. Una donna
bianca appare a una finestra aperta. È la notte mediterranea.[15]

There may be something of De Chirico here, but dissolved in a
Zarathustrian intoxication. Note that this is not an extreme exam-
ple, but one of those which loses least in being taken out of context.
Let us see again, still choosing from among the average examples,
whether it is painting or music that dominates in apparently de-
scriptive observations of this sort:

Tre ragazze e un ciuco per la strada mulattiera che scendono.
I complimenti vivaci degli stradini che riparono la via. Il
ciuco che si voltola in terra. Le risa. Le imprecazioni mon-
tanine. Le rocce e il fiume.[16]

Is everything here? So it seems. But it is obvious that not
even an extensive series of examples could make our metaphor
visible, material. And yet we don't know what other key to offer
to new readers of the *Orfici* than the recommendation that they
take this poet's music in its native form, which is alive here and
there throughout his work and especially in those mythic sketches
—the return, the Mediterranean night, the figure of Michelangelo,
the backgrounds of the "divine primitive Leonardo"—when Cam-
pana pauses at the threshold of a door that doesn't open, or now
and then opens only for him.

Beyond this, beyond these escapes not only into space but also
into the dimensions of a language which is born anew within an-

15. From the bridge above the city I hear rhythmic Mediterranean cadences.
To me, the hills look barren with their towers through the green bars but
below the innumerable butterflies of the lights fill the landscape with a still-
ness of inexhaustible joy. The huge reddish houses among the green mazes
continue to elude the twilight. A rhythmic shout echoes on the cobbled
piazza: a child fleeing melodiously, by fits and starts. A brightness beyond the
desert of the piazza rises tortuous out of the sea where green alleys of mold
set in snares of shadow: in the midst of the piazza, the eyeless severed head
keeps watch from the little cupola. A white woman comes to an open window.
It's Mediterranean night.
16. Three girls and a donkey, coming down the muletrack. Lively compli-
ments from the roadmen lining the way. The donkey who rolls on the ground.
Laughter. Mountain curses. The rocks and the river.

other foreign, passive language entirely unaware of its latent capac-
ity for transformation—and I am not referring to the language of
Marinetti or the more human language of Soffici[17]—Campana's
notebook would seem to have little lasting interest for us, and the
objections of many of his critics would seem more than legitimate.

Campana has nothing to fear from a selection which would
preserve his truest gift: his *diversity* of tone. It's true: the message
of the *voyant* may leave us unconvinced, vague as it is; in his work
"we are given to encounter neither the cultural drama nor the
explosive religious anxiety of a Hölderlin" (Solmi); nor, let us add,
the blaze of light of a Blake, nor the subterranean thematic unity of
a Rimbaud. It is easy to admit that Campana was working toward
structures and perspectives that were very different from those to
be found in the *chimismi*[18] of his time; but it is also clear that he
was not a lyric poet in the exclusive sense, *tout entier à sa proie
attaché*. The sense of limitation, of obstacle, is rare in him; he was
fought over and visited by too many abstract possibilities; his own
notion of a musical, colorful European poetry sounds a bit vague
today. The poet has need of a decisiveness of an almost physical
nature, the impossibility of expressing himself in any other way.
And this decisiveness, which at a certain point coincides with an
artist's greatest spontaneity, we find above all in Campana's prose.
If it were not repugnant to reduce to shreds a spirit who aimed at
total expression and yet has left us with such a fragmentary picture
of himself, we might be inclined to abridge Campana's work, which
is already so short, limiting it to a few incorruptible pages in which
we feel it is impossible to deny that the poet of Marradi had a voice
very different from the others of his time. An anthology which
would include, for example, "*La notte*," "*La Verna*," "*Firenze*,"
"*Scirocco*," "*Piazza*," "*Sarzano*," "*Faenza*," a few of the nocturnes,
some of the poems already mentioned, and a few other fragments
and pensées. Is it little? Is it poetry in prose and therefore base in

17. Ardengo Soffici (1879–1964). Futurist writer and painter. Founded the
futurist review *Lacerba* with Papini in 1913. A Fascist, he was elected to the
Italian Academy in 1939.
18. A *chimismo* is the complex of chemical processes which together make up
a physiological function. *Chimismi lirici* was the title of a well-known book
by Soffici published in 1915.

tone? Let's forget the "therefore," I don't believe it necessarily follows. Dino Campana, who, as Cecchi has said, "passed like a comet," may not have exercised "an incalculable influence," but the traces of his passing are anything but buried in sand. There was nothing mediocre in him; even his errors we should not call errors but inevitable collisions with the sharp corners that awaited him at every step. The collisions of a blind man, if you will. Visionaries, even if they happen to be "visual" like our Campana, are inevitably the most artless, the blindest of creatures on this earth.

Is There an Italian Decadence?

[Published in *La Lettura* (II, 26), Milan, June 29, 1946.]

There are preachers who when they mount the pulpit begin to breathe fire against those who don't go to church. I can recall hearing more than one and being amazed, even as a child, at words which were unfair if they were directed at those present and worse than useless if aimed at those who didn't want to or couldn't hear them, i.e., at those who were absent from God's house.

I think of something similar when I read what has been written in Italian reviews and newspapers (especially since the fall of Fascism) about the failings and isms (decadence, hermeticism, etc.) which supposedly afflict our contemporary literature. I suspect these sermons are often exaggerated in tone and misguided in direction.

In fact, "decadence"—a term which remains in use only in Italy—refers to nothing that is natively Italian, nothing that took hold here more successfully than elsewhere. The phenomenon, which has rather distant antecedents, took shape and became self-conscious in France about eighty years ago, and then grew and prospered throughout the world. All countries, even those which could not be called socially advanced (e.g., pre-Soviet Russia), knew their own form of poetic decadence. In Italy, the wave arrived late and as a reaction; and the term which represents it took on such a vast significance that Walter Binni in his noted book *La poetica del decadentismo italiano* could certainly use it, while excluding every moralistic or diminutive shading from it, as the label,

the brand name, of the so-called modern "taste" in poetry. A taste which includes "pure" or alogical poetry, but embraces something larger, too, and thus also includes the poetry which, through the deepening of musical values, attempts to justify, even while reducing them to a minimum, those gray areas, that connective tissue, that structural-rational cement which the pure poets reject . . . when they succeed. Naturally, there is no modern poet who belongs strictly to one or the other of these schools, between which perennial exchanges and rich confusions abound. But understanding the distinction very broadly, I would cite among the first (the poets of the pure intuitive flash) the Coleridge of "Kubla Khan," the Rimbaud of the *Illuminations*, and much of Ungaretti; while in the second I would place the Foscolo of the *Sepolcri*, the Hopkins of his most considered lyrics, the Valéry of *"Le cimetière marin,"* and the Eliot of the *Quartets*. And it is clear that a common principle unites all the poets of both schools: the sense of the crisis which poetry entered on the day that aesthetic thought brought it to an elevated level of self-consciousness and cast too much light on its means and ends. Decadent poetry, then, in the non-pejorative sense, meant in Italy until recently poetry that was alive, sensitive to our times; and even those who deplored the use and abuse of this adjective, and its strange survival in Italy, also had to come to terms with a living reality and not a simple label.

The question of "hermeticism," a native subspecies of European decadence, is different and simpler. We have here a word coined in Italy a few years ago to attack those recent (Italian) poets and those of their critics who left themselves open to the accusation of a more or less voluntary obscurity. A purely Italian phenomenon? Partly yes and partly no; it is enough to look around us to judge. For several years now whenever one opens up a French or English or American—or worse, South American— review, one normally and constantly finds poems and poetic prose that are uniformly and ineradicably "black as ink"; accompanied (though unfortunately not in Italy) by critical commentary, exegetical glosses of a notable perspicuity. In Italy there is another aspect to the situation: as the difficult poets are few and not all of them are respectable, "obscurantism" seems to have retreated into criti-

cism, and hermeticism appears to be the distinctive characteristic of those "little academies" which G. Morpurgo-Tagliabue mentioned in a recent issue of *La Lettura*.

If our diagnosis is correct, how does one explain the insurrection we have noted, and the terror of isms which is prevalent among our least benighted critics? It is certainly due in part to the anxiousness for total renewal which has pervaded our country after so many difficult trials, the sense that in the world of culture, too, it is necessary once and for all to make a clean sweep of too many mistakes; but it is also certain that there can be no advantage in the arbitrary perversion of certain innocuous terms. To put it plainly: history (or literary history) does not progress by means of poisons and antidotes alone and no malady can be cured with an erroneous diagnosis. The fact is that for many of those who reject outright the mentality of the "little academies," "decadence" today seems to mean only this: art for the initiated, for the cultural priesthood, art "torn away" (the term is obligatory) from everyday life, from those activities which interest our poor, common humanity. There is no concern whatsoever with the origins and significance of a sensibility which still shows no signs of exhausting itself. And one reaches the conclusion that decadence and even hermeticism linked together signify the ivory tower, the *hortus conclusus*, or rather (and the deduction comes as perfectly logical!) non-art. And the term has also been taken outside of the literary field and bloated with various meanings: decadent or rather crepuscular art, or if you prefer petit-bourgeois art, is the art of those who paint still lifes of flowers and bottles rather than sketches of firing squads and hangings; decadent poetry was formerly the poetry of the crepuscular poets, woven out of small sensations and irony, and ultradecadent or hermetic poetry is poetry which goes the way of analogies and metaphors, with added stylistic complications and a stronger reference to the formal problems of our classical, traditional poetry. The common denominator of all neo-bourgeois art is the ineffability or rather the obscurity of its contents. (It is pointless to say that no one shows any sign of recalling the real obscurities of many classics . . .)

In a land of such sullen diagnosticians can you imagine the

fate that would have greeted Hopkins or George, Yeats or Valéry, if one could imagine them being born in Italy? In painting, the decadent Modigliani was accepted in Italy, and then with great suspicion, only after Paris had become infatuated with this artist. *Locuta Lutetia* many prejudices have fallen; but a Medardo Rosso, who was less pleasing to the French, is beginning to be appreciated only now that we have managed to relate him to the Lombard tradition of Ranzoni[1] and other poets of *chiaroscuro*, only now that we can discover a certain element of native classicism in him. In the field of letters there is nothing to say: the obscurity of some of our poets is as sunlight compared with that of the foreign poets who are talked about today. And yet Italy, the country that is most immune from isms among the countries with a high culture, is also the country in which criticism seems most obsessed by this problem. Faced with an artist or a poet, our criticism (with the exception of hermetic criticism, which has perhaps this one merit) does not pose the question of the authenticity of his art or poetry; rather, it asks whether or not he belongs to the caste of hermetics or decadents; and depending on the answers, summary dismissals or hasty recognitions follow. The case of Pascoli is typical; he was idolized for forty years as the "heart of hearts" or dethroned as a "decadent," without the problem—historic or stylistic—of his poetry making a single step forward.

Be it for good or ill, while certain of our critics concern themselves above all with schools and abstract content, the fact is ever more evident that schools and fashions in art were not made for Italians. Thirty years ago, after the success of the crepuscular poetry which imitated French and Belgian writers, but also contributed a few minor original notes, a movement took hold in Italy which had characteristics of a certain virulence: futurism, a typically pre-Fascist epidemic, which aimed, among many other things, at curing the inferiority complex of our countrymen by substituting an equally strong but much more dangerous superiority complex. Then the heralded Messiah, the Big Stick, arrived among us, and in

1. Daniele Ranzoni (1843–1889). Leading painter of the second phase of Lombard romanticism.

the last twenty years Italy has known no movements which can be compared to French surrealism or American imagism. She confined herself to registering what was happening beyond the frontier, to sustaining more or less superficial influences, but in art she remained the most classic (some say the most provincial) country in the world. Even today, one can meet improvisers at Consuma or Pietramala in the Tuscan countryside who actually *answer each other in rhyme* and who reel off octaves of beautiful sound and rich lexical texture by the hundreds, on subjects chosen on the spur of the moment and even of great topical interest, without losing the tempo of their verse accordion which is stretched or compressed to fit its eleven beats with a sense of *rubato* that is truly admirable.

Popular relics, it will be said; one needs to look elsewhere for the traces of our malady. But where? Anyone who goes to an exhibition of paintings can always find some arbitrary extravagances or post-cubist efforts (the inimitable Picasso remains taboo in France and Italy), but they will be exceptions, if not always unhappy ones, to a more normal, domestic average rule. And whoever leafs through an Italian literary magazine can doubtless find "obscure" poems or prose, but nothing comparable to what can be seen in the major foreign publications.

A little calm then, gentle critics, or your noble efforts will run the risk of being more sterile than the art you denounce. There are literary censors today with one foot in Croceanism and the other in the most conventional academic neoclassicism, who live in the realm of the impossible waiting for a new Carducci;[2] there are others who, abusing certain Marxist premises, insist on an urgent renewal of content and look to art not only for the truth of the artist (as would be just) but for their own personal truth; and still others (among them many of the so-called hermetics) who would be happy with an art that is formless and germinal but are not

2. Giosuè Carducci (1835–1907). One of Italy's leading literary figures of the nineteenth century, Carducci was a rebelliously anti-romantic neoclassical poet with strong republican sentiments. Professor of Italian literature at Bologna for over forty years, he exerted a strong influence as a teacher and mentor of other poets (Pascoli among others). Revered as a "national poet," Carducci became a member of the Italian Senate (as Montale was later to do). He won the Nobel Prize for Literature in 1906.

satisfied with the small certainties of form and style. One cannot say that much illumination comes from these critics, who when they are illegible constitute a caste which is truly unique in all the world, and typically Italian. And yet our hermetic critics, inexcusable as writers, perhaps because of their poor digestion of culture, perhaps because of the mistaken pride that besets them, establish if nothing else the premises of a future criticism which will interpret the face of our time.

A further word on poetic decadence before I close. If decadence in poetry, if endless other isms in art, meant art for the mandarins and clerisy of a new cultism (as is too often true), meant the expression of the cabalistic and artificial mentality of those who have lost all ties to the new world which is arising even through pain, errors, and horrors, it is clear that no one could deplore this direction more than we do. But we do not need to believe that there would be a positive advantage in substituting the international Esperanto through which it is attempted to translate difficult or rare sensations (an Esperanto which is now accessible to billions) with another convention, willfully ingenuous and personal, inspired by collective life and the new social ideologies. And above all it is not necessary to require that this must of necessity happen in the country which has been least acquainted with the malady and consequently has least need of reacting to it *before it happens elsewhere.* Can the aspect of a culture like ours, in which history, and events, have always entered into the life of art indirectly, and only insofar as these have found the individual who knew how to give them a definitive form—can it change all at once? Even recently, highly notable books have appeared on the events in which we were not long ago actors and witnesses; diaries, confessions, chronicles, war poems, accounts of partisan life have been published in Italy; but almost nothing (even according to those who foresee a new art) which rose from the level of document to that of art; and nothing (and perhaps this is not a disgrace) which can be situated in a particular literary genre, like, for instance, the poetry of the French Resistance. Evidently, the social awareness or rather the lack of it among Italian writers does not change with the changing fate of our people. And the literature of

the peninsula—while we await the foretold *Weltliteratur* in which every distinct poetry will, who knows? become uniform—evidently goes its own way, which is perhaps that of the Lord, but certainly not the way of those who would like to impose their alarmed critics and custodians upon it.

The Fortunes

of Pascoli

[Published in the *Corriere della Sera*, December 30, 1955. Giovanni Pascoli (1855–1912), a student of Carducci, was one of the most influential poets of the late nineteenth century. A classical scholar, he wrote in a formally elegant and rhythmic style about melancholy subjects, sometimes with mystical overtones. D'Annunzio considered him the finest classical poet (he also wrote in Latin) since the Augustan age. Pascoli had an important influence on the *crepuscolari*.]

The passing of 1955 also brings to a close a centenary of which perhaps not many of our readers are aware: the hundredth anniversary of Pascoli's birth. In a preface to the voluminous *Omaggio a Pascoli*, which includes numerous critical contributions of today and yesterday and correspondence, some of it unpublished, between Carducci and Pascoli and Pascoli and D'Annunzio, Arnoldo Mondadori, the publisher, has reminded us that the time has come for a summing-up, since "one hundred years after a poet's birth is a long enough period to decide between silence or immortality." Apart from this large volume edited by Manara Valgimigli and Augusto Vincinelli, there is also an issue of Calamandrei's *Il Ponte* (November 1955) which includes more than fourteen articles on the singer of the *Myricae*. No doubt numerous other tributes and celebrations have eluded us; but these are enough to make us realize that the silence of which the publisher speaks is one of those hypotheses which a jurist would call "inadmissible" and therefore clearly to be excluded.

As for immortality, we should remember that the turning of the pages of the calendar is not always accompanied by a revolu-

tion in taste, a change in perspective. Forty-three years after his death Pascoli is not yet an "embalmed" poet. He is still talked about, though perhaps the only new development in Pascoli studies is that the nature of his Muse seems less problematic to us today— and that the field is no longer so divided between denigrators and fanatics. The moment of greatest dissension was marked by Croce's essay (1907), which was almost entirely negative; it was countered by studies by Serra (1910), Cecchi (1912), and Borgese (1912), who were far from apologetic, indeed rather inclined (especially the first two) to reduce Pascoli's poetry to a vague poeticality, but who were doubtless more open to understanding. A commentary on the *Myricae* by Onofri also followed this line, while a referendum conducted by *La Ronda*[1] in 1920 reinforced Croce's judgment.

The views expressed on that occasion would seem aberrant were they not attributable to the taste of a restoration that is practically incomprehensible today. It seemed as if Pascoli was being criticized for not being a new Leopardi, but underneath the provisional formulations something true was being expressed. I recall a substantially correct judgment of Cecchi, who had not disowned his earlier book, and yet had become convinced that "Pascoli worked outside any organic idea of style; he gave us something of everything, including many beautiful things." One of the participants at that gloomy symposium, Gargiulo, announced years later that he had changed his mind; and it is regrettable that the Mondadori *Omaggio* does not include this *pentimento*. Pascoli's critical fortunes or lack of them do not end here: later essays by Galletti, Flora, Turolla, Viola, an observant short piece by Baldini, an original book by Natalia Benedetti, and at least twenty other volumes did much to adjust the balance; nor can it be said that we are ignoring the right wing of Pascoli criticism, made up of the poet's devotees, including Valgimigli, Pietrobono, and Orvieto, followers of the first-generation Pascolians: Ferrari, Mazzoni, and the other friends of the poet's youth. Their noble contribution, and the veneration which a Francesco Acri had for Pascoli, remain valuable primarily as personal tributes.

As to the poet's reputation during his lifetime, Dino Provenzal

1. See Note 4 in Introduction.

writes perplexingly in the Mondadori *Omaggio* that "during the few years which remained to him"—the writer is doubtless referring here to Croce's critique and the lack of success of the poet's essays on Dante—"Pascoli enjoyed neither great fame, nor the literary prizes which later became current, nor any true recognition: apart from the Amsterdam medal for the Latin *carmina*, which had been read by perhaps twenty persons in Italy. All he had was criticism, in the pejorative sense of the word . . ."

Unless my memory is playing me a dirty trick, I have the impression that in the last years of his life Pascoli had attained the position of national poet which not even his peer could attain today, and which I would not wish on anyone. How can the *Odi* [Odes] and *Inni* [Hymns] be explained, except that Pascoli sensed that the place assigned him placed him, *inter pares*, next to Carducci and D'Annunzio? The truth is that he was always in the papers, that in those days every new work by D'Annunzio, Fogazzaro, and Pascoli was the occasion for interviews, indiscretions, anticipations, and curiosities that are unimaginable today. The same bourgeois families who gathered under the dining-room lampshade to hear D'Annunzio's *Canzoni d'oltremare* read aloud (they were printed in large type in the *Corriere della Sera*) were not unaware of the name and work of Pascoli. Besides, the idea that every period had to have its three great poets was so widespread that D'Annunzio himself, though he was years younger than Pascoli, and even more well-endowed with egolalia, did not hesitate to make room next to himself for "Virgil's youngest son." Croce's essay, with its numerous addenda and the reactions it provoked, should really be considered one of the poet's major successes. Croce buried Gaeta[2] with his praise (after burying Betteloni).[3] Not that his judgments excited much opposition; but they were "put on the shelf," registered and forgotten. Croce's Pascoli, however, was never shelved, nor has it been today. Even then it was understood that a man like Croce would not have spent so

2. Francesco Gaeta (1879–1927). Neapolitan realist dialectical poet. Croce's edition of his work appeared in 1928.
3. Vittorio Betteloni (1840–1910). Anti-romantic, "realist" poet, precursor of the *crepuscolari*. Croce wrote about him in *La letteratura della nuova Italia*, I, (2nd ed.), 1921.

much space and fury on a second-rate figure. Still, it is undeniable that Pascoli suffered much from Croce's criticism. A writer today feels instinctively that there is no great difference between an apologia and a panning and that the only thing that matters is noise. Today, no one pays much attention to criticism, critics no longer exist or are not listened to. The "slogan" of our time could be—though in an entirely new sense—the old *Calunniate, calunniate, qualche cosa resterà.*[4] Such a climate probably would have been congenial to Pascoli, it would have prevented him from embarking on adventures that were extraneous to his inspiration. But Pascoli lived and wrote in the era of Christian positivism and patriotic socialism. His fame, which was noteworthy, fed on these ambiguities. And in reality it is hard to see what kind of audience a poet without a "message" could have enjoyed in Italy around 1900. In short, to say it all, the times asked for the rabbit to run: and the poet ran without sparing his breath.

Celebrated and much debated, abused and idolized, Pascoli soon earned a chapter, a long chapter, in all the literary histories being written. True, he did not travel far beyond the borders of Italy, and the Mondadori *Omaggio* provides very useful information in this regard; but in this he shared the fate of Foscolo, Leopardi, Manzoni, Verga, and many others. The Italian language is not widely read abroad, and Pascoli in his own way is as untranslatable as Leopardi. I should like to add that he has now ceased to be "modern." If the *Poemi Conviviali* anticipate certain motifs of the middle—not French or Orphic—Rilke, Pascoli's entire *curriculum* does not seem to be based on French or English models; it does not follow at all the lines of development of the so-called contemporary decadence. This poet makes us think of a painter who was a Fattori, a Maurice Denis, and a Sartorio[5] all at once. Frankly, it's a bit much. As an innovator, in short, Pascoli, from the viewpoint of 1955, doesn't have all his papers in order. I don't think one

4. "Slander all you want; something will survive"; i.e., some of the originating animus for the slander will remain in the mind of the slanderer.

5. Giovanni Fattori (1825–1908): One of the great Italian painters of the nineteenth century, a leader of the *macchiaioli* (see "The Cinque Terre"). Maurice Denis (1870–1943). French painter, member of the Nabi group; associate of Bonnard and Vuillard. Giulio Aristide Sartorio (1860–1932): Anti-impressionist Roman painter of the *"In arte libertas"* group.

can see him as the precursor of a social realism which we are still lacking in Italy; and his Puccinian "accessibility" (to which Sapegno alludes in *"Il Ponte"*) is questionable. Puccini is popular, Pascoli was not. Besides, I imagine that many Pascolians of 1910 were, musically speaking, Wagnerians.

It has been said that Pascoli proceeded in parallel and entirely simultaneously in his various styles. One desk (or drawer?) for the *Myricae*, another for the short poems in *terza rima*, another for the *Conviviali*, another for the odes, and so on for the *carmina* and the rest. When the drawer was full, the new book was ready. His chronology allows us to entertain this hypothesis. Pascoli was certainly encouraged in this by a sense of competition with his two great older and younger brothers, Carducci and D'Annunzio. But this is not the whole truth; and in the Mondadori anthology Giacomo Debenedetti—who has contributed one of the best articles—observes that Pascoli always felt the obscure need for an alibi, a justification for his activity as a poet. He found it for himself by multiplying, pigeonholing his efforts. He condemned himself to the "large format," and found inspiration and incentive in "victimism." Thus he would seem to have lacked "the courage, the superior, animal elegance to render the exercise of his own talent valid for its own sake." (One can also see the forcing of this "animality," a glance in D'Annunzio's direction.) In this respect Pascoli is entirely of the nineteenth century, as he is, too, in his enslavement to stanzaic forms. Several of his lapses are famous: the stupendous *"lunghi intagli azzurri / nel cilestrino, all'orlo del paese"* followed by the filler of *"un odorato lucido verziere / pieno de' flauti delle capinere."*[6] Similar examples could be cited by the hundreds. If the reader will consult the aforementioned book by Natalia Benedetti (1934) he will learn the psychological reason for these gaps or drops in tone, which are not merely a failure of the ear.

The Mondadori anthology contrasts the opinions of younger and older critics as to Pascoli's presumed decadence. According to Binni, Pascoli never succeeds in "making poetry the sole means of knowing the real"; and Filippo Piemontese claims that Pascoli's

6. "Long blue carvings in the sky / at the edge of the land . . . a fragrant, shining orchard / full of the flutes of blackbirds."

musicality is accompaniment, not essence. The authoritative Alfredo Schiaffini nevertheless sees Pascoli the disintegrator as a precursor of today's metrical revolution. On this specific point—whether Pascoli has poetic progeny, whether (according to one's taste) corrupt or incorrupt sons descend from him—the discussion is under way and will long continue. For obvious reasons, we would prefer not to take sides.

In my opinion, Pascoli's greatest misfortunes were not lapses in tone (which are frequent also in Baudelaire) or the absence of great memorable lines, though they abound even in the extremely difficult Mallarmé. Even more than the constant formal and psychological indecision which we find in his poetry, what perplexes us in the end is that it is only rarely that a lyric of his is a detached "object" which can live on its own. Only a profound immersion in one's own material can provide this. Pascoli, however, left too many emergency exits open. But maybe we are asking too much; we are not so hard on poets from other traditions and other backgrounds, where our relative incompetence makes it easier for us. A few stanzas of Byron's *Don Juan*, a poem or two by Swinburne, half a monologue by Browning, a few openings of Whitman's, ten lines of Antonio Machado are enough to announce the presence of great poetry. We have asked more of Pascoli. Perhaps we are right; or perhaps the future will find a way to prove us wrong.

D'Annunzio for
Everyman

[Published in the *Corriere della Sera*, January 10, 1956. Gabriele D'Annunzio (1863–1938) was certainly the most prolific and controversial writer of his age. A richly gifted master of verbal dazzlement, he expounded his Nietzschean political, cultural, and social views in a huge number of erotically charged poems, novels, and plays, beginning with *Primo vere*, published in 1879, when the poet was sixteen. Other important works of poetry include *Canto novo* (1882), *San Pantaleone* (1886), and the *Laudi del cielo del mare della terra e degli eroi*, a projected series of seven books of "lauds," of which four were completed; *Alcyone* (1904) is the most noted of these. D'Annunzio also had a flamboyant political career. Claiming to support the Dalmatian Italians' right to self-determination, he occupied and ruled over the city of Fiume (now Rijeka) from 1919 to 1921, when he was finally forced out by the Italian Army. He later became a supporter of Fascism and was granted a title by Mussolini. D'Annunzio gave florid—and eloquent—expression to the expansionist and supermanist tendencies which led to the rise of Italian Fascism. He had an incalculable influence, both positive and negative, on Italian letters and life. When Montale says in "Intentions" that he "wanted to wring the neck of the eloquence of our old aulic language, even at the risk of a countereloquence," the figure of D'Annunzio can be sensed in the background.]

Until now, Giosuè Carducci was the only modern Italian poet for whom there existed (though it was long out of print) an annotated edition of all his poetry. A similar honor is now being bestowed on D'Annunzio. Enzo Palmieri, who has been at work on this laborious project for many years, has just published *L'Isotteo* and *La Chimera* (Zanichelli), the seventh volume, for the moment, in a series which includes five books of lauds (*Maia, Elettra, Alcyone, Merope, Asterope*) and the youthful triptych (*Primo*

vere–Canto novo–Intermezzo). Palmieri, thus, has come more than half way. As of today, the most difficult part of D'Annunzio's poetry can be said to be available to every averagely educated reader, which would not be the case if the publisher had entrusted this burdensome task to a philologist in the strict sense, instead of to Palmieri, a man of letters who is conversant with the scruples of philology and who has kept in touch with the best specialists, but who is also an acute man who has not forgotten the needs of the public and does not feel he is debasing himself by translating even the simplest Latin and Greek quotations and paraphrasing didactically the less easily understood passages. D'Annunzio, in his own way, is a difficult poet. One does not find the obscurity of the modern symbolists in him, the elimination of the necessary links in the chain of analogies or the suppression of the antecedent, which suddenly thrusts the reader *in medias res*, nor the hieroglyphics or emblematics of the old stilnovistic or baroque poets; but in every lyric of his—and particularly in the juvenile poems—one is aware of an inlaying which one must take apart and put back together again if one wishes to say calmly that he has "understood" the text.

In his earliest work the poet found himself possessed with a richly endowed instrument, of which the first requirement, its inspiration in effect, was that it be used. What he lacked was subject matter; selectivity, detachment were virtually impossible for him. We are speaking, naturally, of a material that was already selected, pre-formed for the life of art, not of raw material, which was always extremely abundant in D'Annunzio. The dilemma that every writer is faced with today, whether to write or to live, was discovered very late by the poet; one needs to come to the pages of *Notturno* and *Leda* and other similar works to find this awareness in him. In the early D'Annunzio the double urgencies—of life and expression—are not confused, nor could they be; they run on parallel tracks. The poet's life will thus be able to explain some aspects of his art; and in the art we will be able to find coincidences, "occasions" in the facts of the biography. Yet it will always be evident that D'Annunzio's reading, his "borrowings," his much-discussed "sources," were, more than a stimulant, an honest to goodness subject for his work. The *Parnasse* and symbolism are, in

his case, references which must be understood with a great deal of discretion. In his prodigious technical facility D'Annunzio has something of a Hugo, passing by way of Carducci. When he takes up themes of the French decadents (Verlaine, Lorrain,[1] even Rollinat[2]) he certainly alters their spirit, excludes their most hidden musical essence. He thus appears somewhat removed from decadent symbolism; nor will we find anything in the greatest lauds that recalls the subtlety, the rarefaction of atmosphere which we find in Swinburne's "Garden of Proserpine" or Yeats's "Byzantium." Nevertheless, decadence and neo-symbolism remain the *termini a quo* and *ad quem* within which D'Annunzio's activity as a lyric poet takes place: a very advanced poet within the framework of the Italian culture of his time, but somewhat eccentric and digressive if we attempt to place him in context against a wider backdrop. For just this reason it is helpful to read D'Annunzio with an eye on a good commentary like Palmieri's: a dense commentary but not tedious, literal but quick to notice every point of coincidence of the work with the poet's life. And capable of probing, within the limits of the possible, the "two-sided aspects" of a work—*L'Isotteo* and *La Chimera*—which has brought two highly different experiences together in one volume.

It was only after much hesitation that D'Annunzio consented to publishing the two collections together. The poet wrote to his publisher Treves in August of 1889 that *La Chimera* "is coherent as a drama" and asked that his "beloved work of poetry" remain "kept in one volume alone, apart." Speaking very broadly, he is passing from his "Pre-Raphaelite" nuptial love for Maria di Gallese to the "aesthetic-aphrodisiacal" love for Barbara Leoni; but not without regressions and substitutions of characters; and without one's always being able to give a name to the female figures who crowd the gallery of Ladies and Fates. Palmieri is always at hand, when necessary, with information and hypotheses; and one must be grateful to him for not having gone too far. By now the writings on D'Annunzio in love and the hidden D'Annunzio are so numerous

1. Jean Lorrain, pseudonym of Paul Duval (1855–1906). French poet, journalist, and novelist.
2. Maurice Rollinat (1846–1903). *Fin-de-siècle* French poet, influenced by Baudelaire and Poe.

that a merely biographical or psychological interpretation of his work could be attempted. It is a stage in what could be called the second D'Annunzianism.

It is doubtful, however, that such investigations would aid in the understanding of D'Annunzio's poetry. Palmieri is familiar with all the recent research, but he always remains on the firm ground of literal interpretation. We need his help at every step. How much work it would take us, left to our own devices, to discover that Galaora and Brolangia, in the first lines of *L'Isotteo*, never existed but are proper names deformed and transformed into place names, from Galaor, brother of Amadigi, and from Briolangia, queen of Sobradisa! We could mention hundreds of similar examples. Is it useful to know this? Certainly it is useful, even necessary, in following the flights of an omnivorous fancy which does not always turn what it touches into gold, but which will never cease to amaze us.

Italo Svevo
in the Centenary
of His Birth

[Speech delivered at the Celebrazione di Italo Svevo of the Circolo Triestino della Cultura e delle Arti, Trieste, November 10, 1961. Published in *Umana* (XI, 11–12), Trieste, November–December 1962.

One of Montale's early essays in literary criticism was a re-evaluation of the novels of Italo Svevo (1861–1928), to which he had been introduced by Roberto Bazlen and which had previously gone virtually unnoticed in Italy. Montale's first two articles on Svevo were "*Omaggio a Italo Svevo*," published in *L'Esame* (IV, xi–xii), November–December 1925; and "*Presentazione di Italo Svevo*," which appeared in *Il Quindicinale*, (I, 2), January 30, 1926. Soon after these pieces appeared, the French critic Benjamin Crémieux (1884–1944), a noted expert on Italian letters, published an article in praise of Svevo in *Le Navire d'Argent* (II, 9), on February 1, 1926, which aroused international interest in the Triestine writer. The "Svevo affair" to which Montale alludes brought Svevo international fame and recognition as the greatest Italian novelist since Verga in the last few years of his life. Montale's correspondence with Svevo and his many articles on the novelist are collected in the *Carteggio Svevo/Montale* (Mondadori, 1976). The essays "Poetry and Society" and "In Memory of Roberto Bazlen," as well as this speech, are taken from this volume.]

I consider it a great honor for the Circolo Triestino della Cultura to have invited me to speak about Italo Svevo in his city, in the centenary of his birth. What qualifications could have singled me out for this honor? I have often written about Svevo, it is true, both during his lifetime and afterward, and someone has been indulgent

enough to recall that the first comprehensive examination of Svevo's work to appear in a review with national distribution bears my name. It was published in November of 1925, only just before the short essay by Benjamin Crémieux which led to the so-called "Svevo affair" in Paris in 1926.

But today it has been made abundantly clear that the Svevo affair was the result of misunderstandings and that there is no one who can claim to have "discovered" the master of Trieste. A look at the Svevo bibliography compiled by Bruno Maier shows that Svevo's first novels received critical appraisal and notices when they first appeared, but that criticism of this sort was necessarily confined to Svevo's local area. Trieste, in fact, is perhaps the one Italian city that gives evidence of taking pride in its writers, even if in some cases (think of Virgilio Giotti[1]) it remembers them too late.

But the truth is undeniable and it is bound up with reasons that are all too obvious: more than almost any other Italian city, Trieste has felt the need to affirm the ties that bind it to Italian culture; that bind it and at the same time differentiate it. And it is perhaps for this reason that the label "writer from Trieste" could be said to have taken on a very special meaning: that of a writer strictly involved with the life, customs, and difficult destiny of his city. Not with a folklore, of course, or a local color, but rather with the image of a city unlike any other in Italy. No, I don't believe that the city has begrudged any of the writers of Trieste who were published around the turn of the century the encouragement of opportunity and even praise—the praise usually given to a fellow citizen who "honors himself." Could it have done more for Italo Svevo in the far-off years of 1892 and 1898, for an unknown Italo Svevo, author of two novels clearly—and badly—printed at the author's expense on the presses of a local typographer; or for two novels which through their obvious peculiarities (if you will pardon the euphemism) were capable of putting off the good will of the reader at first glance? And could two such books pass beyond the boundaries of local interest and insert themselves in a literary land-

1. (1885–1957). Triestine dialectical poet. Montale published at least two essays on Giotti, one in *La Fiera Letteraria*, (IV, 49), December 2, 1928; another in *Pegaso* (IV, 2), February 1932.

scape which had only recently seen the publication of *Mastro Don Gesualdo* (a landscape, it should be noted, which barely seemed to recognize this masterpiece of Verga, divided as it was between stylistic realists and Fogazzarian spiritualists)? It is amazing in itself that in 1892 Domenico Oliva, a critic who was well known then and is forgotten today, should recognize the presence of "someone," of an author, in *Una vita* [*A Life*]. But further than that, in those years, it was impossible to go. It is said that the times were not ripe; but to this observation one must add that Svevo's books themselves had not matured in time; and that the maturation which followed could not have been foreseen by anyone, least of all by the author himself.

I will try to explain myself better. A work of art, a work of poetry, not only modifies in later years the cultural ambience from which it arose, but it also acts retrospectively on all the works of art which preceded it. Materially speaking, every work, unless it is destroyed by some external event, remains immobile, is what it is. But beyond its external shell the work of art seems changed by its confrontation with other successive works. By changing the nature of our relationship, altering the conditions in which we come into contact with the work of art, we reopen old books, listen to old music, look at old pictures, and realize that they are not—or no longer seem—the same. They have changed for us. They have lost their former significance and acquired another one. Sometimes (usually) the mutation signifies the final disappearance of the work from our vital horizon: the work turns into a document, it enters the archives of culture, from which—though this is a rare occurrence—an unexpected change in taste can redeem it. In other cases the work appears rejuvenated in our eyes, charged with a significance, a potentiality which only a long incubation in time could bring to light. This is what happened to Svevo's first books.

But here, too, one must make distinctions. Other books have been rediscovered after thirty or forty years: and in the majority of cases the discovery does not take. Think of *La bocca del lupo* [*The Mouth of the Wolf*] by Remigio Zena,[2] a novel published in 1892

2. Pseudonym of the Genoese marchese Gaspare Invrea (1850–1917). A poet and novelist, he was also the author of *L'apostolo* (1901).

and unnoticed even by Croce, who wrote an essay on the Genoese writer. In its genre, it is a masterpiece: and yet a new edition hazarded years ago now by a Ligurian publisher passed without notice. There is no "Remigio Zena affair" and there never will be, because the author who hid beneath that *nom de plume* applied his reading of I Malavoglia with extreme rigor and surpassed himself, but in the later course of his career he got lost in the shallows of Fogazzarian spiritualism or *poesia "scapigliata"*.[3] In cases like this, there is no author, only a book. The remarkable thing about Italo Svevo is that after the failure of his first books he knew enough to keep silent and wait for the end of the long D'Annunzian parabola before creating a third book which continues the earlier ones like the segment of an arc and allows us to read all of them in a different manner.

The truth is that today and only today can we ignore the impossible choice of one of Svevo's books and consider his major work as an indivisible trilogy. Preferences will still be possible within this whole; but it is impossible now to make those distinctions between poetry and non-poetry which impose themselves at first glance in other authors and which Svevo himself permits us to discern in his few minor writings.

To say that Svevo knew how to wait may not entirely clarify the problem, for I do not believe he was ever able to take the critical measure of his own work. It is more probable that he *had* to wait; still, it is undeniable that others are incapable of doing as much.

There are those who wait for the aid of chance or fortune and those on the other hand who, even in obscurity, wait for their own time to come with the aid of fateful circumstance. I knew Svevo for three years, when recognition was already being showered upon him, mixed, to tell the truth, with detractions that were more foolish than ungenerous; and I had the impression of a man who was always fundamentally sure of having taken the right path, the path

3. The *Scapigliatura* [dishevelment] was a movement of Lombard writers and artists in the second half of the nineteenth century which took its inspiration from the French bohemians. Anti-traditionalists who valued "immediacy," they looked to Baudelaire and the French *poètes maudits*. The group included Rovani, Pisani-Dossi, Arrigo Boito and Camillo Boito, etc.

of truth. Let us be frank, perhaps for the first time: the man made an impression such that I would not know how to explain it to the youth of today. I have met many illustrious writers, both Italian and foreign, and almost always, even when I did not come away disappointed, I had to distinguish between the man and the writer: in every case the scales tipped on one side or the other, but they always moved. Not in Svevo's case: in him one felt the presence of a single block, of a certainty which must never have left him. I believe only Verga among our great writers was of this nature, and it was for this reason that in the far-off year of 1929 I dared to write, raising a hubbub that has not entirely died down, that Italo Svevo was the greatest novelist Italy had produced from Verga's day up until that moment. It is a judgment with which many of the young today would be willing to concur; but then? How could the grand old men of those days, who had earned themselves reputations when the last part of Svevo's trilogy did not even exist, reach such a conclusion? How could a Pirandello at the height of his glory, besieged by complimentary copies and requests of every kind, have opened a book by an unknown—*La coscienza di Zeno*—how could he have opened it, read it, and written the man he did not know a note that was anything more than a simple formulaic expression of thanks?

Removed from contact with the world of letters, Svevo developed in solitude, on his own. It is needless, perhaps, to dwell on his youth, which is already well known. The son of an Italian woman and a Triestine of German descent but with Italian sentiments, the young Ettore Schmitz was sent to study business and "languages" (German) at a school in Segnitz, near Würzburg. With him went his older brother Elio, a delicate boy who was unable to adjust to the hard life of the school and died prematurely in 1886. To Elio Schmitz we owe a valuable diary in which the life, studies, and precocious literary calling of Ettore are noted day by day. Ettore, who showed little or no inclination for business, began to write very early on. His education, which he received first in school and later in Trieste, where he attended the Scuola Revoltella, and where he later made his first few contributions to the *Independente* (the training ground of strict *italianità*), was romantic-positivist in nature. At twenty, Ettore had read Shakespeare and Schiller, Bal-

zac and Zola, and had arrived at the shores of realism. But he had also discovered a corrective to realist scientism: De Sanctis.[4] A financial reversal which brought the Schmitz family to the brink of ruin forced Ettore to accept a modest position in the Banca Union, where he remained for seventeen years. But he did not neglect his studies. The theater was his passion at this time. With the exception of his comedy *Un marito* [*A Husband*] which is dated 1903, all of Svevo's comedies and *levers de rideau* belong to his early youth or to his last years. These works have a minor interest among his oeuvre as a whole, but they will be of value to those who decide to return to them after reading the novels. The same can be said for the short critical essays, the fables, and the miscellaneous writings, now collected in a volume in which the only truly important thing is the lecture on Joyce which Svevo delivered in Milan in 1927. What prevented Svevo from becoming an excellent dramatist was his lack of concern with synthesis and dialogue. In his novels the dialogue is indirect, filtered through memory; in the plays it becomes overabundant and indiscriminate. Also the construction— even in the best works, which are the latest—is disorganized. Basically, analytic comedy is a contradiction in terms at best and Svevo is above all an analytic writer. One never senses this at all on the page, in the action, in the situation, but in the delayed-reaction emotion which he arouses in us. But in at least two of his plays, and we shall see which, he shows himself at the height of his novelistic prose. On this occasion, I should not dwell further on Svevo the young apprentice, who is known today to those who have read that valuable book *Vita di mio marito* [*My Husband's Life*], by Livia Veneziani Svevo, and a sensitive essay by Giacinto Spagnoletti which is buried in the Acts of the University of Urbino. These writings document the novelist's unhappy, tormented youth, the protracted period in which family troubles and hardships of every kind brought to life the new Svevo, the novelist and the fortunate and prematurely old paterfamilias who in three successive self-

4. Francesco De Sanctis (1817–1883). Hegelian literary critic and patriot, author of the celebrated *History of Italian Literature* (1870–72). The foremost Italian critic of the nineteenth century, De Sanctis related authors to their social context; his *History* is thus also a study of the development of Italian society.

portraits will create his own myth: the image and I would almost say the category of a senility that is not temporal but is the state of mind of the man who feels he has already lived for himself and for others, who has suffered and lived for all men.

The novitiate to which we have referred in brief was not entirely over when Svevo, who was still employed in the bank, saw his cousin Livia Veneziani, later to become his wife, after many years, and published—in 1892, at his own expense—that peculiar novel *Una vita*, which more than any other book of his gives evidence of the formative period that made it possible. The daring setting of the book—in a certain sense the broadest attempted by this writer—borrows from the most orthodox naturalism, but the romantic overflow has not yet been calmed and the writer is still too aware of the strict ties which bind him to the character of Alfonso Nitti, his first projection and his first real attempt at liberation.

Alfonso, whose father is dead, leaves his mother in his home town and finds work in the Maller bank in Trieste. He knows "languages," it seems, and he is placed in charge of correspondence. His character is complex, spiritually rich and bitter, almost uncultured, but capable of moments of intuition and understanding. From the emotional point of view he is both dry and passionate, humble and proud, clairvoyant and blind. He aspires, without realizing it, to high flights, but he is unsuited to everyday life, to compromise. Among his colleagues in the little bank he feels obscurely *au dessus de la mêlée*, but his true aspiration is to the condition of senility, the peace of renunciation. The situation in which Svevo has placed him can only come to a dramatic resolution. Invited one evening to the Maller house, he is impudent enough to reveal his latent literary ambitions. Now the young Annetta Maller, the banker's only daughter, lays eyes on him and offers to collaborate with him in writing a novel. The two work together for many evenings, drafting an unreadable potpourri. Set by the fire, straw sooner or later will burn. Alfonso is both happy and terrified: what does she want of him? Annetta has a governess who is present during their evening labors but Francesca does not seem overly zealous in carrying out her duties. Nor does it seem that Alfonso's assiduous presence meets with opposition among

Annetta's entourage. One day, a relative of Annetta's, a certain Macario, one of the many presumed to be in love with the girl, takes Alfonso out in a boat and explains to him that one doesn't need brains to catch fish. Alfonso should learn something from the sea gull's timely swoop. "What do brains have to do with it? And you who study, who spend whole hours at table feeding a useless being! He who is born without the necessary wings doesn't grow them. He who doesn't know how to pounce on his prey at the proper time will never learn how, and he will stand by in vain watching how others do it."

Is this a veiled piece of advice? Perhaps Francesca's comment, too, is a warning: "It seems she doesn't appreciate the luck that has befallen her the way she ought to"; or even worse: "It's not my fault if they coo like doves." Then the inevitable happens: one evening the governess is more distracted than usual and Alfonso spends the night with Annetta. And now that the gull has pounced on its easy prey it would seem that the thing was more or less done, but it isn't so. Annetta writes to Alfonso to stay away for several days, long enough to appease her father's anger. The bridesmaid Francesca does not concur in this advice: if Annetta has time to get hold of herself and reflect, all will be lost for Alfonso. The question is all-important for Francesca, the former lover of Maller, who was unable to marry the banker because of Annetta's opposition but who has now allied herself with the girl and could overcome her objection and satisfy her own desire. Of course the novel cannot end like this: Alfonso does not have wings, nor does he want them. He puts his fate in the hands of Annetta and entrenches himself in the alibi of obedience. He will do what Annetta has asked him to do. And it is here that Svevo already demonstrates his maturity as an artist: in the broad, persuasive non-motivation of Alfonso's inertia. The less we are told the why of this passivity, the more we feel its poetic necessity. Alfonso hasn't taken anything: he has been taken: he can accept his fate, but he cannot want it of his own free will: he could love Annetta if she wanted to love him, if she accepted a role that was somehow subordinate in their life together, but in no way can he now give up seeing its defects, in no way is he able to glimpse the possibilities of his role as prince consort. His only choice is not to choose at all, and also to resist Francesca's

furious counteroffensive. Alfonso takes a two-week leave, goes home, where his mother dies (a *deus ex machina* solution which allows the extension of his absence), and when he returns to the bank sees he has been assigned to new duties that are clearly inferior to his previous ones. Annetta has shown no further signs of life; it is rumored that she is about to marry her cousin Macario; one day Alfonso meets her accompanied by Francesca and the two women do not return his greeting. At this point Alfonso writes to Annetta, asking for one last interview; but it is Federico Maller, Annetta's dandified brother, who appears at the appointed place, and the heated encounter closes with a slap in Alfonso's face. A duel ought to follow, but the author has avoided a finale which would be too reminiscent of Georges Ohnet.[5] Alfonso kills himself after turning over his small savings to the daughter of his landlords, the Lanuccis, who has been seduced by a man who is reluctant to marry a penniless girl: and the book ends with the dry announcement, on the part of the Maller Bank, of a funeral "attended by the deceased's colleagues and by management."

Rereading *Una vita* so many years after first encountering it, one experiences anew the impossibility of placing the book precisely within the framework of its time. Narrative was anything but impoverished in the last decades of the nineteenth century; but who so far has attempted a careful survey of it? Croce in part, and later Pancrazi, with criteria that could be called *repêchage*, with an attention to the living and the dead, to poetry and anti-poetry which no longer concern us. And besides, at the risk of repeating ourselves, how to deny the evidence that in the world of the arts there is no before and after, chronologically speaking, no cause and effect? Given that in all probability a book like *Una vita* could give no hint of its author's development in far-off 1892, we can only reread it with the wisdom of hindsight, i.e., with today's eyes. It is a book which contains at least two books: the setting is naturalistic, and not even of an advanced naturalism. The minute description of the Maller bank, of both its insignificant and important employees, of their accounting practices and personal problems, is developed

5. Popular French novelist (1848–1918). His work explored the antagonism of the rich bourgeoisie and the aristocracy.

with an exactitude which I would call Balzacian; and the entire structure of the book is redolent of homage to the idea of the *tranche de vie* which the naturalists were never able to violate. In *Una vita* the scruple of exhausting the subject, of taking the study of Alfonso Nitti to the depths while remaining within a preestablished form is certainly one limit or one side of the work. The first of Svevo's poetic characters live within this limit without being suffocated by it: Alfonso, certainly, though he is more often described than represented and in the last part of the book is led to his destiny without any pity, for after the central crisis the writer is now psychologically liberated from him and has only to make him disappear; but even more the characters Annetta, Francesca, and Maller himself, whom Svevo represents with a clarity which is made all the more surprising by the extreme sobriety of the portraitist. Here Svevo is a painter, a great painter of the *fin de siècle*, unaware of the impressionist technique but very far from any sort of photographic method. He paints and embosses with few strokes, but with a careful sense of volume and of chiaroscuro. Perhaps the painting of his closest friend, Veruda,[6] was like this—Veruda whom we will meet in the next novel, *Senilità* [*As A Man Grows Older*] , as a far from secondary character. And the most unusual of Svevo's characters appears in *Una vita* for the first time, what we could call the city-as-character: Trieste herself, no longer a naturalistic *ambiente* but the secret matrix of actions and situations, the locus, more metaphysical than geographical or geometrical, of collisions which another scenery would render different and no doubt less significant. And at this point every suspicion of naturalistic orthodoxy is now entirely refuted. A vast scene, precise and yet general, definite down to the most pedantic local fact but also elusive, indeterminate; a city of traffic but also a city of souls, a city no less symbolic than the Prague of Kafka or the Dublin of Joyce, this is the Trieste of the early Svevo. But what could Ettore Schmitz, still under thirty, have seen of all this in 1892? And how much could Italo Svevo, lit up now by the searchlights of fame, have known it in 1926? I have never met a writer who was more

6. Umberto Veruda (1868–1904). Triestine painter, primarily a portraitist. He studied with M. Liebermann in Munich.

intuitively aware and less conscious than he of the significance which time was to attribute to him.

In any case, to conclude on his first novel, we read *Una vita* today the way we read or look at a great fresco on which we have worked beside a master, as collaborators ourselves, as studio assistants. The master has painted the most vivid scenes, but has barely sketched out others, leaving it to the apprentice to finish them. And it is pointless to say that master and apprentice coexisted equally in him. Even the landscapes of the book, the desolate, probably karstic plain where Alfonso's mother and the notary Mascotti live, are from the hand of the hypothetical studio-hand, as are all the passages where the tyranny of the novel's construction distracts the reader's attention and makes him wish for a faster pace of the metronome which regulates the machine of the novel.

All the parts of *Una vita* which refer to the Maller Bank and the city library can be considered autobiographical, as more than one of Svevo's letters confirms. Only the principal characters are invented. In the next novel, *Senilità*, published in 1898 (apart from the fact that we meet here at least one character who was familiar to Svevo, Veruda), the autobiographical meaning appears to have been plainly transposed, for two years previously Svevo had left the bank and married Livia Veneziani. His new protagonist, the thirty-five-year-old Emilio Brentani, is an Alfonso Nitti who has never met an Annetta and has come to the midpoint on his road having consumed useless literary velleities. He is a failure, an inept even; this in fact was the first title of the book, which was later changed. He lives on his salary from a minor job: he is cared for by his nubile sister Amalia, whom he cares for in turn; a little bit younger than he, she is also a humiliated person, injured by life. Emilio's sedentary, almost senile existence is disturbed by the appearance of the young Angiolina Zarri. Theirs is a casual encounter, the fire lights slowly. And Emilio tells the girl right off that he does not wish to compromise his career and family.

His first desire is to confine their relationship within the boundaries of a simple adventure. "At thirty-five he discovered in his soul the unsatisfied desire for pleasure and love, and even the bitterness of not having enjoyed them, and in his mind a great fear

of himself and the weakness of his character which in fact he suspected more than he knew it from experience."

From the beginning the young Angiolina seems to accept without difficulty a platonic relationship, one that will not compromise her either. Angiolina has probably had much more concrete amorous experience and Brentani receives clear indications to this effect; but he is flattered by the duty he assigns himself of educating the girl. Gathering the honey of the adventure (for the moment a purely verbal honey), he deludes himself into believing he is remolding the half-ingenuous, half-corrupt Angiolina (Ange to him) and making her into a woman whom men less spiritual than he cannot even graze with their look. Naturally, of the two of them it is actually he who is truly afraid of compromising himself, to the point where he ends up agreeing to a strange pact: the girl will be his only when she has been given to her fiancé, the tailor Volpini. Except that the sculptor Balli, friend and confidant of Brentani, discovers that Angiolina is carrying on a licentious relationship with a man identified only as an "umbrella man," and tells his friend. And so Emilio breaks off his relationship with his young quasi-lover.

But by now the peace of the Brentani household has been destroyed. Love has entered its walls for the first time. Not only the love of Emilio for Ange, but the incredible love of his sister Amalia for the sculptor Balli. Jovial, noisy, extroverted, Balli is the type of man who is successful with women, but he clearly cannot fall in love with a female larva like the poor Amalia, humiliated and rejected from birth and by choice. Terrified by Amalia's agitation, which reaches the point of nocturnal delirium, Emilio sends his friend away from his house; but by now the double infection must run its course. Angiolina meets Emilio, rekindles his fire, brings him to her miserable house and gives herself to him (in fact it is she who possesses him). In actuality, Emilio has only possessed the woman he thinks he hates. Yet he continues to love the other Angiolina, the woman created by his imagination.

Volpini, for his part, has already slept with the girl: he seems reluctant to marry her and in the end breaks his promise. In the meantime Angiolina has agreed to pose as a model in Balli's studio;

and at this point the knots—already tangled to the utmost—come rapidly undone. Amalia, taken with a high fever, is in a state of delirium and dreams of marrying Balli, who is called to care for her. Horrified, overcome with grief, beset by both remorse and jealousy, Emilio confronts Ange, insults her, throws her lovers in her face, including the possibly innocent Balli, chases her into the street, flings mud and stones at her. Then he returns home and finds Amalia dying. The phthisis and alcoholism to which she had secretly given herself have destroyed her. With her death—the unhappy death of those who dream of love—Amalia has cured Emilio of his insane passion once and for all. But after several years Emilio will continue to love and secretly dream of the Ange created in the dream of a man trapped within his own inability to communicate. He thinks that in dying Amalia has transferred her qualities to Ange: and the two women—the one who died and the one who ran off to Vienna with a lover—become one single creature:

> That figure even became a symbol. Always from the same place she watched the horizon, the future, out of which issued the red flashes which reverberated on her pink and white face. The image crystallized the dream he had dreamed next to Angiolina which that child of the people had failed to understand. That great magnificent symbol sometimes reanimated itself to become woman and lover again, though always a sad and thoughtful woman. Yes! Angiolina thinks and weeps. She thinks as if the secret of the universe and of her own existence has been explained to her; she weeps as if in the whole wide world she had found not even a single expression of gratitude.

In *Senilità* the fundamental motivation is jealousy, a theme which did not surface in the earlier novel. Alfonso Nitti does not kill himself because his lover has fallen into the arms of another; the worst offense the Maller household has committed against him is that the banker takes him back into the bank, afraid perhaps of blackmail or a scandal from him. In killing himself Alfonso demonstrates to himself and to the others his fundamental disinterest. Emilio Brentani, on the other hand, is tortured by jealousy, an emotion which increases the more Angiolina demonstrates herself

unworthy of him. And it is precisely the sounding and I would almost say the orchestration of this emotion which makes Svevo the analytic writer he will be from this moment on until the end of his career. Perhaps I have used the wrong word: I should have spoken of instrumentation, for *Senilità* (strange to say for a writer like Svevo who lacked a sensitive ear) has one single tone which is never abandoned for the sake of opportune variations. *Una vita*, as we have seen, is a book which the reader of today can take apart and put back together in his mind: *Senilità*, within its more limited framework, is a work which insists on being accepted as it is, a mature work. There is something imperative about its openings, its closures, which denotes the presence of a style. Its episodes—the memorable encounters with characters who fan the flames of jealousy (the Sornianis, the Leardis who know everything about Angiolina's life); the nocturnal teaching of the presumed "little angel" along a route which perhaps even today can be walked by the reader; the dinner of Emilio, Balli, and their lovers; the lightning-quick portraits of Angiolina's mother and sister and even the faded color of the urban landscape; the extraordinary sensitivity of the gradations of light—all of this acts so that what was once the setting of the narrative becomes its very plot, necessary and irreplaceable. Trieste, a late-nineteenth-century Trieste which we will find, though only years later and with another glaze of paint, in the painting of Vittorio Bolaffio,[7] erupts in Svevo's novel and takes shape, life, and blood, in its characters. It has been called a novel of psychological analysis: and this might seem like scant reason for praise in a period which is eliminating psychology from the realm of narrative. But the fact is that here we are not dealing merely with psychologism. Self-analysis, total self-awareness, is in Emilio's very nature and he is, at least in part, a projection of the author; and one could not have expected Svevo to have given this up in favor of an entirely external, objective representation. What could and should have been expected of him is precisely what Svevo has done: admirably to combine analysis and representation so that the psychological case, the clinical case if you will, is totally incarnated in an act of poetry.

7. (1880–1931). A Triestine painter with surrealist, metaphysical overtones.

Perhaps the complaint of clinicality can be directed exclusively at Amalia, and more at the expedient of her unsuspected alcoholism than at her as a character: here there is at least the shadow of the naturalistic scientism that troubles many books of this period. But it is no more than a shadow or a suspicion: enough to lessen the tension of the book's "musical" tempo, but not enough to weaken a work which is so solid and coherent. *Senilità* is, along with a few of Svevo's last writings (among them the whole first part of the *"Novella del buon vecchio e della bella fanciulla"* ["The Nice Old Man and the Pretty Girl"], his most composed work, which makes us turn immediately, when we reread it, to the precise detachment of certain episodes, to the laconic perfection of certain epigrams which have stayed in our memory like the *leitmotivs* of a symphony. It is certainly for this reason that many critics—and he who is speaking may not be the last of them—have shown a preference for the story of Emilio and Angiolina, recognizing *Senilità* (a bad title, which cannot now be changed) as the writer's masterpiece. At a distance of more than sixty years since the publication of the book, and thirty years after its unsatisfactory republication, I would be more cautious in making such a statement. If Svevo had ceased working at this point, someone sooner or later would have lifted his name out of the archives of literary history, as happened to Luigi Gualdo, but we would not be here to commemorate him. If a "Svevo affair" was possible, the reasons for it should not be sought in an occasional polemic but in the evidence itself of the long road he took, of the peculiarity and timeliness of his apparitions and resurrections. It has been stated, and not without truth, that Svevo wrote the same book three times: but one must add that every book of his is a different book, it is a stopping place on a route that had to be traveled. Those who appreciate the significance of such an evolution (which is not from the imperfect or the approximate to the definitive result, but is the necessary adjustment to new inner themes suggested or even imposed by the altered spirit of the times, of the different periods he passed through), he who sees in its unity the various seasons of his work may point out his own preferences here and there as an anthological reader, but he will never be able to contain or emprison Svevo within the boundaries of only one page or one work. It is not only the analyst in him who

is interesting today, though the literature of analysis, which is poorly represented in Italy, had in him a master and precursor; it is rather the disquiet which he foments in us, the need for an impulse, the sense of something beyond the page. Svevo is a writer who is always open: he accompanies us, he guides us up to a certain point but he never gives the impression of having said everything: he is broad and inconclusive like life. For this reason, when they ask us what of his work should be read there can only be one answer: read everything, if you can, but do not reverse the order in your reading: follow with him a route which in this case is never reversible and let yourself be led wherever it is possible for him and you. Later on you will be on your own but you will not regret the time spent; you will be left with the feeling of having had a necessary experience, of having enlarged your understanding of life.

From this point of view Svevo is not really an artist but a moralist; in this he is modern today, but he was not so in the days when Italian writers were required to build themselves an instrument of art. And for this reason, too, we repeat, it can be claimed that he had his recognition at the most propitious moment and it is impossible to blame anyone for not paying him attention.

The moralist finally breaks through the crust of the novelist in *La coscienza di Zeno* [*The Confessions of Zeno*] and in his last stories.

But not without a long and necessary interval of silence, which was more or less apparent. *La coscienza di Zeno*, published in 1923 and written in 1919, puts an end to a twenty-year silence for which I know no precedents, except perhaps for the interruption of thirteen years which Racine imposed on himself when he was named court historian. There are vague analogies between the two cases. Racine, through his promotion, abandoned the ambiguous class of second-rate actors; and Svevo, finishing *Senilità*, abandoned the class of failures in life and found in family life, in success in business, the means of prodigiously making himself a new existence. Another man was born, and the metamorphosis would have been complete if the poet in him (the poet he was even if he thought he abhorred poetry) had been entirely defeated. Who has not known brilliant artists who after a youthful outburst of genius find in practical life, in economic activity, the total application of

their multiform talent? Potential artists, at the first fork in the road, have opted for real life, forsaking the realm of metaphorical life that is the life of art. I don't believe that Svevo ever found himself at such a crossroads: Alfonso Nitti, transformed into Emilio Brentani, accepts life, life redeemed by an initial failure and precisely because of it exorcised and rendered intangible; and Emilio Brentani will be transformed into Zeno Cosini—a Brentani who has had a career, who has made himself "a position," a man who can smile on himself and others and who keeps the secret of his previous incarnations. But such a character could only mature after many years, because he is not a character born of the imagination. We mention this briefly *en passant* without belaboring it. The fascination of Svevo's art is that it is not the art of a professional. In his greatest endeavors, the industrialist Ettore Schmitz was ignorant of how to manage his gifts. So much the worse if it had not been so: in that case we would have had many perfect works but no truly necessary book. When it is said that Svevo was the novel personified (not a novelist) the point is precisely to note the secret of a positive imperfection, of which it would be difficult to find other examples.

Zeno Cosini, then, is a success; he has a family, he has a perfect wife, a house; he lives in a highly sophisticated bourgeois ambience, he is a successful, respected man. He is rich but takes little interest in his business affairs, which are entrusted to a certain Olivi, an entirely reliable man who administers his property.

On the threshold of his fifties Zeno looks back and, giving in to the desire of his psychoanalyst, lets the memories of his life spring from his conscious and subconscious; in short, he writes a retrospective diary. I don't know how interesting the book is from the psychoanalytic point of view: there is no doubt that in writing it Svevo was familiar with Freud's theories. But at that time not only psychoanalysis but analysis pure and simple was dominant in the novel and it is easy to discount whatever artificiality the prologue of the imaginary doctor lends to Svevo's vast book. In the *Coscienza di Zeno* (and this is the reader's first impression) there is no further sense of time, no development of the narrative drive that one finds in *Senilità*. And it is easy to explain why. He who looks backward cannot make time reversible: he can only reoccupy it

partially, extracting it from the deposits of memory; I speak of "occupation" because recovered time does not unwind its thread, but rather stagnates. This does not prevent the most precious flowers from emerging a second time from the swamp, as happens in Proust, though more rarely in Svevo, who is totally removed from that spirit which for better or for worse we are accustomed to define as "decadent." In Svevo, the release of the psychological discovery is drier, the moralist defeats the painter, who for the first time is totally absent here. *La coscienza di Zeno*, therefore, is a great comedy of psychology and of manners, a performance with no real beginning and no real end, insofar as it is true, as we shall see, that Svevo partially continued it.

The book is made up of long episodes. Zeno is an imaginary invalid, a man without a will, full of good sense, a man who takes things as they come but who actually always takes the right course. An inveterate smoker, he agrees to enter a clinic to disintoxicate himself, but then manages to escape and starts smoking again. Rich and with virtually nothing to do, he decides to marry. He is a friend of the Malfenta family, in which there are three girls of marriageable age. He is rejected by the youngest, concentrates his interest on the prettiest, Ada, and during an evening spirit séance, while everyone is intent on making a table dance, decides to make his advances to Ada by touching her foot, but he is fooled in the dark and the foot he touches belongs to the cross-eyed Augusta. And so, in brief and against his will, he finds himself engaged to Augusta, who will later turn out to be a wife without peer. Ada, on the other hand, will marry a ridiculous violinist, a certain Guido Speier, for whom Zeno nourishes the most egregious dislike. A later section is devoted to Zeno's extramarital affair, conducted with the complicity of a friend, a certain Copler, who is also an invalid but a little less imaginarily so. Zeno becomes the protector and adviser of Carla, a poor girl who is studying singing and needs a disinterested Maecenas. The delightful Carla, a perfect blend of ingenuity and candor, soon becomes Zeno's clandestine lover, without his affection for his wife diminishing, for she is now a necessary complement to his life. Carla is a more cunning Angiolina, she plays the part of innocence better. It is impossible to think of marriage, Zeno is the most decent of husbands, nor does Carla expect as much. The

relationship is prolonged through tormenting highs and lows be-
cause the seduced Zeno hesitates to be a seducer; until Carla, who
has extorted a great deal of money from her protector, is in a
position to let him and her singing teacher go and become engaged
to a man who is in a position to marry her. Zeno thus returns with a
sigh of relief to his conjugal peace, without Augusta ever having
suspected a thing.

Now business awaits Zeno; he has agreed to be a partner in a
commercial firm set up by his brother-in-law Speier, though without
involving his own resources, which continue to be administered by
the wise Olivi. But the business of Speier and Partner will soon take
a turn for the worse. Not only will expenses mount and profits
decline month by month, but Speier will get involved in risky stock-
market transactions that will ruin him. Honest and compassionate,
Zeno decides to give up part of his fortune to help his brother-in-
law and hopes to be able to induce his sister-in-law Ada, who is
richer than her husband, to do likewise.

But Ada seems to resist. To convince her, Speier stages a sui-
cide, swallowing a less than fatal dose of a sleeping potion. He has
arranged things so that medical intervention will be prompt and
certain. Unfortunately, through a series of misdirections, aided by
bad weather, the doctor arrives too late and finds Speier dead. And
here the famous *lapsus* of Zeno Cosini occurs: believing he is fol-
lowing Speier's funeral procession, he actually follows the coffin of
another dead man. It is this *lapsus* which reveals Zeno's secret
anger at his brother-in-law, the faint-hearted and useless character
whom Ada Malfenta years ago chose over him as her husband.
Ever lucky in his misadventures, Zeno does not inherit a debt to
make good, for in the meantime the market has risen and Speier's
suicide is shown to be the last useless gesture of a failure, not in the
game of the market but in life.

Zeno will once again be the successful man whom we shall find
a happy father and still an addicted smoker in the last section of
the book; but here the narrative is interrupted because Zeno has
decided to send the cure and the doctor to the devil. And, on the
other hand, we have reached the war, and in the postwar period
Zeno Cosini has become or is becoming Italo Svevo and memory
can no longer serve. All that remains is to continue with variations

on the same theme, in a different setting, and these will last until Svevo's death interrupts them forever. A strange book, stagnant and yet continually in motion, this *Coscienza di Zeno*: not only does it contain the richest and also the most varied gallery of characters that Svevo succeeded in portraying. In *Una vita* the social scale was limited to the most modest bourgeoisie: the upper classes were examined through the keyhole: no differently in *Senilità* we find ourselves halfway between *scapigliato* bohemia and a little world of employee assistants. In *La coscienza di Zeno*, on the other hand, the high, monied bourgeoisie breaks forth. Except for the ambiguous Carla, all the characters in the book belong to the golden tree of an industrial society, even if they are sometimes its dry leaves. And naturally these characters, who are much more articulate and activated in the sense of human comedy, even while elevating themselves to the universality of a type, keep all the characteristics of well-defined local figures. We have said that Trieste lives at the edges of *Una vita* and absolutely invades *Senilità*; but at this point Trieste is the very weft of *La Coscienza di Zeno*, the first warp, so strong that it could be called the producer of its characters themselves, as if the fundamental tone (the tone and rhythm of a city with a double aspect, intensely European and yet unmistakably linked to a very different stock by language, blood, and traditions)—as if the fundamental tone had created figures, characters, situations, by parthenogenesis. *La coscienza di Zeno* may be a city in search of an author. The note of bohemianism, of the *fin de siècle*, which one hears in the first novels is the Triestine variant of a world we can find elsewhere; but we could not imagine Zeno and his adventures outside this Trieste which is both real and imaginary at once. This is the one connection we can establish between Svevo and Joyce, beyond the innumerable differences that make these two writers incomparable. We know that Joyce and Svevo were friends during the years which the Irish writer spent in Trieste (1904–1914) and that their friendship also continued in later years; we also know how much Svevo owes to Joyce, who was the first cause of the interest aroused in France by his books. And there is no doubt that Svevo, long before the period in which he wrote *La coscienza di Zeno*, knew Joyce's *Dubliners* and *A Portrait of the Artist As a Young Man*; though I believe that

it was only much later that the Triestine had the patience to plumb the depths of the strata and substrata of *Ulysses* and *Finnegans Wake*. Even so it can be admitted that if Svevo became aware of having a Dublin of his own at hand in Trieste, it was due at least in part to the lesson of Joyce. But we can say no more, even though some have wanted to recognize Svevo in one of the incarnations of Joyce's Leopold Bloom and have even found significance in the fact that one of the names of Anna Livia Plurabelle is the name of Svevo's wife. Their roots are too different. Joyce is Gaelic, he is a sophist raised by the Jesuits, a naturalist who changes the course of French naturalism in the direction of an intensely cultural psychologism, fed by psychoanalysis and mythology. Joyce is a furious philologist, a romantic rebel, a polemicist who searches for the universal through the small lenses of his binoculars, in the smallest spiral of his "particular"; Joyce is also the nostalgia of the period; while Svevo remains happily a narrator of a temper we would call Goldonian, a tragicomic poet who is lucky enough to be theoretically ignorant of what poetry is (literature which is expressed in verses, in prefabricated poetic forms, was totally foreign to him). In short, Svevo is a profoundly Italian writer, though in a very special sense of his own, and his form (which saves his reputation from any occasional attack) is what every great Italian writer could wish for himself. As for his possible relationship to Proust (a writer he read very late), every point of comparison fails. Proust is the culmination of a great season of symbolism, he is the poet of a great cultural and social dissolution, and all he shares with Svevo is the gift of analysis, a gift which in Svevo was reinforced by many experiences (not the least that of Henry James), but certainly not by the lightning-swift discovery of Proust's *Recherche*. Which is not to deny that Proust, though he knew him late, made an impression on the Triestine writer. Among the many pages excised from the trunk of *La coscienza di Zeno* is a supposed first chapter of a new novel, *Il vecchione* [*The Old, Old Man*], in which the thick vegetation of self-analysis becomes almost swampy. Here one is truly reminded of Proust. The protagonist of the new book would seem to be a somewhat older Zeno; senility understood as a state of mind and a vocation is replaced by the actual study of clinical senility. Yet if one is to understand stories like "*Il mio ozio*" ["This Indolence

of Mine"], "*Le Confessioni del vegliardo* ["An Old Man's Confessions"], "*Umbertino*" as parts of the new novel, one might think of a prolongation of Zeno, not of a work with a different inspiration. "*Il mio ozio*," the story of the new Zeno's relationship with the cunning tobacconist Felicita, whom he employs, makes a chapter which could replace the Carla episode in *La coscienza di Zeno*. In the other recorded episodes, on the other hand, Zeno's story is carried up to the postwar period without any noteworthy differences. The character of Felicita is the loveliest gift Svevo has given us in his last years, though along with this we should mention the lovely little girl in the story of the good old man. This is a story parallel to that of Carla and Felicita, yet foreign to Zeno's novel. Yet the situation is identical: the unnamed good old man—who is unmarried this time—pays a young female tramway operator to test his idea, or illusion, that he is growing young again; but the illusion, which is followed by his death, is of brief duration. These last stories are among Svevo's best work; when they were published under the title *Corto viaggio sentimentale* [*A Short Sentimental Journey*] I saw fit to call them fragments of the greater Svevo; but I was totally unaware of the tie that binds them to his greater works, which I had not reread for years. They are not fragments, then, but pages of authentic poetry. It's a shame that some of them—such as the "*Confessioni del vegliardo*"—were not edited in manuscript, either by the author or by those who published them.

The above-mentioned *Viaggio sentimentale*, the *Reisebilder* of a Mr. Aghiós who is a near relation of Zeno, stands out, a lively report of a train trip; and, more important, "*Una burla riuscita*" [The Hoax], a story in which Svevo's macabre humor reaches its highest point. Its protagonist is Mario Samigli (the pseudonym under which Svevo published *Una vita*), a failed writer, the author of a forgotten novel. A cruel joke has been planned at his expense. He is led to believe that a great publisher in Vienna wants to translate his novel, and is even sent a false bank check. Once the mockery has been revealed, the mild-mannered Samigli will slap his trickster, but he will also profit unexpectedly from his trick. The false check, in fact, has served to cover a stock transfer which will prove extremely advantageous for Samigli; while the trick will not

destroy his conviction that he is a genius destined to be discovered by posterity. As can be seen, what we have here is nothing less than a back-dated parody of the "Svevo affair"; as well as another little gallery of unforgettable portraits.

Among the last stories I must also mention *"La madre"* ["The Mother"], an unfortunately incomplete tale of a woman, Amelia, who marries a lame man. How many lame men we meet in Svevo's stories and what a north wind blows there! One could say that in them the entire industrial culture in which the poet found himself immersed—against his will—when he changed from Samigli into Cosini is swept away in this very wind. Perhaps the fine story *"Un contratto"* [A Contract] was also part of the sequel to Zeno, while other brief stories, like *"Proditoriamente"* [Treacherously] and *"Vino generoso"* [Generous Wine], came earlier. From the stylistic point of view, all these posthumously published writings are very different; some seem to have undergone some preliminary *labor limae*, others are in the sketch state. The date of several is uncertain. As a whole they are reminiscent of the stratification of Foscolo's *Tomo dell'Io* [*Book of the Self*] even if one thinks of Sterne more than Heine; and they will give the critics of tomorrow much to write about, if tomorrow there are literary critics.

Also unfinished are the two plays of the late period, *Con la penna d'oro* [*With a Pen of Gold*] and *Rigenerazione* [*Regeneration*], perhaps the only plays that are related to the Svevo of the last novel. More than plays, one could say they were parts of a novel set in scenes. It will never be possible to stage them, but they cannot be ignored by Svevo's faithful. They show the signs of an advanced, happy maturity: not of a newly achieved equilibrium.

Before concluding this summary review, I should now touch at least briefly on the thorny problem of Svevo's language, which Giacomo Debenedetti defined as risky and adventitious and which has given the writer's first critics much to discuss. It is indubitable that "Tuscan" (as Svevo called our language) was difficult for him to learn, almost a translation from the language of Trieste. But it has now been made clear by a philologist of the likes of Gianfranco Contini that Svevo's imperfections—which are more syntactical than lexical—can be compared to typographical errors which the reader can easily erase on his own. As for his vocabulary and spell-

ing errors, they need to be examined case by case: in Svevo's so-called "pidgin" there is much that is part of his style and should not be corrected.

Might Svevo's language be edited? Let's not confuse respect with fetishism. Svevo himself accepted corrections, often unfortunate ones, in the second edition of *Senilità*. What is needed for this book is a happy combination of the two extant editions. But in the others, too, and above all in the posthumous writings, something could be done; after all, we don't read the *Divine Comedy* the way Dante wrote it.

But it would be erroneous to think that Svevo gains something when he is read in translation. What I would call the sclerosis of his characters is lost. Svevo appears elegant where he was laborious and profound, entangled yet entirely free, a writer for all time but a Triestine of his own difficult years. Better then to add a few commas and relieve a few anacolutha but leave Svevo with the music that was his.

Yet there is not much to choose from in the few books of this irreplaceable master. His typical character lives in all of them, incapable of living but also (except for Nitti) gifted at getting out of scrapes; threatened by the worst illnesses, inclined to limp out of sheer mimicry, but always present at the funerals of his healthiest friends; besieged by hypocrites and by the wind, by family and business, but also the tenderest of fathers and the most faithful of husbands; in all of them there exists the multifarious life of a city in an historical and social crisis which changed its destiny without destroying its calling to bring a voice of its own into the new context it had just entered. There is no more Italian writer than this Triestine educated in Germany who ignored our classics. And we have no modern novelist who has enlarged the knowledge of the human spirit more than he. So important was his sounding that his immediate successors were infected by it, and not only the Triestines. And I will tell you the reason why, even if I commit one of those indiscretions which a critic should never allow himself. In rereading Svevo one has occasion to bemoan the fact that a column is missing from the vast portico of his work: one wonders what an intermediate book in between *Senilità* and *La coscienza di Zeno* might have been, a book that would have filled the void between

1898 and 1923; a book that would have the spark of *Senilità* and the broad psychological underpinnings of *Zeno*, a bridge between the novel of youth and the anti-novel of old age (if a book can be called such which the novelists of the *nouvelle vague* failed to appreciate because the monster of psychology triumphs in it). All important writers leave such a pathway open. Down it passed Giani Stuparich and Quarantotti Gambini[8] in Trieste, in their first stories, and, beyond Trieste, almost all the best Italian fiction writers of today. In almost all of them there is some character, some situation that reminds us irresistibly of Svevo.

As the poet of our bourgeoisie—a judgmental and destructive poet—Svevo can be considered a follower of Verga. The author of *Mastro Don Gesualdo* thought that with *La Duchessa di Leyra* he was bringing us into the world of a modern noble and perhaps political feudalism: one cannot imagine a novel of his (after his first more or less failed novels) that was truly bourgeois. Verga in a certain very great sense was not a democratic poet. As the continuator or completer of his work, Svevo has given us the epic of an expanding bourgeoisie, already close to dissolution, and this is enough to assure him a posterity which is not made up solely of epigones. By now, he has entered the small number of our necessary writers. One can feel that in Italy his fame, which is continually growing, has only begun. Besides, an imposing critical effort has brought him back from the ambiguous world of *Weltliteratur* into the world of our greatest national writing.

For me, if it is permissible to close with a personal confession, Svevo also remains something more than an eminent writer: he remains a piece of Trieste, of the city which I visited for the first time after its liberation, as a pilgrim who had contributed as the last among Italy's infantry to bringing the city into the living body of our nation. I met Ettore Schmitz in the very days when his name was in all the papers, I was his friend, I spent unforgettable days at Villa Veneziani, I knew his wife, his family, his little grandchildren who later suffered a cruel fate; I saw his earthly parabola come to a

8. Giani Stuparich (1891–1961): Triestine novelist who shared with Svevo an interest in the contrast between morality and sensuality. Pier Antonio Quarantotti Gambini (1910–1965): Psychoanalytically oriented Triestine writer influenced by Svevo and Stuparich.

close, and was present at the creation of his fame. It is impossible for me to recall this episode of my youth without associating him with the face of Trieste, the city which in honoring one of its most illustrious sons once more proves herself worthy of him and his difficult message. It is impossible for me to pay tribute to Svevo without also paying tribute to the entire city of Trieste.

Aesthetics and
Criticism

[Speech delivered at the commemoration of Benedetto Croce held by the Amici del Mondo, Teatro Eliseo, Rome, December 1962. Published in *Il Mondo* (50), December 11, 1962. Benedetto Croce (1866–1952) was the foremost Italian philosopher and critic of the first half of the twentieth century. A Hegelian rationalist greatly influenced by his fellow Neapolitan Francesco De Sanctis, Croce founded the review *La Critica* in 1903; here he published all his work for the next forty-three years, as well as a large body of criticism which sought to promote libertarian political ideas and, in Italian letters, clarity and concreteness. Croce's "philosophy of the spirit" was a circular schema which divided the spirit into four phases, aesthetic, logical, economic, and ethical. Beginning in 1938, Croce modified his system in favor of an absolute historicism, in which he saw history as the unique mediational principle for all aspects of the spirit. Croce played a determining role in Italian life, first as the moving force behind a movement for renewal in Italian intellectual life (see "Style and Tradition") and later as the symbol of moral resistance against Fascism. Though Montale was never a "strict adherent" to Croce's system (or to any other, for that matter), the philosopher's influence on Montale's thought and indeed on that of several generations of Italian intellectuals can be felt throughout this book. See also Montale's poem "*A un grande Filosofo*" in *Diario del '71 e del '72*.]

I confess my extreme embarrassment: I don't know by what right I have been asked to speak here, I who for many years have lived far from what Anatole France called the city of books, who for many years (and through no fault of my own) have not had a single book by Benedetto Croce on my shelves, and who carry out my mundane work far from the elevated spheres of philosophy and learned criticism.

I knew Benedetto Croce, I met him twice in Florence before

the last war, when asking to see him and speak with him was not devoid of a certain inconvenience. I believe it was at the Hotel Bonciani, and later at the home of Luigi Russo. And on two other occasions I visited Croce, at his home in Naples, in the last years of his life. I don't remember what was discussed: certainly nothing that concerned my literary efforts. But the fact was that I had gone to pay him a visit, and that was eloquent enough in itself; so that twice the philosopher had occasion to remember himself to me in the most gracious manner, sending me a copy of his *Aesthetica in nuce* and later—through the offices of a friend—his book *La Poesia* fresh off the presses, with a very courteous inscription. I never belonged to the small circle of Croce's disciples and friends—made up for the most part of men who represented official culture (the schools, universities, academies). Instead, I breathed the air of other surroundings, which Croce's teaching had penetrated by rather indirect means. Thirty or forty years ago there were writers, journalists, artists, men of varying culture and background who, though they could not be considered Croceans in the Master's strict sense, had received his imprint in certain ways. These men were different from the typical *mittel*-European intellectual of those days; even when they did not sparkle with geniality they distinguished themselves by a clarity and a calmness of judgment which would have been impossible elsewhere, under other skies. I won't say they were all friends and disciples of Croce, nor were they making new discoveries, but they had kept the secret of good sense and they looked to Croce as to a master who was severe with "professionals" (philosophers and pedants of high degree) but indulgent and understanding with the newcomer who absorbed his thought with a mind unclouded by prejudices. In short, my first friends and teachers were men who could have been called infrequent or non-observant Croceans.

Several were noted philologists, like Giorgio Pasquale,[1] always in contention with Croce but incapable of doing without him; others were literary men and men of action like Gobetti and Ragghianti,[2] who was barely sixteen when he told me about Croce, while

1. (1885–1952). Noted classical scholar and critic of education.
2. Carlo Ludovico Ragghianti (b. 1910). Art historian and art critic.

I was advising him not to pass over Charlot and the execrated
"decadent" writers; others like Emilio Cecchi[3] and Pietro Pancrazi[4]
had continually touched on Croce while reserving for themselves a
wide margin of independence; still others like Alfredo Gargiulo[5]
even tried to rebel against their master, proposing a categorical
division of the arts which was later limited to a few scattered ideas
derived in part from Winckelmann and perhaps Lessing. To these
names I could add those of Mario Fubini,[6] one of the most indepen-
dent of the Croceans, and Luigi Russo,[7] at times a most observant
Crocean, at other times furiously heretical for reasons that were not
always philosophical.

The Croceanism which influenced me in my youth is all here:
let others judge whether it was insignificant; I wouldn't know. What
is clear is that when I read the *Aesthetic*—the first version, and
later, the *Aesthetica in nuce*—and the essays on the literature of
the new Italy, I was already in some sense a cautious initiate; so
much so that ever since I have preferred those who were "re-
freshed" (as it was said) by Croceanism to the most orthodox
defenders of the term.

I began with the *Aesthetic*, knowing virtually none of the
works in that discipline which had preceded Croce, or perhaps only
De Sanctis's *History of Italian Literature*, a necessary antecedent. I
cannot say I was much surprised by it, because in that work Croce
arrived at a conception of poetry that had been in the making for
many years. I had read the poets, not the theoreticians of poetry;
and the poets I had read were all agreed in seeing poetry as di-
vorced from eloquence, from rhetoric, from everything that can be
hedonistic, discursive, decorative (or better, illustrative) in a poetic
composition; divorced, in short, from the muddled obstructions of
what the idealist philosophers considered the practical, utilitarian
spirit. From Coleridge to Baudelaire and beyond there existed a
conception of *pure poetry* which Croce's first aesthetics did not

3. (1884–1966). Leading modern critic and writer. An expert on English
literature, he was one of the founders of *La Ronda*.
4. (1893–1952). Critic of contemporary literature and writer.
5. (1876–1949). Aesthetic and literary critic, interested in reconciling Croce's
rigorous system with the irrational elements of "pure" lyric.
6. (1900–1977). Historical literary critic, aesthetician, and professor.
7. (1892–1961). Historicist literary critic, professor at the University of Pisa.

explicitly contradict, even though later in his actual criticism he showed no sign of accepting it. Croce created a theory of poetic language which equates intuition and expression, relegating the philosophic spirit, logic, and even (to one side) economics and morals to another part of the spirit (a higher part, but at first we weren't necessarily concerned with the distinction). I can't say whether at first this division of the human spirit into four parts seemed satisfactory to me, nor whether it seems more absurd today than other schemes which make all the spiritual faculties cohabit together, even against the evidence of common sense. Go tell the man in the street, the man who hasn't been to college, that a man can be a great artist and an immoral man and even a criminal at the same time; the man in the street will have no difficulty in admitting that within a single man there can be two, three, four men, each different from the next. Roughly speaking, the idea that the poetic faculty is separate from man's other faculties demonstrates that it is not useless or stupid to search for poetry's place in the circle or sphere of the human spirit. In this sense Croce was a great liberator. At a time when learned positivism and scientism were looking to the work of art as the evidence or raw material in the historical and philological quest for a "form" considered as a shell from which to extract a "content" to be studied as an object of value with psychological or moralistic criteria—a tendency which was hardly countered by an aestheticizing or even superhuman spiritualism—Croce restored to the poetic faculty its dignity and autonomy. After Lombroso,[8] Fogazzaro,[9] and D'Annunzio we returned, by way of the Neapolitan school of idealism, to the truths that had been glimpsed by Vico.

I don't know when I became aware of the objections which had been raised against the *Aesthetic* as linguistic science since its first appearance. They amount to this: if every cognitive act is intuition, how is artistic intuition to be distinguished from the others? "By means of taste," is the answer, i.e., by means of an empirical faculty. But if so was it in fact necessary to create a philosophical

8. Cesare Lombroso (1835–1909). Psychiatrist and criminal anthropologist.
9. Antonio Fogazzaro (1842–1911). "Modernist" Catholic novelist interested in the idea of evolution. His works include *Piccolo mondo antico* (1895) and *Il santo* (1906), which was condemned by the Church.

aesthetic? I don't recall how Croce responded; but for my own part it would be impossible to imagine an aesthetic which would set aside taste, and therefore, the sensible, in its application. Nor could Croce imagine it, if he could write that "the limits of those expressions-intuitions which are called art in relation to those which are commonly called non-art are empirical; it is impossible to define them. The entire difference is therefore quantitative and, as such, indifferent to philosophy, *scientia qualitatum*."

Croce concerned himself with issues related to his *Aesthetic* for many years; and the stages which allow us to follow him from the primitive concept of art as immediate intuition-expression to the concept of lyricity, later specified as the totality of artistic expression, are represented by a series of works, the most important of which are: *On the Lyric Character of Art* (1906); *The Breviary of Aesthetic* (1912); *The Character of Totality in Artistic Expression* (1917); *Art as Creation and Creation as Making* (1918); *Aesthetica in Nuce* (1929); and *Poetry* (1936). In these works Croce's thought was deepened, but he left himself open to other objections. If in every form of spiritual activity all other forms of the spirit are also present or implicit, how can an aesthetic be founded on immediate and alogical intuition? It is true that the formal synthesis defers a judgment as to the existence of its contents, but if content cannot be discounted and if it enriches art (and the mature Croce never doubted this), up to what point is an aesthetic of pure intuition sufficient? After all, no one ever doubted that art was also intuition; but Croce's originality, in his first aesthetic, was precisely that of making art coincide with a primitive, dawning intuition from which the philosopher later on seemed to dissociate himself. Perhaps the truth is that at first Croce's aesthetic thought was not necessarily bound to an idealist and systematic conception of the spiritual faculties, and that later on the philosopher was forced to reckon with his own system. Taste could no longer suffice as a standard of judgment, even if a taste developed through a long experience of works of art in their concrete historical development might be considered empirical and alogical up to I don't know what point (and in fact many non-systematic Croceans did proceed in the direction of taste). But the internal logic of Croce's idealist system did not permit any concession to empirics, and taste, though it was neces-

sary, since poetry "is understood only by the poetry that lives in him who receives it," taste could only remain marginal and extraneous to the system. A system of thought which admitted a material extrinsification of intuition, a formation of the work successive to intuition, would have created a dualism that was inadmissible to the system. Because for Croce (and this is the basis of his thought, unrenounceable from the moment it was clarified in the idealistic sense) the intuitive act is purely ideal and the work of art is already perfect within it. The painted picture, the poem written on paper, the music translated into notes are extrinsifications of the ideal work, belonging to the communication of the work, not to its creation. And this is the stumbling-block which Croce seemed not to realize because his experience of art was always limited to the art of the word, but which was momentous for whoever wished to be faithful to his thought in the other arts. A stumbling-block, but also a veritable necessity in the Crocean system, because to admit that the material of art could in some way act on the ideal intuition and modify it would have cast doubt on the principle of the fundamental unity of the arts and destroyed at its foundation the principle of the ideality of art.

We all know the consequences: Croce's criticism, born of a principle of absolute formalism, could not condescend to compromise with form understood as matter and thus had to develop in the direction of content, of its harmony and congruity with what became identified in each poet as his leading, dominant theme. In a certain sense the system compelled Croce to mistrust art that was too lyrical, too impassioned, too compromised by the pressure of a rebellious subject matter that was always ready to renew itself. And in fact, Croce always found himself at ease with completely "delyricized" artists, artists utterly adherent to one basic theme, to a unified state of mind. Artists like Ariosto and Verga seemed made for him because each page of theirs contains them entirely. Not that they lack a framework, a "machine" that makes their poetry possible; but in them fancy is victorious over abstract imagination and renders inoffensive a content which in itself creates no problems. One can certainly study their language, but this can be the task of stylistic criticism which is concerned with communicated art, the object, not the ideal work. The aesthetic critic isn't obliged

to do this: it is enough for him to have ascertained and recognized the poetry which existed in their soul and which covers the entire skeleton of their works as a fundamental tone. Nor will the aesthetic critic be able to delude himself that a passageway or a conducting wire exists among the various artists. If poetic intuition is individual, it cannot be made into material for history, and there can be no history of art or poetry except in the monographic sense, by reliving and defining the intuitive activity of each individual poet, case by case. A similar critical activity cannot extend to aggregate portraits, and the many extant histories of art or poetry (including De Sanctis's) are histories of a particular era in the human spirit, in custom, in literary and cultural tradition, they are not really histories of poetry. Finally, and to conclude on the theoretical aspect of the *Aesthetic*, it is clear that it was impossible to maintain the criterion of the fundamental unity of the intuitive, aesthetic act without violating the prejudgment of the so-called literary genres: though they can be considered as empirical aspects of the development of the poetic art.

An aesthetic, then, which is rigorously formal, but just as rigorously committed to conserving the ideal character of form. From this derives the close-to-absolute absence from Croce's criticism of any remark of a technical nature, any linguistic analysis, any pleasure in the particular, the fragment that can be isolated and enjoyed by itself. So conceived, poetry resolves into the harmony of its contents, i.e., into a purity which must be understood as a total absorption of its ideological material (whether this is a more or less indiscriminate state of mind or the essence of thought) into that non-judging, suspensive contemplation which is poetic fancy. A purity, thus, which as it clarified itself by degrees in the thought and taste and character of Croce, carried him far indeed from the modern post-romantic and irrational conception of pure poetry. This, in rapid and summary synthesis, is the aesthetic thinking which remains understood or at times explicit in Croce's vast literary-critical work, which he practiced on Greek and Latin writers, on the Arcadians, on the entire Italian eighteenth century and on part of the eighteenth century abroad, on poets like Dante, Ariosto, Shakespeare, Corneille, and Goethe, as well as on entire

epochs in the Italian literature and culture of the Renaissance and the Baroque; I pass over these last works because they are distant in my memory and far from my competence; and even they do not exhaust an activity as historian, moralist, and memorialist worthy of the greatest phase of The Enlightenment.

But to return to aesthetics and literary criticism as it bears on the period closest to ours, it should not seem contradictory that the man who denied the possibility of a history of poetry should then have labored so intensely as a critic and historian, for Croce does not think poetic activity is a bolt from the blue, a miracle manifested in a vacuum. Next to poetry he puts literature, which has a positive value of its own, but of a different order; and it is this which permits the historian to sketch those points from which true poetic fancy—alogical and ahistorical—rises in flight. One can make history out of literature because it belongs to the order of philosophy, though probably in a subordinate position, just as true criticism, which does not exhaust itself in critical works or aesthetic treatises but lives in the thoughts and reflections and in the non-poetic writings of many poets, like Flaubert and Baudelaire, is essentially philosophical.

Thus we have in Croce a critic whose work is based on a theory which he wanted to be rigorous, even if to some there seems to remain a contradiction in him between his early conception of art as immediate lyricity and the later conception of art as totality and cosmicity (but this is the province of the philosophers), and a Croce who judges according to a particular temperament. And here we must also consider whether it is true that good sentiments often make for bad literature and whether the most correct of theories are not enough in themselves to make a good critic. Sainte-Beuve was a good critic though he lacked his own philosophy of art; some of Croce's followers were mediocre critics, incapable of re-vivifying and, I would almost say, of forgetting, their theory. As for Croce, he was less Crocean than many of his followers due to the fact that his temperament and taste were almost never dominated by his theoretical schemes.

He was not afraid of contradicting himself, as in the case of Manzoni and the *Promessi Sposi*, which seemed to him artistically tainted by a moralistic intent until the day when he thought he was wrong and admitted it openly, though this error was inherent in the early nature of his system of thought and was not a true theoretical flaw. And we don't know whether in his last years he would have rewritten the essay on Dante with such a rigid distinction between poetry and structure; but here, too, I touch on a problem which it would be impossible for me to discuss here or perhaps anywhere. In his greatest critical analyses there is virtually no trace of that material, and I would almost say topical, distinction between poetry and non-poetry which he himself, for that matter, had recognized as impossible, admitting that the distinction cannot be made by pointing to a place on the page. Or rather, a trace did remain, for example in his essay on Pascoli, which we consider essentially fair but too formalistically justified. Pascoli had an entirely opposite temperament from Croce's; a feminine temperament, unaware of its limitations, in fact devoid of that strength of character and of that internal security which even a poet like Baudelaire (who was the father of so many later decadents) securely possessed. Croce could not fail to recognize this; but in order to do so it was not necessary to point out with such fury what was beautiful and ugly in Pascoli; after all they are present in every poet, even in Baudelaire, and it was enough to concentrate on the general tone of Pascoli's poetry. And it was precisely in his sureness in capturing this tone that Croce did justice to Vigny, a poet whose leaps in the air and whose vacuities have not escaped any critic. It was Croce's temperament which allowed him to draw us a miraculous portrait of Foscolo in a few pages and which induced in him a certain reserve toward Leopardi, a reserve which was present in the entire classicist strain in our poetry and was certainly active in Carducci (not to mention Tommaseo)—and which was still present in the Italian schools in the first years of the twentieth century. What then did Croce demand of the poet? I would say he demanded character; and character could manifest itself as fidelity to the poet's own themes, as gift, as the capacity not to be corrupted by issues extraneous to poetry, as a pure faculty that could justify the whole man, even if the poet himself seemed to be only half a man (this

was the case with Ariosto); or even an impure faculty, but always dominant and overwhelming whenever the poetry revealed the image of a man who hadn't surrendered to the forces of evil and had confronted his destiny with courage. One could say that Croce would have loved the poets he loved as men, had he known them; be they the Olympian and demonic Goethe or the Catholic and self-proclaimed reactionary Balzac or the miraculous Nievo[10] and the robust and sanguine Carducci, the last standard-bearer of a poetry that aimed at remaking man, and in this, but only in this, and only on a strictly theoretical plane, far indeed from Croce.

It has been observed that in positing the principle of art as totality, and no longer as primordial lyricism, Croce was in danger of leaning toward the theory of sympathetic identification (*Einfühlung*) toward which he had always been indulgent. Yet I believe that this gift of identification (which is fatally linked to taste and character) was always the basis of the critical judgments which Croce made about poets and writers. And I believe this is the strongest point, the point of resistance, of his criticism. At times identification is impossible for him, as in the case of Kleist, that strange perfectly translatable poet, who pushes the objectification of his world to the point of an apparent coldness and gratuitousness (and certainly the figure of the man Kleist, incapable of settling his quarrels, must have been distasteful to Croce); and in the case of Pirandello, who for him must have belonged to the clan of philosophizing pseudo-poets, which was partly true. On the other hand, Croce had sympathy for a number of religious poets, including the extremely difficult Hopkins, because he was always prompt to recognize the religious sentiment as material for art, though his essay in the *Discorsi di varia filosofia* (Volume 1) shows scant understanding of the poetry of Hölderlin.

I have listed the examples that have stayed in my memory: perhaps they are not the most significant. What counts is that Croce succeeded in making history from poetry by bringing to it

10. Ippolito Nievo (1831–1861). Novelist, poet, and patriot, author of the celebrated *Confessioni di un italiano* (1858).

his entire passion and his trust in the human spirit. He was the last of the great critics who had faith in life and who considered man as the sole true and concrete expression of universal life.

But now that he has left us—and in all honesty the times had changed before he did so—we must compare the era in which he made his first steps with the time in which we live; and we must ask ourselves if the enemy forces which he sought to defeat still live among us under other names. And here my difficulties arise, because Croce was not only an aesthetician and a literary critic, and my discussion, which is intentionally fragmentary, covers what may be only a very small part of his legacy. In an essay of 1907 called *Di un carattere della più recente letteratura italiana*" ["On one aspect of the most recent Italian literature"] he enumerates the attitudes and vices of that period: positivism, legitimate insofar as it was opposed to the intoxications of the facile philosophy of nature and revindicated the autonomy of the exact sciences; realism, which had an erroneous program but was honest because it was founded on the study of man; pedantry, i.e., the positivism of historiography, which claimed to study human history apart from human ideals; and, summarizing the terrors of the greatest poets of the day in the accusation of insincerity, he goes on to identify the major error of the early twentieth century: to have "abandoned the principle of the power of thought to endue and dominate all of reality, which is and cannot be anything other than spirituality and thought." A backward step, in short, after the thought of Kant, Fichte, and Hegel.

Yet as far as philosophy is concerned, the backward movement seems to continue without the possibility of return. Absolute empiricism, analyses of language, attempts at resurgent religious spiritualism, Marxist postivism, existentialism, accepted (until yesterday) as both atheist and religious, and today phenomenology, a philosophy of the spirit which seems ready to accept any sort of reality whatsoever, including the form that is most convenient to the social and academic careers of the philosophers (and unfortunately this danger has afflicted the degenerations of idealism). Thus the dangers of yesterday still exist; they have grown, but they bear other names; and we all know their effect on the general condition of art. It is no longer a matter of insincerity, but of a

boastful declaration of universal ignorance. It is said that man is in crisis because society is in crisis. It is said that metaphysics is dead and buried and that its place has been taken by science. It is said that the individual exists only in relation to what is other than himself (and it is true), but since the accent always falls on the other, the individual is always excusable, innocent, irresponsible. So it was too for the early, not the late, Croce.

This is our dominant spiritual condition, which however presents diverse aspects, depending on whether one has faith in the conquests of science (which idealism had unfortunately relegated to the attic) or feels life to be tragic solitude and understands industrial progress as the transformation of man into a machine created by him but destined to devour him. Agnosticism, trust or mistrust in the least responsible part of man, the decay of language which is now reduced to a sign, the development of culture in a purely visual, spectacular sense, art understood as a drug or a product destined for immediate use, preferably substituted by good surrogates—this is our time. In this climate of gloomy vitalism, of resigned trust or sullen mistrust in the fate of a science which is ignorant of its own limits and places the destinies of men in the order of probabilities, not certainties, what can be the future of an idealistic philosophy? I couldn't say, nor is it up to me to give an anwer on this occasion. But insofar as a possible philosophy of art is concerned—which is only one aspect of Croce's thought—our problem is to consider up to what point the aesthetic proposed by Croce is valid in a conception of the world and of history which is no longer idealist. Is it possible to believe in the autonomy of art even if one is convinced that matter confronts man in a non-dialectic relationship, as an obstacle which is different from ourselves? I believe it is possible, because common sense (as we have seen) sanctions this autonomy and because each and every one of us feels that a certain *quid* differentiates an arid moral tract from a truly poetic composition animated by the same ethical principles. Years ago a curious debate took place in England. The poet Eliot asked how one could admire the work of a poet (in this case Goethe) whose ideas and whose concept of life one did not accept. And the problem was declared insoluble. Yet the problem had already been solved by Marx, an admirer of Greek tragedy, which grew out of a

conception of the world that was certainly not his. And even Friedrich Nietzsche did not deny Wagner's art when he declared that *Die Meistersinger* was an assault on culture, nor did he raise the issue, for he recognized that there is no necessary relationship of cause and effect between aesthetic admiration and ethical consensus. In any case, a similar issue cannot be raised in Italy, because in Italy we have had Croce.

Another vital though controversial point: the unity of the arts. It is a profound, subterranean unity, but evident from the reciprocal influences of the various arts, from their growing need to cross over from one to another, and from the fact that in the course of history the same schools, the same problems, the same directions present themselves in all the arts, often simultaneously, sometimes in successive periods. Without classic poetry great periods of sculpture would not have existed; without Romantic poetry we would not have had the German symphony; without architecture polyphony would make no sense; without the painting of the later nineteenth century the poetic and musical impressionism that followed it would not be comprehensible; without the expressionism of the poets the musical expressionism of the school of Vienna would not have arisen. Is there then a thread which unites the arts? In Italy this thread is always present in the best critics because Croce existed; outside Italy there is talk of separate, *ad hoc* aesthetics, but the sense of the universal and human value of art has been lost. Forms (or rather the abstract psychological themes that underlie them) are studied abstractly, as if they had an autonomous life of their own, but it is forgotten that art as a formal "piece," history as an imaginary museum, the picture as the radiograph of a psychosis, are the beginnings of the end of art, because the forms and the themes themselves can be created by the culture industry, and the very notion of an art destined to last disturbs a humanity that no longer wants to reflect, suspended as it is between anxiety and the obscure need to put an end to every individual problem.

Yet a third point, a very difficult one, but essential. I do not believe that the written poem, the painted picture, the music inscribed on the stave are doubles of an ideal image which is preexistent in the soul of the artist. An artist is such only insofar as he

creates an object in which he recognizes himself and which was not exactly in his expectations. But this cannot make us think that art coincides with technique and that the analysis of the artist's technical procedures exhausts the task of criticism. In short: technique is present in every work of art but it is not art and it does not make art, for in itself it is perfectly imitable and its progress can be studied, while no reasoning being, at least in Italy, believes in the progress of art. And this too we owe to Croce.

Can these three points be extrapolated from a system as complex as Croce's philosophy of the spirit? It is probable that they need to be considered in relation to other aspects of his thought as an historian and logician who carried the immanentist conception of life to the threshold of an earthly religiosity which sees man in perpetual struggle to actualize his liberty, to defeat the dark forces of a vitality which is present in the late Croce as the primitive source of life, but also as an evil to combat and expunge. I don't know how art will be thought of tomorrow; nor do I know whether art as it was understood for many centuries up until now, as the creation of forms expressive of an individual feeling, is destined to survive. For me, the principle that was enunciated by Tommaso Ceva[11] on the day that he said that poetry is a dream dreamed in the presence of reason, still holds. Nor do I believe that Croce would have found him substantially in the wrong, even if reason was logic for Croce, while for Ceva it was doubtless something else. What is clear is that to his greatest pages Croce brought not only the pure intuition of the critic but also the complexity of his whole spirit, the profound sense that it is necessary to look for the whole man in the artist. And the idea of art which Croce created was noble, the noblest that has appeared in modern Italian thought. True, in his comprehensive system the poet could seem to be a man confined to the intuitive plane of the spirit, though certainly possessed of a grace which in its own way and through its own virtue was impregnated by all of life, for there is no distinction which does not implicate all the other levels of the spirit; but basically the ultimate understanding of life, the total clairvoyance which dominates the

11. (1649–1736). Jesuit mathematician and poet.

passions and comprehends and justifies all, true and proper wisdom was reserved for the philosopher. And yet when Croce came upon a poet with whom he could vibrate in syntony, (not only Goethe, but also Ibsen and Carducci and even Maupassant, who passes through life "like a meteor"—and rarely was Croce so moved by a poet abysmally distant from him), the note of admiration in the voice of the philosopher-critic celebrates a supreme value in art: the absolute justification of life. This explains why Croce made studies in every field of scholarship and art in Italy, and why lovers of the visual arts outside Italy also owe him much. Even today, though the times have changed and an epoch has begun that is partly revisionist and partly blindly rejecting of the culture we have inherited (though it was always a great humanistic culture), if there is still someone in Italy who does not consider art as the "gestural" act, as it is called, of putting colors or words on canvas or paper or dreaming up algebraic combinations of notes, even if he is not entirely aware of it he carries within him the teaching of Croce. This in itself is a great deal and it covers only one part (not the largest perhaps) of the prodigious activity of a philosopher of the spirit who was also a great writer, certainly our last great writer who had faith in man and who believed man was born to find his freedom in a faith.

Here I realize I have exceeded the limits I proposed, which excluded the examination of Croce's moral philosophy, as it is the province of others. Let it suffice for me to say that Croce is not alive for us solely because of his contributions as an aesthetician and literary critic. What most surprises us in him today is the defense of man's freedom and responsibility by a philosopher who had made man the transmitting antenna of the Spirit, thus denying the guilt of the guilty as well as the merit of the artist, and seeing in history an infallible progression not from bad to good but from good to better. Perhaps the Croce who has most aided us in the hardest years of our life entered into contradiction with these, his first principles, but what was important above all to us was the faith we discovered in him, that area of shadow we could make out at the edges of his thought and which reminded us (as I have recently written) of the faith of the Stoics.

I close with the words with which I recently ended a short

commemoration of Croce,[12] and with which I am sure not all of my audience are familiar:

"It is this shadow which more than anything brings Croce close to us and makes him seem still with us. His denunciation of the innocuous 'decadence' of sixty years ago almost makes us smile, now that the dance of the irrational and of the instincts has become deathly in a very different way. But his faith in man, his certainty that the forces of reason will never be definitively vanquished, will never find us indifferent. Even more than his aesthetic—which is still very much alive insofar as it answers to the needs of contemporary culture—it is his incitement to moral responsibility, to paying one's own way, which today, beyond any political or religious conviction, makes us feel the force of his presence."

12. *"Presenza di Croce,"* published in the *Corriere della Sera,* November 20, 1962.

Dante, Yesterday and Today

[Final address delivered April 24, 1965, at the International Congress of Dante Studies held in Florence to mark the 700th anniversary of Dante's birth. Published in the *Atti del Congresso Internazionale di Studi danteschi*, Vol. II. Florence: Sansoni, 1966.]

In a celebration like this one, to which illustrious individuals have contributed the weight or grace of their authority, he who is called to speak at the close is always received by the master of ceremonies with the ritual and consoling "last but not least." Which may be entirely justified in other circumstances; but for me, today, I don't feel it is necessary to gild the pill, for here before you I truly feel myself to be "last *and* least," last without extenuating circumstances.

And yet I am here, I have agreed to speak on this occasion, though I lacked the time and perhaps even the capacity to find something in myself which, in relating it to my own particular experience of Dante, could amount to something more than personal and therefore worthy of being reported and discussed here. It seemed to me, once my first bewilderment was over, that if Dante is a universal patrimony (beyond a certain level of necessary study)—and such he has become, even if he remarked more than once that he was speaking to few who were worthy of hearing him—then his voice can be heard today by everyone as it never was in other ages and as may never again be possible in the future, so that his message can reach the layman no less than the initiate, and in a way that is probably entirely new. After he was crowned

with glory in his own lifetime, Dante's readership gradually declined up until the seventeenth century (his dark age), to dawn again with the advent of Romanticism and the simultaneous flowering of an entirely worldly philosophy which sees man as the master and even the creator of himself.

I am not unaware of the differences between these two movements, though I note their convergence. Romanticism looks to the ancient world for inspiration, not because it has renewed and emphasized its myths, but because it is dissatisfied with its own rationalist, enlightened age, and therefore it resolves into a poetic art. Materialism, which appears on the heels of Romanticism, not only accepts its own era but believes that it represents the highest phase in the total evolution of reason. The Gods are dead, even if they had to slake their thirst with human blood in the process, and the divine has come down to earth. Though they differ and are even opposed, these two movements both deserve to be called "modern," and for different reasons both look to Dante. For the first, Dante is a distant precursor of Romanticism and as such deserves to be rediscovered; for the second, his work is a miraculous product of poetic imagination, but this imagination is not Dante's wisdom, it is only one step and not the last, the *som de l'escalina*, of a Spirit which has not yet become conscious of itself.

Poetry, they have told us, is not reason and only reason can understand it and do it justice, but in the way the strongest does justice to the weakest. It would be unjust to reduce the eighteenth- and nineteenth-century understanding of Dante to this dichotomy. In fact, the nineteenth century saw the birth and early growth—not without some antecedents in the mid-1800s—of research by those who hope to raise the veil which obscures Dante's great creation and fully penetrate the mysteries of his allegory. In the nineteenth century the esoteric Dante is born or reborn, the Dante who even as an historical person (the most absurd hypotheses come to mind) was supposed to have had two faces, one of which remained virtually unknown: the Dante who was a Knight Templar or who enrolled as a Franciscan but then left the order before taking his vows, and above all the Dante who was supposed to have spoken a sectarian tongue that is only decipherable today, and only to the slightest extent, by those who have exhausted themselves in long

and deep study. It is easy to criticize this particular aspect of modern Dantology (which in fact has been contested and rejected by a more modern philological and historical approach), but one must admit that apart from its pathological aspects it has the merit at least of having affirmed one great truth: that Dante is *not* a modern poet (a fact also recognized by modern critics and philosophers), and that the instruments of modern culture are not ideally suited to understanding him (a fact denied by the modern philosophers who believe themselves specially authorized to raise the veil). And how? By the extension of modern reasoning.

My conviction, however—and I state it for what it is worth—is that Dante is not a modern in any of these respects: which does not prevent us from understanding him at least partially, nor from feeling that he is strangely close to us. But for this to happen we must also come to another conclusion: that we no longer live in a modern era, but in a new Middle Ages whose characteristics we cannot yet make out. Since this is a personal conviction of mine, I shall refrain from discussing the reasons for it here, where it serves only as an hypothesis. The era which lies before us does not allow for short-term predictions, and to speak of a new Middle Ages is to speak equivocally at best. If the future sees the ultimate triumph of technico-scientific reason, even accompanied by the weak correctives which sociology can devise, the new Middle Ages will be nothing but a new barbarousness. But in such a case it would be wrong to speak of them as "medieval," for the Middle Ages were not merely barbarous, nor were they bereft of science or devoid of art. To speak of a new Middle Ages, then, could seem a far from pessimistic hypothesis to the man who does not believe that the thread of reason can unwind *ad infinitum*; and yet an entirely new barbarousness is possible, a stifling and distortion of the very idea of civilization and culture.

But I see that I must return to my argument and ask myself who was Dante, and what he can represent (and this is my theme) for a writer today: I don't say for a poet today, for compared with Dante there are no poets. The literary historians have asked themselves who Dante was and they have succeeded in sketching the outlines—though with many lacunae—of his existence on earth.

Shakespeare, more fortunate than he, has so far covered his tracks. It is well known that Sidney Lee, after demonstrating that many of the themes and subjects of Shakespeare's sonnets belong to the *topoi* or commonplaces of the Renaissance sonnet, reached the conclusion that in the sonnets Shakespeare did not "unlock his heart" as Wordsworth believed but rather disclosed something very different. According to Lee, the only biographical inference which is deducible from them would be "that at one time in his career Shakespeare . . . disdained few weapons of flattery in an endeavour to monopolise the bountiful patronage of a young man of rank": the famous "onlie begetter" whose identity is disputed.[1]

Whether or not such a conclusion is just, it certainly fails to reveal the great poet of the tragedies. Not that unanswered questions do not hang over his life and part of his work; but modern criticism has managed to set them aside. Only his poetry exists. These are the conclusions of the new "close reading" which approaches poetry in a totally ahistorical manner. Dante's case is very different; his life and works are so closely associated that we shall never lose interest in the poet's biography. And there are many obscure points in Dante's life and work. The dates of his *rime estravaganti* [miscellaneous poems] have only been partially established; and not only poems, but also letters and until recently a treatise are disputed. Conversely, it may possibly be shown that he wrote the *Fiore*,[2] which until now has been attributed to Ser Durante. We do not know the year in which the first *cantica* of the *Commedia* was begun, nor do we know (apart from its uncertain beginning) when the poet started the actual drafting of the *Inferno* and the *Purgatorio*. We know only that for something like twenty years (some say fifteen) he dedicated himself, while also writing other works, to the composition of the *poema sacro*. There is also the question whether the *Vita Nuova* is known to us in a later

1. Sidney Lee, *A Life of William Shakespeare*, revised edition (London: Smith, Elder & Co., 1915), p. 230.
2. An allegorical poem of 232 sonnets written between 1280 and 1310 in imitation of the *Romance of the Rose*. Ser Durante is the possibly symbolic name (*durante* = persevering, constant) of the author of the *Fiore*. The poem has been attributed to Dante da Maiano, an imitator of the Provençal poets and poetic correspondent of Dante's, and also to Dante Alighieri himself.

version, which was necessary in order to connect that book to the poem, passing over the compromising second treatise of the *Convivio*. And certainly the questions do not end here. All this demonstrates that a reading of the poem, and naturally of the *rime*, which entirely neglects Dante's life, his background and education, cannot take one very far. And yet an attempt to read him as one reads a modern poet, selecting the most vivid parts and leaving aside the rest—which is judged extraneous to the poetry—has given rise to strange complaints. De Sanctis seems to deplore the fact that too many medieval superstitions overshadowed the poet, impeding him from giving free rein to his characters. The conclusion of his analysis of the *Inferno* in his *History of Italian Literature* is well known: "these great figures, there on their pedestals, rigid and epic like statues, await the artist who will take them by the hand and toss them into the tumult of life and make them dramatic beings. And that artist was not an Italian: he was Shakespeare."

Dante, then, is more poet than artist. De Sanctis was very careful to distinguish between poetry and art, but he was never very sure of his distinction. This gave rise to misunderstandings which have lasted up until today. The truth is that if there was ever an artist in the fullest sense of the word, that artist is certainly Dante. But what was art for this Dante about whom we know so little, the first Dante? It was an art of convention, of tradition, the *ars dictandi* common to him and to those whom we can consider as his correspondents (the *stilnovisti* were not a *tertulia* [conversation club] and their precursor Guinizelli[3] died when Dante was ten). Within the limits of the school, the problem was not originality, but fidelity to one's Dictator. It was an accepted convention inherited from the Provençal troubadours that the poet was dictated to. But the poets of the *Dolce Stil Nuovo* adhere more closely to the Provençal theme and enclose it in a more perfect canon. Their language is the vulgate, but purified and therefore sweet. Guittone[4] can no longer serve as a model, he is considered rough and coarse.

3. Guido Guinizelli (1230/40–1276). Bolognese Ghibelline poet and forerunner of Dante, originator of the *"Dolce Stil Nuovo"* [sweet new style]. Originally a follower of Guittone d'Arezzo (see below).

4. Guittone d'Arezzo (1220–1294). Leading poet of the generation preceding Dante's, he wrote in the Provençal-influenced style of the Sicilian school.

Dante starts from Guinizelli but simplifies and strengthens his style; he takes even more from the second Guido [Cavalcanti],[5] and the *Vita Nuova* cannot be understood at all if one does not recognize the presence within it of themes, contrasts, and "disruptions" from the poetry of his closest friend.

Nevertheless, there is also a new "style" in Dante, and consciously so. This should not surprise us. Always, at all times, poets have spoken to poets, entering into a real or imaginary correspondence with them. The poets of the new school pose problems, raise questions, expect answers in their poems. Contini has said that "the *Dolce Stile* is the school which with the greatest consciousness and good grace contains the idea of collaboration in a work of objective poetry"; and after analyzing the sonnet *"Guido i' vorrei"* in which he notes the theme of the flight to an unreal world, he adds: "The absolute separation from the real which is converted into friendship, this is the definitive emotional element in the *stil nuovo*." The *donna salutifera*, the lady who heals and redeems, which is the most evident theme of the entire school, is lost in a chorus of friends, and the poet, insofar as he is an empirical individual, recedes. Naturally, the collection of *rime estravaganti* cannot be read as a *canzoniere* [a collection of thematically and/or stylistically related poems], nor as a collection of lyrics in the modern sense of the term. Although there is a great variety of tone in the so-called *canzoniere* and there are signs of an even greater technical restlessness, the fact remains that we cannot read this collection without recognizing it as the first step in a great poetic undertaking which will become conscious of itself in the *Vita Nuova* and which will continue through the doctrinal works to the three *cantiche* which posterity called divine and which Dante defined at two points in the *Inferno* as the *Commedia*.

Beatrice makes her first appearance in the *rime*, and some of the most famous *canzoni* and sonnets are dedicated to her; but it is also possible that the *Donna gentile* whom we shall meet again in the *Vita Nuova* and in the *Convivio* and who has given Dante's hagiographers so much yarn to spin, appears along with her, in a

5. (1255–1300). Florentine Guelph poet, leader of the *Stilnovisti*, friend of Dante.

group of poems composed between 1291 and 1293. And there are other ladies, other names which may be *senhals*:[6] the *pargoletta* [little girl] whom several readers identify with the *donna pietra* [lady of stone] and who in this group seems to have been the most dangerous for the poet, and later Fioretta, Violetta, Lisetta, Guido's lady, and still others, and finally the two *donne-schermo* [ladies who stand in for or screen us from Beatrice] whom we shall encounter in the *Vita Nuova*. And since the corpus of the *rime estravaganti* also included the poems inspired by the *donna pietra*, which are almost certainly later than the *Vita Nuova* and which indicate a familiarity with the *miglior fabbro*, Arnaut Daniel,[7] thus we see that the poems which will be fundamental in studying Dante's stylistic development and which will also influence Petrarch, as Ferdinando Neri has exhaustively shown, appear together in a rather unconvincing miscellany. It has been the fate of the *rime pietrose* to have been the source for "black" nineteenth-century Pre-Raphaelitism, which goes as far as Gustave Moreau in France; along with an entire school of English painting, the "white" variety includes considerable poetry, most notably "The Blessed Damozel" of Rossetti—a poet whom Eliot attacked. Perhaps *donna Pietra* really did exist; insofar as she is a stylistic experiment, however, she will never coincide with a real lady. But if Dante had a precocious intuition of Beatrice's ultimate significance (and the *Vita Nuova* leaves little doubt of it), I would say that both *donna Pietra* and the *donna gentile* would have had to be invented out of thin air if they did not exist; for it is impossible to imagine a process of salvation without the counterpart of error and sin.

After the research of Isidoro Del Lungo, which aroused great interest in 1891, one can no longer doubt the historic existence of a Bice or Beatrice whom Dante could certainly have known and loved, even without her having been aware of it. But what significance can this discovery have? There are two hypotheses: either

6. *Senhal*: Provençal term related to the Italian word *segnale* [signal], used to refer to the fictitious name designating the person to whom the troubadour addressed his poem.

7. (1150–ː?) Provençal troubadour, inventor of the sestina and leading practitioner of the *trobar ric*, or rich style, which advocated intense condensation of style.

the meaning which Dante attributed to her has no relation whatso-
ever to her actual existence; or one can believe, as Pietrobono came
to, that the miraculous lady not only lived but was an actual mira-
cle. For those who believe as I do that the miraculous may always
be lying in wait at our doorstep, and that our very existence is a
miracle, Pietrobono's thesis cannot be refuted by rational argument.

Dante's last years in Florence before his exile saw the com-
position of the *Vita Nuova*, which narrates in prose and verse the
history of his love for Beatrice. We know about her that her short
life and her death, as well as her apparition to the poet, took place
under the sign of the number nine, and her own name appears nine
times in the book. Fate has protected this mysterious girl and pre-
vented many facts of her life from coming down to us: thus she can
remain as the image of absolute perfection and the necessary
intermediary in Dante's ascent to God. For a modern reader, the
realization that the poet has mounted the tiger and can no longer
get down begins with the *Vita Nuova*. At this point his destiny is
definitively marked. One cannot speak of the *Vita Nuova* without
forgetting that it would occupy an intermediate position in the *rime*
if it were possible to place the poems in chronological order. Apart
from the *rime pietrose*, the *estravaganti* include *canzoni* and *rime*
in various forms which were written after the *Vita Nuova* and
certainly after the period of inner darkness and distraction which
Dante suffered following the death of Beatrice—a period of thirty
months during which the poet immersed himself in the study of
Boethius and Cicero and completed his reading of the classics (the
litterati poete, i.e., the great Latin poets) and of Thomist
philosophy.

The *Vita Nuova* thus comes at the time of an extraordinarily
receptive and digressive poetic experience and gives a preliminary
shape, already complete in itself, to what will become Beatrice's
process of transhumanization. It does so in a form that would be
called narrative today, if the term were appropriate, in which verse
compositions alternate with others in prose, according to a scheme
that Dante did not invent, narrating from beginning to end the
history of Dante's love for the *donna salutifera*. The story, which is
better called a vision, also dwells on details which seem realistic
today but are included to give form to the conflict between human

spirits and transcendent vocation that is defined here as never before in Dante. We shall never know whether the poet, who begins here to reveal himself as protagonist-author (which is apparent from the choice of poems included and even more from the prose commentary), also wished simultaneously both to hide and reveal the names of two ladies well known to his circle of friends in the episodes of the two *donne-schermo*. The problem is to know how deeply the playful spirit of mystification insinuated itself into the texture of his serious poetry. An analogous problem arises with the apparition of the *donna gentile*, who will be a rival here, if such she can be called, of Beatrice, and whom we shall later find transfigured as Philosophy in the *Convivio*, with no apparent reference to the significance which Beatrice assumed in the *Vita Nuova* and which she will take on again in the *poema sacro*. I shall pass over other episodes where the book steps out of its frame of mystical-intellectual adventure and becomes the material for a secular story. Perhaps this great technician of poetry invented these episodes to give greater emphasis to the last pages, with their blood-red color, which will become the color of the entire book in our memories. Certainly one does not err in seeing a distant prefiguration of the *Commedia* in the *Vita Nuova*, which is also indicated by the poet's desire to speak of her—of Beatrice—elsewhere. And the fact that the little book was composed with a great deal of rigor, excluding poems that would have been repetitious and others that would have been extraneous to its general design, only confirms one's sense of the work: that its structure is already determined, but is still in a certain sense preliminary. Perhaps readers who do not see a mystical experience in the *Vita Nuova* are correct. In it worldly experience is recreated as Christian experience; but it is not structured in steps as an ascent, but in a story set entirely within the worldly sphere (as D. De Robertis puts it).

But we have now arrived at the period of the poet's exile, which coincides with the beginning of the two treatises, the serving up of the high rhetoric of the *Convivio* and the *De vulgari eloquentia*, both of them left unfinished; and a similar parallelism will prevent us from creating a sort of psychological itinerary as we follow Dante. It was the opinion of Ferretti, confirmed by numerous internal and external indications, that the first seven *canti* of

the *Inferno* were written before Dante's exile, hidden by the poet, and sent to him "four and more years later," according to events referred to by Boccaccio.[8] If Parodi is correct in his conjecture identifying Henry of Luxembourg as the 515 [DVX] (in which number the Jesuits saw Luther and the Reformation), it seems possible to claim that the composition of the *Inferno* and the *Purgatorio* should be placed between 1307 and 1312: while it is almost certain that the *Paradiso* occupied the poet's last years. Several scholars assign the commencement of the poem to 1313. Others (including Barbi) propose intermediate dates. The question of dating, however, is not merely academic, as is the problem of the *donne* to which I have alluded above. It involves affirming or denying the possibility that Dante submitted his work to revision and to later re-elaboration. Modern readers are undecided on this issue. On the one hand, we have the impression that many episodes in the *Commedia* were written at a single sitting, with little reworking, thus giving rise to the great prose that is hidden in the texture of the rhythm and rhyme, which, if it had been understood and brought to fulfillment, would have spared us centuries of curial, ceremonious prose. (An impossible hypothesis because the involuntary lofty prose of the poem did not prevent Dante from writing prose in Latin, which was also remarkable.) On the other hand, if we consider all the contributions which the rhetorical, philosophical, and theological culture of the Latin Middle Ages made to the poem and which make it virtually impossible to read its immense theophany in an ingenuous, virginal manner, we are stunned by Dante's encyclopedism and constrained to doubt our initial impression that he could have written at a gallop. That Dante knew and practiced the *labor limae*,[9] as Foscolo believed, seems undeniable to those who know the *rime pietrose*, the doctrinal *canzoni*, and the passages in the *Commedia* where he returns to the play of harsh and difficult rhymes. And yet there is no doubt that the conception of his poem, its very structure, had not been predetermined from its first line, but rather modified and enriched itself as it developed,

8. Giovanni Boccaccio (1313–1375). The great writer's works included the first biography of Dante, as well as a commentary on the *Inferno*, based on the lectures on Dante he began giving in Florence in 1373.
9. "Revision." See Horace, *Ars poetica*, line 291.

though at the cost of evident contradictions in the course of its elaboration and of its hypothetical revision. Along with Dante the scholar, the learned poet, whom after the studies of Curtius and Auerbach we can no longer ignore, there is Dante the man of letters discovering and exploiting the possibilities of his new language, the man who turns inward and enriches his thought, the exile who hopes to be allowed back into his own country and who later, disillusioned, intensifies the expression of his rancor. Because of this, internal proofs and references are not always decisive in aligning the life and the poetry. The *Convivio*, the treatise which was supposed to have fifteen parts, only four of which were completed, is the work of a theoretician who wants to demonstrate to himself and to his patrons what he had learned in his study of grammar and to derive as far as possible from it the limits of a poetry written in the vernacular. It includes commentaries on three doctrinal *canzoni*, and there are indications that lead us to conjecture which two or three additional *canzoni* would have gone along with the others to make up the fifteen parts the poet planned. His use of the vernacular, on the other hand, is illustrated in the *De vulgari eloquentia*, a treatise planned as a sort of encyclopedia of linguistic science. The *De vulgari* is written in Latin because Dante believed that only Latin, the universal and eternal language, could master an argument which involves the developments of human language up to the "three-forked tongue" after the fall of man (the tower of Babel) had forever confused and corrupted the primitive language of men.

But my chosen subject, Dante's poetry for a writer of our time, forces me to leave behind his doctrinal works, the two I have mentioned, the *Monarchia*, which should be assigned a later date, and the *Quaestio de aqua e terra*, which is extraneous to my subject. Let me simply say that in respect to *gramatica* [Latin], to the *litterati poete*, Dante always had what today would be called an inferiority complex. He defended his choice to the last, but he made use of Latin as if to underline the exceptional nature of his undertaking; and if after him the vernacular won the field in the areas in which the *sermone umile* was called for, no other great early poet made use of it in approaching the subject matter of the sublime style, the epic.

And now I find myself face to face with the *Commedia*, which in certain respects could be considered an epic poem, but differs substantially in others. Indeed, the *Commedia* does have an heroic protagonist, and sings his adventures, not without the aid and presence of the Muses and the Sacred Scriptures; but to do this Dante employs a style which is not always tragic but is in fact an extraordinary mixture of styles and manners which certainly do not conform to the dignity and uniformity of the epic style. In the dedicatory epistle of the *Paradiso* addressed to Cangrande della Scala, the Poet explains that his method is poetic, fictive, descriptive, digressive, transumptive, and at the same time definitive, divisive, probative, reprobative, and exemplative. (We can imagine Cangrande's surprise if Dante wished, as we assume, to overwhelm him.)

Furthermore, here too, as previously in the *Vita Nuova*, but with many further complications (and these are poetically the richest of all), the protagonist-hero, protagonist of an undertaking which had up to now been reserved for Aeneas and St. Paul, is the writer himself, the Poet, accompanied of course by Virgil. Hence the poem's continual countersong, the possibility of reading it as a narrative which unfolds on only one level, and the temptation— even the necessity—to see it in filigree—not forgetting the significance of the journey beyond the tomb and into the nine heavens, or the reactions of the man either, his feelings and resentments, and the paradox of a double vision which on one side gives on the landscape of eternity and on the other describes earthly events which occupy a few years' time and one fixed place: the life of the city of Florence and what transpired there during the years of the poet's tenure of public office, and the part which the character Dante played in those events. And the fact that the journey into the beyond takes up at most seven days, though the canvas of the poem must extend to 100 cantos (the perfect number), is the reason for the extraordinary diversity of the figures who appear in the three *cantiche* and for the stroke of genius (as Curtius says) of introducing persons still living at the time of Dante's journey, friends and enemies of the poet, next to heroes or villains out of myth or ancient history or the history of the Church, with its blessed, its saints and angels (who are certainly not the last in the exalted

hierarchies of the heavens and the general structure of the poem). What unifies material of this sort? First of all, the allegorical sense of the poem, which is extremely clear in its general outlines but vague in many particulars and thus not dense enough to hold together all the episodes of the narrative, in which the allegorical veil is often dropped and only the symbols are allowed to emerge, not all of them transparent. Here our insufficient familiarity with Dante the man and with his ideal library creates obstacles which would seem insurmountable. That Dante was at once a profound theologian and a particularly learned philosopher is not an opinion with which everyone will concur. That he was a mystic—he who was so rational and so taken with the events and concerns of life on earth —has itself been disputed. A great reader and a great observer, he is supposed to have derived his theological ideas not only from St. Thomas but from other sources which he often misinterpreted. He even made use of the heretic Siger de Brabant and then reserved a place for him in Paradise. But even if this were true (and I am not competent to decide it), how useful to us can his allegory be? Yet there is a primary unity to the poem—which is sufficient because it has created countless readers of Dante all over the world who are happy with his literal meaning and pass over or are in fact ignorant of the allegorical and anagogical significance of various episodes—an undeniable unity afforded by the concreteness of Dante's images and similes and by the poet's capacity to make the abstract sensible, to make even the immaterial corporeal. It is a quality we encounter also in the English metaphysical poets of the seventeenth century, including mystics who did not read Dante or could not read him in his own language. So that one is permitted to question the opinion that questions the poet's mysticism.

But let us return for a moment to the possibility of sticking close to Dante's merely literal meaning and of reading him in the light of a poetic art that was not his. When I was young and had just begun my reading of Dante, a great Italian philosopher[10] admonished me to be attentive to the letter alone, and to ignore every obscure gloss. In Dante's poem, the philosopher said, there is a structure, a framework, which does not belong to the world

10. Croce.

of his poetry but has a practical function of its own. This framework is constructed with the materials which Dante found in his time and which permitted prefabricated structures: theological, physical, astronomical, prophetical, legendary materials which no longer resonate for us. These show us the medieval man in Dante, the man ensnared in prejudices which were not always different from the knowledge of his day, but which are certainly toneless, devoid of meaning for modern man. But over the inert scaffolding trails an efflorescence of bluebells or other vegetation which is Dante's poetry, poetry outside time as all true poetry is, and such that it makes us welcome Dante into the pantheon of the greatest poets if not precisely into the heaven of the great seers. This is a view which has found wide acceptance in Italy and will do so in the future as well: but it leaves unexplained the fact that the poem contains an enormous number of correspondences, of references which the literal arouses, while sending us back to its echoes, its mirror-games, its refractions; and that there is hardly a place in the poem—not one episode or line—which is not part of some web, which does not make its presence felt even when its totality appears to us to be more of an attempt at emulating divine wisdom than a universe in which we can dwell without asking for anything else. No poem was ever so crowded with figures, in the literal sense and in the sense of prefiguration or prophecy; in no other poem have actual history and the a-temporal history of myth or theology been so closely fused. Dante is really the end of the world or its anticipation: in historical terms, his prophecy is not of this world, and the symbols of the Cross and Eagle had already fallen into disuse before the *Commedia* was completed. But Dante was summing up, he was bringing an epoch to a close, and he needed many different threads.

Auerbach has shown us that the multiplicity of created things was necessary to Dante because no one of them *in una species* can achieve a total resemblance to God; adding that such multiplicity does not conflict with perfection and is not immobility but movement. He has also asked whether we can read Dante and accept forms and premises which are unrelated to us, as one submits to the rules of a game, and if perhaps there is the possibility in the *Commedia* of metamorphosis without loss of character. "It seems to

me," Auerbach concluded, that the limit of the poem's power of transformation "has almost been attained when philosophical commentators begin to praise its so-called poetic beauties as a value in themselves and reject the system, the doctrine, and indeed the entire subject matter as irrelevancies which if anything call for a certain indulgence."[11] Certainly the limit is reached by philosophical commentators (though not by all of them, thank heaven), but it has proved unreachable for those endowed with a different sort of competence. In fact, anyone who has a feeling for poetry soon realizes that Dante never loses his concreteness even where his structure is least clothed by his so-called efflorescence. Thus one could say that his technical virtuosity reaches the height of its possibilities when plastic, visual representation is no longer sufficient. Look for example at the canto of Folchetto da Marsiglia [*Paradiso*, IX] in which the musical theme of the character is anticipated by a return of rough, difficult rhymes, which remain constant throughout the canto. There is nothing in effects like these to make us think of a formal game, of the skill of a Parnassian of the period. And here only a deaf man could try to distinguish between art and poetry. Dante doesn't write poems to make an impression according to the rules of a literary genre or school. The school is partly our invention, even if the poets of the *Dolce Stile* did in fact belong to an ideal community. Bonagiunta[12] can reprove the first Guido [Guinizelli] for having departed from the style of his predecessors, but Dante's verse would have been little different even if he had had other masters. His voice is entirely his own from the outset, even if he vulgarizes it in a noted *tenzone* or amuses himself in marginal exercises or agrees to write a few poems "on commission," thus giving future scholiasts something to write about; and there is no doubt that after the allegorical *canzoni* of the *Convivio* the poet's life has been well documented, and it is not the life of a man who aims at rhapsodic lyrical splendors. And if

11. Erich Auerbach, *Dante, Poet of the Secular World* [1929], tr. Ralph Manheim (Chicago: University of Chicago Press, 1961). The quotation on transformation appears on p. 159 of Auerbach's text.
12. Bonagiunta Orbicciani, also di Lucca. Thirteenth-century notary, leader of a school of poets influenced by the Sicilian school and Guittone d'Arezzo. Dante criticizes him in the *De vulgari eloquentia*, and he appears in *Purgatorio* XXV.

not everyone will accept the hypothesis that the poem's possibilities of transformation (or rather our capacity of understanding it) are virtually exhausted, it will be necessary to see what other literary hypotheses can give us a satisfactory reading.

While the allegorists have kept on desperately marking time— though not in every case—a method of reading which is still acceptable is that suggested by a modern poet, T. S. Eliot, in his essay of 1929. The poet hardly knew our language when he started reading the *Commedia*. And he found it an easy introduction. He thought that Dante's vernacular was still closely related to medieval Latin and that therefore a reading of the poem aided by a good literal version provided a first and sufficient approach. Further, in his view the allegorical process creates the necessary condition for the growth of that sensuous, bodily imagination which is peculiar to Dante. In short, the metaphorical meanings demand an extremely concrete literal meaning. Thus, from the still-massive figures of the *Inferno* (those figures which to the reluctant Goethe seemed to reek of the stable) to the more modeled figures of the *Purgatorio*, to the luminous, immaterial apparitions of the *Paradiso*, the evidence of the images may change in its colors and forms but remains forever accessible to our senses. The complexity of the embroidery never changes. Words like "carpet" and "tapestry" reoccur in this brief essay. In the *Paradiso* even abstraction is visible, and the most abstruse concept is inseparable from its form. And if in the carpet of the third *cantica* the plastic relief is less pronounced, this does not signify a lesser concreteness of imagination, but merely reveals the inexhaustible complexity of the meanings, and at the same time their ineffability. Our world no longer experiences visions, but Dante's world is still that of a visionary. Dante creates objects by naming them, and his syntheses are flashes of lightning. This is the source of his peculiar classicism, which is linked to a creationist and finalist philosophy. Through the narrow channel of the sensible, through the exaltation of forms, Dante negotiates the straits of scholastic thought; but let the experts discuss that. Eliot, however, doesn't mention it; instead he discusses the religious thought, or rather the faith, which the allegory supports. Is it necessary for the reader to share the "Belief," the faith of the poet? For Eliot it is only necessary for belief to be understood

as a function of the poetry which it explains. This is a suspension of judgment which belongs to aesthetic experience, and it is the typical mode of certain Anglo-Saxon culture to grant a certain autonomy to art while denying the distinctions between the aesthetic and the conceptual proposed by idealistic philosophy. No less interesting in Eliot is his rejection of that late falsification of the stilnovistic world which we have already mentioned: Pre-Raphaelitism. Yet even he, as we shall see before we finish, has felt the stilnovistic temptation from time to time.

I am not familiar with all the attempts which undoubtedly have been made to supersede Eliot's theory of Dante's sensible imagination. Setting aside the security that one who can explicate the allegory in its entirety must feel, the most interesting interpreters are those who see the *Commedia* as an immense web of correspondences and who try to follow every strand—or rather certain strands—back to its center. The undertaking cannot be accomplished without an analysis of Dante's metaphors and an examination of the consistency of the situations and characters with the particular psychological-moral and even topical states or levels through which the poet must pass. And, as metaphors are not as frequent in Dante as Eliot would have us believe, and in fact become increasingly rare as the poem progresses, we thus reach a limit or an insufficiency in Eliot's proposed reading of the *Commedia*. Irma Brandeis has devoted herself to an analytic study in the sense I have indicated—though certainly not an exhaustive one, for that would require the labors of a generation of scholars—in her book *The Ladder of Vision* (1961),[13] which is the most suggestive study I have read on the theme of the stairway which leads to God, and which is entrusted for good reason to the patronage of St. Bonaventura. "Since, then, one must climb Jacob's ladder before descending it, let us place the first step of the ascent far down, putting the whole of this sensible world before us as if it were a mirror through which we may pass to reach God." Ladder or mirror, or mirrored ladder? I confess I don't know, for I have never

13. Brandeis, *The Ladder of Vision: A Study of Dante's Comedy* (Garden City, N.Y.: Doubleday and Co., 1961).

read St. Bonaventura, who sooner or later was certainly part of Dante's library. What is clear is that for this new interpreter Dante is an apprentice who must "undergo an immense schooling", i.e., complete his initiation into an immense patrimony of universal culture. And the entire poem is didactic, in a certain sense, because his instruction—which was equated with philosophy—was considerd an integral part of the poetic work. In this way alone shall we be able to understand passages in Dante like Statius's discourse on the generations of men [*Purgatorio*, XXV, 29–108], for Dante's point of view cannot coincide with the reader's, or rather the reader cannot expect that the poet is going another way, by other means.

And I would say that in general, once he has passed the stage where he is content with an ingenuous reading, the reader's interest grows rather than diminishes as the tangle of symbols becomes more problematic. This does not mean that one should ignore the literal meaning, which is primary in Dante. Precisely by basing her case on the literal, Miss Brandeis makes us feel how vivid and concrete the presence of Beatrice is throughout the poem and how the passages from the *Song of Songs*, St. Matthew, and the sixth book of the *Aeneid* are structurally necessary in order to make possible—and, I would add, credible—the apparition of the lady dressed in the three colors of faith, hope, and charity who can arouse the poet who has not forgotten his earthly love, and make him say to Virgil: "*Men che dramma / di sangue me'è rimaso che non tremi: / conosco i segui dell 'antica fiamma*" (*Purgatorio* XXX, 46–48).[14]

It is late, and it is time now for me to ask, not of my audience but above all of myself: what does the work of Dante mean for a poet today? Is there a lesson, an inheritance which we can take from him? If we consider the *Commedia* as a *summa* and an encyclopedia of wisdom, the temptation to repeat and emulate the prodigy will always be irresistible; but the conditions for success no longer exist.

Dante brought the Middle Ages to a close; after him—once the

14. Less than a drop / of my blood remains which does not tremble: / I know the signs of the ancient flame.

Monarchia was burned in 1329 at Bologna and the wind had changed—the Frezzis and Palmieris[15] will certainly not win our attention. The chivalric poems of the sixteenth century are great works of art, but their encyclopedism does not engage man's deepest thinking. I can also pass over Milton, who is already neoclassic. In the one poem Byron left us which we can still read, his *Don Juan*, the irony and the sense of pastiche produce octaves of a vaguely "Italian" inspiration. I haven't forgotten *Faust*; but the Enlightenment esoterism that pervades it (to what extent I don't know) makes its protagonist and his pact with the Devil a story of greater interest to the anthropologist and the mythologist than the habitué of Dante's Middle Ages. Shelley and Novalis[16] were certainly among the Romantics who knew Dante, but were more musicians than architects. In our time, I would not think of Daübler's[17] *Das Nordlicht*, which is written in *terza rima* but brings down the light from the North; nor of *Ulysses*, which borrows themes from the *Odyssey* against the background of an infernal, almost symbolic Ireland. But Joyce doesn't look to Dante, nor does he have his monumental formal simplicity: reading him demands philological erudition, but the writer does not create language, he destroys it. On the other hand, the hundred and more *Cantos* of Ezra Pound give evidence of an attempt to "put one's hand" to a total poem of man's historical experience—but Pound did not try to imitate the symmetry and the rigorous structure of the *Commedia*. The *Cantos* contain all that can be known about a disintegrating world, and in them the sense of the "carpet" dominates that of a structure, of moving toward a center. (Though if it were true that the ultimate message of Dante's poem was the so-called donation of Constantine, then perhaps we could find a parallel in Pound's usury theme.) To sum up, it does not seem possible,

15. Federico Frezzi (1346–1416?): Poet from Foligno, author of the allegorical poem *Il Quadriregio*, written in imitation of the *Divine Comedy*. Matteo Palmieri (1406–1475): Florentine politician and writer, author of *La città divina* (1461–1465), poem in tercets imitative of Dante.
16. Pen name of Friedrich Leopold von Hardenberg (1772–1801), great German romantic poet.
17. Theodor Daübler (1876–1934). Expressionist German poet born in Trieste and educated in Italy. His *Das Nordlicht* (1910) is a long religious allegory, showing the author's progress from agnosticism to mystical religion.

in a world where encyclopedism can no longer create a universe but only an immense amassing of notions of a provisional character, to repeat Dante's itinerary in a highly structured form and with an inexhaustible wealth of both obvious and occult meanings. Even the illusion that a sensual imagination can give life in an acceptable manner to a Pre-Raphaelite tapestry is to be accepted with reservations. To convince ourselves of this, let us reread a few lines from Eliot's "Ash Wednesday":

Lady, three white leopards sat under a juniper-tree
In the cool of the day, having fed to satiety
On my legs my heart my liver and that which had been contained
In the hollow round of my skull. And God said
Shall these bones live? shall these
Bones live? and that which had been contained
In the bones (which were already dry) said chirping:
Because of the goodness of this Lady
And because of her loveliness, and because
She honours the Virgin in meditation,
We shine with brightness.

At moments like these we find ourselves face to face with the work of a poet, a great poet of our times: though if we had to choose, we should prefer the highly concentrated post-symbolist and quasi-cubist Inferno of *The Waste Land.* But it's useless to search for other examples: Dante cannot be repeated. He was considered practically incomprehensible and semi-barbarous a few decades after his death, when the rhetorical and religious invention of a poetry dictated by love had been forgotten. The greatest exemplar of poetic objectivism and rationalism, he remains foreign to our times, to a subjective and fundamentally irrational culture, which bases its meanings on facts and not on ideas. And it is precisely the reason for facts which eludes us today. A concentric poet, Dante cannot furnish models for a world which is progressively distancing itself from the center, and declares itself in perpetual expansion. For this reason the *Commedia* is and will remain the last miracle of world poetry. It was such because it was still possible then for an inspired man, or rather for a particular conjunction of stars in the

sky of poetry, or must we consider it a miraculous event, beyond the humanly possible? Around Dante every opinion, indeed every suspicion, revolves. In opposition to those who claim that he really saw the *visibilia* in his poems (and they are few) are others who emphasize the mystificatory nature of his genius. To them, Dante would have been a man who invented himself as *poeta sacro* and at a certain moment, with the help of forces greater than himself, saw his invention become reality. That he was not a true mystic and that he lacked the total absorption in the divine which is characteristic of true mystics is suggested by the fact that the *Commedia* is not the last thing he wrote and that once he had finished the third *cantica*, he was obliged to come out of his labyrinth and rejoin his fellow men. But not for long; and an aging Dante present at the creation of his controversial legend is unimaginable for us. Still, I can consider Singleton's affirmation that the *poema sacro* was dictated by God and that the poet was only his scribe with equanimity. But I can only cite secondhand and I wonder whether that eminent Dantist meant his judgment literally, or whether here one should recall the inspired and thus received character of all great poetry. But even in the first case I would not object, and I would have no evidence to contest the miraculous nature of the poem, just as I was not frightened by the miraculous character attributed to the historical Beatrice we had thought we could do without.

But I will stop here. That true poetry is always in the nature of a gift, and that it therefore presupposes the dignity of its recipient, is perhaps the greatest lesson Dante has left us. He is not the only one to have taught us this, but he is certainly the greatest of all. And if it is true that he wanted to be a poet and only a poet, the fact remains, almost inexplicable to our modern blindness, that the more distant from us his world becomes, the greater grows our desire to know him and to make him known to those who are blinder than ourselves.

On Other Writers

Pièces sur l'art,
by Paul Valéry

[Published in *Pan* (III, 1), Florence, January 1, 1935.]

Paul Valéry, a poet who brings to a close a period which is already distant from our own, remains a contemporary artist. His recent, frankly desultory and impressionistic *Pièces sur l'art* [*Pieces on Art*], on various subjects in various moods (they include occasional writings on Manet, Corot, Berthe Morisot, on the minor and applied arts, the reading of poetry, the art of typography, etc.), have the merit as a whole of offering a number of excellent aesthetic alibis which confirm this poet's personality as it has been seen for some time. Valéry, as we have said, is a poet who is not of today, but who remains contemporary. The young, even in Italy, who, rushed to make him into a more or less confessed idol, *locuta Lutetia,* forgot the first of these truths; those who "rely on received opinion and appeal to statistics" (in Italy today they are called *contenutisti,* believers in content) and who allow themselves to express distaste for the mannerism, the posing, the artificiality of Valéry, largely forget the second.

Raised in the school of Mallarmé and the typical world of the most fully developed French symbolism, Valéry brings a process to its conclusion; he does not initiate, he terminates. In the years after 1905 that were marked by a temporary forgetting of the teachings of symbolism, he knew how to be still, keep faith with the destiny within him and wait. The publication of *Charmes* after the war must have been above all the triumph of an exceptional talent for timeliness. It was his task and his merit to harvest the inheritance

of Mallarmé (i.e., a part of the inheritance of Baudelaire), dropping the master's Anglophilia and method and giving free rein to the vein of neoclassic Italianism (as Bonfantini in Italy has already shown) which has also flowered at other times in the history of French poetry.

Less naturally of a piece than Baudelaire (and perhaps he knows it when he says "an incomplete spirit can suffice to create work which is valid and excellent"), less profound than a Mallarmé, Valéry, with the genius of a prodigious recapitulator, knew how to be what the times demanded: all head and sense with respect to the fecund disorder of recent French philosophy; trusting in the reasoned sensuality which he so admires in the *Fleurs du mal*, he succeeded in creating a kind of poetry of the second rank, a poetry of the poetic act, which will survive thanks to the rage for objectivity that pervades it, its need to see the poem as a work to be labored over, hammered into shape, "constructed." An illustrious reductionist, an anthologistic sensibility *par excellence*, Valéry nevertheless has behind him a tradition of preciosity and obscurity in which he will take his place with honor. It will be difficult for posterity to reverse this judgement, and besides, the lack of interest and suspicion which have recently greeted his poetry (a necessary reaction to its success) are now on the wane thanks to the failings of his successors.

And now? What is still contemporary in this art and in the poetics it implies? It is easily said: in his poetry, Valéry remains modern as an improviser and a craftsman; as a theoretician, he does not teach us a great deal, but he provides us with many correctives. Furthermore, it has yet to be seen whether a taste substantially different from his own will manage to triumph in France.

"The fresco demands improvisation," writes Valéry about the frescoes of Paolo Veronese. But, as he will add later about Corot, the point is to earn "the right to improvise," to act so that what results is "the miracle of a superior kind of improvisation."

This is one of the correctives I have mentioned. Who does not think of "*La jeune parque*," of "*Le cimetière marin*," of a poetry which is wholly calculated and invented, which allows for unforeseen detours and adventures, but is ready to lead them back into

the realm of possibility? A poetry which justifies and even provokes chance? This has probably been the aesthetic of many great painters and it demands total mastery of one's material. Valéry, conscious *à la* Baudelaire that for the artist today smells, colors, and sounds are blended together, has reintroduced this aesthetic into the poetry of his time, making it aware, far too aware, of its possibilities. And it is here, as we have said, that the technician appears, the artist who reveals his strings to the point that he makes his instrument the actual subject of his song; the awareness of the craft which reasserts its rights at the same time that the excess of feelings that "appeal to statistics" compromises the metaphorical aspect of the act of expression.

Valéry writes about painting here because *ut pictura poesis*[1] is his canon to an extent; but it is easy to see that the range of his needs is broader. And if we do not wish to go so far as to see a new theory of consciousness in his simple search for emotion, let us ask whether the typical shuffling of the cards in Valéry's poetry does not belong to the time and taste of *Six Characters in Search of an Author* and *Les Faux-Monnayeurs*: whether the taste which this poetry implies is not still modern. A taste understood as recapitulation, a summary of earlier styles stripped of any force of their own and reduced to a purely decorative function; along with that irreducible something, that X which proves the vitality of the—how shall we call it?—new compound.

Technique, craft, taste: it is difficult for us to discuss these concepts without being annoyed or relegating them to the realm of cultural history. Our tradition is too different. Having set poetry apart in order to assign it its own place in the activities of the spirit, idealistic philosophy was then forced to see it—and to see itself in it—at its greatest, only in the broadest, most fantastic or realistic possible kinds of objectivism. It is not by chance that *Orlando Furioso* and *I Malavoglia* are the great successes of this criticism. Philosophical criticism goes instinctively to the opposite pole, anxious as it is to close the circle of the spirit. From the concept of classical poetry, which is an historical concept, taken as a touchstone, one was obliged to pass to an abstract, extra-temporal notion

1. "Poetry is like painting." Horace, *Ars poetica*, line 361.

of classicism, the classicism of art that is always contemporary. A strange idea, to make oneself a "contemporary" of every period but one's own. And this obsession with totality, with synthesis (which is, in fact, our precious heritage), also involves the risk of a painful distortion, even in those minds who think themselves freest; so much so that recently we have seen a young and intelligent critic assert in the columns of our most respected daily that now that the Italian spirit has been incarnated in the practice and ethics of Fascism, contemporary poetry and art in Italy today would be nothing less than inconceivable and undesirable. . . .

Paul Valéry, to whom we must return, represents a culture which by blending art with life, by accepting it as a serious joke, by being in love with it and unable to define it, has succeeded in making it more familiar, frequent, and constant, in making it a currency which circulates, and an instrument of empire. And obviously, we do not wish to point to this culture as a model, but to make use of it, to appraise its products when they offer us, as they do, certain indispensable antidotes. Italian criticism has reached a dead end. If it must remake itself, and it should do so on the firm basis of thought, it must be revived through a courageous, careful empiricism; not by the superficial who are quick to generalize, but by those who, working on "particulars" and possessing the true tools of their craft, spend many years exhausting a single problem. In this respect, too, eclectic essayists such as Valéry, Du Bos, etc., can teach us something. And as for Valéry: though the dialogues and the *Monsieur Teste* must be seen in relation to the poetry of *Charmes*, and though in the recent *Idée fixe* his pleasure in paradox and problematics sometimes resounds in a vacuum, the *Pièces sur l'art* still contain more than a few subjects of interest. In "*Les arts du feu*" and "*Regards sur la mer*" and in the pages on the embroidery of Marie Monnier, the thought which dwells on the unpremeditated artistry of the *Natura naturans*[2] or on the dangerous arts which allow no repetition or *pentimento*, he certainly draws no more exquisite arabesques than our own Emilio Cecchi; but in "*De la diction des vers*" we, who can only imagine with terror how

2. In medieval theology, a term for God the creator. *Natura naturata* was the complex of created things.

Leopardi's lines might be recited, witness the almost mechanical unfolding of the possibilities of a poetry-song contrasted with the reasoning of a prose-discourse, according to the well-known French schematism. We feel less comfortable with the *"Infini esthétique,"* where practice and aesthetics are differentiated according to two different series of physical stimuli; or with other essays, where Valéry delights in obeying the demon of Explanation (nor does he always know when to tell his evil genius, as he does in *"Le Problème des musées,"* "Farewell, I'll go no further.")

But it does not matter. There is no lack of things to admire in the masterful notes on Corot, the great familiar and discreet constructor whom Valéry contrasts with the Impressionists obsessed with the real and with the great transformers of the natural vocabulary ("Nature—a dictionary for Delacroix; for Corot—his model"); as in the entire book, which deserves to be placed beside the two series of *Variétés*, and which forces us to revise our picture of Valéry, who took his first steps when Mallarmé was pursuing his great chimera, beset by petty professional cares, and Wagner's music was first being played in the Paris concert halls. The Rue de Rome,[3] the tragic waking dream of Des Esseintes, the *Revue Wagnérienne*, the Lamoureux[4] and Valvins concerts. . . . Yes, it's true, *les lauriers sont coupés*,[5] and only the great genius of Paul Valéry looking back from the troubled postwar era could bring us once more for a moment the bitter and penetrating aroma of those leaves.

3. Mallarmé's famous Tuesday evening gatherings were held in his apartment at 87 rue de Rome, Paris, in the 1880s.
4. The French conductor Charles Lamoureux (1834–1899) instituted a series of concerts in 1881 at which the music of Wagner, then little known in Paris, was played.
5. 1888 novel of the symbolist writer Edouard Dujardin (1861–1949), notable for its early use of the interior monologue.

Chinese Poems
1753 B.C. - 1278 A.D.

[Preface to an anthology of ancient Chinese poetry edited by Giorgia Valensin (Einaudi, 1943). The Valensin anthology appears to be closely related to Arthur Waley's *Chinese Poems* (London: George Allen & Unwin, 1946), which in itself is a selection from Waley's many translations of Chinese poetry. The translations quoted in the essay are Waley's.]

Both in its internal workings and its historical development, what our Western world understands as "poetry" tends wholly toward a condition of pure art of which total abstraction is the unreachable outer limit. A certain dualism between sound and sense, between form and content, persists in all written expression with aesthetic or predominantly aesthetic aims, much more so than in a picture or a statue, though perhaps not in a different manner. The two terms appear to converge in expressions of a practical nature which satisfy our daily needs. In the expression "I'm hungry" it seems a bit difficult to distinguish between form and content. But confronted with a poem, even a poem like *"All' amica risanata,"*[1] for example, in which the idea is absolutely overcome by the sound and no part of it seems as if it could be substituted for, we still find ourselves faced with the question: if the meaning is valid, of what importance is the beauty of the sound? And if the sound matters, why waste time on the rational meaning? In the greatest instances we witness a certain mediation of the two elements: in others it will be a matter of simple dominance of one

1. *"All' amica risanata"* [To His Recovered Friend]. A poem of Ugo Foscolo.

over the other; but there continues to be an obvious—and extremely rich—tension in the alternation of classicism and romanticism (closed and open forms, received meanings and new meanings, the universal individual and, as he is called today, the existential individual), which lies at the root of all art, but more specifically at the root of all Western poetry. This tension, of course, exists not only between periods, but is also alive in the heart of every single artist. Our sense of and taste for poetry is becoming constantly more historical: it is not poetry that interests us but this poetry, from that particular moment, in that form and that (interior) space, in relation to a specific poetic individuality. A whole web of definitions, in the reliving of which we have the illusion of existing outside ourselves, in a monad which at once includes and transcends us, in a moment which exists in time and yet succeeds in eluding it. A sense of poetry developed in this way makes infinite and partial originalities possible. The moment that they seem minor to us because they are partial, the lines tend to open, the meaning rushes forward and tries to free itself from its so-called form, and this is the new moment, which lasts a shorter or longer time, with names that are always new, to make room later, through the mediation of phases or periods of transition, for a return to the classic which is entirely untrusting in meaning, in the values of content. Thus, though it happens that now and then we reflect with a deep sense of dissatisfaction on the uselessness of so many revolts and restorations, and see so many other probable neo-romanticisms, neo-symbolisms, neo-classicisms, etc., lining up in a likely development of our future poetry (the poetry of 2000, if you like), we can be impressed by anything but the *horror vacui* of a stagnant world, devoid of meanings. Our world, in fact, is dense, crowded, inhabited by human divinities who perpetually re-create and devour time; time is tied to man, is made by man.

In a book like the one we are presenting today, on the other hand—an anthology which covers more than two thousand years of Chinese poetry—every standard of consideration or proportion escapes us. We find ourselves face to face with poetic ideas which—for us who are ignorant of Chinese—survive their original form; with poems, that is, which both are and are not poems in our

deepest sense of the term. They are something else, then: at once larger and more delicate. And I don't believe that if by some miracle we woke up fluent sinologists tomorrow this first impression would entirely vanish. We should understand, then, that we are not concerned here with imitations or pastiches of an original artist whose material has been borrowed because it was susceptible to modern musical variation: this is not at all a repetition of the case of the *Rubáiyát*. Giorgia Valensin has not given us her own poems in Chinese dress; but neither (though she is far from ignorant of Chinese, as FitzGerald certainly was not ignorant of Persian) has she shouldered the crushing burden of a direct translation which aims at imitating the original, even formally. An encounter like Fenollosa's and Pound's which has admirably brought some Japanese Noh plays to life is not a phenomenon that is possible every day. The loving and intelligent labor of this new translator (whom we would still like to see engaged one day, even experimentally, in some attempts at full-scale transfusion and re-creation, precisely because the heart of this language remains unreachable) could in no way ignore the renowned body of translations of Arthur Waley —especially in such a broad overview of Chinese poetry. Rather, her new book is in part a sensitive imitation of Waley, whom Miss Valensin has followed, as far as the much less monosyllabic character of our language has permitted, even in the musical scansion of the verse. Valensin, thus, has found in Waley an instigator and guide similar in some respects to the highly literate Ting Tung-ling whom Judith Gautier[2] encountered amid the bric-à-brac of her father's salon, and who started her translating the *Book of Jade* (1867), which was later retranslated into Italian by Tullio Massarani. And the vast secular landscape which opens before our eyes leaves us once again deprived of references and disoriented, even in our admiration.

This poetry is not a microcosm which reveals and perfectly illuminates the macrocosmic entity that has allowed it to come into being—the teeming, troubled, public, and very ancient life, the

2. (1850–1917). Daughter of the poet Théophile Gautier, she published *Le livre de jade* in 1867 under the pen name Judith Walter.

thousand-year-old life of an immense nation, entirely different from our own; rather, it is a gathering of drops of water which ought to reveal an ocean yet remain closed in their delicate, subtle phials. It is a flash of mother-of-pearl which lights up a tragedy that is much too much more than individual to suggest words of this world to us. Through centuries of war, plague, famine, and horror, these few poets, who in reality are very numerous and are counted by dynasties (and they are emperors and ministers, generals who correspond in verse, abandoned wives and bureaucrats in exile) have transmitted the jade flower of their art, have elaborated and perfected it, adorned it with meanings and higher meanings, with conceptual parallelisms and technical subtleties; in short, they have completed well ahead of us the entire evolutionary and involutionary cycle with which the major literatures of our countries have made us familiar over the course of a few centuries. And the unique subject of this immense flowering, if we look closely, seems to be poetry itself as instrument and subject of conservation and exchange, and the love of poetry as a super-individual entity, a tradition, a *bouteille à la mer* handed on from initiate to initiate. A poetry, then (but in a very special sense), which is public, social, I would almost say humanitarian. Our own divisions into genres are not lacking, though they are relative here; but for the most part, lyric and satire seem to stand side by side freely in this enormous medley; the epic is almost unknown here, if not the epos, and the primitive, essentially popular poetry of the *Book of Songs* (1753–600 B.C.) was all Confucius needed to unravel the threads of his moral teachings and allegorical interpretations. Later, with Chu Yuan and the eleven poets of the Han dynasty, even amid the din of war and the clangor of battle, the poet's craft is refined and stanzaic composition, which the T'ang dynasty will bring to great perfection, begins to dominate. But from here on we note that tone of correspondence, confession, epistle which remains for us who don't know the texts the fundamental tone of Chinese poetry. There is nothing implicit in the work of these poets, who at a certain point were also painters and calligraphers; there is no gap which divides cultivated poetry from what is popular or anonymous. Certainly there are great figures, and the names of Chu

Yuan, Pao Chao, Li Po, Tu Fu, Po Chü-i are known not only to specialists; but everything seems as if submerged and leveled by an atmosphere, a taste which has allowed one period, the T'ang—which flourished between six and four centuries before Dante—to leave us important specimens by more than two thousand poets. There is the *Ballad of Mulan*, for example, by an unknown hand; it tells of the girl-warrior who only after many years of battles, struggles, and victories lays down her armor, binds her hair in a knot, paints her forehead yellow, and appears before her stupefied warriors: "They had marched with her for twelve years of war / And never known that Mulan was a girl." And the poem ends:

> *For the male hare sits with its legs tucked in,*
> *And the female hare is known for her bleary eye;*
> *But set them both scampering side by side,*
> *And who so wise could tell you "This is he"?*

Anonymous, too, are the authors of the *Seventeen Old Poems* of the Han dynasty, which vie in popularity with the most famous works of the great.

If we don't want to get lost in a forest, or rather a garden maze, let's confine ourselves to pointing out that this is on the whole a poetry of friendship and supplication. Male friendship, that is—

> *Oh that I could shrink the surface of the world,*
> *So that suddenly I might find you standing at my side!*

—love poems are rare, while complaints about bad government and the endlessness of war are innumerable; but these are not precisely satires in our sense of the word, even if Horatian and Parinian[3] passages come to mind as possible points of comparison; rather, they are laments by those who don't believe it is possible to reform man or improve their own destinies. They are the laments of

3. Giuseppe Parini (1728–1799). Ironic, anti-aristocratic poet, author of *Il Giorno* and the *Odi*, called by De Sanctis "the first man of the new Italy."

bureaucrats assigned to remote outposts, of small landowners who try in vain to reenter the good graces of their implacable yet all-too-human Emperors, who are poets themselves, unfortunately, and thus hard-put to be pitiless toward the melodious swans of their age. Not infrequently resignation and irony are so closely intertwined that it would be useless to try to identify the point of transition. Here is "The Scholarly Recruit" by Pao Chao:

> *Now late*
> *I follow Time's Necessity:*
> *Mounting a barricade I pacify remote tribes.*
> *Discarding my sash I don a coat of rhinoceros-skin:*
> *Rolling up my skirts I shoulder a black bow.*
> *Even at the very start my strength fails:*
> *What will become of me before it's all over?*

And similarly with the Po Chü-i of "An Early Levee" who rises at dawn to go pay homage to the Emperor, falls off his horse, gets icicles in his beard and thinning hair, and sends a memorable thought to his friend the hermit Chen Chu-shih who gets up when the sun is high in the sky and is free, his own master. . . .

Po Chü-i, who lived from 772 to 846 A.D., is the Goethe of the Chinese world, and probably of the entire Oriental world. When he plays with children, he is also the sage that Hugo tried to become in *L'art d'être grand-père*, when he was tired of sounding the trumpet. A fertile, vast, and familiar poet, Po Chü-i had all the strings possible in a man of his time and hemisphere. What Giorgia Valensin tells us about his concern for *feng* and *ya* (the double intent, both satirical and normative, which he felt was essential to poetry) does not separate him at all from the community of Chinese poets as far as a modern European reader is concerned. He too was a formidable "friend" (and his originality lies in his being so to a degree and extent that were new at that time) and a man who is more than human in the inextinguishable passion of his song. Poetry and friendship are the inspiring forces for this naturalist who knew both the favor and disfavor of the powerful without ever attaching himself to any worldly possession. He sang for all men, remote from every art for the initiated or poetic man-

darinism; yet hear him when Yuan Chen finds one of his poems
written on the wall of an inn:

> My clumsy poem on the inn-wall none cared to see;
> With bird-droppings and moss's growth the letters were blotched
> away.
> There came a guest with heart so full, that though a page to
> the Throne,
> He did not grudge with his broidered coat to wipe off the dust
> and read.

(The work has reached its destination, has finally found its reader.)

And another time, reading the poems of his beloved friend on
board ship:

> I take your poems in my hand and read them beside the candle;
> The poems are finished: the candle is low: dawn not yet come.
> With sore eyes by the guttering candle still I sit in the dark,
> Listening to waves that, driven by the wind, strike the prow of
> the ship.

Or follow him, when Po Chü-i sends a silver teaspoon to his young
niece, with an *envoi* of such delicacy that it reminds us of the
famous fan which so many centuries later will be offered to Mlle.
Mallarmé.

Nor do these seem like extreme cases, in which the poet no
longer discourses on criticism or edification but travels in the eter-
nal regions of the spirit. Actually, the precepts—today one would
say the poetics—of the man must have been one with the very
possibilities of his imagination; the pedagogue had to be insep-
arable from the poet. What is clear is that with Po Chü-i, and this is
perhaps a result of the abundance of the selection, a profoundly
human face enters this anthology and stands apart from so many
craftsmen who for us have been crowned and veiled. After him—
and he soon became a kind of demigod of the Oriental world and
was venerated in Japan when the Chinese considered his art too
simple and commonplace—poetry takes refuge in the *tzu*, becomes
exquisitely musical and perhaps (it's pointless to say it) "decadent,"

but we have only come as far as 1278 A.D. and since then many things must certainly have happened.

No longer confined to their original form, dissolved of their rhyme (the 34 rhymes of the *Ku-shih*, the old style, and the 106 of the *Lü-shih*, the new style: a treasure trove for the Parnassians . . .), these poems of nearly two thousand years leave us with a sensation in which admiration verges on dizziness or seasickness. Extremely limpid as they are, they escape the new order which the Christian era bestowed on the Western world, and perhaps not only on the West. It's not only that these poems lack the humanization of time and nature and the deification of woman which are proper to the European lyric; it is rather that here, as in the miracle of Egyptian sculpture and to a lesser degree of Greek art, man and art tended toward nature, *were* nature; whereas with us, for many centuries, nature and art have been tending toward man, becoming man. Consider the relative translatability of these Chinese pearls, which are clearly more accessible rendered in another language than a great many Greek fragments. The contradiction between substance and form, between meaning and style, which we consider fundamental to all poetry, certainly did not reach its apogee in them. Their impalpable formal authority, which dominates the truth without negating it, must have been a conventional beauty to some degree, something that could be learned and passed on. A beauty that could be attained, in fact, even by two thousand poets in the course of three or four centuries. And a transmittable rhetoric, of course, exists among us too, and is the basis of all our classicism. But in the Western, Christian world, the beautiful has become more intrinsic, form has become a ghost-form, and the disparity between beauty and its meaning is now dialectical, it has descended into man's time and his destiny. It is not beauty that counts, but man; and once we have reached this point, it becomes not man but beauty that matters: an alternation in imbalance to which Western man, and especially European man, has entrusted his dignity and his protest. The sphere of art has become broader, even if more uncertain, because the space inside us which art aspires more and more to reflect and (extreme paradox) to immobilize, has grown larger. Hence the greater brevity of our artistic seasons, starting with the same Greek art in which the point of

transition between the two worlds—nature which exists and humanity which becomes—was already developing. And out of this revolution which is anything but over came the struggle between man and God which lies at the heart of our human condition and which will continue until the civilized world (which means less and less our Western world) acts once again to take a new measure of itself and turn over a new leaf.

Eliot and Ourselves

[Published in *L'Immagine* (I, 5), Rome, November–December 1947. This is the first of Montale's several articles on Eliot, two of which are included in this volume. A third, *"Ricordo di T. S. Eliot,"* published in the *Corriere della Sera* on January 9, 1965, after the English poet's death, can be found in the special issue of *Pequod* (II, 2, Winter 1977) devoted to Montale. The translator has benefited from a close reading of Bernard Wall's sensitive translation of this essay of Montale's, published in *T. S. Eliot: A Symposium*, ed. Richard March and Tambimuttu (London: Editions Poetry, 1948).]

My friends at *L'Immagine* have asked me to write a tribute (though not a serious study, which the lack of sufficient documentation would make difficult for me) for the number of their review dedicated to T. S. Eliot on the occasion of the poet's visit to Rome. I am happy to take advantage of an occasion which may not soon be repeated. Even less than today could I consider myself an expert on the subject when I translated "A Song for Simeon" (*Solaria*, 1929) and *"La Figlia che Piange"* for the American number of *Circoli* (1933), prefacing them with a note which remains one of the first things to appear in Italy on the author of *The Waste Land*. Those poems had been lent me by Mario Praz, in their edition (I believe it was the first) as the *Ariel Poems*, a series of chapbooks of only four pages containing a short poem and a post-cubist illustration. Before that, I had read only one or two of Eliot's early poems, from what was called his Laforguian period: "The Portrait of a Lady" and "The Love Song of J. Alfred Prufrock," translated into French. But even then the conjunction of the new poems with the old, which were more guessed-at than apprehended due to the inevitable distortion of their foreign dress, created in me a sense of an arch erected between two pillars, indicated a direction. This is the direction that Georges Cattani, one of the most recent and

perceptive of Eliot's critics, suggests in the title of his essay *T. S. Eliot, or the Return of the Mayflower*, published in Paris by Egloff: which is the rediscovery of Europe by an American of old stock. Later, personally assisted by *il miglior fabbro*, Ezra Pound, who made a similar return of his own, but in a more aberrant fashion, under the influence of Joyce and with a more antiquarian, archaeological sensibility barely concealed by an apparent nonconformity, I was able to visit other way stations of Eliot's return: from *The Waste Land* (which I read after the *Ariel Poems*) to "Ash Wednesday," down to the latest *Four Quartets*, with important interludes for his dramatic work, the hardest to judge for an Italian reader. But after all some of Eliot's work—he is not only a poet but an extremely acute critic and essayist—remained merely catalogue entries, and now I fear I shall never be able to be a real and proper expert in the study of Eliot.

Yet I could not decline to pay homage to a poet whose career and significance I consider exemplary. There are men who meet every day without being able to be friends, and others one has barely touched or glimpsed with whom one feels an immediate intimacy. Like Valéry, T. S. Eliot is this kind of man: as a poet, he has a voice one does not forget and it is recognizable even after a long period of silence. As a man and poet, he does not demand deference of those he meets, nor is he not subject to the fluctuations of the many crises to which the poets of the thirties who have followed him have accustomed us. (And not for nothing, considering that it was too easy and inconclusive to surpass him in the volume of work he has produced, that several of them, including Auden, have made his journey in reverse and attempted to reconquer the New World.)

Eliot, too, as we know, has had his crisis: it brought him from the youthful romantic nihilism of which he was a master (as early as 1929 Eugene Jolas[1] spoke of Eliot's *"métaphysique de la désillusion"*) first to Maurras' notion of "order" and then set him down in the gilded garden of Anglo-Catholicism. He is a revolutionary (though he calls himself a classicist) in poetry, a conservative in politics and religion, and one can also be grateful to him for this:

1. Surrealist writer, editor of *Transition* (1927–1938).

for not having made use of the stages of his moral and religious development to conceal an ideological sleight-of-hand or the dangers of a possible literary decline. In other words, for not having converted due to gazing at himself in the mirror.

The fact is, if one looks closely, that Eliot made gradual contact with the world of his origins, a reconquest which is hard to reconcile with the very idea of a crisis or conversion. Let us keep to the letter, which in poetry is always revealing, and leaf through the modest volume of his *Collected Poems* of 1939, which includes "Burnt Norton." What is Eliot's experience?

Without a doubt, one finds here the strong imprint of French symbolism (the symbolism which all over Europe had the same potent but generic influence as impressionism had in painting); and then that very Anglo-Saxon way of looking to our *Dolce Stil Nuovo*, which he shares with Pound and which is often confined to inlaywork, to the mosaic game of quotations and references, also plays a part. Not last, and dominant in fact, is the discovery of the great English metaphysical poets. But above all one senses, from the beginning, a peculiar and not at all Poundian "sprung rhythm" of his own: the sense of an upsurging, very personal music, which makes all the harmonic possibilities vibrate from the subsoil of the simplest words. This is not his discovery alone, mind you: it is the lesson of the imagists, their sense of the prosodic impromptu, which here finally bears fruit. But it is certainly Eliot who has best gathered this fruit, as much in his objective lyrics as in the chamber music of the *Four Quartets*.

Of the English-language poets who have chosen to write in free or mixed forms, T. S. Eliot is one of the few for whom a linebreak is not signaled by the bell of the typewriter or by the intimidating *non possumus* of the last syllable of the iambic pentameter. His verticality is not external, superficial, like that which Monsieur Prudhomme[2] thought to be a distinguishing characteristic of written poetry: to backtrack often instead of forging ahead. It is an intimate, inner gravitation, all of which leads back to a center: a

2. A creation of the nineteenth-century caricaturist Henri Monnier (1805–1877), Monsieur Joseph Prudhomme was the personification of bourgeois conformity.

gift that was already present in Eliot from the time of "Prufrock."

Some Englishmen who otherwise have excellent literary backgrounds consider Eliot's European success exaggerated, and insinuate that his consistent excellence should be considered in relation to the rate, which is quantitatively not torrential, of his poetic output. Others even venture, though without forcing the comparison very far, that Europe is unable to judge English literature, as is demonstrated by the case of Edgar Allan Poe, the most ill-famed in their country of the poets who found glory abroad.[3]

But setting aside the infinite differences and the fact that we believe it unjust and anti-historical in art to make a rigid distinction between the favored and the unfavored, one must still observe that Poe was aided in Europe by a translator of genius—Baudelaire— who gave him a definitive form and introduced him into an ambience and a culture; while Eliot has up until now been badly served (with few and partial exceptions) by translators who are well-meaning but constantly struggling with inadequate means of expression, with language which inevitably flattens the lightness of his recitative. The French—to take the best example, Gide's "Little Gidding"—are very good at keeping the nuances of the "fading" of the original, but are forced to do quite a lot of watering down thanks to the rational nature of their language; and the Italians, when they are not content with a modest literal version, are forced to look for monosyllables, elisions, and caesuras which certainly distort the naturally plastic and distended genius of our speech. While a German Eliot, one believes, would be too romantically spattered with ink, as they say happened to the Valéry of Rilke.

But one should not fear that a misunderstanding lies at the root of Eliot's recent success in Europe. The truth is that Eliot, like Valéry before him, has contributed, at least in Italy, to our contact with the great European tradition which had been lost for many years. They have recalled Italian readers to a less superficial familiarity with their poetic heritage, a more intimate sense of their classicism.

3. When I wrote these lines I did not realize that Eliot would speak perceptively on the fate of Poe in Europe in his second Rome speech (December 12, 1947). [Author's note]

Are they, too, classic poets? Certainly not for those who limit the moment of classicism in art to the felicitous expression of the familiar and the obvious, for those who reject any injection of poetry as such into the current of history, because of its peculiar ineffability; definitely not for those who do not believe that poetry is a laborious discovery that each generation carries out itself, with its own means. But these are poets who are strongly vital and meaningful, and not reducible to membership in a school, for all who will refuse to impoverish them by placing them in the vague ranks of an anti-decadence that is trite at this point. They are different, even opposite poets, for starting from the Pascolian terror of the individual I and its solitude, both have arrived at very distant positions: the one dissolving his native immobility in the Heraclitean flux, the other accepting, through the experience of the mystery of the Incarnation, the unchanging Presence beneath the changing veil of phenomena. And they are not gratuitous poets, facile sons of themselves, but artists who owe something to more than one person and who even tomorrow will have a recognizable face, if the men of tomorrow still look for poetry. True originality, as Eliot has warned us, does not lie in not resembling someone; it is what cannot be reduced to resemblances and is insured and conditioned by them.

They are poetry's poets, poets' poets, whose example could also lead to the prolixity of some of their untalented imitators; but it will never justify the passivity of those who deny an entire era in homage to a prejudice. Through these poets and a few others, how the landscape changes which, from Leopardi on, seemed to many critics to be occupied only by episodes of realist or grotesque-romantic poetry (Heine, a truncated Baudelaire, a few minors sprinkled here and there . . .).

Let us turn back, swim against the current, even if, moving in this direction, more than one great poetic tradition will for a moment disappear from sight. Eliot, Valéry, and two others, a little further back in time: Yeats (older, but more rejuvenated by contact with the young) and Apollinaire—their gift of apparent spontaneity cannot exhaust them; and still further back, the first-generation symbolists, the *maudits*, and their almost-contemporary Hopkins, and in the distance—though she is not the initiator of the

series—Emily Dickinson, suspended between sublimity and non-sense poetry. . . . In less than a hundred years, what voices "a certain idea" of poetry (an erroneous idea, to some) can leave to the world of tomorrow, if today's world even has a history!

> *Quick, said the bird, find them, find them*
> *Round the corner . . .*

Through and for these voices, and through the suggestion of their teaching, other voices (and it doesn't matter where or when)

> *Other echoes*
> [Will] *inhabit the garden . . .*

Invitation to
the Reading of
T. S. Eliot

[Published in *Lo Smeraldo* (IV, 3), Milan, May 30, 1950.]

Two years ago, in the springtime, I was present at a reception in honor of T. S. Eliot at the house of the Principessa Bassiano in Rome. Eliot had not yet won the Nobel Prize, but he was considered the most likely of the *papabili* and his fame among the young of two worlds was undisputed. Which did not preclude a feeling of embarrassment among those present who, as they entered, were unable to make out the poet on first sight. Naturally, those who had seen his photograph did not hesitate; but the rest—attracted by a name that remained simply a name, unrelated to some physical image—were unable to choose among so many heads of hair, so many pairs of glasses, so many authoritative faces. Then a murmur arose among the uncertain, a direction was pointed out, an indicating arrow shot in the air toward a distinguished gentleman, thin and unbearded, somewhere between fifty and sixty, more "clergyman" than professor but for his limpid and penetrating gaze, which was protected by a pair of tortoiseshell glasses. This was a poet? (It is difficult to escape this obsession with the "great" or even the "greatest" poet, even for those who do not consider poets as runners to be judged, chronometer in hand, according to their "records.")

A poet, yes, and probably a great poet, but entirely irreducible

to the idea which the public at large has of the Bard, i.e., of a being who even in physical terms is out of line, classless. The carrot-colored beard and Robespierre collar of Ezra Pound, the bald head and pointed beard of D'Annunzio, the hoary rayed locks of the Nordic writers whom the Swedish Academy often prefer and honor with its laurels—these "play the poet," they exhibit those charac-teristics and that behavior which the public still expects of the exceptional writer. But T. S. Eliot, bourgeois poet, former bank employee and currently member of the staff of a London publish-ing house which makes money publishing gardening books and thus can print poetry at a loss—T. S. Eliot, no longer Esquire but O.M. (Order of Merit, an exceptionally rare decoration), stands out from among other poets through his aristocratically neutral air of the man-of-the-street. He is the true Englishman as imagined by those who have never been in England: measured, distinguished, incapable of raising his voice or of making an unseemly gesture; an Englishman not at all English to tell the truth, for he is an Ameri-can (born in St. Louis, Missouri, the 20th of September, 1888) who found his second home in England and has lived in London for nearly forty years.

British subject, ornament of the Anglo-Catholic wing of the Anglican Church (the branch or tendency that is called High Church), T. S. Eliot, when he receives guests in his office in Russell Square, at Faber and Faber, imposes the same decorum on every-one. I visited him there with two other friends a few months before seeing him again in Rome and was surprised that in such a re-stricted space, in a closet filled with books and dominated by two large photographs (of the Pope and Virginia Woolf), such an in-tense and harmoniously ordered four-way conversation could un-fold without physical discomfort or oppressiveness.

The appointment had been made two weeks in advance, and was duly noted in our program as guests invited by the British Council; and everyone told us that a two-week delay should be considered a minimum, for usually one has to wait much longer. There is no organized literary world in England as in France, no visible, tangible atmosphere in which *la chose littéraire* manifests itself in social and ritual forms. Here, too, as at home, men of letters are isolated, they do not form groups and rarely meet, and

then only briefly; but when a man attains prominence in this world, he never ceases to be important. And this has happened to Eliot, who is important as a critic, as the theoretician of a new classical order, and as an exemplary citizen even for those (and they are many even in England) who do not understand his poetry. Much honor for a poet who lives in London unfortunately means many visitors; to whom one must also give something, for Eliot does not entertain simply out of the requirements of etiquette. This, doubtless, is the source of his technique of entertaining, of conversing, of knowing how to ask and how to listen, which attains a high perfection in this man of the world and playwright. His is not the *politesse* of the Frenchman; it is truly the opening up of a spirit who feels he can learn something from even his least-known readers, but who never abandons a certain reserve. A reserve which he also imposes on others, and which prevents me from revealing the nature of our conversation. On the other hand, Eliot has many reasons for discouraging certain of his admirers. How could a poet who has been so imitated take those who parrot him seriously? Eliot is a cold man, in appearance; and yet he is the only contemporary poet who can read his own poems in public without making one laugh. In Rome, after a speech on Edgar Allan Poe, he read several of his lyrics (the "Triumphal March," "Marina," "The Journey of the Magi," *Ash Wednesday*) to a small crowd who followed his performance while reading the "score" of the poems. No one understood, yet everyone understood. Those who wish to have this pleasure have only to buy the recording of the *Four Quartets* issued in England, not forgetting to follow the printed text as they listen; I would recommend the experience even to those who do not know a word of English and above all to those who, with good reason, distrust poetry read aloud. Before hearing Eliot I did not believe such a miracle was possible: *an inner reading performed aloud.* The miracle occurred even in the "Triumphal March," a sort of parade, an Aida-style procession in honor of a modern dictator, in which

> 5,800,000 *rifles and carbines*
> 102,000 *machine guns*
> 28,000 *trench mortars*

pass, the list continuing at length to the refrain, "Dust! Dust!" until the boy Cyril is brought into church and at the peal of the bell shouts excitedly, *"crumpets"* (bombs). The last line is in French, perhaps a quotation:

Et les soldats faisaient la haie? ILS LA FAISAIENT.

What sort of poetry is this? the uninitiated reader will ask. Despite the fact that it is impossible to do so, we will try to give him a few indications, happy if then one reader in a hundred will wish to continue the journey on his own. This poet, of whom it has been justly said that he pronounced himself the heir of the great European poetic tradition, is a link in that chain which runs from Poe and Coleridge to the latest French post-surrealist poets: an extremely concentrated lyric poet who says in ten words what a romantic would have said in a hundred. For more than a century, the lyric has been conscious of its own nature in a rigorous and exclusive way, refusing to be decorative, explanatory, didactic. In a period that has seen the negation of literary genres in the work of Croce, the lyric has made itself into a genre, thereby provoking a crisis in the other genres, which in order to survive must provide themselves with a clearer theoretical physiognomy. The pure lyric has given birth to the pure novel, the "theater-as-theater," and even the pure essay (critical or moral). Technically speaking, the so-called pure lyric is not limited to verse, but even when it is written in prose it still always draws its strongest emphasis from music. Eliot, however, is not a "pure poet" as was Mallarmé (and Valéry much less) and as are the recent post-surrealists referred to above (for example, René Char): he is not a pure poet in the sense of eliminating every rational element from the poetic act. Like Gerard Manley Hopkins, like many of the best modern poets who have passed by way of Baudelaire, Eliot tries to invest the act of inspiration musically without reducing it to simple "dawning" ineffability and without reducing himself to the status of an automaton who mistrusts his own thought and writes only in a state of somnambulism. In a certain sense Eliot is even too rational: the poem which brought him fame in 1922, *The Waste Land*, is a dense weaving of citations ranging from the Bible to Shakespeare, from

the Rig-Veda to the Arthurian legends, from Dante to Wagner. The verse is low in tone, the tone of *récitatif,* and subscribes to the teachings of the imagist school (Ezra Pound et al.); it is a verse that is invented anew each time, a knowing dismantling and reduction of the line already present in Whitman, not based on any fixed formula, except for the frequent recurrence of blank verse, the improperly named iambic pentameter which in English poetry plays a role somewhat similar to our loose hendecasyllable. To us Europeans who have followed the evolution of free verse by other routes (Laforgue, Rimbaud's *Illuminations,* all the way to the Biblical-Whitmanian line of Claudel) such experiments do not sound so terribly new; but one cannot ignore the French influence on recent Anglo-American poetry. After *The Waste Land,* "an edifice of a low epoch erected deliberately upon the Ultima Thule of European thought, to the very limit of the oppressive desolation which threatens to sweep away every trace of a secular culture" (I quote from Mario Praz), came other lyrics (the *Ariel Poems*), more objective in the sense that here the poet's emotion is more hidden, never directly stated (Eliot never writes in the first person, never says *I*). Like the cubist painters, he attempts to construct objects which will emit feeling without declaring it. Such a procedure has also found a theoretical formulation: the work of art, the *poetic object,* should be the "objective correlative" of the emotion itself; poetry can, indeed must, be metaphysical, expressing not ideas but the emotive basis of ideas. In this respect Eliot returns to Dante, to the *Paradiso,* and on Dante he has written an essay which can be extremely useful to non-Italians.

Does an apparent objectivism, formed in this way, and maintained even in the *Four Quartets* (1944), which mark the high point of Eliot's poetry, allow us to speak of their author's classicism? T. S. Eliot has told us "What Is a Classic?" in an essay on Virgil. The classic poet is the poet of a mature era, the man who resolves and interprets the spirit of his times with all the simplicity of a natural phenomenon; he is a man who has arrived at the opportune moment, who speaks for all and is accessible to all. He is born a classic who, endowed with the necessary genius, *is born at the right time.*

It is clear that according to this notion, which we have in fact

oversimplified, we should deny that one can speak of classicism in the case of Eliot and the modern poets close to him. It seems to us, however, that posed in this way the question is merely academic. The classics, doubtless, did not know they were classic, the Greeks in a certain sense did not know Greek. To say "I am a classic" is already to admit you are not one. Only posterity, distance in time, allows that illusion of perspective by which the asperities of a poet seem to be leveled and the poetry appears totally detached from its author. It is probably an illusion to think that open subjectivity, that saying "I," makes poetry more precarious, less universal. Dante, Petrarch, the Shakespeare of the sonnets, and Leopardi all wrote in the first person. Are they romantics or classics? Eugenio d'Ors,[1] who sees romanticism as a simple variant, historically localized, of the eternal category of the baroque, would say that (with the exception of Leopardi) they are great baroque poets; but neither would this answer the question, which has clearly been badly put.

The Waste Land (433 lines in all), another thirty short epical-lyric compositions, an extremely terse long poem, Ash Wednesday, and the Four Quartets make up the rest of Eliot's poetic output. With the exception of Gottfried Benn, there may not be another poet in Europe today who presents himself with such light poetic baggage. Valéry was a river compared to him, Rilke an endless torrent. But this is precisely Eliot's originality: to have written only after a profound inner accumulation. This does not mean, however, that he has held to the prejudice of those pure poets who reduce the lyric to the moment of simple contemplation, of elegy. In Eliot we also find irony, sarcasm, invective. Certain of his parodies ("Sweeney Agonistes") are reminiscent of the Mikado and other musical libretti of Sullivan. Prosaic language in Eliot exists side by side with the aulic, the tone becomes lyric through inner animation, not because it obeys the laws of the metronome. Starting from récitatif, Eliot often arrives at song, reaches a high tone from the lowest, most conversational tone possible. He is above all (let us

1. (1882–1954). Catalan intellectual, leader of the "Novecentismo" movement. Montale's interest in Catalan culture is attested to by several articles in Fuori di casa, his collected travel writings.

say it) a poet-musician; and he is never or hardly ever (as was Valéry and, often, Rilke) a neoclassic. This is his greatest modernity: and let it be said without attempting comparisons, which would be odious. Not for nothing did Eliot come after them; so we can see how much "arriving on time" mattered for him.

T. S. Eliot is not only a poet; he is also an essayist, critic, and playwright. We cannot summarize his critical thought with a formula, for it is that of a connoisseur, an "expert," and not that of someone who adheres to an organically formulated system of thought. Let us limit ourselves to saying that his criticism does not contradict but rather completes what has been being elaborated in Italy, by the Crocean school, which is rigorous in its premises but too seldom based on the expressive means, on the concrete in language. Many of Eliot's essays were published in the review he edited for many years, *The Criterion*, which ceased publication at the beginning of the war.

The most controversial Eliot is the playwright. Two religious works: *The Rock*—a sketch, the pretext for several choruses—and *Murder in the Cathedral*, which has been produced everywhere, including Italy; and two bourgeois plays: *The Family Reunion* (performed on radio in Milan) and the recent *The Cocktail Party*, modern in spite of the fact that the Eumenides appear in the first. In these last, Eliot adopts an irregular line with four strong beats and a caesura (which our Latin ear does not always catch). Every line has a meaning in itself. It is a line which lends itself, much more than the choruses *à la* Péguy in *Murder in the Cathedral*, to a large theatrical undertaking and allows for strong stylization of common speech. Although the public and the critics prefer the religious dramas, we feel that it is only in his bourgeois comedies that Eliot has been able to open a way for himself and others. But these are practically untranslatable works which seem too British to us, though some English critics found the characters of *The Family Reunion* too Bostonian (from a Boston of 1880). It may interest the readers of *Lo Smeraldo* to know that the protagonist of *The Cocktail Party* is a doctor of souls, not exactly a psychoanalyst, but one who cures, or kills, the sick by meddling in their affairs, which is not unheard of in Italy either. . . .

Realism and mysticism, satire and moments of poetry pervade

Eliot's theater, which will probably never attain popularity and which is too dependent on a familiarity with the poetic Eliot. Faced with this, one can wonder if there is any sense in a theater for "the happy few." Perhaps it can exist in England where the theater is an institution; but not in Italy where it is a practical joke supported and fed (badly) by the State to keep the vast "class" of actors from dying of starvation. In any case, it should be understood that those who want to become acquainted with Eliot should leave his theater for last, for it cannot be approached without a deep familiarity with English letters and life. His is a theater of vehemence and polemic, remote perhaps from those "classical" simplifications that to some are necessary for the practical and aesthetic vitality of a truly theatrical age. Time will tell. It may be that Eliot is not or is no longer a poet who can win his battles on the stage (apart from special theaters and "festivals," which I believe matter little to him). The important thing, in any case, is that he has already succeeded in winning them elsewhere.

The Way of
the New Poetry

[Published in the *Corriere della Sera*, January 24, 1951.]

The indisputable fact that modern poets no longer write verses which are easily memorized has led some to believe that verse is dead today, and with it poetry. This conclusion is clearly absurd. True, memorizability is one of the requisites for poetry, but it must not be understood in a mechanical, material sense. A meaningless but highly rhythmic poem can stick in the mind after one reading and never leave us, while a profound and disturbing lyric can leave an indelible trace in us without our being able to repeat a single line. The truth is that when one absorbs the tone and accent of a poet in relation to the psychological situation he presents, and when one succeeds in recognizing that tone and accent in his imitators and apes, with the annoyance that is inevitable in such cases, a poet is already well enough remembered and memorable.

This truth does not detract at all from the observation that "that certain mnemonicity," often hedonistic, but welcome and caressing, which the old poetry did not disdain, is in fact disappearing from poetry today. Once the literary genres had declined in the absolute, categorical sense, the rigorous distinction between verse and prose was also bound to fall by the wayside; it was illusory at times, even in periods that seemed richer than our own, when a didactic poem was considered poetry because it was written in lines which break at every eleventh syllable, and a letter of Galileo or Pascal or Madame de Sévigné was considered prose because it was written . . . in prose.

It is not for this reason that we can say today that verse is dead. The old distinction which has declined as a standard of theoretical classification has survived formally as well as spiritually. In short, verse is written today which does not seem like verse any more, but which is entitled to present itself as such even in spirit, leaving aside its typographical arrangement. Nor are we speaking of isolated cases. Thus, if we are not lacking in examples, even rather notable ones, of poets who "don't break," who write on and on, horizontally, in prose or seeming prose, far more numerous are the poets who arrange their lines or quasi- or pseudo-lines *in a column*, according to the visual perspective of the old poetry. The modern poetic age—the post-Baudelairean age—has created a line which may be prosaic in its metrics (Whitman) or in its excess of content (Browning) but which still remains a line in the sense that writing it differently would make it impossible to recite to the beat of a metronome; a recitation which may well be silent or interior but cannot fail to conform to the rhythm willed and suggested by the author.

Browning and Whitman, poets of strong superstructure, would not suffice on their own to explain modern syncopated, fragmentary poetry, poetry at odds with memory. Along with them, next to them, it is necessary to remember the revolution which occurred in France after 1857 (the date of *Les fleurs du mal*)—a strange revolution which for many years, though not without important exceptions, did not disturb the metrics of French verse but allowed for stridencies, mixtures, and harmonies which had not been seen in France since the days of the reforms of Malherbe and the decline of the Pléiade. So much so that today reading Apollinaire we are reminded of Villon, and reading Prévert of Rutebeuf. In France, in short, there was no real rupture and even less so in America, where a tradition had just begun to arise; as for England, her Elizabethan theater and the baroque poetry of the seventeenth century are sources that authorize every kind of audacity. Still, the so-called poetry of disintegration—from Eliot to the Apocalyptics—was born in America and England of the counter-influence exercised in those countries by certain French poetry which was over-involved with English poetry. Where the genius of the language allowed it, an

actual free verse was born which could be free while subjecting itself to new abstract rules, as in the case of Gerard Manley Hopkins; where the genius imposed a tighter fit (due to the more logical nature of French and the greater weight of Italian and German) the line was modified internally but did not break ties with the past.

In Italy too, then? I was confirmed in this opinion reading Whitman's voluminous *Leaves of Grass* in Enzo Giachino's outstanding translation (published by Einaudi), a work which will immediately supersede the old though meritorious version which Luigi Gamberale made in his day. Whitman was read early on in Italy and aroused great hopes and illusions. His poetry, which is only half-poetry because it is unacquainted with the art of the word, pleased even our aesthetes. De Bosis[1] paid it homage, and some of his lyrics run on the parallel tracks of Whitman and D'Annunzio. A conjunction was impossible. Thanks to its strong panic quality, D'Annunzio's poetry had certain features in common with Whitman's; but it remained an erudite poetry nevertheless, and D'Annunzio's free verse is the least free there is. Among others who were deluded, the futurists also tried to open the sluiceways; their first Anthology is rich in movements which make us think "Here we are! This is the start of something really new." But under the surface the old hendecasyllable was lurking, and the threat of the French "crepuscular" temperament of those poets. Govoni[2] rescued himself more than any of these poets, but he was the least D'Annunzian and Whitmanian of them all. If we correct the hypermetry or hypometry of some of his lines which lacked the courage to "break," we would have proof that Govoni was an entirely respectable poet, even if less revolutionary than was then believed.

From that time—more precisely speaking, after Campana— there were no more directly Whitmanian influences in our poetry. Or rather, these influences, along with so many others, made their

1. Adolfo De Bosis (1863–1924). Poet, translator of Shelley; editor of *Il Convito* 1895–1907.
2. Corrado Govoni. (1884–1965). Crepuscular poet, influenced by Pascoli and D'Annunzio.

entrance under the surface, they worked underground, they revised themselves according to the nature of our language and our tradition; and what was bound to emerge from them was not a free verse but a more or less liberated verse. But I don't want, at least for the moment, to enter into this territory.

A little bit above I mentioned "Eliot and the Apocalyptics." This is almost the title of the immense anthology *Poesia inglese contemporanea da Thomas Hardy agli Apocalittici*, edited by Carlo Izzo (Guanda), which includes very careful literal versions with the text *en face* of work by about fifty poets ranging from the novelist Thomas Hardy (1840–1928), who emerged late in life as a poet, to the lyric poets of the newest generation. Hardy is not an especially modern poet; nor are some of the best of the others included, among them A. E. Housman and Walter de la Mare. But the majority of the anthology is dedicated to poets who are modern in both form and spirit, poets who could not have existed before the poetic revolution which is now coming to a close. They are all Apocalyptics, not just Henry Treece (b. 1912) who proclaimed himself such, because they write as if the Last Judgment were imminent; taking the most destructive, most corrosive temperament the world has ever known to the depths; and all of them are English, with the exception of Eliot, an Englishman by choice whom it would have been impossible to have excluded. The American Pound, too, deserved to be included because his experiment with highly fragmentary and kaleidoscopic epico-lyric is inseparable from Eliot's.

The anthologist has very correctly given Browning the large place that is his due, though for reasons of chronology he has kept him outside the gates of his book, in the long introductory essay. It would be ridiculous to claim that Browning deserves vindication, since his reputation—entrusted in his own country to clubs of extremely intransigent faithful—has never languished. But Browning's reputation certainly has two aspects, and in Italy, even an ugly aspect. Translated (in his best work) many years ago, illustrated with flowery lithography, he was the preferred poet of

inconsolable widows and girls with broken hearts; he was the poet
who is bound in Florentine leather and put next to the *Vita Nuova*
in the bookcase, over which of course hangs a three-color print
representing Dante's encounter with Beatrice. He was, or he soon
became, an Art Nouveau–style archaeological-sentimental poet, the
poet of the English who live in Florence, dine in the *buche*, and are
happy if they can rent an apartment two doors down from "Casa
Guidi Windows." The true Browning is very different; he is the
beloved poet of the exiles and imagists of thirty years ago, those
who at the same time reevaluated Byron's *Don Juan*, those in short
—Pound & Co.—who did not accept the limits of the lyric genre in
writing their own lyrics, but who dreamed of a poetry that was at
once lyric and epic, chronicle and romance, elegy and hymn, satire
and invective. I know this is a polemical interpretation; one can't
make Browning into a simple precursor of Pound's *Cantos* and
Joyce's interior monologue. It is possible that posterity will choose
those poems of his which conform most closely to the requirements
of the lyric genre—the purest ones, in short—and will reject the
integralist requirements of our contemporaries. It is possible, even
probable, that the vast poetic *reportage* attempted by the new
English lyric poets, from Auden on, will prove to be vitiated at the
base and that the lyric will once again come to be considered
what it is, a contemplative genre par excellence which is always
tending toward a limit of purity. But Browning will survive even
in pieces. Is it possible to say this of others today?

Reading Izzo's anthology, some names stand out from the
schools (which are the well-known ones): the decadents and
Georgians, the poets of the thirties (Auden, Spender, MacNeice,
et al.), the apocalyptics and independents of every age and sub-
school. The eaglet is Hopkins and the eagle is Yeats, though he
trifled too long with a crypto-philosophy he didn't believe in. Hop-
kins composes from within and is closer to the classics than one
would believe; Yeats already composes from outside, but still he
composes. Each of his poems is an object. T. S. Eliot has the tone of
a great poet, but in him music and thought often have difficulty
harmonizing. *The Waste Land* seems to me to be only externally
unified, sewn together with thread. His first lyrics, several of the

Ariel Poems, and various scenes from *The Cocktail Party* are probably his high points. Eliot can talk all he wants about classicism; to succeed he has to make us smell the odor of chloroform. And perhaps this is the only classicism possible today.

After him, we descend: Auden is a prodigious virtuoso, overburdened with too many intentions, and his teammates are not his equals; Dylan Thomas moves forward, continually giving off sparks, but does not open the secrets of his Gaelic laboratory to us. The old or dead or independent stand apart: Hardy, who has no problems of language that are truly his own, but is always robust and incisive (there are those who prefer him as a poet, and even forty years ago George Moore did not want to hear about his prose); Owen, who died young, intense in several poems; Edith Sitwell, always in progress, too much in progress; and Aldington and Read and Muir and many other younger writers.

Carlo Izzo has translated well, literally thank goodness, because all other forms of translation were bound to fail; and he has contributed highly useful bio-bibliographical information about each poet. In another edition I would hope that he could expand the biographies further and not relegate them to the back of the book. How do these gentlemen make their livings? Are they all professors? Or are they supported by the BBC or the British Council (a sort of Minculpop[3] of large proportions)? What do they think? What clothes do they wear? A smidgen of journalistic indiscretion would have enlivened the picture. Which, in its totality, describes a landscape that one can no longer ignore. These dismantlers of the spirit and language of a great literature, these poets of the contemporary crisis, are without doubt, along with a few others from other countries and other languages, the only lyric poets of today. Perhaps they have not succeeded in amplifying substantially the concept of the "lyric" which we have inherited from the classic tradition; but they have created a new language, a period style which will be recognizable tomorrow. And if one day a new humanism *sui generis*, a new rationalism or illuminism, should

3. Derogatory (because of its obscene associations) abbreviation for the Ministero della Cultura Popolare, the Fascist propaganda organization.

cast them in another light and study them from another point of view (an hypothesis which presupposes a Europe at peace, free of the collective incubus which weighs on us all today), the worthiest of these poets will have little to lose and the best of their work will be required reading for the poets of tomorrow.

The "New Columbus" of French Poetry

[Published in the *Corriere d'informazione Sera*, Milan, March 26–27, 1951.]

The tenth *Cahier de la Pléiade*, edited by Jean Paulhan, is dedicated to a poet as famous as he is obscure: Alexis Léger, pen name St.-John Perse, born on the island of Saint-Léger-les-Feuilles, Guadeloupe, in 1887, currently librarian of Congress[1] in Washington after having been for many years (up to 1940) secretary general and *éminence grise* at the Quai d'Orsay. The works of this diplomat poet are few in number: a small book of *Eloges* with an exotic tropical background, containing poems from 1909–1925; a longish poem, *Anabase* (1924), which has now been translated into every language; and several even shorter "poems of exile": *Exil* (1942); *Poèmes à l'étranger* (1943), *Pluies* (1943), *Neiges* (1944): a few scores of pages all told. And in prose, or what seems like prose, not verse.

The glory of S.J.P. (the glory of very limited editions, for initiates) has lasted now for many years and is only on the rise. And that Perse is a terribly difficult, if not in fact indecipherable, poet is something that disturbs no one in France. I allowed myself to ask an extremely intelligent critic, Albert Béguin, who was talking to me enthusiastically about him a short while ago, "Do you understand a great deal of what he's saying?" The critic looked at me with surprise and after answering, "No; but so what?" began

1. Perse worked in the Library of Congress in Washington during World War II after being stripped of his French citizenship by the Vichy government.

praising him again. It was not many years ago that Thibaudet and Alain[2] were laboring to annotate Valéry's *Charmes*; and today something is possible which would seem strange in Italy but which evidently is not so elsewhere: that a poet may win the unanimous admiration of his public (two hundred persons, but Leopardi certainly had fewer in his lifetime) without the issue of his comprehensibility even being raised. I have explained the reasons for this phenomenon elsewhere. Poets and artists in general today (not all of them, but many of those who count) are convinced that art does not arise from content, from the "subject," but from the mode of treating it, from how you cook the dish; and as a result they have tried to reduce the occasion or pretext that gives rise to the poetic work. Poets at one time explained and commented on their state of mind within their poetry itself; every lyric of theirs was a well-apportioned mixture of poetry (intuition) and "literature" (connective tissue, explanatory comment). Today poets like Perse want to give us the music, the tone, denying us the gray matter, the given, the pretext. Clearly, there are infinite variations on this approach; the surrealists, for example, claim to fish directly in the St. Patrick's well[3] of the subconscious without any intervention of reason; others, like Perse and certainly Eliot, do not reject consciousness, the rational nexus that binds the images together, but they refuse to include the logical connections in the poem. More than Eliot, who even in his verse often reasons like a Scholastic, Perse has struck out audaciously on this path. For him, it is a virtually hopeless undertaking; for in fact he is an epic poet, and a hidden epic at his core—an epic that does not run swiftly to its conclusion but rather distracts one's attention, confining it to subtle and precious particulars, like spun sugar—may be a contradiction in terms. A lyric may reduce its subject matter to practically nothing: all it takes is an amorous shivering, the reflection of the moon on the flowing waters, the sadness of a rainy evening, to give us the best of itself; but for St.-John Perse—or for Ezra Pound on another level—the problem of composing a long poem without any *ficelle*, without

2. Albert Thibaudet (1874–1936): Leading French literary critic between the wars. Alain: Pen name of Emile Chartier (1868–1951), radical French philosopher.
3. The *Pozzo di San Patrizio* in Orvieto is legendary for its depth.

believing at all in its argument, seemed practically insoluble. To invent a series of actions interpolated into an historical period or even into several simultaneous periods, as does Pound in the *Cantos*, does create the tone of the poem but does not establish the authenticity of the narrator. One is too aware that the connecting thread is made of twine and that the poetry lives only in particulars, in the lyric, of the epic.

In the *Anabase*, the poem which brought Perse fame, and which has been translated or written about by men like Hofmannsthal, Eliot, Valery Larbaud, and Ungaretti, the author has conceived an extremely elementary action and has played with only a few cards with the aim of achieving that superior impersonality, that "dilation of the crystal" which is proper to the epic genre. Here is the outline of the ten brief cantos, according to the critic Lucien Fabre:

 I. Arrival of the Conqueror at the site where the city will be built.

 II. The plan of the city is drawn.

 III. Consultation of the augurs.

 IV. Foundation of the city.

 V. Uncertainty regarding further exploration and conquest.

 VI. Plans for new foundations and new projects.

 VII. The decision is made to depart.

 VIII. March in the desert.

 IX. Arrival at the borders of a great new country.

 X. Acclamation, feasting and repose. Then a new urge to depart, this time with the Navigator. . . .

With the aid of such synopses, and after six or seven consecutive readings, according to T. S. Eliot, there are no further difficulties with the *Anabase*. When the reader has understood that the poem has nothing to do with either Xenophon or the journey of the Ten Thousand or Asia Minor and that only the literal sense of the ancient *Anabasis* is involved, he will be able to concentrate fully on the heroic background of the poem "which in its lighting recalls the severe delicacy of Poussin" (Hofmannsthal); and he will be able to make use of the key words ("severity, purity, self-control,

balance, pure salt, pure idea . . .") which the Austrian poet points out as the most obsessive in the poem.

Now are we contradicting ourselves; could the *Anabase* be a perfectly understandable poem? We would like to be able to say so; but we have before us the example of a critic, Saillet, who has provided a minute explanation of this and other later poems of Perse's in the review *Critique* (nn. 17–21), which was subsequently refuted by the poet and by Jean Paulhan, organizer of the *hommage* to Perse which has served as the pretext for this article. In this pamphlet (Gallimard, 700 francs), in any case, explanations are not lacking; in fact, Perse's poetry is praised on all sides here, no discordant voice is heard, and everyone, from Claudel to Char, from Béguin to Larbaud, is unanimous in affirming that Perse's work is one of the cathedrals of our time. (There are five cathedrals in all, wrote Larbaud in 1925: Claudel, Jammes, Valéry, Fargue, and Perse; but Larbaud has been gravely ill for years and it is impossible for us to know, as far as cathedrals are concerned, whether he thinks of a *numerus clausus* or whether he would be inclined, today, to add to them.)

An erudite, antiquarian poet whom Roger Caillois compares to the historian Toynbee for whom the various civilizations are simultaneous and not consecutive, Perse appears in the new *Cahier* in all his rich and dangerous ambiguity: man of Asia and man of the Occident, man of both shores of the Atlantic, man of silence and *homme de langage*, man of power and *homme de dépouillement, homme d'avoir et homme de vacuité*, man of nudity and of *parure*, of solitude and multitude, of enjoyment and asceticism. . . . Positivism and magical pragmatism. *"Le sacré est partout dans cette oeuvre, mais tout laïcisé et tout en poésie"*[4] (Gabriel Bounoure). Yet this "successor to Columbus religiously avoids the name of God and would never let it escape his lips, not even for an Empire." It doesn't matter, for the poet has fought at length *"aux réservoires de l'Incommensurable"*; Perse breathes with the rhythm of our planet and the rest will come of its own accord . . . (so says Claudel, in brief).

4. The sacred is everywhere in this work, but entirely laicized and all in poetry.

Conclusion? No conclusion about a poet who has been on my bookshelf for many years but whom I have not yet read seven or eight times in a row with the aid of the aforementioned synopsis. To save the reader the effort by translating a few untranslatable selections would be to betray him. It's better, then, to suggest the direct "attacking" of the texts, all of which are published by Gallimard. Perhaps for us Italians, who have had a Vico, this search for myth through the *parades* of literary language (*"Une bible d'ombre et de fraîcheur. . . . Les grandes proses hivernales. . . . Un ciel pareil à la colère poétique"*)[5] will seem less convincing; but on the other hand we cannot suppose that so many first-rate writers have agreed in order to impose a second-rate poet on us. No conspiracy; St.-John Perse is certainly a poet; and it is not his fault if France did not have a D'Annunzio (or had him a century earlier in Chateaubriand) and if to us foreigners certain post-Claudelian experiments sound strangely aestheticizing, D'Annunzian. But is Perse's biblical style Claudelian? Where we hear Claudel, a sensitive spirit like Larbaud hears Scève and Ronsard, La Fontaine and Racine, and even Malherbe (someone has even mentioned the religious prose of Bossuet). If we didn't have to doubt our foreigner's ear we might conclude (provisionally, and probably wrongly) that it is easier to be a great poet in France today than in Italy. Without taking any pride in the fact, for Italian skepticism, when all is said and done, can be useful as an immunizing agent but is not favorable in itself to any kind of art or poetry. . . .

5. A Bible of shadow and freshness . . . The great proses of winter . . . A sky like the anger of poetry."

W. H. Auden

[Published in the *Corriere della Sera*, August 12, 1952.]

I have already drawn a brief portrait in this column of W. H. Auden, the poet who wrote the libretto for Stravinsky's *The Rake's Progress*, after the opera was performed at La Fenice in Venice. I said then that the verse of *The Rake's Progress* seemed to me to be among the best by this writer, who is considered the most gifted of his generation: the generation of English poets who became known about 1930 and who can be seen, according to several chroniclers, as the typical poets of the "Age of Anxiety." (The others are Stephen Spender, Louis MacNeice, and C. Day Lewis, to confine ourselves to the best-known names.)

What is the source of the anxiety that is said to be the distinguishing characteristic of this team of contemporaries? Certainly it lies in the philosophy of Existence (from Kierkegaard on down) in which our age loves to see itself. Man's anxiety per se—call it *tedium vitae* or ennui or spleen—cannot be said to have been discovered in 1930. There is nothing more anxious than T. S. Eliot's *Waste Land* (1922) or than other poems written at this time, some of them Italian, for that matter. There is nothing more fretful than several stanzas of Jules Laforgue (late nineteenth century), if we don't in fact want to go all the way back to Leopardi. In any case, we could not maintain that in the case of Auden and Co. the label of anxiety is entirely arbitrary, because the acceleration of speed is progressive as far as psychological movements, too, are concerned, and never before have we seen such a robust platoon of men in the field of lyric poetry who both suffer from seasickness and are its cause.

The recent poets of anxious tedium, when they are born in

England, are very similar, even in the biographies we have read of them. They studied at Oxford, thus providing themselves with an enviable springboard in life. Briefly they were Communists or fellow-travelers, they participated for months or weeks in the Spanish Civil War, they experienced religious crises, and today they travel, give lectures, write articles in the big magazines, attend numerous conferences, defend cultural freedom in various ways, and express their disgust with contemporary life in verse or prose—with differing degrees of ability, but all without stint. To put it plainly, one can say that with them the reign of pure poetry—a poetry which settled in late among us and may last longer in Italy than elsewhere because it grafts naturally onto the trunk of the Petrarchan tradition—comes to a close or is obscured.

Then is pure poetry—which, understood in the largest sense, ought to include the names of Baudelaire and Hopkins, of Yeats and Valéry; that poetry theorized for the first time by Edgar Allan Poe which demands great expressive concentration, a strong capacity for musical transformation, and a total interpenetration of idea and meaning—is pure poetry dead? I couldn't and wouldn't want to say so, but it is certain that in this genre the great poets are and always will be rare apparitions. It is therefore legitimate for poets of a less ascetic nature to turn to a wider but also vaguer conception of poetry, that one return, in short, to the belief that poetry is any composition in verse (or quasi-verse) which expresses something intelligible and is produced according to the rules of art.

W. H. Auden is a poet in this sense, and a supremely interesting one; and a large selection of his work (*Poesie di W.H.A.*, translated by Carlo Izzo with the English text *en face*), has now been published by Guanda. Auden has many friends in Italy, where he spends several months each year. At forty-five he is still a young man, full of vitality and energy; he has had a *curriculum vitae* similar to but different from Eliot's, for he was born an Englishman and became an American citizen, but he too has taken refuge (at least he claims to) in the port of Anglo-Catholicism, and he is a man and a writer as productive as he is genial. Moreover, the reading of his poems is delightful even for those who do not generally read poetry, for his work seems to have issued from a crystalline fountain in a continuous jet. One should add that his

vocabulary is not very difficult and that in doubtful cases a glance at the literal translations clarifies all problems. Or most of them. There are some places where the translator inquired directly of the poet and learned that there was nothing to understand or explain, or where the writer himself authorized any interpretation. . . . But in general Auden is not gnarled or contorted; his alleged "journalism in verse" (which his competitors decry) demonstrates a facility which is not at all facile, a true gift for the musical *impromptu*.

A cosmopolitan poet in every sense of the word, deeply cultivated, Auden has valued the tradition of his country and read Pope as well as Eliot, Donne as well as Shakespeare, melding all of these in his crucible. He has also taken a look at Barth as well as Kierkegaard and the prodigious Dr. Groddeck[1] as well as Freud, and in short has richly laid his table with the rarest of specimens. There must be an implicit meaning which binds together all these strands and makes a cable or a resistant cord out of them, and it must be sought in the serious studies which the good Oxonian carried out in his day, in the continuity of a tradition which still has classicism in its blood.

Auden is not pure poetry, we are told; but a poetry which also knows how to be gnomic, satirical, discursive, eloquent, and very often—why not say it?—prosaic. There is nothing amazing in the fact that the Auden generation has reevaluated Byron's *Don Juan* and defends its right to play *toute la lyre*, not simply the harp of pure lyricism. Nevertheless, it remains true that in artists of this kind the reader in another language and another tradition is constrained to separate the wheat from the chaff, to find what in them is true for all and what will be of interest only to familiars, initiates in a certain way of life. We come to them full of faith but after a few pages we feel the need to accept them with reservations. Will their triflings, their trapeze tricks, interest the readers of tomorrow or those readers of today lacking a certain kind of education, who already find themselves in the situation of posterity? We have already asked ourselves the same question in regard to Pound, who certainly had an immense gift.

1. Georg Groddeck (1866–1934). Physician, writer, and associate of Freud. The self-proclaimed "wild analyst" was the author of *The Book of the It, The Unknown Self*, and other works.

In William Butler Yeats—probably the last great lyric poet that the United Kingdom has had—his neo-Gaelic paraphernalia and all the weaknesses inherent in the thought of a drawing-room spiritualist were overcome and outweighed by a wave of melody. The Byzantium of Yeats does exist, as does the Renania of Hölderlin. One could admire Yeats (as one could admire D'Annunzio in part) without believing anything he said. I wouldn't say this would be so easy with Auden and the recent poets of thirties' anxiety. They lack the *côté bête* that saves Yeats and makes him purely a poet, if not a "pure" poet of the orthodox type. Not that an ultimate base level of credulity, of sublime simple-mindedness does or should always exist in every poet. A poetry founded entirely on intelligence is possible, when it discovers and reveals the emotion in an intellectual beauty and knows how to organize itself into objectively perfect forms. But such a poetry requires concentration and synthesis; in it images and feelings which had to wait a long time before coming to life must flow together. Play, if it is not the sublime play of a Bach, seems excluded from this field.

The question I am raising here concerns not only Auden but all the poets of today who seem to be decided on having done with so-called pure poetry. They think poetry must essentially be discourse, and in fact they discourse with elegance and facility, passing from the sacred to the profane, from the useful to what gives pleasure, impure poets but true representatives of a world which is fretfully in search of itself. If only an echo of their fretfulness stayed with them! More often their virtuosity seeks to extract applause, like the last pirouette of the ballerina elevated on one toe.

Not that I wish to depreciate the already considerable poetic baggage of W. H. Auden. He is not only the most gifted poet of his generation but also the one who has so far achieved the most important results. In love with language, which for him represents the form of Life and therefore Life itself for a life without form would be unknowable to us, he writes that Time

Worships language and forgives
Everyone by whom it lives

demonstrating that the same Time which

With this strange excuse
Pardoned Kipling and his views

will also in the end pardon Yeats (as well as Paul Claudel) "for
writing well," i.e., will forgive them even bad works for the sake of
their best.

Here the poet almost seems to be suggesting an approach to
reading which would be adequate in reading him as well. But
would it really be so, for him and for us? In reality, if one day
Auden and Spender were seen as so many neo-romantics, their
attitude could appear in another light. Thirty or forty years ago,
anyone who read Shelley and tried to understand his "world" came
to the conclusion, as was inevitable, that his poetry seemed utterly
inconsistent. Whereas today the most advanced critical opinion
seems to have reached other conclusions. We are too close to
Auden and to Eliot, too, to enjoy the benefits of a correct perspec-
tive. To compare them with poets who are already settled, jelled in
their period, may even be a vain, childish effort. The selection from
Auden which has provided the occasion for these remarks does not
perhaps contain "anthology pieces" and therefore it is rather diffi-
cult to talk about them. It is not a book to take to the beach and
read under an umbrella. But the quasi-sonnets of "The Quest" and
"In Time of War," different parts of the oratorio "For the Time
Being" and some of the *Poems* (read "Atlantis," and see what At-
lantis has become since Rapisardi![2]) reassure us in themselves that
the anxiety of W. H. Auden is not an "up-to-date" ingredient but a
form of the eternal restlessness of all men. Can an elegant, too-
elegant poet also be a man in despair? A prejudice which is perhaps
romantic inclines me to say no. And yet if Auden, who defines
himself as "dialectic and bizarre" and who adores opera, were one
day to become his own Da Ponte and write a little opera in
miniature, a libretto like *Don Giovanni* which was not intended for
the beautiful non-expressive music of the recent Stravinsky, but
could definitely not be put to music; if, in short, the poet of anxiety
were to give birth to an operetta like Sullivan's *Mikado* (but with

2. Mario Rapisardi (1844–1912). Sicilian poet. His *L'atlantide* (1894), a long
socialist-inspired poem in academic octaves, is not considered his best work.

the word-music of an Auden), I believe that few of those who are nostalgic for pure poetry would have cause to lament. It would not be the first time that the Comic Muse came forth from the Tragic Muse and overcame her. And our age, after years, would know a work of poetry, modest perhaps but unquestionable; a touchstone of which we are all in need.

Uncle Ez

[Published in the *Corriere della Sera*, November 19, 1953. Montale's *Sulla poesia* contains five pieces on Pound, more than on any other writer. A second one, "Voluntary Exile in Italy," appears in the "Tributes" section of this volume. A third, "If Our Money Were Ezra Pound's," can be found in the *Pequod* Montale issue (II, 2, Winter 1977). Montale had known Pound at Rapallo in his youth, and the frequency with which he wrote on the American poet would seem to have more to do with this personal association than with any artistic—or political—affinities between the two men. Also, Pound's long residence in Italy insured that Montale's audience, the readership of the *Corriere della Sera*, would be interested in his fate.]

Nothing since the wave of Russian literature which hit Europe beginning in 1880 has had a more powerful impact on our continent than the "barbarian" message—in Vico's sense—that has reached us from the United States. Out of it has arisen a truism, which it would be excessive perhaps to reverse, that makes the American writer the prototype of the cultural "self-made man," the primitive artist who creates freely the way a plant gives off its shoots, in direct contact with Nature or, if you will, with God, without any mediation of school or tradition. The misunderstanding will continue for a long time to come; but in fact one does not need to be profoundly familiar with American culture to realize that since its very beginnings it has called the European tradition desperately to account.

It has done so and does so today, of course, in very high-velocity fashion, jumping from the Greek and Latin classics to French impressionism (both literary and pictorial) after a brief excursion into the territory of the Italian *Stil Nuovo*, the English Elizabethan, and the Metaphysical, or baroque, poets; and its effort has not been in vain, for it has provoked a counterreaction,

and in fact there is no poet of any importance in Europe today who can say he owes nothing to American poetry or to "Americanized" English poetry.

Around 1910 and in the years following the First World War the stream of so-called "exiles"—young Americans who came to be subjected to the "electric shock" of Paris—became so strong that these exiles were in fact no longer isolated as Browning and Henry James were in Italy, but made up a colony in the cultural sense as well. A colony to which Ernest Hemingway (the most naturally European—Stendhalian—of the American writers) belonged for a brief moment, but which always found its high priest in Ezra Pound, the poet whose latest book we now have in an Italian translation (*The Pisan Cantos*, tr. Alfredo Rizzardi, published by Guanda).

Among the many curiosities of Pound's biography—he was born in Hailey, Idaho, in 1885—this stands out: that though he owed a great deal more to a certain period of French culture, from Flaubert to Rémy de Gourmont, than to Italy, he nevertheless settled in Rapallo, where he spent close to thirty years. Those who knew him (and I had the good luck to meet him on several occasions) have often wondered, though in vain, what this great experimenter in stylistic forms and models was hoping to find in Italy. It was no secret to anyone that for him our poetic tradition had ceased to be fertile in the fourteenth century. No one could call his a Nazarene, neo-primitive, or purist taste. Perhaps his position, at the beginning, wasn't all that different from that of Browning, a poet whose importance he always defended: perhaps he saw Italy as an archive more than anything, an archive not of learned information, but of cultural stimulants. If we wanted with a great deal of exaggeration to make him into a sort of self-taught, crazed American Carducci, it would be clear that a good dose of history was called for in this poet, who was already planning in his *Cantos* to give America and the world the vastest Dantean-Joycean poem our times have conceived.

Italy was probably the most advisable *pied à terre* for anyone who wanted to attempt such an experiment: not the Italy of today,

but the eternal Italy, the country where nature and culture are one and the same and where even the landscape seems to have been worked by centuries of civilization. And if in fact Pound had been content to live at the window of history (and of our history), his poetic labor would have been carried out in peace. He was not an unknown when he came here in 1924: some of the poems in *Personae* and a long poem (*Hugh Selwyn Mauberley*) had already earned him a place in the first rank of the new American poetry. As the leader of imagism and later of vorticism, he had even exercised an influence on poets—Yeats, Eliot—to whom he himself owed a great deal. His position, which he shared with other imagists, could be defined in broad terms as an ingenuous, inverted futurism.

Our futurists, in fact, were ignorant but saturated with implicit culture, while Pound and Company were rich in an abridged, night-school, accelerated-course culture. It was not for nothing that in college, at age sixteen, Pound had demanded to study only what interested him. And so the imagists imported "modern poetry" into America, keeping clear of the poetry derived from Virgil and Petrarch which, by way of Leopardi and Baudelaire, is still the secret of the European lyric. Perhaps they misunderstood this tradition, which for them was linked with the detested Swinburne. They, who could already boast of a Whitman, imported "French-style" free verse and achieved rare and exquisite technical effects, assimilating what they could of the music and painting of today and all the while maintaining, for the most part, an experimental, anthologistic frame of mind. Thus W. B. Yeats was not unjust when he wrote that Pound seemed to improvise by translating from unknown Greek originals. And not only Greek, for the originals were also Latin and Provençal, Chinese and *Stil Nuovo*, Anglo-Saxon and modern French: with the result that Pound became the most originally composite poet known to modern history: a poet who certainly is not a contemporary of Picasso and Stravinsky by chance.

Once he had arrived in Italy, Pound began the *Cantos*, of which there are eventually to be 100 and which now number 86. He initiated that very modern literary genre, the epic that willfully generates lyrics, or rather the search for a frame adequate to contain the latticework, to cover an abundant series of *morceaux*

choisis. An epic-pretext, in short, which from the outset rejects the first purpose of an epic, which is narration (and a faith in the act of narration). We are still close to Browning, but with technical contributions from Whitman and immersed in a climate of cubist decomposition and reconstruction. And we should add another, more serious complication: that Pound, rather than standing at the window of the world, fell in love with the economic theories of Douglas and Gesell and that for him sociology and economics became an ever more obsessing Dada. It is pointless to say that Pound didn't give a fig for the myth of Rome and the Tables of the Law created by Fascism; but he was both interested and convinced by what seemed to him to be the experiment of a new State, a new civilization, in which the capital sin of the world—usury—would no longer be possible.

Philosopher, economist, aesthete, desperately individualist and egocentric, an aristocratic socialist who denied both Marx and the rights of man; anti-democratic, anti-capitalist, anti-American, and, alas, anti-Semitic and pro-Nazi, Pound turned these feelings and resentments over and over in his *Cantos*, in bits and pieces, in sobs and hiccoughs; and above all in these eleven *Pisan Cantos*, written in prison when he was arrested at the end of the war for the anti-Allied propaganda work he had done as Zio Ez, Uncle Ez, on Italian radio. Adjudged insane by those who wanted to save him from the electric chair, Pound recovered in a psychiatric hospital, was awarded the Bollingen Prize for the *Pisan Cantos* in 1949, and from that point on became a mythic personage who will give the critics much thread to spin. And we are happy to say that his Italian translator and editor Rizzardi has acquitted himself of his close-to-impossible task with a moderation of judgment that is proof of true intellectual seriousness.

And now we must present the *Pisan Cantos* to our readers. But who will give us the thread, not the thread to spin, which is already too long, but rather the Ariadne's thread that will allow us to enter this very dark wood? In a case like this, and after reading the poem only once, all that is possible, perhaps, is to offer a few

provisional impressions and to conclude with a dispatch that will leave whoever reads the poem entirely free to judge it for himself.

The *Pisan Cantos* are a symphony, not of words, but of loose phrases. Yet we are not in the midst of chaos, because these phrases are held together by a "montage" which far exceeds that of some parts of *Ulysses* and of Eliot's *Waste Land* in its apparent incoherence. For this is a montage from which the connectives, the conducting links, are entirely missing. Imagine if it were possible to radiograph the thoughts of a man condemned to death ten minutes before his execution and suppose that the condemned man was someone of Pound's stature, and you will have the *Pisan Cantos*: a poem which is a flashing recapitulation of world history (one world's history) without any link or relationship of time or space.

We find ourselves, of course, beyond what is understood as "art" in ordinary parlance. Thousands of characters, heavily inlaid quotations in every language, Chinese ideograms, bits of music, allusion to everything in history, medicine, economics, art that has fed modern thought for fifty years, not without dizzying leaps into the world of myth and prehistory. Freud is missing, for which we can be grateful, but for the rest the catalogue is complete. Poetry-as-painting at times, on the verge of the non-figurative, a mosaic broken in pieces and later reconstructed without the tiles being properly refitted. One can get one's bearings, according to the translator Rizzardi, through the recurrence of several themes, above all that of usury; but this could also be helpful to the reader who essays the poem backwards. But one's interest is revived due to the fact that here and there in these prisoner's songs we catch sight of a new Pound tried by sorrow, a voice which cries, wails, suffers; and then we feel that the game becomes serious and the spectacle of the clown turns into tragedy. Phrases like "As a lone ant from a broken ant-hill / From the wreckage of Europe, ego scriptor" and unforeseen flashes ("Arachne che mi porta fortuna," "Thou art a beaten dog beneath the hail," "That butterfly has gone out through my smoke hole"), sudden visions of Provençal landscapes or of Venice, as from the mouth of a tunnel, a deluge of haiku which would stupefy posterity if the poem were largely destroyed—these confirm to us that the hypothesis of Pound as

archaeologist should be set aside, but they do not destroy the final impression that even in his outbursts most worthy of Jacopone[1] ("Pull down thy vanity") this poet, once again, has gazed at himself too much in the mirror.

That a poet remain a child is a necessary condition for his poetry: but perhaps Pound stayed too much on this side of the proper dividing line, and whoever talked to him, in his last years, could not have failed to leave with the painful impression of a man who had not grown up, of a force not mobilized in one single direction and, in the final analysis, spent wholly on surfaces.

In any case, such a poetry, which presupposes that the end of the world is near, cannot become common currency if the world, even without bimetallism and monetary reform, continues to exist and live as it now lives. But this does not take away from the fact that the *Pisan Cantos* repay the effort of a careful deciphering and that Rizzardi—with love and compassion—has produced a highly praiseworthy achievement. The prisoner of Pisa and Washington, a great musician of poetry, and perhaps, in flashes, a great poet, deserved the homage of a young man who does not serve in the choir of his political admirers.

1. Jacopone da Todi (c. 1230–1306). Franciscan poet who wrote in the Umbrian dialect. He was imprisoned from 1298 to 1303 for his satire against Pope Benedict VIII.

A Greek Poet

[First published in the *Corriere della Sera*, June 5, 1962. Montale's article originally concluded with a translation—his second—of Cavafy's "Waiting for the Barbarians," based on an English version. The first appears in his *Quaderno di traduzioni*.]

I have already had occasion to write twice at some length about the modern Greek poet Constantine Cavafy. My first article goes back to 1957. Five years ago little of Cavafy had been translated in Italy, and what I had to say then was based on the English versions of Sir John Mavrogordato. Now the entire body of his work is available in an Italian translation by F. M. Pontani with the original text *en face* (in the Mondadori *Specchio* series). Thus I can now resume my interrupted story and be virtually certain that it will not fall entirely on deaf ears. Cavafy in fact is the one modern Greek poet who has won international fame, and his reputation (paradoxically it may seem) is greater due to the fact that, unlike some of his great predecessors, he was never a national bard, a father of his country; i.e., he has not suffered the fate of those *"risorgimento"* poets whom Greece (no less than Italy) has sanctified and who strike foreigners as local products, not for export.

Cavafy belonged to the Greek community of Alexandria, which is greatly diminished today; as a boy, he spent several years in England but later returned to his native city. He became a bureaucrat in some sort of office in the Irrigation Department, and was also a broker on the exchange. He traveled twice to Athens, the first time around 1901, the second in 1932, for an operation on his throat; he died in Alexandria the following year. The poet's fame has been posthumous because he published little in his lifetime: one chapbook only, which was later reprinted with additional

poems; much of the rest of his work appeared in broadsides. But we should not think there was anything popular—as with the fisherman of Chiaravalle—about these broadsides, of which I have seen several examples. They were very delicately printed and were intended, no doubt, to end up in the hands of a bookbinder. Cavafy's followers have various collections of them and today there are also regular editions of the poet's lyrics, and the contributions of the critics to the understanding of his 150-odd short pieces is growing daily.

There are also a number of repudiated juvenile poems, which can be read in the biographical-critical essay written by Michael Peridis in 1948. Peridis, an Alexandrian lawyer now understandably living in Athens, knew Pea and Ungaretti in Egypt and is a good source of information on the ambience in which Cavafy grew up. No less rich in firsthand observation is another writer of my acquaintance, George Papoutsakis, who has translated all of Cavafy's acknowledged poems into French. Papoutsakis, too, lived for a long time in Egypt and is capable of giving us a portrait of Cavafy *en pantoufles*, of which I can give a few hints here, in anticipation of his long-awaited book on the subject. Not, however, before recalling that Cavafy transformed himself into more or less imaginary characters (or ones barely mentioned by Suetonius or Plutarch or other more recent historians and chroniclers), bringing to life a Hellenistic and late Byzantine world which he brings close to our own day and which he experiences as our contemporary.

Of course this coming near is the product of nostalgia; it is the cult of that type of man, the Hellene—"the most precious thing humanity has ever produced"—who would be hard to find in the Greece of today but who must have continued to live as a myth in the communities of the Greek diaspora, like a coal glowing under the ashes. I know nothing of Alexandria, and less of the Alexandria of today, so harshly "cleaned up" by the laws of Nasser; but anyone who has read Durrell's *Justine* and certain passages of the early E. M. Forster will be able to understand how the life and poetry of Cavafy are inseparable from the background and underground of an Alexandria which must be very different today.

In anticipation of all that will be written during the upcoming year of Cavafy (1963, the centenary of his birth), let us see how the four or five critics—beyond the two I have just mentioned —who compete here in Athens in preserving his memory, recall him. Cavafy had a very beautiful voice and was proud of his mother's Phanariot pedigree (the Phanar was the educated quarter in Constantinople). His mother was the only woman he ever loved; his other loves were of the "sterile and censured" kind which he attributes to many of his characters. It seems that his future biographer Papoutsakis—who has collected many of the poet's papers and things in a small museum—will demolish the legend of those loves and that it was on this condition that Cavafy's heir, Alexander Singopoulos, entrusted this material into his hands.

The poet's house on the rue Lepsius in Alexandria was furnished with heavy pieces of sculpted wood, inlaid and encrusted with mother-of-pearl—furniture in the Arab style. The poet loved shadows and candlelight. When a guest pleased him he would light extra candles; otherwise, he would extinguish them one by one, thus indicating that it was time to go. Likewise with beverages: to close friends he offered whisky; to others he would say with a distracted air, "Oh yes, I seem to remember you don't drink."

Judging from his photographs, Cavafy was small, bespectacled, of about medium height, and elegant in his bearing. Neither slovenly nor bohemian, he felt it necessary to surround himself with a certain *bric à brac*, connected with family memories. On an *étagère* he displayed the family jewels, rings, out-of-style diamond studs which he wore when he was invited into Alexandria's Greek society. They say he spent much of his life perfecting "the part of Cavafy": voice, phrases, gestures, everything was scrupulously studied and memorized. An impeccable performance. With the period that concerned his poems (the entire Hellenistic age—200 B.C. to 655 A.D.—and the entire Byzantine age—842 to 1355 A.D.) he had an immense familiarity, such that history professors avoided him so as not to be caught by some trick question (one of his amusements). I suppose, however, that his erudition was that of the artist who takes what he wants where he finds it and can't be bothered with historical niceties—the erudition, in short, of a modern

aesthete, of a Parnassian, someone has said; but how then does one reconcile the frost of Parnassus with the tragicomic "sense of humor" of many Cavafy poems?

Yet the aesthete in Cavafy is revealed in certain possessions and articles of clothing he left behind: embroidered velvet slippers, archaic statues, beautiful enameled vases; also by the pains he takes in citing his sources (a jumble that would drive a true historian to distraction); and finally by the insistence with which he describes himself as sculptor and craftsman, as a character who occupies a vital position in the culture of his time.

It is surprising to note that Cavafy, who knew English perfectly, wrote in a language he was forced to relearn at the age of nine, though it had been his native tongue. Thirty years ago modern Greek was in a very fluid phase (as it is today) and the riches of the language seemed inexhaustible. On the one hand the official language [*katharevousa*] (which is also the language of the newspapers), on the other the demotic, the true spoken tongue. Cavafy, it seems, drew freely from both sources and made himself a language entirely his own. Perhaps the difficulty of the undertaking explains why he preferred to express himself in Greek rather than English. But there are those who go even further and even have purely literary explanations for Cavafy's "misplaced feelings." Love of this sort had disappeared from Greek letters after Strato, while in England there would have been nothing new about it; such considerations are supposed to have played a decisive role in the poet's choice, or choices. These are hypotheses, in any case, probably suggested by the wish to leave no area of shadow in his life and growing fame.

A fame—it is almost pointless to say—that is almost entirely posthumous, and rather recent. In his lifetime Cavafy was more ridiculed than applauded; he had published little, and in an age of declamatory poetry his lyrics (though they are hardly lyrical in the ordinary sense of the word) could be understood only by the young. Still, when he came to Athens for his operation, the most illustrious Greek men of letters paid their respects. The greatest of them all, Sikelianòs, arrived at the door of his room wrapped in a

luxurious blue cape which covered a huge bouquet of white roses. Cavafy went to open the door; theatrically the visitor let fall his cape, tossed the flowers on the bed, and embraced the Alexandrian, crying in a thundering voice, "Most beloved poet and brother!" After which the young poets gathered around the bed of the sick man, each of them reciting his poems and asking his judgment and advice. But Cavafy, being almost entirely deaf, was able to spare himself that torture. And not long after, he returned home to die. He passed away in the Greek hospital in Alexandria on the 29th of April, 1933, and is buried in the cemetery of the Community.

Observations &

Encounters

Report on the Cinema

[Published in a special film number of *Solaria* (II, 3), Florence, May 1927.]

Dear Editor, you have asked for my opinion of the cinema and I have done what I could to come up with one for *Solaria's* investigation. I must say, first of all, that I am somewhat afraid that the first response your new review will elicit will be yet another attack on the moribund serious theater—not a new or unpredictable response, but one which by now is a bit pointless. To praise the cinema in order to destroy the theater is an idea that may occur to more than one writer, as it has to me; and I should say it *ought* to occur, for I hope that no contributor to *Solaria* is excessively fond of the dramatic "genre": what the aesthetes of years ago, with compunction, called "good prose" as opposed to the vulgar "opera," operetta, varieties, and now, *horribile dictu*, the cinema. Such is my wish: and I apologize to my friends who are theater critics. But it is a wish that could be denied; and perhaps my colleague Gerbi, who doubted in the *Convegno* (October 1916) whether one writer in thirty could be found in Italy who had anything good to say about the cinema, will find that he has not been excessive in his predictions and that I am the only one, or practically the only one, among those invited to participate who will say that I am in favor of the silent art. Let it be clear then that I am praising the cinema; but let it also be clear that I know very little about it. So little that in order to educate myself on the subject, as well as to fire a few obligatory rounds at the theater, I made a selection a few days ago of right opinions and statements drawn from newspapers and reviews to present "on request," stamped with my seal of approval.

One opinion which pleased me was that expressed by A. S. Luciani in the *Fiera letteraria*, where we read that if today we

confine spiritual pleasure to books and visual pleasure to film, it is hard to understand what the devil can be expected from the theater —and why we hesitate to do away with it (the addition is mine). It was easy for me to find other opinions—or effusions—in the above-mentioned *Convegno*, which contains many such by young French writers: There are those who claim, for example, that the worst film is still a film, still signifies something moving and mysterious. Here I was tempted to appropriate this phrase for myself, with a few revisions, and to respond to your request that, while I am ignorant of the aims and problems of the cinema, it expresses something more alive, ineffable, and fertile than the theater, which more and more seems like a "genre" that is irremediably remote from the most authentic spirit of our times. But I managed to resist the temptation, and in the end it seemed more reasonable to agree with Gerbi's conclusion, which does not make the cinema into an art *per se* but a new technique (and we know that no technique is art of itself, even if it is inseparable from art); a technique which can be mastered—the successful examples are not many, but they exist— with art as a result, art *sui generis*. The case of the *auteur*-actor is the most propitious for these results. And the most perfect achievement so far (though not the only one) is Charlie Chaplin's *Gold Rush*.

I too have seen *The Gold Rush* and I share Gerbi's admiration, which is also that of the best foreign writers. However, I must express a reservation in this regard: Chaplin seems to me to be a difficult artist; the Jewish basis of his art and his undeniable sadness, the two- or three-sided nature of his humor, seem hardly accessible to the "public." Does the "public," then, understand what for Chaplin's theoreticians constitutes his *specific* art (cinematographic art, not the actor's art)? Or do most people see only a circus clown projected on the screen?

This should not seem like an empty question. The point, in fact, lies precisely here. The theater (apart from the musical theater) is accused of having strayed from its popular, choral, religious, etc., origins and of having closed itself off within four walls for the benefit of a few initiates; and the cinema is praised as art for everyone, art for the crowd, an entirely timely and current art of the moment—classic, in short, the way popular songs and the

fashionable Charlestons are classic. But is it not the case that for the masses the cinema is only a kind of inferior theater, more economical, domestic, and quick than the other; and that its specifically artistic essence, which is found not in the genre itself but only in certain works, is only the solitary perception of a few privileged individuals who are much less numerous than the few haggard admirers of our recent serious theater?

If this were so, no objections of this sort could be raised against that cinematic technique which can be mastered for the purposes of art: an art for the few, a difficult art, but art; and definitions don't matter. But it would be unjust to accuse the theater alone of having betrayed its origins: it would be just as valid to blame it for having risen to the status of art, given that the public runs in droves to the inferior theater (the film) which does not concern itself with art. This is perhaps the truest hypothesis, and the approval which surrounds the cinema is due only in small part to a new cinematographic sensibility, but depends to a much greater extent on practical reasons which it would be easy to enumerate.

It remains to conclude that the true art of today (including the outstanding achievements of the special art of the cinema) is more than ever art by and for the few: and that the collective phenomenon *cinema* belongs to the world of fashion, recreation, etc., but does not fall within the strictly spiritual field. And yet this conclusion, too, which is the most probable, must be considered very premature given the present state of the art of film, which is younger than the other arts by far too much. Time will tell; it will tell if the roar of laughter which greets Charlie Chaplin today as he steps into the abyss is the same that was aroused by the pratfalls of Ridolini;[1] or whether in itself it contains something sadder and more aware, as some feel, and as I myself sometimes feel.

In this case, an ever more widespread filmic sensibility would be undeniable: a new sensibility which will certainly find nourishment not only in the film of the future but which will lead the "new rich" of the senses to confront the silent art—even that which is not

1. Italian name for the American comic movie actor Larry Semon (1890–1928).

cinematographic—with a new spirit and new needs. On that day the gap which separates the so-called public from so-called serious art might be partly bridged.

But is all this possible, or even desirable? Allow me, my dear Carocci[2]—and this may be the only sure statement in a note that threatens to be ambiguous beyond the point of tolerance—allow me not to be entirely convinced. . . .

2. Alberto Carocci. Editor of the Florentine review *Solaria* (1926–1936). *Solaria* in some respects followed in the line of *La Ronda*, but with a broader range of interests. Though perforce it was primarily "cultural" during the Fascist period, it published many writers hostile to the regime, and in literary circles represented an anti-Fascist, internationalist, progressive attitude. Writers who appeared in *Solaria* include Saba, Svevo, Vittorini, Montale, Quasimodo.

Poetry and Society

[Published in the *Corriere d'informazione*, February 21, 1946.]

At the end of the winter of 1926, on an almost springlike morning, a rather elderly gentleman, not tall, somewhat corpulent but elegant, stopped in front of the entrance to the Teatro alla Scala in Milan to read the poster advertising *Lohengrin*. With him was a lady many years younger who in her day must have been very beautiful. The old man bore a strange resemblance to a picture of the Triestine industrialist Ettore Schmitz which I had seen not long before in *Les Nouvelles Littéraires*. Accompanied by a friend I followed the couple for a while down the via Manzoni, then screwed up my courage and risked asking, "Signor Schmitz?" I had not been mistaken. There in front of me was the novelist Italo Svevo, the man who had written me two months before from London to thank me for an article in which I had anticipated (slow courier that I was) the outbreak of his unexpected celebrity. Signor Schmitz (and so he remained to me until his death) invited us to sit with him at a café and badgered me with questions which were not exactly literary. My name had aroused his curiosity. An importer of resins and turpentine with the same name as my own had sold him merchandise for years; were we perhaps related? I admitted that he was speaking of my father without supposing that I was acquiring a claim to distinction in his eyes, which was in fact the case. And from then on there was always an odor of turpentine about our relationship, which I never succeeded in carrying very far on the literary plane.

Our first dialogue was brief, for the friend who was with us—a *précieux* and a notorious caviler—bombarded Schmitz with question after question about his "peculiar Triestinity," which had the predictable effect of chasing him away: but I recall that I was

immediately struck by the resemblance between Schmitz and his characters. Pirandello, too, in his last years had become strangely Pirandellian, problematic and hard to pin down; but to realize it one had to see him alone and when he was willing to let himself go, which was rather rare. In Italo Svevo, on the other hand, everything was Svevian from head to toe. A great traveler who was also greatly sedentary, this manufacturer of marine paints who divided his time between Trieste and London carried his world with him the way a snail does. But he was also irresistibly drawn to the world that had formed him: to a city and a house. The Villa Veneziani, where I was his guest for several days a few months later, a villa by the sea a short distance from the city and two steps from the paint factory, was his *Sans-Souci*, the place where he truly reigned.

Rumor had it that his eighty-year-old mother-in-law, a small, restless woman who wore glasses and was the sole keeper (it was said) of the secret of the inimitable paints, was principally in charge of the business. But anyone who ever saw Svevo moving through the crowd of guests on Sunday afternoons with a kind word and a smile for everyone, and then retiring like a good-natured eighteenth-century prince, understood that if there were two sovereigns in that kingdom, the old Signora Veneziani did not lack for moderation and discretion. Not long before, in a meeting of Triestine "rotarians" I had met other characters who had seemed to spring from the pages of Svevo, men of much curiosity, reading, and experience, half merchants and half artists, products of an environment which was also new for me, the son of a man who had perfumed the working recesses of the Villa Veneziani with oil of pine. And I recall that I attempted, in myself, to construct an entire problematic on the basis of a few single cases, to discover a connection between art and environment, art and society, which did not even have the merit of being new. Yet the question has tempted many critics who are not insensitive to the special note that has entered our literature from Trieste; and since the city is now a thorn in the side of the Italians,[1] one can bet that in one way or

1. In April 1945, Marshal Tito's troops occupied Trieste, claiming it as part of Yugoslavia. The city was a disputed "free territory" until 1954, when it once again became part of Italy.

another the problem will arise again. In itself the problem as I tried to pose it was at best superfluous. That a city which is profoundly different from other Italian cities should have produced more than one writer and more than one book that are *sui generis* was not unnatural or problematic. An artist who takes nothing from his ethnic, social, civic surroundings is a creature we cannot even imagine. But the homeland of an artist does not always coincide precisely with the region where he lives or with the dates of his statistical existence. The spokesmen for the "humiliated and offended" of Florence and Naples did not come from the rank and file of the people, and one needs to look in the books of Henry James and Huxley rather than in those by Italians to find the typical "high life" characteristic of Florence until a few years ago: and yet many Italians knew that life. As for Verga, he was naturally inspired by Sicily, although certain of his Milanese stories should not be ignored; but for a long time Verga needed to see Sicily from Milan, to construct himself an imaginary island in a certain sense. It's pointless to note that his islanders never or hardly ever belong to the same social class as the poet, an aristocrat who studied the life of those who today would be called the proletariat. Not for nothing is the extremely fortunate Verga idolized simultaneously, though for different reasons, by men with extremely divergent backgrounds and attitudes.

Svevo's experience was different: he went away from Trieste periodically, but never too far; he wrote his first novels and I believe part of the last in Trieste, and he seemed to take the material for his books immediately from his city and even from his social surroundings. I say seemed because there was a mediation if an artistic result—and what a result—was achieved. And yet the illusion persists that if our recent novelists too often lack a real, consistent subject matter, one that we would call almost public or political in the sense of the *polis*, the fault lies not only in the writers but also in our society, which has lost all the distinguishing features it had before, so far without acquiring new ones. In Svevo's case, if we wish to place him in context, perhaps we should not forget the particular literary coloration of the Veneto, a land where from Goldoni to Fogazzaro our bourgeoisie has made itself heard with peculiar insistence. Different in her intellectual open-

ness, typical because of problems that are hers and hers alone, Trieste too has probably shared in this literary spirit. And that a city with a full, rich social life such as she had, at least until the first years after the war, has produced a few books which do not seem to have been written by an islander but by a man who was truly living among other men, is a fact which speaks for itself, after all, and which can be admitted without leaving oneself open to overly simple accusations of literary "determinism."

The Cinque Terre

[First published in the *Corriere della Sera*, October 27, 1946. The Cinque Terre, or Five Towns, lie about seventy kilometers southeast of Montale's native Genoa, northwest of the Gulf of La Spezia, where Shelley drowned in 1822. Until fairly recently the picturesque, arduous stretch of the Ligurian coast where they are situated was inaccessible except by boat or railroad. The poet's father, Domingo, was born in Monterosso, the largest of the villages, and the family built a summer house there in 1906 when Montale was nine years old. Here he spent the summer months throughout his youth. The locale figures in many of his early poems, most notably perhaps in the sequence *"Mediterraneo"* in *Ossi di seppia*.]

The hypothetical and poetic beachcomber, who feels the breath of a gentle *mistral* one lovely morning and—therefore unafraid of a disastrous outcome *à la* Shelley—decides to point the prow of his cutter toward the horizon line that joins Point Monesteroli to the Cape of Mesco, can see them all contained in one enchanting arc of rock and sky: the Cinque Terre, known to many only by the name of their wines and by the pictures of them (and of Riomaggiore in particular) that Telemaco Signorini[1] has left us. But there are many, many more who have come on them in flashes, slivers, lightning-quick, dazzling fragments, through the occasional portholes in the tunnel that runs from Levanto almost all the way to La Spezia. And I couldn't say that such an introduction by rail is entirely out of keeping with the features of a landscape

1. (1835–1901). A leading member of the *macchiaioli* (from *macchia*, meaning blotch or spot), a group of atmospheric realist painters who flourished in the 1860s. Comparable in some respects to the French Barbizon school, the *macchiaioli*, as precursors of impressionism, are generally considered the most important movement in nineteenth-century Italian art.

which that *macchiaiolo* has overrefined and "Tuscanized." A strange fate for a corner of the world which still awaits its true painter, and which meanwhile, as far as that most slowly traveled of the arts is concerned, has never even been born, never earned its passport to that world of visual and sentimental culture which plays such a large part in the development of a complete "culture," without adjectives. Capri didn't need painters (not that it lacked them); though difficult to reach, it has always been available to the inspiration of the most restless and discriminating of foreigners. Taormina, Syracuse, and Bordighera had no need of them either, nor did numerous other locales to which a travel agent could dispatch express trains and steamers packed with visitors in search of Mediterranean mythology and local color. But the Cinque Terre? The main road abandons them to themselves when it leaves Sestri to rise to the Bracco pass; until a few years ago the only convoys that stopped here on their way through were milk trains, workers' trains, cargo trains; the miserly landscape is unwalkable except by those who are willing to clamber like goats across the terraces of vineyards that step down to the sea; comforts, at one time practically nonexistent, remain scarce, for there are few hotels or *pensioni* equipped with modern facilities. A rocky and austere landscape reminiscent of the harshest parts of Calabria, refuge for fishermen and farmers living hand to mouth on a strip of shore that is given, in places, to constant erosion; a barren and solemn shelf, among the most primitive in Italy. Monterosso, Vernazza, Corniglia—haunts of hawks and gulls—Manarola, and Riomaggiore: these, from west to east, are the villages, the hamlets, barricaded thus between the cliffs and the sea.

Few got this far before travel was easier. In summer an occasional native returned from the city to open the house he was born in; and every day, at rush hour, the workers came from the arsenal at La Spezia, when there was work. The bishop—for many years the bishop of Sarzana, Luni, and Brugnato, whom these good fishermen felt for reasons of geography to be a stranger—made rare and cautious visits. (later, the new diocese of La Spezia took them under its wing, and everyone was happier.)

Hoers of gardens, sailors of coasting vessels, the inhabitants of the Cinque Terre speak a language which is not Genoese—though that dialect is preserved almost intact in the colony of Portovenere—and which varies notably here from village to village. At a distance of two kilometers, but two kilometers of sea, and with no road between them, a greater difference may exist between the idioms of Monterosso and Vernazza than between Milanese and Bergamasque. Even today there is little communication among the various towns: only an occasional festival, an occasional regatta, a procession to the sanctuaries of Soviore, Reggio, or Montenero, unite the scattered populace of the coast.

When I was a boy, the names of the most impressive locomotives—Bellerophon, Astarotte—played a part in the mysterious local mythology. Politics didn't reach that far. Once (more than thirty years ago) an orator with the unlikely name of Papirio Triglia arrived to deliver an anticlerical blast, "The Ruins of the Vatican," but hardly anyone went to hear him.

Arturo Toscanini, too, spent some time among these shoals in the first years of the century. The natives didn't know who he was and called him "The Trickster" because to them he had the air of a juggler or conjurer. But in those days a horse or a mule were much more of a rarity than an artist fallen from heaven! People were amazed by the world around them, not the faraway world of which they'd only heard. Destinies were soon assigned in the large families: a priest, a fisherman, a farmer, and a luckless son who never did a thing; often, also, an emigrant, an exile no one would hear from for thirty years and who'd then return, if he returned at all, to build himself a house.

It's easy here to recognize the homes of these returnees. They have steep roofs, "bungalows" with salt-gnawed columns, turrets of multicolored glass; white-haired men used to stroll in front of them reading *La Prensa* or *Caras y Carejas*; in their dining rooms they hung portraits of Porfirio Diaz[2] or General Belgrano.[3] Once in a

2. (1830–1915). President of Mexico 1876–1911. Overthrown in 1911, he died in exile.
3. Manuel Belgrano (1770–1820). Hero of the struggle for Argentine independence.

while there were muffled voices on a boat, news from La Paz or
Capetown; but now that's water under the bridge. . . . Today the
sons of these *revenants* (in every sense of the word) have gone to
the cities themselves, and if now and then they return to their
villages, their blood runs cold when they recognize their childhood
playmates, the poverty-stricken sons of their old *manenti* (tenants
who share a single plot and survive on countless odd jobs, eating
virtually nothing but bread and onions). Verga's shepherd Jeli is
alive, only a few hours from Genoa.

The war has left visible traces here, too, and the damage has
been substantial, but there is no lack of desire to rebuild. One day a
road from Monterosso will meet the Bracco highway, near Pignone;
and then perhaps an almost Castilian landscape will be lost, in
which Pabst's[4] Don Quixote might have found his most worthy
backdrop. From the graffiti on the walls one might say that the era
of Papirio Triglia is also a faded memory. I see shields crossed with
the word *Libertas*,[5] the hammer and sickle, even the insignia of the
Paevècciu (the *è* is pronounced as in the Milanese *cotolètta*), a
kind of separatist group similar to the Madonnina of Milan which
will take part in the local elections. Note that the *Paevècciu* (the
old father) is the largest cliff of the region, and at this point one
may also think of the Mexico or New Mexico of Lawrence or
Steinbeck—but with a simpler, more Italian coloring and virtually
without a trace of animism.

Thus they appear, little altered but poised on the brink of
enormous change: the five classic towns of the *sciacchetrà*, the
wine known to Boccaccio as *vernaccia di Corniglia*. Drunk on the
spot—i.e., when it is 100% authentic—the red clearly surpassed
the medicinal port that had such a heyday in England after the rise
and fall of Marsala. But today, after the grafting of so many new
vines, will the old *sciacchetrà* still exist, and will it survive certain
comparisons? Luckily, the fishing for anchovies, which this year has

4. Georg Wilhelm Pabst (b. 1892). Viennese cinematographer. His *Don
Quixote* was produced in 1933.
5. Symbol of the Christian Democratic Party.

been stupendous, hasn't changed. And he who hasn't seen one of these boats return at dawn, half-submerged by a hundred *rubbi* (eight hundred kilos) of anchovies, its oarsmen seeming to plow the waves as they stand on the water, cannot say he is somehow familiar with the fishermen of the New Testament.

Words and Music

[Published in the *Corriere della Sera*, May 7, 1949.]

Words set to music, words that are sung, are not pleasing to the most refined connoisseurs of the art of sound. Among those who still tolerate them, many prefer choral works in which the word disappears; others want to hear only the sonorous arabesque of the voice (without being able to make out a single syllable); while still others (the minority) would like words set to music to come across stressed, clear, intelligible. These are the partisans of the so-called *recitar cantando*, a very Italian notion. I would be happy to go along with these last if the game, as they say, were worth the candle, i.e., if I were sure that music in certain cases can make poetry, which is already music in itself, bring forth a secondary music worthy, or not unworthy, of the first.

I know I am touching on a problem on which there exists an entire literature of which I am unfortunately familiar with only a very small part. Can poetry be set to music? And what kind of poetry? And to what extent? And to what degree must the words preserve their independence and be understandable by the listener? Recent operatic tradition has generally ignored the problem and considered the word a necessary precondition for the human voice *qua* instrument to play along with the other instruments and be counted among them. But there is also a school, stretching from our great musicians of the 1500s down to Debussy and even to the Schönberg of *Pierrot lunaire*, which claims to have an absolute respect for the word, to create the proper prolongation or halo of sound for it without destroying its individuality. These more or less informed theoreticians of recited song have nevertheless ended up admitting that only a "certain kind of poetry" can be set to music

and the choice of their texts reveals clearly that they have almost always taken the route of compromise. At one time they set little ballads, little Arcadian poems, stanzas written expressly for the music; today they take up dramas of scant poetic value (*Pelléas et Mélisande*) or lyrics of an even incredible vacuity, like the suite for *Pierrot lunaire*, the work of one Albert Giraud who owes his unhoped-for *repêchage* to the Viennese composer. The worst decision was made by composers who wrote their texts or libretti themselves: undecided about their double vocation, poetic and musical, they let themselves be hypnotized by horrendous words and only saved themselves by allowing the voices to be submerged in the immensity of the great mystic gulf. Richard Wagner is partly an exception, but this is due to the superb nature of his genius, and not to the fact that the word does not endure an overwhelming bullying in his work.

If we move on from schools and theories to the observation of facts, we see that from the nineteenth century on, at least, a wise compromise has prevailed in the performance of vocal music. With the exception of a great many *Lieder* or chamber *romanze*, or a few recitatives from comic opera or some superb fragments of *Boris Godunov*, the practical solution to this difficult problem has always been the same: the words are both there and not there, are both heard and not heard, they enhance or detract from the effect according to the case. Here too a tradition has grown up which the best singers respect almost instinctively. It is obligatory for the words to be heard in certain miraculous *attacchi*, "openings" which even poetically speaking have a certain primitive freshness worthy of our thirteenth century ("*Casta diva che inargenti . . . ,*"[1] *La rivedrà nell'estasi / raggiante di pallore . . ."*)[2] or at the beginning of certain thematically important moments ("*Fuggi, fuggi per l'orrida via / Sento l'orma dei passi spietati . . ."*[3]). In other cases everything is entrusted to intuition and the capabilities of the artist. Rosina's acrobatic flourishes cannot be pronounced like the syl-

1. From Bellini's *Norma*.
2. From Verdi's *Un ballo in maschera*.
3. From Verdi's *Aida*. The lines have been criticized because it is impossible to hear a shadow. *Sento l'orma dei passi spietati* means "I hear the shadow of those despised steps."

lables of a Schubert *Lied*; it is proper that Vasco da Gama free
the suggestive words "*O paradiso dall'onde uscito*"[4] from the vague
tremolo of the orchestra, but it is just as proper for the great nav-
igator to hide the later developments of his surprise from us, espe-
cially when they are entrusted to the penetrating power of a simple
B natural or a high C. Rigoletto's invective "*Solo per me l'infamia*"
is the sound of a gong more than the sound of human syllables:
woe be unto him who pronounces too much, who disturbs the full
roundness of that Day of Judgment thunder. On the other hand,
every time a theme is announced in advance by one or more in-
struments, the *attacco* of the first words must be extremely clear.
When old Sir George in *I Puritani* penetrates in full voice with "*Il
rivale salvar tu puoi . . .*" the audience is happy to hear a melodic
design they already know made incarnate in words: but soon after,
the waters are muddied and the theme, taken up by too similar a
voice, Sir Richard's, does not succeed in becoming flesh with words
like "*Fu voler del Parlamento*," a veritable stumbling block. Not
that this line is worse than many others; but words that are too
abstract or technical or specific support music poorly, and evidently
this quasi-Carduccian parliament is no exception. (It is one of a
great many deserved misfortunes of the parliamentary institution;
but let's go on. . . .) The problem of the word set to music, of the
recitar cantando, or of singing without reciting at all thus remains
open and insoluble: Moussorgsky, Debussy, and a few composers
of Negro spirituals seem to be those among the moderns who have
been most successful in bringing word and sound together, but
their very personal solution cannot be valid for everyone. There
have been very great musicians of the theater, and we hope there
will be others in the future, who used the written word as a simple
point of reference: Mozart, Bellini, and Verdi, for example. Their
ideal was not that of Stravinsky, a dead language, a Latin text
virtually indecipherable to the public at large; rather it was a clear
and neutral discourse to which they could do violence. This re-
mains true even though Mozart liked Da Ponte's libretti and Bellini
those of Felice Romani.

And Verdi? There has been a slight exaggeration of the horrors

4. From Meyerbeer's *L'Africaine*.

of the words he put to music. The sadly famous *"orma dei passi spietati"* does not move me to disdain. Woe be unto us if we read Shakespeare in this way: don't tell me, for God's sake, that a shadow is seen and not heard. Besides, even the old libretti, which were written expressly to be set to music, confirm when they achieve certain successful expressions that poetry and music proceed on their own and that their conjunction remains in the realm of occasional serendipity. It is worse when they involuntarily enter the realm of the surreal. I knew a man (entirely normal in every other respect) who felt required to repeat a hundred or a hundred and fifty times a day a line which had become his favorite expression: *"Stolto! ei corre alla Negroni!"* He even said it on the telephone, during business transactions. When I revealed to him that this came from *Lucrezia Borgia*[5] he paled, jealous of his secret, and told me he had never heard the opera for fear of being disappointed by the music set over his "divine words." Avoided like the plague by everyone, he eventually made friends with a certain individual who repeated *"La nostra tomba e un'ara"* (a variation on Foscolo's *"vostra tomba"*) at intermittent intervals, and with a third maniac who had chosen the longest expression I can recall: *"Speriamo di morire prima che le Pleiadi si colchino."* He must have been a classicist out of work or a retired professor. The three, finding themselves banished because of their incorrigible if innocent and epigraphical ecolalia, ended up meeting clandestinely in a rented room where they could repeat their favorite lines over and over, and where later (this happened fifteen years ago) they were arrested, accused of plotting against the regime, and threatened with prison.

After this misadventure the trio disbanded and I couldn't say today whether any of its members survives. Unknowing witnesses to the magical self-sufficiency of Language, these three wretches would be surprised indeed to find themselves in a piece that touches on but does not pretend to resolve the vexed question of the relations, both marital and extramarital, of the Word and Music.

5. Opera by Donizetti (1834).

Two Artists of
Yesteryear

[Published in the *Corriere della Sera*, October 29, 1949.]

A book of critical essays which ranges from the legend of Tristan to the *Colloqui* of Guido Gozzano[1] and from Salimbene da Parma to our late-nineteenth-century *Scapigliatura*[2] has good reason to be called *Poetry in Time*. Yet one would be wrong to attribute the simple meaning of a "temporal series" to the title of the excellent book by Ferdinando Neri[3] which has inspired these reflections. The author himself explains the source of the title and thanks the friend who suggested it to him. And an editorial note makes clear that the book's aim is to bring together thirty-eight poetic "situations" from across the centuries, thus focusing the critic's interest on the idea of time, or, if you will, on the historical scruple. All of which seems simple, almost obvious, but unfortunately is not so. It took centuries of critical thought before this activity—the placing of art in time—was possible. *Poetry in Time* is a title that would have been inconceivable a hundred years ago, and it may become impossible tomorrow, if the irrational currents

1. (1883–1916). Leading poet of the Italian crepuscular movement, an early-twentieth-century school of Italian poets related in temperament and subject matter to the "twilight" movements elsewhere in *fin-de-siècle* Europe (cf. the Celtic twilight). Influenced by the European decadents, the *crepuscolari*, who included Gozzano, Martini, Corazzini, Moretti, and Palazzeschi, wrote about disillusion, nostalgia, and simple things in a direct and simple style in reaction to the floridity of D'Annunzio. Many *crepuscolari* later became futurists.
2. See Note 3 to "Italo Svevo in the Centenary of His Birth."
3. (1880–1954). Noted literary historian. His *Poesia nel tempo* appeared in 1948.

of art and criticism continue for long. Not everyone is convinced that the work of art is born of the conjunction of an individual personality with the expressive possibilities that have developed in a certain period. Yet a poetic situation is nothing more than this: the possibility, urgency, necessity of doing today what could not be done yesterday and *will no longer be possible* tomorrow. In a certain sense, the history of art is nothing but a series of seized opportunities.

Neri gives us many good examples of this: Chamisso,[4] for one, who was born in France and taken to Germany as a child, who became a German poet but never had a Country, feeling he was German in France and French in Germany. Neri sees a similar malaise, within the context of a certain German romanticism, in the fable of Peter Schlemihl, the man who lost or rather sold his shadow; and he arrives at an interpretation which is subtle without being forced, and which leaves entirely open the masterwork of that poet without a shadow who spoke French in delirium all through the night before he died.

It is relatively easy, in those cases where criticism has long been tilling the field, to perceive the historical incidence of a classic (unless its author was actually prehistoric). This kind of understanding becomes more difficult when we turn to the so-called moderns or even to our contemporaries. Here we lack distance, room for perspective; to live in a period makes it difficult in certain respects for us to see it and judge it. Here every error is possible: one can sin from myopia or out of an excess of clear-sightedness; passions and personal interests muddy the waters, cloak things. And the curious fact is that when a consensus, an average contemporary opinion likely to survive, is reached about a poet, when a poet is safely inserted into a period, it is precisely then that he seems to have been removed from our time, out of the flux of our personal sentiments and resentments. Or perhaps it is not so curious, for understanding a work of art means transposing it from its psychological, individual time into another which seems, or actually is, different.

4. Adalbert von Chamisso (1781–1838). French-born poet who wrote in German, author of *Peter Schlemihls wundersame Geschichte* (1813).

In any case, only when an artist seems "dated" (as the English say) do we feel relaxed and fair in relation to him; but fair in a sense that the young could not claim to be. Ask a young "intellectual" his opinion of Puccini's music or Gozzano's poetry and you will be surprised to see him "execute" these two important and authentic artists with the greatest of ease. Bourgeois sentimentality, cheap tears, a prosaic, banal sense of life, no capacity for abstraction, deficiency of style: these, among others, are the accusations you will hear. The young man living his own period cannot be fair to a period that belongs to others; and the artists who show the worst signs of age are precisely those who have immediately preceded us. And yet . . .

And yet, try to erase Puccini and Gozzano from the picture of the years that were theirs, and tell me whether an unbridgeable gap is not created: which probably cannot be said of Mascagni, whom thirty years ago as intelligent a critic as Bastianelli compared favorably to Puccini, finding in Mascagni a more turgid, more sensual, more Mediterranean vein.

Puccini and Gozzano were not exactly contemporaries, and they were not a case of Siamese twins. Still, there are many affinities that link them: a taste for the poetry of the humiliated and afflicted; the bourgeois, sentimental climate that inspired them; the extraordinary plasticity which they had in common and which allowed them to draw the lyrical from material that for others was only secondhand goods, small-time romanticism, folklore, and gossip.

Sensual and sentimental—never metaphysical or heroic—complacently happy in their felicity of expression, Puccini and Gozzano are the maturest, the richest in sugar, of the many artists who flourished in the unrepeatable period between 1870 and 1914. Note that I did not say the greatest. The fruits of their labors should be eaten with a spoon.

Gozzano's precursors are well-known. Jammes[5] and the Flemish poets in a blend, a mixture that comes out of D'Annunzio's

5. Francis Jammes (1868–1938). French poet and novelist, preoccupied with everyday life.

Poema paradisiaco, though half a tone lower and enriched by some rhythmic techniques of Pascoli's. Perhaps one could also mention Stecchetti's[6] *Guado*. A step was still missing, and Gozzano took it, realizing the dream of a bourgeois poetry that had been being dreamt for more than fifty years.

Because music always comes into its own after the other arts and repeats their experience, I wouldn't know where to find Puccini's literary predecessors (his musical ones run from the French harpsichordists to Massenet . . .). The fact that he based an opera on *Madame Chrysanthème* mustn't make us think of Loti.[7] The spleen, the Celtic indolence of the *Pêcheur d'Islande* and *Ramuntcho*, can be more easily found in *Pelléas* than in Puccini. On the other hand, it is pointless to think of Murger;[8] Puccini's *Bohème* is something very different. Puccini lacked both the cultivation and the self-irony of Gozzano and in this he reveals a greater intellectual narrowness; but he had a vivid sense of humor (*Gianni Schicchi*) and he also comes close to Gozzano in a certain very slightly decadent aestheticism, more literary than poetic. But as a lyric artist in the strict sense Puccini, in his best moments, sings more, reaches greater heights. Proceeding almost systematically by pieces, and alternating the successful pieces with tired ones, he did not create (except perhaps in *La Bohème* and the first part of *Il Tabarro*) a unifying surface for his operas; but I don't believe that the unity of Charpentier's *Louise* is worth the vital parts of Puccini's works. Puccini was intelligent and a gifted man of the theater, but he was more than a shrewd administrator of his talent.

To make a distinction, for what it's worth, he was more of a poet than an artist: which cannot be said of Gozzano, who was perfectly balanced between art and poetry. There was a strong vein of bazaar exoticism in both of them (*Turandot, Paolo e Virginia*): the exoticism that goes from Chateaubriand all the way to . . . De

6. Lorenzo Stecchetti, pseudonym of Olindo Guerrini (1845–1916), a leader of the nineteenth-century realist tradition in Italian poetry.
7. Pierre Loti, pseudonym of Louis-Marie-Julien Viaud (1850–1923), exotic French novelist. His works include *Pêcheur d'Islande* (1886), *Madame Chrysanthème* (1887), and *Ramuntcho* (1897).
8. Henri Murger (1822–1861). Author of the novel *Scènes de la vie de Bohème* (1847–1849) on which Puccini's opera is based.

Amicis.[9] And here, in a certain illustrational Parnassianism, both sinned alike.

The differences remain, I know; and they will be felt as long as Puccini is not an anthologized author. Gozzano's *faux exprès*, his apparent (and willed) prosaicness, make the *Colloqui* an eminently intellectual book; while Puccini's work is much more limited in its background, more immediate but in a certain sense more popular, more uncultivated. But it has its song, Mimi's song above all, the song of the heart

> *donde lieta uscì*
> *il* suo *grido d'amor*,[10]

the song that Guido intentionally renounced. Guido was not a totally original poet; nor did he wish to be; and this is the entire secret of his success. For art is *also* originality, not *only* originality. Those who claimed the opposite (like Tilgher[11]) have provided evidence which is all the more persuasive for being involuntary—reducing their thesis to an absurdity.

9. Edmondo De Amicis (1846–1908). Popular Italian writer, author of the celebrated *Cuore* (tr. as *A Schoolboy's Journal*).
10. from which *its* cry of love / came joyous
11. Adriano Tilgher (1887–1941). Pessimistic essayist and moralist. Author of philosophical, historical, aesthetic, and theater criticism.

The Intellectual

[Published in the *Corriere d'Informazione*, June 26, 1951.]

The intellectual dresses his salad with oil and lemon.

The intellectual thinks that Verdi succeeded in learning his craft very late and as an old man produced the great masterpiece that is *Falstaff*.

The intellectual prefers pure music, above all Bach (whose name he pronounces with strong palatal friction).

The intellectual quits the Communist Party but does not admit that those who never joined it were in the right.

The intellectual can also discover Verdi, but the problems then are even greater.

The intellectual thinks modern poetry is lacking in humanity, but has a weakness for abstract painting.

The intellectual decides in the end that modern poetry is full of humanity; and then the disaster is irreparable.

The intellectual confuses the prelude to *I Pagliacci* with the *Ode to Joy* but laments that the Italian language is so unmusical.

The intellectual decides to come down from his ivory tower. Luckily, no one notices.

The intellectual is convinced that art has been made to be understood by him.

It's worse when he thinks it is made for the people.

The intellectual dreams of a salary in dollars and declares that "Europe must unite or perish."

The intellectual does not receive a salary in dollars and says that "the decline of the West is imminent."

The intellectual loves ballet, twelve-tone music, and aperitifs with vitamin B1.

"But a very 'dry' cocktail, please."

The intellectual wears a white caftan with club-shaped buttons and says Paris is in decline.

Perhaps; but the true decline would come if Paris gave him a thought.

Unfortunately, this sometimes occurs.

"Still, St. Germain-des-Prés maintains a certain character . . ."

The intellectual says it is time to emerge from intellectualism.

The intellectual says that Switzerland is a boring country.

The intellectual says that in England the food isn't so bad after all.

No *caffelatte* for him: he breaks his fast with Chinese tea and "grape fruit" (*pompelmo* in the vernacular).

The intellectual is looking for his "second profession." But the first?

The intellectual defends freedom, leaving for Prague and Warsaw; when questioned he says that "they made him do it."

The intellectual fails to win the literary prize and declares that all prizes are a camorra.

The intellectual wins the literary prize and admits that camorras have their uses. (The poets of the *Dolce Stil Nuovo* were a "gang," too.)

The intellectual writes poems that nobody reads and concludes that our age was not made for poetry.

"It's a shame the M.S.I.[1] lacks a Leader."

The intellectual fails to sell his books and asks the State to take a part.

The intellectual wants poetry for the people, "serial" music (i.e., by series—or in series?), and abstract, i.e., concrete, painting.

The intellectual says that the critics who are not interested in him are failed artists.

The intellectual converts to neo-realism because the bourgeoisie is exhausted. "But afterwards we shall have to remake man."

1. Movimento Sociale Italiano, or Italian Social Movement, the postwar manifestation of the Fascist movement, especially that part of it responsible for the Italian Social Republic (1943–1945).

The intellectual has been or will be translated into other languages. His publisher has managed to "place" his book.

The intellectual does not permit State interference in the arts but laments that the theater and cinema are poorly subsidized.

The intellectual thinks it would be a good thing to reestablish the Academy, provided that he is included, and above all, that A, B, and C are not. . . .

The intellectual is against planning in the arts but is of the opinion that A, B, and C should be prevented from writing.

The intellectual detests the third force[2] because ours is the age of the masses.

The intellectual detests the masses and thinks the *hortus conclusus*[3] is a good thing.

The intellectual says that if Shakespeare were alive today he would make movies.

Meanwhile, he would like to make them himself.

The intellectual arrives at his appointment with a stack of newspapers in hand; he apologizes for being late and takes his leave saying he "has to go somewhere."

Where will he go? A "prediction competition" has been established to find out.

2. The Partito d'Azione after the fall of Mussolini was an attempt at establishing a "third force" between socialists and liberals. See also Note 2 to "A Dialogue with Montale on Poetry."
3. Phrase from the Latin version of the *Song of Songs* (IV, 12) meaning "closed garden," used by extension to refer to the intimate secrets of a writer or school. D'Annunzio used the phrase as the title of a group of poems in his *Poema paradisiaco*.

The Poet

[Published in the *Corriere d'Informazione*, July 11–12, 1951.]

The poet has attempted (with equal unsuccess) to write for the Masses and the Initiated. In his failure he sees his greatest triumph, believing himself to be ahead of his time. He lives in the future and awaits his hour.

Two agencies, Lynx Quotes and the Argo Clipping Service, send him cuttings from the papers that mention him. They are always the same little "pieces," printed perhaps by the agencies themselves so as not to lose their client. The poet pastes them in a large album and counts them with satisfaction. He has more than a thousand, and the number is growing every day.

Still, when he presents a form filled in with his name at the telegraph office window, the attendant isn't roused out of his somnolence, doesn't lift his head, doesn't give the slightest indication that he wonders, "Is it really him?" It seems the poet's name is entirely unknown to the man at the window. Is this some kind of bad joke?

The poet isn't fond of other poets, but from time to time he turns into an anthologist and collector of the poems of others so that he can include his own as well. He's obeying a "scruple of objectivity," a scientific duty. It's not that it matters to him, but posterity must be informed.

The poet doesn't write in prose, in fact he detests prose, which he considers a utilitarian instrument, destined for the communication of ideas, not the afflatus of art. Words set in lines *expound*, those set in rows *sing*. And the poet sings!

Having performed his civic duties (the poet pays his taxes), he

intends to exercise his rights and would like the State to assume the burden of printing, and buying, his poems. "Maybe in Russia . . ." But the poet fears that in Russia his freedom to create would be shackled.

The poet has paid homage, in poetry and prose, to certain knavish gerarchs of yesteryear. But he did so spontaneously and never renounced his spiritual freedom. Also, he almost always did it in prose, and prose doesn't count, *it's another story.* . . .

The poet is undecided between Form and Content. In the first mode he was recommended for the San Burgonzo Baths Award; in the second, he figures in the Presentist Anthology, of which he was required to order fifty copies.

The poet is over forty, and would not think it inopportune if the Nation showed him its gratitude by granting him the Laticlave (for life). "After all, who was Trilussa[1] but a simple versemonger in dialect?"

The poet despises journalism but travels at a seventy-percent discount. He attends all the conventions, signs all the public statements, answers all the questionnaires, and protests unfailingly against "the alienation of modern man." The poet is Marxist, Christologist, urbanist, technician, and progressive.

The organ of the Party printed one of his poems "in 5½-point type," illegible. Pintacuda, Malacrina, and Raspanti—better trained in the art of bending their backs—were very differently treated. The poet is considering quitting the Party.

The poet wants to be subsidized but expects to be free to insult those who subsidize him; he wants a free criticism, but a criticism that is also obliged to concern itself of its own accord with him; he wants the papers to be independent as long as they cannot praise his rival Pintacuda. Such are the contradictions which make up what he calls "the crisis of contemporary conscience."

1. Pen name (and anagram) of the satiric poet Carlo Alberto Salustri (1873–1950) who wrote in *romanesco*, the Roman dialect. Although the Fascists (whose party officials were called gerarchs) campaigned strenuously against Italian dialects, Trilussa's poetry was popular with Mussolini and remained available throughout his regime. Trilussa was granted the Laticlave (i.e., was made a member of the Italian Senate) shortly before his death in 1950. Montale himself became a Senator for life in 1967.

The poet is unaware that if the 100,000 poets of his ilk were to organize, the State would really be in hot water and would have to open the tap *for them too.* . . .

The poet doesn't know it, or perhaps he's too proud to organize. He doesn't admit that other poets should enjoy his rights. This vanity makes him the most neglected and the least dangerous of "taxpayers." . . .

The poet speaks of God allusively. "He," "Him," "His Voice" . . . Thus he reconciles Progress and Tradition. He is visited by Him, but is able to protest the abuses of the *Celere*.[2]

The poet believes he is profoundly understood if the critics discover in him a "denunciation of the human condition." This can actually happen, for although the critics may have time to write about him, they are too busy to read him.

The poet has heard of Plato and Hegel, he knows the Republic will have no need for poets and that one day art will be finished. Still, the event isn't imminent, and there's still room for him, *the last of the poets.* (The last, but the first.)

The poet can also be different. He can have an uncontroversial past, so much so that no one mentions him any more. In such cases he's rich, owns a car, earns a great deal, and doesn't shrink from writing in prose. He is a species of poet who is disappearing and would require a separate study.

In the literary Zoo there are still a few specimens of the poet who doesn't talk about his poems, doesn't collect clippings, and works honestly at another profession. I wouldn't suggest that we put him in a cage and exhibit him to the public, for then he'd become vain and would pass automatically into the class of poets I've already described. I don't know if he deserves to be honored, but he certainly deserves not to be disturbed.

2. Emergency riot police under the control of the (then) Christian Democratic government.

On the Trail of
Stravinsky

[First published in the *Corriere della Sera*, September 19, 1951.]

Venice, September 8. I have a lovely room overlooking the Riva degli Schiavoni, and an endless Canaletto, teeming and alive, unfolds before my eyes. I am ending my vacation here so as to be present at the birth of a presumed masterpiece; or rather to spy on its baptism from the wings, from the back of the shop. But God only knows whether I'll be able to get near Stravinsky, who has arrived with his entire *suite* (wife, son, personal physician, etc.). The Maestro, it seems, is rather *"arancino,"*[1] as they say in Florence, with journalists. At Naples after questioning him at length, they described him as "the great violinist"; *inde irae*[2] which discourage any direct approach. I go out into a maze of streets and arrive at the famous bar where Mister Cipriani, the friend of Hemingway, honors me with an aperitif and a *pallina* of fried rice. Then I go out and walk some more and get bored. It's hot and terribly crowded. Everywhere, big posters advertise artistic events of all kinds. Why doesn't the city of Venice announce to the entire world that from now on no further attractions (be they artistic, social, or athletic) will be permitted in this divine city, which is free of the roar of "scooters"? The buzzing of the drones of the *beau monde* would disappear, too, as if by magic, and Venice would gain an infinitely larger and more enduring colony of new guests. A city of

1. A small bitter orange; hence sharp, haughty.
2. "Whence the wrath" (plural in Latin). See Juvenal, *Satires*, I, 68.

silence well organized against every form of social organization would attract people from every corner of the globe. I toss out the idea without any hope, alas, that it will be taken up and realized.

September 8, evening. I have managed to obtain a copy of the libretto of *The Rake's Progress*, which is a jewel of its genre and may contain Auden's most beautiful verse. With all due respect to those near-masterpieces the libretti of Giacosa and Illica, how long has it been since such a perfect web has been woven? On the other hand, all recent English poetry tends toward opera or operetta libretto (without music, or with the music of its words alone). This is not a functional libretto, however, as Auden perhaps thinks. What music will be able to underscore lines which range from the style of Sullivan's *Mikado* to the monologue of Baba the Turk, which is reminiscent of certain parts of Eliot's *Waste Land*? I fear there will always be an imbalance between Auden's highly ramified and allusive intelligence and the naked, almost abstract intelligence of the late Stravinsky. Meanwhile I hum to myself, with music of my own,

> *What deed could be as great*
> *As with this Gorgon to mate?*
> *All the world shall admire*
> *Tom Rakewell Esquire.*

(This refers to Master Rakewell and his predicted coupling with the terrible Bearded Lady: an exploit which will fill the world with admiration. But I do not envy the translator, who must preserve the sense and the rhythm, here and in many other more difficult passages. And even if he performs miracles I have the impression that this text, which is dry as bamboo, will always gain from being read and sung in its original language.)

September 9. Stravinsky's doctor said to me, "Why don't you try to attack the son as well as the father? He knows everything about him, he's even written a book about the Maestro." I followed his advice and spent half an hour with Theodore Stravinsky, a painter living in Geneva and author of *The Message of Stravinsky,*

which the great Igor has pronounced definitive. Unfortunately, Theodore has not seen his father for twelve years and prefers to tell me about his own painting. I ask if it is impressionist painting, but understand from the way he starts that I've made a *gaffe*. Theodore has been deeply affected by the *esprit de Génève* and would like to decorate entire churches with his frescoes. He speaks perfect French; with his father he talks in Russian but I gather that the Russian of father and son is somewhat rusty. When I try to get him back on the right track he dwells at length on Stravinsky's religiosity. In several statements printed in the program of *The Rake's Progress* the composer has in fact declared his love for the Orthodox Church; though without excluding the possibility that he may become Roman Catholic one of these days. At the moment his religion is "in progress." I pocket a copy of the *Message* and take my leave. My assault has not yielded the results I was expecting.

September 10. From a box at La Fenice I watched the dress rehearsal of the *Rake*. Leitner conducts, like a man of experience: tomorrow, when the composer will take the podium, it's said that everything will be more diluted. I don't presume to make a judgment on Stravinsky's new work, but I cannot fail to note with satisfaction the reappearance, after so many years, of an opera with *parts* for the singers. Performed in English, the *Rake* seems to me like the delicious creation of a furniture- or cabinet-maker; an opera which draws like a Dunhill pipe made of old briar. I have never heard anything so exquisitely woody and finished. It may be that here the eighteenth-century style results in a Chippendale that is more sober than elegant; but I don't dare decide. Another welcome innovation is the abolition of the large orchestra, of symphonic padding. Here the devil is accompanied by a piano; and it's enough. On the day that a theatrical composer will believe in the expressive power of music (Stravinsky is a rationalist who hates expression and wants to reduce music to pure Platonic idea) this score will be able to suggest a great deal to him.

September 10, evening. Three of the most renowned English poets of the thirties, W. H. Auden, Stephen Spender, and Louis MacNeice, were eating a mussel stew half an hour ago, in a restau-

rant in the Frezzeria. Since I already knew the latter two, meeting Auden was the most fruitful for me. Wystan Hugh Auden, the librettist of the *Rake* in collaboration with Chester Kallman, is forty-four years old and five feet seven inches tall, and lacks, or has lost, the youthful expression and the flowing hair that certain photographs lent him. He is a strong, cordial, human man, whom one seems to have known forever. He divides his time between Ischia and New York; now an American citizen, he has taken the opposite route from Eliot, who was American and became English. According to Stravinsky, who chose him on the advice of Huxley, Auden is the Bach of modern poetry. He does what he likes and knows every secret of technique. And in fact his poetry is sweet like Spenser's, ironic and witty like Pope's, dry and discursive like Eliot's. He jumps from the old to the new with perfect nonchalance, enjambs his stanzas like the best of Byron's *Don Juan*, juggles modern thought with acrobatic agility; moving through time and space among the ghosts of Kierkegaard and the invective of Karl Barth, he has abandoned the religion of Marxism for the Anglo-Catholicism into which he was born; and finally (and for me, today, this is his greatest attraction) he loves opera and in the libretto of the *Rake* has succeeded in writing a masterwork of the genre. The (formerly) blond Spender, who has come from Lake Garda to be present at this "world premiere," has defined Auden's work as "chameleon poetry." Chameleon in that it takes on the color of ideas without becoming their prisoner. And since Auden is the kind of personality who excites the air that surrounds him, this evening in the Frezzeria a little breeze was blowing, more redolent of sacred oratorio than comic opera. "When will this scandal of three divided Churches (Roman, Orthodox, and Anglican) come to an end?" Auden asked me. Yet he practices his own religion "in progress," and doesn't expect the lesson to come down from on high, from the "bosses" or gerarchs. It's a difficult endeavor, which needs to be begun by small groups of "private citizens," by individuals. Better to let things take their own course and open one last mussel.

I leave him, full of envy. I will never experience the joy of being a foreigner living in Italy. God knows I've tried; but when you're born here, you haven't a chance!

September 11. Grand triumph of *The Rake's Progress* at La Fenice. Stravinsky was called to the stage, where he bounced up and down like a rubber puppet. When he conducts, with large, imprecise gestures, preoccupied and absent, he looks like Benedetto Croce bent over an old codex. Like Croce, moreover, he belongs to the past, a great past. Through Stravinsky's filter Auden's libretto has lost much of its modern coloring but has gained in density of style. Style or technique? A man like Stravinsky who confuses form and technique rather seriously and distinguishes absurdly between opera and musical drama (venerating one and ridiculing the other) could not have attained a different result. It's not a little result, mind you. With *The Rake's Progress* a great European by choice warns Europeans not to become barbarians. I foresee, however, that many born and not made Europeans will respond that without barbarisms Europe will lack a new face. And they will continue to write tedious musical dramas, not operas constructed like a chamber sonata.

September 12. A vermouth in the composer's honor, given by the city. Stravinsky arrived at the imbarcadero at the Rialto, followed by his troupe, and was greeted by the applause of a hundred peasants in worn-out shoes, wearing open shirts over messy trousers, worn-out pullovers twined around them front and back, wisps of yellowish hair sticking out from the lenses of their black glasses. I am told these are not peasants at all, but the very cream of the fashionable intelligentsia. They speak an Anglo-Roman *koiné* ("*Il progresso del racchio*" instead of "*La carriera del libertino*") and they all know each other. In a room of the City Hall we crowd around the mayor, who makes a well-received speech which makes mention of Aeschylus, Hugo, and Arrigo Boito. Stravinsky, who is seated, takes the beating and expresses his thanks. He is a bent little man, sickly and smiling, who bows in the Russian manner, as if diving. I manage to exchange a few words with him and am not surprised to find him so simple and humanly solitary. Fame, Hollywood, and dollars have not marred in the slightest his personality which is that of a small *barine* who is afraid of the devil and would like his whole life to be a beautiful opera, closer to Tchaikovsky than Wagner.

September 13. I return to Milan. And at the airport I see Auden again, leaving for Rome to return to Ischia. He nearly speaks Italian, takes my snapshot, repeats his admiration for Dante, a poet whom the English cook in their own style (and with reason); then he jumps aboard the plane like a roebuck. His carrot-colored head enters the cabin, disappears. A little later, the plane for Milan takes off, too. Seen from above, Venice is bathed in mist. It was worth it to end the *Rake's* epiphany with this vision.

Malraux

[First published in the *Corriere della Sera*, June 18, 1952.]

The best portrait of Malraux is contained in that strange little book, the *Galerie Privée* of M. Saint Clair[1] (known to the world as Mme. van Rysselberghe). Returning from Iran, Malraux exits from the plane, shakes many hands, and installs himself in the car that will take him to the conference of intellectuals at Pontigny. His first words are, *"Voyez, en Perse la Divinité . . ."*

Perfect; and for a French reader there would be nothing more to say. In Italy, however, where Malraux also has friends and admirers, this portrait would no doubt be insufficient. Traveler and aesthete, a man who has participated in many of the revolutions of the past quarter century and who fought in the Spanish Civil War, an unorthodox and unregimented ex-Communist (Trotsky himself boxed his ears in a diatribe published in the *Nouvelle Revue Française* of April 1, 1931), author of novels that are fundamental for the understanding of our time (one title alone, *La condition humaine* [*Man's Fate*], is enough to tell us how much Sartre and all the problematicists of today owe him), until recently minister in de Gaulle's government, and today a writer on art who has amazed everyone with the breadth of his culture and the originality of his anti-methodical and anti-systematic method, Malraux remains almost an unknown quantity for us. Is he a D'Annunzian? I asked myself, listening to him in the Salle Gaveau, or a revised and cor-

1. Pen name of Maria Monnom, wife of Theo van Rysselberghe (1862–1926), leading neo-impressionist Belgian painter. In 1910 the van Rysselberghes built a house in Saint-Clair, Var, Switzerland.

rected French Malaparte?[2] I beg his pardon now for my uncertainty, which after all was not offensive.

I had been seated behind him and was unable to see his face. A young man, lean, without a white hair on his head, he had acknowledged the ovation aroused by the mere announcement of his name with a nod, and had begun to speak in a sonorous voice, with barely a glance at his notes. Seated, bent forward, he seemed to collapse into himself, then re-emerge; nervously, his hands ran over the clavier of his personal effects. He began as if he had to give a political speech. "What can we offer," he shouted, "to the young who have not made up their minds to submit to the discipline of Stalinism?" An interesting question, which remained partially unanswered. To the young, Malraux offered, basically, the culture of the West, a culture which above all is an "awareness of what has made man something other than an accident of the Universe." (I wouldn't say that precisely all the thinkers on our continent have excluded such an accident, but let's continue.) He went on, speaking at length about man's aloneness faced with the cosmos; he argued against Soviet realism, which imposes on the artist not only his content but also the style of his work; asserted that art is the expression not so much of society as of genius, and concluded that man the artist is not born *"pour partager le mensonge mais pour trouver la grandeur."*[3] Unanimous acclamation greeted the speaker, who rose and clasped his hands over his head as if he wished to give an accolade to all the public. Then suddenly he vanished, swallowed up in the crowd, before I could see his face.

The next day, I went to pay him a visit in Boulogne-sur-Seine, where he lives on a quiet street a few steps from a swimming pool. "It's a wealthy neighborhood, very wealthy," said the driver who took me there. I entered a garden where three blond children were playing, and a maid asked me if I had an appointment with M. Malraux. My answer was to her satisfaction, and, following her instructions, I walked up a flight of steps and was let into a "living room" with the dimensions of one of our cinemas. M. Malraux

2. Curzio Malaparte, pseudonym of Curzio Suckert (1898–1957), D'Annunzian journalist and writer.
3. To share in falsehood but to discover greatness.

approached me and I saw immediately that he does not have the look of an agitator or a demagogue. A handsome man, tall but not too tall, lean, wrapped in a black shot-silk dressing gown over blue pajamas with dark-striped pants. Fifty years carried magnificently, gray eyes, glossy hair, a tic which makes him snort through his nose, an expression at once energetic and concentrated. Introversion and retroversion are two psychological clichés that are inapplicable to him.

Our first words are dry. Actually, he does the talking, which is what I had hoped for. I confine myself simply to drawing him out. He instantly corrects the rank of colonel which I had assigned him. He was a colonel in Spain, but now he is a brigadier general in the reserves. He commanded the brigade of volunteers who retook Strasbourg; seventy percent died or were wounded.

"We have reserve generals, too," I say. "But they are rare, and I believe they are usually specialists."

"I too am a specialist," he answers. "I commanded armored tanks."

Our monologue-conversation is intense and digressive. Malraux makes it known at once that he does not want to discuss politics. His relations with General de Gaulle are excellent, but his movement, insofar as it is a party among other parties, doesn't interest Malraux a great deal. He had hoped that a national renewal, a transformation that was not simply political, would come from that direction. But France is tired and sorely tried by the war and has no will to renew herself. Collectively tired, you understand; there are still individuals, and they are active in every field. Also and above all in the field of the arts, which is what excites him most. He makes no judgments worth mentioning about his fellow writers: but one senses that they don't interest him a great deal. He considers contemporary French painting still alive and vital, without having any illusions about the School of Paris. Yet he believes Paris will remain the arbiter of taste in the figurative arts for another century. From Chardin up to 2050 will continue to be a good period for painting. Naturally, when a new face for man has been discovered, much of the stuff of our time will have to disappear. (He makes a gesture with his arm as if sweeping a littered table clean.) Then he refers to the enthusiasm of a noted Italian profes-

sor for everything relating to cubism and post-cubism. "He's intelligent," he says, "but he must realize that we know Picasso better than he does." He himself admires the lesson of Picasso the composer and destroyer of forms; but for pictorial rendering he prefers the more limited Braque and even some good Rouaults. I ask him about Bonnard. He was a genius in his last years, but only then. An explosion of genius at an advanced age is not unusual in the arts, and you Italians know something about this.

Is he familiar with Italian criticism? He is, and has a fair appreciation of it. Croce's aesthetic is the most serious and rigorous in the world. But he, Malraux, doesn't believe it to be fruitful in the visual arts. To start from an analysis of the concept of art is, according to him, a hopeless undertaking. One must begin with the concrete, with an analysis of a group of works about which there is a universal consensus, and then draw the logical consequences. In his next book he will examine seven hundred sculptures, three or four thousand years of expression translated into marble, bronze, or stone, and the stylistic constants, the formal currents and recurrences in these masterworks. For him, the last great sculptors are Donatello and Michelangelo. Rodin makes museum pieces; he seemed modern because he lived a long time but to Malraux he seems like a contemporary of Delacroix. The last great modern statuettes are those of Degas.

And today's painters? "Look at Dubuffet" (he points to a sort of brown drawing that turns out not to be a drawing but an oil: a sublunar landscape in which several roughly sketched animals can be discerned, a cave painting); "look at Fautrier" (he points to a little picture which contains a very faintly drawn oval, perhaps a human face). Then he shows me a monograph he has written on Fautrier, which costs 80,000 francs in its least expensive edition. It contains original lithographs, faintly blotched with color. Fautrier is fifty-five today; he is tonal like Morandi and approaches the limits of abstraction as does Paul Klee. He paints no more than three or four small pictures a year, after long meditation. He is a painter of blotches, or rust, of subaqueous efflorescences. One must wait months to obtain one of his works. *Pas d'espoir* (and in my case) *pas d'argent*.

Malraux talks about Italy, which he knows like no other

Frenchman of the generation after Larbaud.[4] Perhaps his is a museum Italy, but what can be expected from a critic who sees in the museum (this institution that is only two hundred years old) the true revolution of our times? *The Imaginary Museum* is the first of his four books on art, which have now been collected under the title *Les voix du silence* [*The Voices of Silence*], published by Gallimard. Museums and reproductions provide contemporary man with a pictorial experience that was unthinkable in other times. Baudelaire never knew Italy, and Gautier, who never visited Rome, only came to Italy when he was thirty-nine. These were the greatest connoisseurs of art of their time. Today even someone who hasn't traveled as widely as Malraux can stand face to face with Sumerian, African, Indian, Chinese, Japanese, and all the pre-Columbian arts. We are taking part in an unprecedented revolution in taste.

What is art for Malraux? I ask myself as we leaf through his voluminous missal. The greatest human activity, certainly, the only one he considers absolute after his disillusionment with social and political activism. Through the imaginary museum which any of us can make for himself, the works, the paintings and sculptures, have left behind their primitive functions and definitions and have become comparable "objects," provoking and creating what is supposed to be our century of formal metamorphoses. We are on the threshold of another humanism, but reversed, projected into the future, and the new historicism that is arising does not explain and comprehend the past but continues it. A richly imaginative, mythic historicism, barely or not at all rational, which alternates with outbursts that one could call Vichian critical analyses which may perhaps have sprung from the lesson of Focillon[5] and calm contemplative pages like those Pater once was capable of writing about our miraculous Renaissance. And Malraux's conclusion, entirely personal, entirely in key, makes art into anti-destiny, and therefore,

4. Valery Larbaud (1881–1957). Cosmopolitan French poet, novelist, critic, and translator. His most famous work is the *Poems of A. O. Barnabooth* (1913). Larbaud was an enthusiast of Italian culture and a particular admirer of Svevo.
5. Henri Focillon (1881–1943). French art historian, author of *La vie des formes* (1943).

if I don't misinterpret him, the liberation from the impasses of determinism, the inner freedom which subdues and defeats fate. Malraux's is a world without God, but indubitably full of gods. How much it contains of Nietzsche's *Übermensch*, of Stendhal's Napoleonism, I couldn't say. Certainly the final component is very personal; it belongs to the same man who created Garine, the character in *Les Conquérants* [*The Conquerors*] who says, "There is no room in Communism for the man who wants, first of all, to be himself."

No longer a Communist, is he perhaps a Fascist today? We can find the answer in his novel *L'espoir* [*Man's Hope*] (1932): "An active and pessimistic man is a fascist, or will become one, if he has *no faith behind him*." No one can doubt that André Malraux has such a faith.

This is an unique writer, still a young man, who can answer the problems of today with words of twenty years ago, and who after living the life of an adventurer remains so private and discreet that his biographers are forced to write not his life but those of his characters.

I rise, and he does, too. He has spoken for an hour and a half, giving the illusion of talking to a friend and of having opened himself up for the first time. What more can one ask? From the window he shows me the route I must take (but which I will certainly miss) to find a taxi stand.

I go out under the first raindrops and skirt the deserted pool. I don't know whether to envy the regal destiny (or anti-destiny) of André Malraux, but this evening I am less unhappy with my own. And for this too I can thank the regal author of *The Voices of Silence*.

A Visit to Brancusi

[First published in the *Corriere della Sera*, May 1, 1953.]

I hope I haven't created the impression in my previous articles that the French are undergoing a crisis of literary nationalism, of artistic xenophobia. Nothing is further from my intentions. On the contrary, the average French intellectual is abundantly willing to admit that there are writers, composers, creators of the first rank outside of France, though he shows no curiosity about getting to know them. This is something to be admitted in whispered tones, even if only recently a writer who is anything but mediocre like Jules Renard could find Dante and Shakespeare "ridiculous" and say that the name Nietzsche only made him think of a typographical error.

But the touchiness and intransigence of the French reveals itself to be truly unanimous in defense of the painting that is being done in Paris. If you believe so, you can say that Proust bores you, that Claudel is a *bourgeois*, that after Valéry no poets of absolute importance have emerged; no one will protest and some will even agree with you at the very moment when you think you're wrong. But if you question the vitality, even the greatness, of the *Ecole de Paris* in the "visual" arts, you will immediately earn yourself a reputation as a hick and an incompetent. I am speaking, naturally, of the post-impressionist school, for in the long span that reaches from Courbet to Vuillard and Bonnard (except perhaps for the intermezzo of the Nabis) no one in the whole world denies that France was supreme in painting. After cubism, things got complicated and today Paris is not so jealous of its "visual" artists as it is of the *taste* that it continues to impose everywhere.

No Frenchman admits that there can be any salvation outside

this taste. A foreign artist who accepts it, who recognizes his own ideal membership in the *Ecole,* can find intelligence and understanding here, and perhaps success; but all doors would be shut to the visual artist who asserted his own independent judgment. How much longer can this taste survive? If we recognize that we do not need works and personalities to feed it, but only educable and accommodating talents, its future appears limitless. "We'll have it for at least another hundred years," André Malraux said to me. "Then the succession will be thrown open, but first the face of man must change."

If I have understood correctly, according to him contemporary man, who is horrified by his own appearance, has decided to make it disappear, to suppress its features. It is for this reason that I speak of the visual and not of the figurative or plastic arts. Once the figurative has disappeared from painting and the plastic from sculpture, the arts which are enjoyed by the eye cannot be called anything else. From this point of view all the differences among the various isms that followed impressionism are smoothed over, and all the subschools which come under the *Ecole* flow together—for one who looks at them from the outside—in one effort, one intention, one cliché.

There is no French critic or intellectual who questions the importance of such a phenomenon. Abstraction (if we want to use this label arbitrarily for all the work in non-figurative or rather non-imitative painting or sculpture) is taboo in Paris today, a sacred and unquestioned thing.

This goes for judgments *coram populo,*[1] whether published or not. In private, the critics' and specialists' perplexities are many. A museum curator has two truths, one for himself and one for his friends. Some time ago I said to Jean Cassou that I considered impressionism the last great period of French painting. He agreed enthusiastically but six months later wrote exactly the opposite in an apologetic essay on cubism. In general, these curators of modern museums are literary men, not technicians, though Chamson, who runs the Petit Palais, comes from the *Ecole de Chartres.* Their museums require constant innovation and must offer shows one

1. Latin, "before the people."

after the other, and this could not happen if they were entrusted to misoneists, men with passé taste.

To be *à la page*, even as far as the visual arts are concerned, is a definite necessity of life here. The problem is not to be right or wrong but to be up to date. And apart from the dubious critics who have two truths, public and private, there are the enthusiasts, who are convinced that abstraction is the beginning of a discovery of incalculable importance. A man like Marcel Brion, an omnivorous reader endowed with an encyclopedic education, for example, condemns twelve-tone music as cerebral and then exalts the escapism of non-figurative painting and sculpture which—in his view— carries all of humanity "over the wall." And the wall would seem to be the dimensions, the categories according to which *Homo sapiens* has constructed all of his several thousand years of experience. "It's no longer a question of understanding, but of feeling," they claim. But rational intelligibility implies judgments, without which the very concept of a work of art falls by the wayside. The cry of a seagull, the zigzag of a flash of lightning, the thrusting of a salmon against the current can produce an emotion that is clearly "artistic." In a world of active, sensible men, men who don't have time to read a book or space to collect pictures or statues it's unclear what room there is for the work of art *qua* object. The man endowed with refined antennae can create the works he likes best all by himself, in the *métro* or the phone booth.

We have not yet reached this point: the works exist and the specialists can point them out to you. And the creators exist, too, enveloped in an enormous and at the same time clandestine fame. Let's leave aside the *genii loci*: Picasso, who fled after the success of his portrait of Stalin, and Braque, who is, practically speaking, virtually invisible: these two are not abstract artists, though they have distorting tendencies that are very close to abstraction; but a man like Brancusi who says he is an enemy of abstraction and yet is not terribly figurative at all, is considered a god here. When I told several friends that I had managed to approach him they couldn't believe their ears. Brion himself, who adores him, confessed he had never met him.

My safe-conduct was an old friendship that linked me at one time to Ezra Pound, the first discoverer, critic, and biographer of

Brancusi. My guide, my Virgil, was the abstract sculptor Berto Lardera, maker of sculptures in sheet iron or bronze which look like enormous aloes and can be highly suggestive planted among the trees of a park.

The Impasse Ronsin (a strange name, all the same, for a modern artist!) is a blind alley, out of which a squalid courtyard opens; it contains two shacks, and on one of them the name Brancusi is chalked in block letters. I knocked and knocked again several times and was about to leave when the door opened. Before me stood an old man in overalls; a little man with a very long, unkempt, curly dirty yellow beard. His equally long moustaches were the same color. He wore a bathing cap on his head. I noted the suspicious sharpness of his eyes, which were a fine brown. The cynic Apemantus in Shakespeare's *Timon of Athens*, the crafty old idolator and butcher of kids whom W. H. Hudson described in his novel *Green Mansions*—I had not imagined them any differently from Brancusi. Hostility, sarcasm, diffidence, boredom, irritability seem to be his characteristics. In that shack, crammed with sculptures covered by large sheets, Brancusi lives, eats, sleeps. He lives alone, runs his own errands, has no visitors. Those who wish to see him have only to stand at the end of the Impasse and wait for the hour when he returns from the nearby shops, armed with one of those yard-long loaves of French bread.

Having opened the door, he regarded me with profound antipathy. "I'm sick," he said, without asking me in. Stammering, I reminded him of our appointment and mentioned Pound's name. He signaled for me to enter, went up to the "works," and began uncovering and then instantaneously re-covering them with their hoods. In a flash of light I saw highly polished torpedo-like forms, spiral rings, columns of wood on which an eye or an ear was faintly marked, two cubes side by side (*Les pigeons*), several other structures of ramified metal, a pair of funnel-shaped umbrella stands; but the inexorable hoods fell over everything, and after an instant I found myself confronted with a hostile beard and a look devoid of all human sympathy. What to say, what to do? In my confused state, I remembered a theory attributed to Brancusi: that every

25,000 years the world is submerged in a flood and that today the catastrophe is more than near, it's imminent.

Actually, those larval apparitions had left a strong impression on me. Brancusi seemed for an instant like the powerful creator of that "dehumanization of art" which found its voice thirty years ago in José Ortega y Gasset: the sculptor of a world which aspires to reenter prehistory, of a humanity which knows only how to create grandiose formal symbols, monograms, diagrams, warnings of Apocalypse. But no sooner had I begun to mutter, "*Oui, le déluge,*" than the sinister old man lay down writhing on a broken-bottomed sofa, claiming he was dying and pointing to the door. I left with a cold nod and certainly I will never again see Constantin Brancusi, the very rich and indigent man who can scratch a piece of wood and earn a million francs, the practically ninety-year-old faun who until a few years ago still welcomed lady visitors to his studio, the sculptor who has been called the last classic, "Phidias without the anecdote."

Exactly: this is precisely the problem of the moment: art "with an anecdote" (i.e., with something that recalls the life of man) or without it. Almost none of the grand old men of Paris (including Jacques Villon, whose work sold for 6000 francs a few years ago and now goes for a million, and of course Brancusi) have completely burned their bridges with anecdote. Many of the young, however, prefer to express themselves in a language which is entirely without reference to the European figurative tradition. According to their apologists, however, they still retain their individual personalities: Hartung, who makes color vibrate, is supposedly a German, an expressionist; Magnelli, who is more linear, is a "Florentine," etc.

This whole world is reigned over by the dealers: Carré, for instance, who told André Lhote, "If you want me to take on your work, disappear for two years, become unfindable, then reappear with an entirely new style." Lhote, who wasn't dying of hunger, refused; but how many of the young do not dream of being made a proposal like Carré's?

A Visit to Braque

[First published in the *Corriere della Sera*, May 13, 1953 under the title *"La complice Marietta"* (Marietta the Accomplice).]

An "accelerated course" in French taste for tourists who are still in need of it ought to begin, in my opinion, with a visit to the *marché aux puces* and end with a visit to the studio of Georges Braque. On the one hand the odds and ends, coffee pots, cast-off rags, the secondhand goods, in short, produced by several centuries of a unified and centralized culture; on the other, the same objects interpenetrated and flattened out in compositions that have little to do with the well-known genre of the *nature morte*, although they deserve the name much more legitimately than, for example, those by Chardin or Cézanne, which are so much more alive.

Braque's work presents itself as a conglomeration, a *torrone* of old and exquisite objects. If the term "crepuscularism" had been invented in France instead of Italy, one could say that crepuscular poetry (the world under glass) had found its classical expression in France, in the work of Georges Braque.

Among the artists over seventy who still maintain the high prestige of French painting, Braque is the one whose reputation is most secure, who has the least to fear from the passing of time. A poll of the man in the street throughout the world would reveal that Picasso is much better known, but if one really examined the opinions expressed one would easily see that Picasso has as many detractors as admirers, while there is almost no one who knows Braque's work and does not express admiration or deference.

And French criticism lacks the proper terms of comparison in discussing him: as in the case of Corot, the name most frequently invoked is that of Mozart. Braque, it would seem, is not only *the*

painter, the true painter, of the cubist team, but also the greatest expression of French genius in the last fifty years. It is to his cautious and prudent instinct (as well as to the much less cautious instincts of Picasso, Matisse, and Rouault) that we owe—or are supposed to owe—that modern French painting, that new beauty "in the face of which even the painting of Renaissance Italy pales." (I quote verbatim from Jean Paulhan.)

These are not the views of isolated critics, but common opinions, widely held and widely accepted. Even those who continue to mistrust the spoiler Picasso and the other holy fathers of his generation bend the knee before Braque. And even those who admit that the Maestro's last works represent a standing-still or an *embourgeoisement* hasten to concede that for Braque everything is permitted, and that a Braque nodding is worth a whole generation of other painters awake.

But to see Braque, to talk with him or at least listen to him talk? In Paris, everyone was agreed that this was an impossible enterprise. Only old friends and a few important dealers, trailing several millions of dollars behind them, could cross the threshold of his studio. Everyone else was supposedly turned away by the immortal Marietta, a *femme de chambre* who will live in history like Proust's Céleste. In the last few weeks, besides, Braque had been especially busy painting certain *plafonds*, cartoons intended for the ceiling of a room in the Louvre, which because of them will become a place of pilgrimage no less visited than the one in the Orangerie which houses the *Nymphéas* of Claude Monet.

I had already given up the audacious notion of a visit to Braque when one day Stanislas Fumet, a Catholic critic as well as a hagiographer of the Maestro, came to my hotel and said to me in broken tones, "Good news. I have overcome Marietta's resistance. We can go." "When?" "*Dépêchez-vous.* Immediately. A taxi, let's not waste time. Later could be too late."

The rue du Douanier, which flanks the Parc Montsouris, is a modern street, one of the few in Paris where the residents can paddle around in a lovely tile bath and go up in elevators that do not present mortal dangers. The well-proportioned houses by the architect Perret are of brick, and they blend well with the mother-of-pearl light of the Ile-de-France. Stanislas Fumet (round-bearded

with bangs, halfway in between Giorgio Morandi and Fra Meli-
tone[1]) was agitated. He got out first, rang the doorbell of a small
house, bowed to the sullen old woman who came to let him in, took
her hands and held them a long time in his own, introduced me as
a decent person who would not unduly disturb the *Patron*, and
pushed me up an extraordinarily spic-and-span spiral staircase
which led directly into the large many-windowed studio where the
Maestro was awaiting us.

Braque! A tall, handsome, white-haired old man, wearing a
jacket of blue cloth and olive-colored velvet trousers, with felt
slippers on his feet. His eyes are blue and penetrating, his face
massive but also chiseled. He wears a slik scarf around his neck
and his glasses hang on his chest, attached to a cord.

One's first impression is that he carries his ninety years marvel-
ously, but the facts belie this erroneous impression. Georges
Braque, in fact, is barely seventy-one years old, for he was born at
Argenteuil, that city of caulkers and painters, in 1882. There, as a
boy, he saw Claude Monet at work and his fate was sealed: aban-
doning his studies at the *lycée* he dedicated himself then and there
to painting. "Not so bad," his father thought. "He can paint houses,
apartments."

Although cubism was already knocking at the gates by the
time Braque was twenty, his first attempts at copying Raphael (in
the Louvre) or at imitating Renoir had discouraged the young
painter, who soon found himself herded into the most curious team
of painters our time has known.

Misfortune never struck this sedentary man who has traveled
little and whose biographers note only one important event: the
serious wound he sustained in combat as a second lieutenant of
artillery at Neuville-Saint-Vaast in May 1915. He healed miracu-
lously, then returned to civilian life and painting, and had his first
success. 1919 marks the triumph of cubism, but by then the *Patron*
was already bored with it, he had already, as he says, *"foutu le
camp."*

He presents himself (in conversation at least) as a typical non-
conformist and there is nothing eccentric in his talk. *Braque* in

1. Comic character in Verdi's *La forza del destino*.

French means madcap, harebrained, as well as French pointer, but few men are less deserving of the name than he. Prudence, economy, good management, horror of risk ooze from every pore of his squarish face; a *bourgeois* is talking, a great French *bourgeois*, not a foreigner or a *parvenu*; he talks like a man for whom the figures will always add up. The critics say that in the (ideal) Picasso-Braque couple, Braque would have been the woman, the receptive being, the sharper, the stabilizing and conservative force. But this is a metaphor for saying covertly that Braque is less daring but a better painter: an opinion faintly whispered yet never openly expressed by French critics.

Braque talked at length: of himself, of Normandy, where he lives six months of the year, of Italy, which he knows as far south as Naples. He remembers Modigliani, from the time when the young man from Livorno received five francs and a bottle of rum a day from his patron. He also recalls Soffici, who used to complain about a miserly old aunt. Marinetti always struck him as mad; among the Futurists, he was interested in Balla. Medardo Rosso? A fine talent but a *sale caractère*. No one in Paris remembers him any more.

De Chirico's first pictures were very odd, but more literary than pictorial. He knows nothing about the other Italians. (Stanislas Fumet turns out to be better informed; as a former Jew and a Catholic he reveals an intellectual curiosity lacking in other French literary men.)

Braque now shows us photographs of the frescoes he has painted for the Louvre: great black birds fluttering on a deep blue background. These are oil cartoons of colossal proportions. "One can't be Raphael any more," he mumbles, lighting the end of a rather evil-smelling Gauloise. "But then," he adds, "it was impossible to do Renoir over again; each era has its own recipe." Then he talks some more about his Norman *atelier* in Varengeville; about Dieppe, which he advises me to visit out of season, when fishermen from all over the world gather there; about his wife (who does not appear); about Marietta (who does, menacingly, from behind a screen).

Braque talks splendidly, like a great gentleman farmer. In

Italy, only Count Sforza[2] talked as well, though with a more aris-
tocratic accent. He speaks and perhaps listens to himself with some
self-satisfaction, and takes a look at the works that surround him:
manikins with lobsters, carafes with guitars, high reliefs on medals,
a vase of flowers, a small seascape that might be by an Italian
chiarista. He is weighed down by years and glory, he knows he
has become a national monument and shows he is happy but also a
bit bored by it all. And I listen and look at those great painted tarts
of his, that universe which to the critics is the poem of the discon-
tinuous but which here on the contrary seems strangely car-
amelized, fused in one casting and then cut up into slices; a world
served on a tray like a *gâteau*, an entirely mental and peaceable
world unpenetrated either by faith or despair.

I look . . . but Marietta has reappeared and made a sign.
Stanislas draws her aside (a *pourboire?*), takes her in his arms,
then pushes me toward the door. Braque relights the Gauloise,
which he does not smoke. The light of sunset sets the trees of the
Parc Montsouris on fire, dissolves them into one gigantic honey-
colored Braque. The same thing happened in Florence on leaving
the Villa Loeser: everything around seemed strangely Cézannian.
And this sensation, more than anything else, contributed to my
feeling that this time I had truly encountered someone of uncom-
mon stature; one of those of whom it will one day be a pleasure to
say, "I knew him." Be he genius or talent, such is the impression left
by the boy, now in his seventies, who saw the greatest masters of
French impressionism working *en plein air*.

2. Carlo, Conte Sforza (1872–1952). Italian foreign minister 1920–1921 and
1947–1951. An opponent of Mussolini, he spent the war years in the United
States.

René Char

[Published in the *Corriere della Sera*, November 27, 1962 as the second part of the article *"Personnaggi,"* about Georges Auric and Char.]

I was visited by René Char, the poet who today enjoys the highest reputation in France, and also perhaps abroad. At fifty-five he is tall, robust, his hair is slightly curly, his gait could be that of a soldier, even if the cane he leans on reminds me of certain of his auto accidents. He was a hero in the *maquis*, but according to him it all began by mistake: the Germans were looking for him because they thought he was someone else. Yet a tough partisan fighter resulted from their error, as well as the *Feuillets d'Hypnos*, which remains the most beautiful book of poetry published in France in many years. The "pages" are the fragments, illuminations, aphorisms of an exceptional season in life: in them physical sensation is completely cauterized by a sensation that could be called metaphysical if the word were not suspect. In Char the instant, the real moment, throws open its doors and immerses him in the concrete experience of eternity. I am not surprised to hear him talk of the pre-Socratics, the only philosophers who interest him, and the only ones unknown to the philosophers of today.

Char lives in Provence, in the Vaucluse, at L'Isle-sur-la-Sorgue. Petrarch, naturally, is one of his poets. And talking with him I feel as if I am putting my fingers in a burning brazier.

He rarely comes to Paris, he abhors the cabals and cliques of the literary world, the stuffing (*saucissonnage*) of every ingredient into the current products of literature and the theater. One could call him a pessimist if his were not a pessimism which reveals a profound faith, perhaps hidden even to himself, perhaps the only faith possible for a man today. Poetry as a profession, as a literary

genre, cannot interest him; today it is a product which can be perfected *ad infinitum*, a dead thing, a tool. Yet it can happen that the poet finds someone who receives his message and shows signs of life from afar: these are the cases when the *bouteille à la mer* has reached its destination. Is there any value in this invisible network of correspondences and echoes which seem to have come from beyond the grave? It certainly serves to confirm to the poet that he is not living in a dream but in a more real world, the only world that guarantees a reality. There is nothing true about all the rest (politics, parties, business, social and economic structures), they simply exist; the man who has understood life can only keep his distance.

Aestheticism, *art pour l'art*? Nothing could be less true of a poet who had been described to me as irritable and difficult, and who in fact is the very model of cordiality and intellectual honesty. The straitjacket of the *esprit de finesse*, of the old French rationalism, has not confined the soul of this man of the south who is exposed to all the winds but stands steadfast on the shoals of an ancient ancestral wisdom. And the fact is that one feels comforted leaving this pessimist, while after meeting the many Panglosses of today one can be given over to the darkest kind of despair.

Tributes

—————

For Lina Saba

[Published in the *Corriere d'Informazione*, December 1–2, 1956. Originally followed by a poem from Saba's *Canzoniere*. A friend of Saba's from 1925, Montale was also one of his earliest and most sympathetic critics, though the two poets were temperamentally and artistically extremely different. See Lanfranco Caretti, "*Il Saba di Montale*," *Nuovi Argomenti* (#57 Nuova Serie), January–March 1978, for a discussion of the literary relations between these two great poets. Saba, who was born in 1883, died in 1957, less than a year after the passing of his wife Lina.]

A telegram from Linuccia Saba in Trieste informs me of the death of Lina Saba, who was not only the wife of the poet Umberto Saba, but one of the most vivid presences in modern Italian poetry. One of the greatest parts of the *Canzoniere* of the great poet from Trieste—*Trieste e una donna* [*Trieste and a Woman*]—is dedicated to her, "to Lina the seamstress." The grief that I share at this moment with Umberto Saba and his Linuccia, whom I knew as a baby, makes it extremely difficult to describe the memory that Lina Saba leaves in those who loved her. In such cases, there is always something unbelievable in a mere notice, a cold announcement. Those who have met Saba and lived a little with him cannot think of him as separated from Lina, the astounding, keen, earthy Lina, blessed with an unchangeable disposition, with a resistance to life which made her steadfast in the face of the worst experiences fate had reserved for her. Always herself, kind and serene, farsighted and shrewd, tender and blessed with a pungent, sharpened irony in Trieste as in Florence, where the Sabas took refuge in a shameful hour in our national life, Lina Saba was always equal to the image of her drawn by the friends and admirers of the Poet. Neither good nor adverse luck could ever bend a character that was entirely worthy of her destiny as inspiration and companion of a

great spirit who was devoted to—who had a vocation for—suffering. In terrible times, when even to leave one's molehill was a grave risk, the author of these lines did not feel he was performing an act of courage in leaving his hiding place to set out for the market district of Florence, where the Sabas had found refuge. Perhaps the risk was less serious than it seemed; or perhaps the Sabas were the kind to lend courage to those who don't have much; but it is certain that in that year, as long as it was possible, I never missed my daily appointment with Umberto and Lina Saba; and it is just as certain that one part of my quiet rashness was suggested to me, inspired by her, by the marvelous, serene, confident Lina Saba. Those who knew her can never forget her, and will perhaps come to consider her transit, her passage on earth, as an insignificant fact, a mere phenomenal apparition. For others . . . the poems of the *Canzoniere* will remain, of which the poet dedicated a great many to her which will long preserve her memory.

In Memory of Roberto Bazlen

[Published in the *Corriere della Sera*, August 6, 1965.]

I have known two B.B.s in my life, but the one who left the larger trace in me was not the Lord of *I Tatti*, Berenson, though he honored me with his benevolence; rather it was the Bobi Bazlen who was found dead in a hotel in Milan on the 27th of July, and whom only a few friends were able to accompany for a last farewell at the cemetery for those who die without heirs and without being listed in the Milan record office. Two evenings before, I had expected him for dinner at my house, and had had prepared for him a dish that he adored: the *pan cotto* of the Tuscan peasants. He never came, and this surprised me, for I knew him always to be punctual and exact, in spite of his apparent disorder. I even had an unhappy premonition, which I hastened to dismiss. Only the next morning did I learn that I would not see him again.

Who was B.B.? I must try to explain him to those who know nothing about him, and it's not easy. He would have been offended to hear himself described as an "intellectual," but with him in fact disappears the last and most unusual representative of the Triestine intelligentsia of the thirties; and in his case I could even say of the twenties, for it was in 1924 that he began to export from Trieste the riches of its wisdom and its uneasiness.

His father was an evangelical Swede. He died when his son was barely three, and Bobi remembered only his whiskers. His mother, Clotilde, a Jewess and an extremely loving woman, lived in fear that "something was going to happen" to her only son. I still

remember her embrace and her imploring "Roberto mio" when Bobi left the house for more than a few hours.

Bobi had studied in a German school in Trieste and he spoke several languages, but German alone (at least in his early years) was his most congenial tongue. He had had an education which today would be called Hapsburghian, though there was nothing nostalgic or retrospective about his culture. When he came to meet me in the winter of 1923–1924, sent by I don't know whom, he was for me like a window opened onto a new world. We saw each other every day in an underground café near the Teatro Carlo Felice in Genova. He told me about Svevo, and later had the author himself send me his three novels; he introduced me to much of Kafka, Musil (the plays), and Altenberg. I was already familiar with Saba's poetry, but Bobi also revealed Giotti and Bolaffio[1] to me, and later Carmelich. On my own, I added Benco, Stuparich, and, years later, Quarantotti Gambini[2] to the list. Between 1925 and 1930 I too became practically an adoptive citizen of Trieste, though I did not then foresee that one day I would marry a woman of Triestine origin whom Svevo in time would introduce to me.

When I moved to Florence in 1927, I believe Bobi was still living in his native city. From then on, I saw him less and less, but our friendship did not suffer, for Bobi's faithful were always multiplying and I was always hearing news of him as if "broadcast live." Among the faithful I should mention at least Sergio Fadin,[3] an exquisite poet who died young. During my twenty-year stay in Florence Bobi spent several years in Milan and then in Rome, which he left after his house in the via Margutta was destroyed.

One mustn't think of him as the usual type of German in love with the South. He was simply a man who liked to live in the interstices of culture and history, exerting his influence on whoever could understand him but always keeping out of the limelight. A *bon vivant*, a lover of good wine, curious about everything, and

1. Giotti: See Note 1 to "Italo Svevo in the Centenary of His Birth." Bolaffio: See Note 7, *ibid.*
2. Silvio Benco (1874–1949): Irredentist Triestine novelist and editor. Stuparich: See Note 8 to "Italo Svevo," *ibid.* Quarantotti Gambini: *Ibid.*
3. See Montale's poem *"Visita a Fadin"* in *La bufera e altro* for a moving tribute to this Florentine friend of Montale's.

capable of walking twenty kilometers to find a new *osteria*, he was above all incomparable at suggesting and raising ever-new intellectual and moral questions. Regularly ahead of his time, he often abandoned his ideas when he saw they had become too accepted by others. As far as I know, he never held a normal job, but many publishers made use of him, sending him out "on patrol" into unexplored territory. Many good and rare books published in Italy would never have appeared if B.B. had not forced them on reluctant editors. A phenomenal *voyageur autour de sa chambre*, I believe he also traveled a great deal abroad, but I don't know how, for his disdain for money was enduring. In his last months a distinguished publisher in Milan granted him a modest salary, but Bobi collected only a small part of it, the little he thought was sufficient to live on.

Was there a mystic hidden in him, or at least a religious without a religion? One can suppose so, even if the idea would have been offensive to him. He never uttered words like "spirit" or "soul." And yet the fact that, after a long youthful immersion in Freud and Jung, he made a deep and broad study of every possible Orphic and mystical tradition, would seem to confirm the hypothesis. He did not believe that the substance or even the body of man had a real existence. He thought death was a word without meaning. In any case, no one ever knew what kind of transcendence flashed in his mind. I believe it was not the transcendence of the philosophers (whom he detested); perhaps it was a very private alchemy elaborated in the depths of an assiduous experience of the absurd. (But here, too, we need not think of the absurd of the existentialists.) If he had a faith, it must have been practiced iconoclastically and been entirely unnameable. The books he loved (poetry above all) were not the *great* books, but those he could make over and integrate into his thought: unusual books, underground or nearly so. But he made an exception for one great: his Strindberg.

He left some unpublished poems (written in German) and many drawings: nothing he intended to publish and certainly nothing that can be considered a body of work; nothing, probably, that can give his true measure. Master of a culture that was entirely subterranean, he left those friends who wish, as they say, "to pre-

serve his memory" in an awkward situation. I imagine such an undertaking would horrify him. Perhaps all his teaching is summed up in what he said one day to Sergio Solmi (one of his oldest friends): "To understand something you have to go crazy and keep your head at the same time." This he must have succeeded in doing perfectly. He paid dearly for his experience: certainly it was such that it could not be measured in the currency of this world.

Recollections of Sbarbaro

[Published in the *Corriere della Sera*, November 5, 1967. Camillo Sbarbaro (1888–1967) was a leading poet of the Ligurian crepuscular school, and an important influence on the young Montale. See the two *"Poesie per Camillo Sbarbaro"* in *Ossi di seppia*. See also "Intentions (Imaginary Interview)".]

Sbarbaro tells this story in his book *Fuochi fatui* [*Will-o'-the-wisp*]: "Rimbaud was the addiction of my adolescence. Montale found a copy of the Mercure de France edition that was missing Fantin-Latour's portrait of the poet in a bookstall one day. 'I knew from this that it was your copy,' he told me." For me, this was simply an indication of the physical existence in my city of the author of *Pianissimo* and of a few poems published in *La Voce*, *Lacerba*, and *Riviera Ligure*,[1] which devoted an entire issue to Sbarbaro, a whole plateful of shavings.[2] My idea of the poet was that he was a *maudit* with all his papers in order; but not so much a man given to drunkenness as an impeccable dandy. I didn't know anyone who knew him personally, or even anyone who had heard of him. So for some time, I'm not sure precisely when, but certainly after the publication of that issue of *Riviera Ligure*, I tried without success to make him out among the few night-walkers who frequented the arcades and galleria of the city.

1. A leading literary review, founded at Oneglia in 1899 by Mario Novaro. Among the writers he published were Pirandello, Soffici, Cecchi, Saba, Jahier, Slataper, Govoni, Moretti, and the Ligurians Roccatagliata Ceccardi and Boine, whose critical *Plausi e botte* appeared here. The review ceased publication in 1919.
2. *Trucioli* [*Shavings*] was the title of Sbarbaro's third collection of poems, published in 1920.

Then one day someone, probably the highly *maudit* Pierangelo Baratono, introduced me to a short, rather ruddy young man who looked nothing at all like Huysmans' Des Esseintes, and said, "This is Sbarbaro." I have called him a young man, but there was eight years' difference between us, and this made me very shy. Yet it wasn't very long before the ice was broken. Pierangelo, who worked in the post office and was the author of extraordinary stories and unfortunately impeccable Parnassian sonnets (I remember three of his "sonnets to Sbarbaro") had met him several times in the company of Ceccardo,[3] but I had kept my distance: perhaps I feared the "whiplash" of the author of *Viandante*. I don't know if Sbarbaro was still working for the Ilva.[4] He lived in the via Montaldo, on the hill which runs down to the Staglieno cemetery, and might have been called a collector of funerals. Later I learned that he collected mosses and lichens instead. "He who diagnosed this at the time as a form of despair was correct." I believe I was the author of the diagnosis. But here's more of what Sbarbaro thought of this passion of his: "I've just returned the proofs of my latest botanical compilation: thirty years of research, 127 new species for science. I too have lent a hand to the inventory of the world."

I continue to dig around in my memory. From the year when we first met until 1928 when I left Genoa, I spent hours and hours with Sbarbaro on many occasions, not only in the Galleria but also with mutual friends: with Lucia Rodocanachi at Arenzano, and with Angelo Barile a little bit everywhere (the poet of *Primasera* was much more elegant than Camillo and was then trying to start a business in an office in the Piazza San Lorenzo; later he returned to Albisola Capo to devote himself to the family company). Not infrequently we were joined by Adriano Grande,[5] who was then a

3. Ceccardo Roccatagliata Ceccardi (1871–1919). Ligurian poet and journalist, contributor to *Riviera Ligure*, author of *Sillabe ed ombre* [Syllables and Shadows]. A decadent poet in classic form, he adopted the *maudit* role of the "wayfarer" in his work, most notably in his *Viandante* [*Wayfarer*] (1904). He influenced both Sbarbaro and Montale.
4. *Ilva* is the Latin name for the island of Elba, famous for its iron mines; by extension, epithet for the *Alti forni e acciaierie d'Italia*, Italy's principle steel-making concern.
5. (b. 1897). Genoese poet, editor of the reviews *Circoli* and *Maestrale*.

night watchman in a factory. After 1928 we saw each other rarely. Then in 1934 we met for two or three days near Siena at the hospitable home of Elena Vivante, who was virtually Sbarbaro's soulmate. Still later a few cards, news brought by Vanni Scheiwiller,[6] who was a great comfort to Camillo in his old age. This was enough to keep alive a friendship that nothing could obscure.

And the poetry? The poetry that will preserve Camillo's name when other collectors of lichens have buried his research? Here, to speak the truth, I must say that literary institutions rarely entered into our conversation. A highly cultivated man, a formidable translator, an excellent student of Greek though he never went beyond high school, Sbarbaro believed firmly that life was more important than literature. But which life? All the critics who have written about him, and they are many and authoritative, have emphasized his dramatic, perhaps tragic, sense of life: and they have questioned how much of his work is documentary and how much is resolved in the crystal of achieved form. Before them, Giovanni Boine[7] had said that the poetry of *Pianissimo* was of the sort that survives the ages; and Sbarbaro was then all of twenty-four. Could he go on? He went on to a different maturity and in another key, though he later revised his early work without success. Today it is easy to see that his development, which led to *Trucioli* and the later prose of *Liquidazione*, was coherent, and that the range of his experimentation was anything but restricted if it could bring him to the *Ammaestramenti a Polidoro*, which may be the first example of the confidential style in our literature, and certainly is not the least successful.

Sbarbaro's art consisted of brief flashes, and the drug that brought him to these happy moments was life; life sensed as something inexplicable but nonetheless worthy of being accepted. To write for him was to wait for the moment when the dictation—whose dictation?—was fully matured. . . . Yet Camillo never con-

6. Publisher of the distinguished small press *All' Insegna del Pesce d'Oro*, founded by his father, Giovanni. The house has published many important writers and artists, among them Ezra Pound and Montale himself.

7. (1887–1917). A leading Ligurian poet and critic, contributor to *La Voce* and *Riviera Ligure* (see above). His best-known works include *Frantumi* [*Splinters*] and *Plausi e botte* [*Plaudits* and *Gibes*], contemporary literary criticism.

ceded anything to the irrational and always stood apart from literary groups or cliques. After leaving Genoa, then a city of slight intellectual interchange, he immediately sequestered himself in Spotorno, facing the sea, which rarely appears in his poems and prose. He was a man of *terra firma* and of few but faithful friendships. It is also my impression that, all in all, his was the life of a successful, maybe a happy man. Fate had granted him the gift of expression and for him that was enough. I don't know what book he said this in, but one doesn't have to flip through his not so many pages to realize it. He led the life of a just man, a man who never asked anything from the world and tolerated poverty, if not indigence, because every other form of wealth would have offended his sense of common dignity, of decency.

Ungaretti: A Tribute

[Published in the *Corriere della Sera*, June 4, 1970. Giuseppe Ungaretti died on June 1, 1970.]

Ungaretti had returned two months ago from Oklahoma, no less, where he had been awarded an important "international" literary prize. It is probable that at the age of eighty-two he had embarked on that voyage and the attendant celebrations with that enthusiasm, that gusto for life and experience, which touched all of those who came into close contact with him: friends, critics, admirers, nuisances, and disciples, too, for the poet for many years was also professor of Italian literature at the University of Rome. It was a prodigious leap from the University of São Paolo (Brazil) to Rome, an indication of the by then undisputed reputation that his work as a poet had earned him.

Ungaretti was greeted early on (by Papini in 1917, after the publication of *Porto sepolto* [*Buried Port*] in 1916) as one of those poets—so rare in Italy—who "wring the neck of eloquence." His short poems, the so-called *versicoli*, came apart vertically on the page, giving the illusion of a spontaneous poetic percolation. The white page, the capital letter at the beginning of each line gave the impression, on the other hand, of a newly rediscovered classicism. Both impressions were correct because Ungaretti did not sing like the birds, in fact he was a relentless tormentor of the written page (his variations are famous and innumerable and they have now been recorded by his very faithful Leone Piccioni). But along with the torment there was grace: the moment of truth, the climax of a waiting period that was often long.

This first book was reprinted several times (it later became *L'allegria di naufragi* [*The Joy of Shipwrecks*] and *L'Allegria*) and

it was followed by other collections, which were brought together under the title *Sentimento del tempo* (1933). The critics, and Alfredo Gargiulo in particular, spoke of a restructuring of the hendecasyllable, which had always been evident because even the *versicoli* (if we ignore their ideographical arrangement) can almost always be reduced to traditional meter. Ungaretti's true value was something else, something truer: to have given us something like a summing up of the various tendencies that animated European poetry beginning with French symbolism. The fact that this work was also carried out without deviating from the genius of our language and tradition, rather than making Ungaretti a destroyer, only confirms the authenticity of his work as poet and translator. I lack the time and space to follow the later developments of Ungaretti's poetry. But the poet's reputation, apart from the lack of understanding of certain "strict" Croceans, never truly suffered obscurity. I will leave to others the task of a summing up. There are already those who have done a great deal in this regard.

Of Ungaretti the man, whom I met only rarely, I can say that he gave the impression of an overflowing vitality. In 1968, when his eightieth birthday was celebrated in the Campidoglio,[1] I was among the speakers chosen to present him with those due and proper wishes which certainly expressed the feelings of all who were present: ministers, parliamentarians, men of culture. The poet of *L'Allegria* answered in his own way: with a wit that could be called joyful. But the man was already visibly bent and tired. He continued to live and even to travel, perhaps not imprudently. And now that he is completing his final voyage toward the *porto sepolto* I would like to thank him much better than I was able to on that occasion.

1. The ancient Roman Capitol, now headquarters of Rome's municipal government.

Voluntary Exile
in Italy

[Published in the *Corriere della Sera*, November 3, 1972. Pound died on November 1, 1972.]

I was introduced to Ezra Pound for the first time in 1925 by Carlo Linati,[1] and saw him on frequent occasions in Rapallo and Florence. In those days, another great poet also came frequently to Rapallo, the Irishman W. B. Yeats, one of the few moderns whom Ezra admired without reservation. Yeats didn't speak a word of Italian, but Pound already spoke our language with fluent incorrectness. At that time he was preparing his edition of the poems of Cavalcanti, which was judged a disaster. His small, difficult-to-obtain anthology of American poets, *Profile*, published by the Italian Scheiwiller, dates from this period. This little book in itself would be enough for us to intuit not the Poundian *ars poetica* but his concept of poetry as a perennial "work in progress."

The culture of Ezra—Uncle Ezra to his friends—was audaciously retrospective; this may seem paradoxical, but in him it was reality. And it was not that far, for that matter, from the position of a poet who owed Pound more than a little: T. S. Eliot. I daresay (while maintaining all the distances, for the late Eliot was all order and discipline) that these two Americans were two barbarians (the word should not be understood in the pejorative sense) who assimilated European culture, carrying out an exploit of extremely clever but also superficial revision of whatever in our classical heritage

1. (1878–1949). Lombard novelist and translator of Yeats, Synge, Stevenson, Joyce, Lawrence, et al.

could be of use in their personal evolution. I don't allude to a common idea of a possible *Weltliteratur* but rather to an ideal constellation of the Great of every age, of every century. Pound created an imagism of his own, and with great success, but he also cast an eye on the China of the golden dynasties and immersed himself in the study of the Provençal poets. One of his poems on the troubadour theme, "Provincia Deserta", will remain one of his undisputed masterpieces. The book which includes it, *Personae*, if I am not mistaken, is without a doubt one of his best. In his more than one hundred, perhaps one hundred and ten *Cantos*, the poem aspires to be the *summa* of world history as seen by a poet "as an old man." Not a Dante *redivivus* but a Dante on the threshold of insanity.

Yet I believe Pound's insanity was a happy invention on the part of those who wished to save him from the electric chair. Pound loved Italy, he certainly loved it better than his Italian accusers, but this feeling of his was bound up in a socioeconomic bundle which came together in a fierce hatred for the Demiurge (I mean the organizing demiurge, not the supreme Creator) who rules the world: Usury. Whence his aversion for the American economic system, which has or is supposed to have usury as its supreme god. A socialist or even a Communist Pound? Not a chance. Rather, a libertarian utopianism which is not even historical anarchy because its foundation is laid by an aesthete, a man for whom beauty—his beauty, not that of the crowd—is the only value that matters.

Curious about history, but even more anti-historical than Eliot, Pound could therefore not consider himself badly off in an Italy which for him was still a country uncorrupted by the capitalist fever. He loved the Italy of the Renaissance and its music, he loved the France of Flaubert and Laforgue and Rémy de Gourmont; he was convinced (this was his happy discovery) that poetry is born of prose; he loved many artistic currents that made Europe an avant-garde continent; and thus he was the most qualified among so many exiles in Paris and later in Italy not to grant any importance to the regime that kept Italy out of the hated community of usury. The American in Paris, the American in Italy! How happy these irresponsible self-exiles must have been!

And up to this point we can understand why Uncle Ezra had

no substantial objections to Fascism. The behavior of many Italians much more cultivated than he was much worse. But let us be careful: to understand is not to justify. And when they come to tell us (I did not hear him myself) that Pound on Radio Roma sided against his own country in war and bestowed unconditional admiration on the figures of Hitler and Mussolini and on the anti-Semitic measures that later became a terrifying genocide, then we must think that the mature Pound could not have spoken so if the irresponsible man, the man alienated from himself and his world, had not prevailed in him.

I have not heard the tapes recorded by Pound as a guest of Rome and *persona grata* to that regime. I am very sure that the massacres and the crematory ovens were news, facts of which he never had any idea. But all of this renders more plausible that sense of the unfinished which his body of work always left, for all its very brilliant aspects. Pound was a profoundly good man, of this I am sure. But the playing with words, the reduction of the facts of history (it doesn't matter whether Chinese, Japanese, or Italian) to so many Stravinskian *jeux d'artifice*, this was the worry that always concerned his best friends: among them Eliot who looked for his own new roots and found them where he could, while Pound's uprooting amounted to an almost involuntary self-destruction. When he returned to Italy for several years after his harsh American punishment, Pound hardly spoke again. He was always dignified, polite, human, but absent. I will continue to think of him as I saw him in Rapallo and in Florence, the great tennis player and the almost-professional discoverer of geniuses who did not always turn out to be such.

Interviews &
Self-Criticism

On Contemporary Poetry

[Published in *La Gazzetta del Popolo*, Turin, November 4, 1931.]

I. If as many do we understand poetry to be a specific liter-ary genre, fixed in inviolable formulae and forms, it seems clear to me that the "current situation" of poetry is a very bad situation indeed. But if we make the effort to delineate some principles, to point out some signs of life and newness, in the automatic produc-tion of the "genre," then the problem changes aspects, and signifi-cantly so. I don't believe in the fated, pre-established line (as in D'Annunzio's "the line is all") but I do believe in certain great possibilities of feeling and imagination, certain combinations of word and rhythm, which even seem to have a life of their own, and undoubtedly have an incredible fecundity, for when the true poets give us something of the sort, crowds of imitators arise and some-times not even the shrewdest of critics can tell the original from the imitation.

In any case this is not a crisis that is peculiar to poetry. The poets for their part renounced their "role" as annunciators and prophets, at least in the old sense of the term, some time ago, and I believe this is a good thing. Think of the "public" Pascoli and you will be convinced. Of course, solitude is difficult for poets, who are condemned to not even understand each other. But it is only out of such suffering that poetry can redeem itself.

2. There has been talk about the "Adamism" of the Spanish spirit. I believe one can also speak of it in relation to the majority

of today's poets, who tend to make a *tabula rasa* of their own culture and history, availing themselves of the most rarefied means in their worldly experience for this purpose. Out of this paradox— when it is felt as a necessity and isn't window-dressing—comes the most notable poetry of our time. Naturally, there are many exceptions.

3. The new poetry has been marked physiologically by the "mechanical culture of our time," but it overcomes its surroundings, when it overcomes them. If automobiles were to disappear one day, what would remain as evidence of the automobile age would in fact be the poetry of today. (Naturally, not the "motor poets," who belong to the category of the most delicate Arcadians.)

4. The problem of open or closed forms is of little interest. All good poems are open and closed at the same time: they obey a law, even if it's invisible. Leopardi is obviously more "closed" than Carducci. Yet pre-established architecture, rhyme, etc.—apart from the uses the great poets have made of them—have had a more profound significance than the free-verse poets recognize. Essentially, they are obstacles and artifices. But poetry is impossible without artifice. The poet must not only give vent to his own emotion, he must also work his own verbal material "into a certain sign," he must provide what Eliot calls an "objective correlative" for his own perception. Only when it reaches this level does poetry come into existence and leave an echo of, an obsession with, itself. Sometimes it lives on its own and the poet doesn't recognize it any more: it doesn't matter.

Therefore the free-verse poets who renounce traditional forms, rhyme, etc., do not escape the necessity of finding *something* to replace what they have lost. Some find it, and these are the true poets; the others continue to pour themselves out and achieve nothing: though they be at least as well read as the Parnassians of old.

Let's Talk About Hermeticism

[Published in *Primato* (I, 7), June 1, 1940. *Ermetismo* was originally a de-precatory reference to the supposed obscurity and subjective impressionism of Ungaretti, Montale, Quasimodo, and other poets of the 1930s. The term was coined by Francesco Flora in *La poesia ermetica* (1936), where he attributed Ungaretti's esotericism to French symbolist influences. Pier Paolo Pasolini, on the other hand, saw hermeticism as a kind of passive resistance against Fascism. Montale always denied any willful obscurity in his work, and dissociated himself from membership in any such movement. If, in fact, a hermetic movement can be said to have existed, its membership would probably be made up of younger poets imitative of aspects of the work of Montale and Ungaretti, such as De Libero, Gatto, Sinisgalli, etc. See also "Is There an Italian Decadence?"]

I have never purposely tried to be obscure and therefore do not feel very well qualified to talk about a supposed Italian hermeticism, assuming (as I very much doubt) that there is a group of writers in Italy who have a systematic non-communication as their objective. Yet I will try to respond in a few words to the problems raised by your questions. Let us set aside, if you will, the obscurity of certain critics, though it is notable; in the best of hypotheses they are poets in embryo—collaborators and partici-pants in a poetry that is coming into being and would do so per-haps even without their cooperation. And let's set aside, too, the neo-surrealist sympathies that flourish here and there in the writ-ings of the young, products of mimicry or of elective affinities which so far have led to nothing noteworthy. If they do amount to

something, those who try to understand and confuse mediumistic creations with works of art in the normal sense of the word will evidently be in error. Let us limit ourselves to poems which *are not understood* and yet clearly ask to be understood, that is, judged as works of art, works of effective communication. And while we wait for them to be understood tomorrow, let us try today to see the reasons for this phenomenon without recriminations. It is directly related to the process of liberation, of achieved "autonomy" of the artistic act, which is well known to aesthetic theorists and which has even recently been the subject of a well-documented book by Anceschi. Poetry, to limit ourselves to this one subject, has tried itself to discover the laws of its own purity, and has sometimes managed to take direct inspiration from the self-knowledge it has achieved. Let us follow didactically one single thread to orient ourselves (though there are many indeed). There is a well-known notion—which Poe took from Coleridge—according to which only the short poem is acceptable and legitimate, as we are unable to tolerate long-lasting pleasures or emotions. A long poem according to this theory would be a collection of short poems, with a more or less fictitious, extrinsic unity. To which it was (more recently) objected that the ethico-psychological unity of a long poem may resolve into a general tone which effectively brings together its scattered parts. This is debatable (one can imagine what a Poe, a Croce, a Valéry, and even . . . a Leopardi would say in response); but let's set this aside for now. The fact is that the theory has been successful: not only the theory in and out of itself, of course, but the works from which and in which it developed, accompanied by the increasing "sensitization" of the other arts. And the short autonomous poem has prevailed, enriched by precisely what it has borrowed from the other arts, which also find themselves in crises of autonomy. Today it is clear that the short poem was bound to gain in intensity what it lost in extension; it is a brief step from the short poem to the intense, concentrated poem; and it is an even briefer step from the intense poem to the obscure poem. And here we have arrived at a sufficient explanation: one of a great many, we realize. The supposedly *obscure* poet is, according to the theory most

favorable to him, the one who works his own poem like an object, instinctively accumulating meanings and metaphorical meanings, reconciling the irreconcilable within the poem so as to make it the strongest, surest, most unrepeatable, most definitive correlative of his own internal experience. Note that the new poet, who is independent in the severity with which he excludes every finalistic, extra-aesthetic element from his work, is anything but independent in his definition of his art, and accepts considerable borrowings from the other arts, which also borrow similarly from his own art, poetry. Which further complicates the nature of poetic-painterly-musical production and increases the possible causes of obscurity in various ways. But the tendency, among all the infinite variations, remains the same: toward the object, toward art invested, incarnated in the means of expression, toward emotion which has become *thing*. Understand here that by thing we don't mean the external metaphor, the description, but simply the resistance of the word within its syntactical nexus, the objective, finished, and not at all Parnassian sense of a form *sui generis*, to be judged case by case. Is this anti-traditional poetry? Not at all; rather it is poetry in the one tradition that has made Italy matter in the world for centuries. Is it poetry at a far remove from the idea of imagination as it developed from Vico to De Sanctis? It is certainly not unrelated or without consequence, if idealistic philosophy, which today has dissolved into a new, profound empiricism, is in fact one of the causes which has contributed to the current "sensitization" of the arts. But it is precisely here that we touch on the most difficult point. Lyric poetry as a genre is an abstraction which can become concrete *only* in certain cases; poetry, which has only recently been admitted into the company of the Fine Arts, has a tendency—as it always will—to leave them (which is the same as acknowledging that it also has and always will have the tendency to reenter them: a swing of the pendulum). The objective looks for a justification in the subjective which it implies, in the spirit; the impurity, if it is shooed away from the door, reenters through the window. Thank goodness! Here a great space opens up for investigation by the historians of tomorrow who will have to distill our spirits from our work and

find the thread of continuity that binds the past to the future; to the great confusion of the pure aesthetes who cannot succeed in restoring the Word as a general law and the great relief of those who hold fast to the belief that there can be no great poetry without great spirits.

Intentions
(Imaginary Interview)

[Published in *La Rassegna d'Italia*, (I, 1), Milan, January 1946.]

—If I've understood your question correctly, Marforio, you would like to know at what moment, and due to what accidental cause, in front of what picture, I was able to declare prophetically, "I too am a painter." How I became committed to and recognized in my own art, which has not been painting. It's very difficult to explain. I never suffered from an infatuation with poetry, nor from any desire to "specialize" in that sense. In those years almost no one was interested in poetry. The last success I remember in those days was Gozzano,[1] but the strong-minded disparaged him, and I too (wrongly) shared their opinion. The better *littérateurs* who were soon to gather around *La Ronda*[2] thought that from then on poetry should be written in prose. I remember that after my first poems had been published in Debenedetti's[3] *Primo Tempo* I was treated with irony by my few friends (who were already immersed in politics, more or less anti-Fascist, by 1922–1923). And Gobetti,[4] who printed my first book in 1925, wasn't overjoyed when I sent

1. See "Two Artists of Yesteryear."
2. See Note 4 in Introduction.
3. Giacomo Debenedetti (1901–1967). Leading literary critic and writer influenced by Gobetti and Gramsci. Editor with Sergio Solmi of *Primo Tempo*, 1922–1924.
4. See Notes to "Style and Tradition."

him a political article for his *Rivoluzione liberale*. He too believed, as the various Scrutators and Babeufs[5] of Roman monarchical journalism believe today, that a poet can't and shouldn't *concern himself* with politics. He was wrong; not that I was very sure of being a poet.

— . . .

—Am I sure of it today? I wouldn't know. Besides, poetry is only one of a great many possible positive activities in life. I don't believe a poet stands taller than another man who really exists, who is someone. I too acquired a smattering of psychoanalysis in its time, but even without recourse to its lights I thought early, and I still think, that art is the form of life of the man who truly doesn't live: a compensation or a surrogate. Which is not to justify a deliberate ivory-tower attitude: a poet mustn't renounce life. It's life that undertakes to flee from him.

— . . .

—I wrote my first poems as a boy. They were humorous verses, with bizarre, truncated rhymes. Later, when I'd discovered futurism, I also made some *fantaisiste*, or if you will grotesque-crepuscular, poems. But I didn't publish and wasn't sure of myself. I had more concrete and stranger ambitions. At the time I was preparing for my debut as Valentin in Gounod's *Faust*; then I studied the entire part of Alfonso XII in *La Favorita* and Lord Astor in *Lucia*. My experience, more than intuition, of the fundamental unity of the various arts must have come to me from that source. The indications were excellent, but after the death of my teacher Ernesto Sivori, one of the first and most famous *Boccanegras*, I changed course, also because I was suffering from unrelieved insomnia. The experience was useful for me: there is a

5. *Scrutator*: Latin, "examiner"; cf. Alfieri, "*tu sovrano Scrutator dei più ascosi umani affetti.*" François Babeuf (1760–1797): Extremist political agitator in the French Revolution; known as "Gracchus."

problem of pitch outside singing, too, in every human activity. And I believe I am one of the few surviving today who understand our opera. To Verdi we owe the surprising reappearance, in the midst of the nineteenth century, of a few sparks of the fire of Dante and Shakespeare. It doesn't matter that it's usually mixed up with the fire of Victor Hugo.

— . . .

—Yes, early on I knew some of the Ligurian poets (though not personally, except for Sbarbaro): Ceccardo and Boine,[6] among others. Where they come closest to the consistency of our soil they certainly were a lesson to me. I admired the fidelity and art of Sbarbaro, but Boine was only half a poet, and Ceccardo, who was wholly one, never really understood his instrument. He lived facing the past, always in need of academic recognition. Far from proclaiming himself a boy wonder, he was too suspicious of the child within. Still, none of his contemporaries had a voice comparable to his in stretches:

> *Chiara felicità della riviera*
> *quando il melo si fa magro d'argenti . . .**

— . . .

—When I began to write the first poems in *Ossi di seppia* I certainly had an idea of the new music and the new painting. I had heard the *Minstrels* of Debussy, and in the first edition of the book there was a little something that tried to imitate it: "*Musica sognata*" ["Dreamed Music"]. And I had looked at the *Impressionisti* of the much-maligned Vittorio Pica.[7] I should add that after the grotesque poems I wrote a few sonnets—halfway between philo-

6. See "Recollections of Sbarbaro."
*Clear felicity of the seacoast / When the apple-tree becomes thin with silver
7. (1864–1930). Italian man of letters and art critic, one of the founders of the Venice Biennale.

sophical and Parnassian—like those of Cena's[8] *Homo*. But by 1916 I had already written my first fragment *tout entier à sa proie attaché*: "*Merrigiare pallido e assorto*," of which I later revised the last stanza. The prey was, it's understood, *my* landscape.

— . . .

—No, I knew even then how to distinguish between description and poetry, but I realized that poetry can't grind on nothing and that there can't be concentration until there has been diffusion. I didn't say *waste*. A poet shouldn't spoil his voice with too much *solfeggio*, he shouldn't lose those qualities of timbre which later he'll never recover. There's no need to write a series of poems where one exhausts a specific psychological situation, an occasion. In this sense the lesson of Foscolo, a poet who never repeated himself, is exemplary.

— . . .

—Don't misunderstand me, I don't deny that a poet can or should exert himself in his calling, inasmuch as it is such. But the best exercises are internal, acts of meditation or reading. Reading of all kinds, not poetry: it's not necessary for the poet to spend time reading the work of others, though he shouldn't be ignorant of what has been accomplished, from the technical point of view, in his art. The language of a poet is an historicized language, a relationship. It's valid to the degree that it opposes or differentiates itself from other languages. And naturally, the great seedbed of every poetic invention lies in the field of prose. At one time everything was expressible in verses, and these verses resembled, and sometimes were, poetry. Today only certain things are said in verse.

— . . .

—It's not easy to say what things. For many years poetry has been becoming more a vehicle of consciousness than of representa-

8. Giovanni Cena (1870–1917). "Eloquent" socialist poet and novelist. His *Homo* appeared in 1907.

tion. Often it's called to a different destiny, and some would like to see it *in piazza*. But those who take the bait and go down into the marketplace are soon given the hook.

— . . .

—No, I'm not thinking of a philosophical poetry, that diffuses ideas. Who thinks of that any more? The task of a poet is the search for a specific, not a general, truth. A truth of the poet-subject which doesn't deny that of the empirical man-subject. Which sings what unites man with other men but doesn't deny what separates him and makes him unique and unrepeatable.

— . . .

—Those are big words, my dear Marforio. Directly, I know few existentialist texts, but many years ago I read a few writers like Shestov,[9] a Kierkegaardian very close to the positions of that philosophy. After the first war, in 1919, the absolute immanentism of Gentile[10] gave me a great deal of satisfaction, although I was bad at deciphering the very involved theory of pure act. Later, I preferred the great idealistic positivism of Croce; but perhaps in the years in which I wrote *Ossi di seppia* (between 1920 and 1925), the French philosophers of contingency, especially Boutroux,[11] whom I knew better than Bergson, influenced me. For me, the miracle was evident, like necessity. Immanence and transcendence aren't separable, and to make a state of mind out of the perennial mediation of the two terms, as modern historicism proposes, doesn't resolve the problem, or resolves it with a showy optimism. One

9. Leon Shestov, pen name of the Russian existentialist philosopher and religious thinker Lev Isaakovich Schwartzman (1866–1938), author of *Athens and Jerusalem* and other works.
10. See Note 12 to "Fascism and Literature."
11. Etienne-Emile-Marie Boutroux (1845–1921). Professor of the history of modern philosophy at the Sorbonne, formulator of the philosophy of contingency, an idealist, anti-positivist philosophy which stressed the non-absolutism of natural cause and effect and by extension argued against necessity and in favor of human free will.

needs to live his own contradiction without loopholes, but also without enjoying it too much. Without making it into polite gossip.

— . . .

—No, writing my first book (a book which wrote itself) I didn't commit myself to ideas like these. The intentions I'm outlining today are all *a posteriori*. I obeyed a need for musical expression. I wanted my words to come closer than those of the other poets I'd read. Closer to what? I seemed to be living under a bell jar, and yet I felt I was close to something essential. A subtle veil, a thread, barely separated me from the definitive *quid*. Absolute expression would have meant breaking that veil, that thread: an explosion, the end of the illusion of the world as representation. But this remained an unreachable goal. And my wish to come close remained musical, instinctive, unprogrammatic. I wanted to wring the neck of the eloquence of our old aulic language, even at the risk of a counter-eloquence.

— . . .

—I knew as much of the French symbolists as one can learn from the anthology of Van Bever and Léautaud[12]; later, I read much more. But those experiments were already in the air; familiar even to those who didn't know the originals. Our futurists, and the writers of *La Voce*, had learned them and, often, misunderstood them.

— . . .

—No, the book didn't seem obscure when it appeared. Some found it retrograde, some too documentary, still others too rhetorical and eloquent. Actually, it was a book that was hard to place. It

12. Their enormously popular anthology, *Poètes d'aujourd'hui; morceaux choisis*, was published by Mercure de France, Paris, 1910, and reissued in an enlarged version in 1918–1919.

contained poems that were unrelated to the intentions I've described, and lyrics (like *"Riviere"*) which constituted too premature a synthesis and cure and were followed by a successive relapse or a disintegration (*"Mediterraneo"*). The transition to *Le occasioni* is signaled by the pages I added in 1928.[13]

— . . .

—It's curious that *Ossi di seppia*, later, seemed to some to be clearer and more concrete than the following book. In fact, I'd written it with clenched teeth and often without the calm and detachment many find necessary for the creative act. Perhaps the classicist antidote, which is always alive in the Italians, was working in me. From childhood on, I've never understood Dostoevski and I spoke of him almost the way the *rondisti*[14] did. I preferred books like *Adolphe, René, Dominique.*[15] I read Maurice de Guérin.[16] And soon I began to decipher a few sonnets and odes of Keats. I felt very strongly the difference between art and document; now, I'm more cautious, more incapable of rash judgments and dismissals.

— . . .

—With a change of scenery and occupation, and after I'd made a number of trips abroad, I never dared reread myself seriously and I felt the need to go deeper. Before I was thirty I'd hardly known anyone, now I was seeing too many people, but I wasn't any less alone than at the time of *Ossi di seppia*. I tried to live in Florence with the detachment of a foreigner, of a Browning;

13. The poems added, all of them written in 1926 and 1927, are *"Vento e bandiere," "Fuscello teso dal muro," "Arsenio," "I morti," "Delta,"* and *"Incontro."*
14. Writers for *La Ronda*.
15. *Adolphe*: Novel by Benjamin Constant (1816). *René*: Novel by Chateaubriand (1802), originally published as part of *Le Génie du Christianisme*. *Dominique*: Novel by Eugène Fromentin (1863).
16. (1810–1839). Highly original French romantic poet, brother of Eugénie de Guérin.

but I hadn't taken into account the henchmen of the feudal authority on which I depended. Besides, the bell jar remained around me, and now I knew it would never be shattered; and I feared that the dualism between lyric and commentary, between poetry and the preparation for or spur to poetry in my old experiments (a contrast I had once, with youthful presumption, recognized also in Leopardi) remained heavily with me. I didn't think of pure lyric in the sense it later had in Italy, too, of a game of sound-suggestions; but rather of a result which would contain its motives without revealing them, or better without blabbing them. Admitted that there exists a balance in art between the external and the internal, between the occasion and the work or object, it was necessary to express the object and conceal the occasion-spur. A new means, not Parnassian, of immersing the reader *in medias res*, a total absorption of one's intentions in objective results. Even here I was moved by instinct, not by a theory (Eliot's theory of the "objective correlative" did not yet exist, I believe, in 1928, when my "Arsenio" was published in *The Criterion*). In substance, I don't feel the new book contradicted the achievements of the first: it eliminated some of its impurities and tried to attack that barrier between external and internal which seemed insubstantial to me even from the gnoseological point of view. Everything is internal *and* external for contemporary man: not that the so-called world is necessarily our representation. We live with an altered sense of time and space. In *Ossi di seppia* everything was attracted and absorbed by the fermenting sea, later I saw that the sea was everywhere, for me, and that even the classic architecture of the Tuscan hills was also in itself movement and flight. And in the new book I also continued my struggle to unearth another dimension in our weighty polysyllabic language, which seemed to me to reject an experience such as mine. I repeat that the struggle wasn't programmatic. Perhaps the unwelcome translating I was forced to do helped me. I've often cursed our language, but in it and through it I came to realize I am incurably Italian; and without regret.

The new book was no less romantic than the first, although the sense of a poetry which delineates itself, watching it physically form itself, gave *Ossi di seppia* a flavor some missed. If I'd stopped

there and repeated myself I would have been wrong, but others would have been happier.

— ...

—*Le occasioni* was an orange, or rather a lemon, that was missing a slice: not really that of pure poetry in the sense I first indicated, but of the pedal, of profound music and contemplation. My work to date ends with the poems of *Finisterre*, which represent, let us say, my "Petrarchan" experience. I've projected the Selvaggia or Mandetta or Delia[17] (call her what you will) of the "Motets" against the background of a war that is both cosmic and earthly, without an end and without a reason, and I've pledged myself to her, lady or shade, angel or petrel. The motif had already been contained and anticipated in *"Nuove Stanze,"* written before the war; it didn't take much then to be a prophet. It's a matter of a few poems, written in the incubus of 1940–1942, perhaps the freest I've ever written, and I thought their relationship to the central theme of *Le occasioni* was evident. If I had orchestrated and watered down my theme I would have been better understood. But I don't go looking for poetry, I wait to be visited. I write little, with few revisions, when it seems to me I can't not do so. If even so I can't escape rhetoric then it means (at least for me) it's inevitable.

— ...

—*Finisterre*, with the epigraph from D'Aubigné castigating the bloodthirsty princes, was unpublishable in Italy in 1943. Therefore I printed it in Switzerland and it appeared a few days before the 25th of July. The recent reprinting contains a few unrelated poems. But in key, terribly in key, among the new additions is *"Iride"* ["Iris"], in which the sphinx of *"Nuove Stanze"* ["New Stanzas"] who had left the east to illuminate the ice and mists of

17. *Selvaggia*: Woman addressed by Cino da Pistoia (1270–1336/7), a friend of Dante and Petrarch, in his poems. *Mandetta*: *Senhal* of Guido Cavalcanti (1255–1300) in his ballad *"Era in penser d'amor."* *Delia*: Roman freed-woman sung by Tibullus in the first book of his *Elegies*.

the north returns to us as the continuation and symbol of the eternal Christian sacrifice. She pays for all, expiates all. And he who recognizes her is the Nestorian, the man who knows best the affinities that bind God to incarnate beings, not the silly spiritualist or the rigid and abstract monophysite. I dreamed twice and rewrote this poem: how could I make it clearer, correcting and interpreting it arbitrarily myself? I feel it's the one poem which merits the charges of obscurity recently brought against me by Sinisgalli; but even so I don't think it should be discarded.

— ...

—The future is in the hands of Providence, Marforio: I can go on and I can stop tomorrow. It doesn't depend on me: an artist is a driven man, he doesn't have freedom of choice. In this field, more than in others, there's an effective determinism. I've taken the route my times imposed on me, tomorrow others will go in other directions; I myself may change. I've always written like a poor fool, not a professional man of letters. I don't possess the intellectual self-sufficiency some would attribute to me, nor do I feel invested with an important mission. I've had a sense of today's culture, but not a shadow of the culture I'd have wished for, and with which I probably never would have written a line. When I sent my first poems to the printer I was ashamed of them for a while, now I can speak of them almost with indifference. Perhaps I would have done wrong not to write them and make them known. I've lived my time with the minimum of cowardice consigned to my feeble forces, but there are those who have done more, much more, even if they haven't published books.

Two Jackals on a Leash

[Published in the *Corriere della Sera*, February 16, 1950.]

Many years ago, Mirco, a noted poet who has now changed professions, wrote in his head, transcribed onto pieces of paper that he kept balled-up in his jacket pockets, and finally published a series of short poems dedicated, or rather sent by air mail (but only on the wings of the imagination), to a certain Clizia[1] who was living about three thousand miles away. Clizia's real name wasn't Clizia at all; her model can be found in a sonnet of uncertain authorship which Dante, or someone else, sent to Giovanni Quirini;[2] and Mirco's name isn't Mirco either; but my necessary discretion doesn't detract from the import of this note. Let it suffice to identify the typical situation of that poet, and I should say of almost every lyric poet who lives besieged by the absence/presence of a distant woman, in this case a Clizia, who had the name of the woman in the myth who was changed into a sunflower.

Mirco's little poems, which later became a series, an entirely unmysterious little autobiographical novel, were born day by day. Clizia knew nothing about them and may not even have read them until many years later; but every now and then the news of her that reached Mirco provided the impetus for a motet; and thus new epigrams were born and shot off like arrows across the seas, though the interested lady hadn't offered the pretext for them, even involuntarily. Two very different cases, of which I'll give examples. Here is the first:

1. Poetic name for the sunflower, after the nymph loved by Apollo, who turned her into a sunflower.
2. Fourteenth-century Venetian writer of ballads and sonnets, and a poetical correspondent of Dante's.

One day Mirco learned that Clizia's father had died. He felt her loss, and regretted even more deeply the three thousand miles which kept him distant, too distant, from her grief. And it seemed to him that all the anxieties and risks of his life up to that point had converged on a Clizia who was then unknown to him, and on a meeting which would have to wait for many years. Perhaps, he said to himself, the war saved me precisely for this: for without Clizia my life would have had no meaning, no direction. He dredged up his past, saw himself again in certain contested villages in Vallarsa, at Cumerlotti, Anghébeni, under Monte Corvo; he found himself in mortal danger again, but already aided even then, unawares, by Clizia's star, by the umbrella of her sunflower.

That day Mirco sat in a café and wrote these lines on the margin of a newspaper, then cast them into the wind, which carried them to their destination:

> Lontano, ero con te quando tuo padre
> entrò nell'ombra e ti lasciò il suo addio.
> Che seppi fino allora? Il logorio
> di prima mi salvò solo per questo:
>
> che t'ignoravo e non dovevo: ai colpi
> d'oggi lo so, se di laggiù s'inflette
> un'ora e mi riporta Cumerlotti
> o Anghébeni—tra scoppi di spolette
> e i lamenti e l'accorer delle squadre.[3]

Second and final example: One summer afternoon Mirco found himself at Modena walking in the galleries. Anxious as he was, and still absorbed in his "dominating idea," it astonished him that life could present him with so many distractions, as if painted or reflected on a screen. It was too gay a day for a man who wasn't

3. Distant, I was with you when your father / entered the shadow and left you his farewell. / What did I know before then? The strain / of *before* saved me only for this: / that I didn't know you and should have: by today's / blows I know it, when an hour from down there / bends and brings me back Cumerlotti / or Anghébeni, among exploding fuses / and the cries and rushes of the squadrons. *"Mottetti"* [4] in *Le occasioni.*

gay. And then an old man in gold-braided livery appeared to Mirco, dragging two reluctant champagne-colored puppies on a leash, two little dogs who at first glance seemed to be neither wolfhounds nor dachshunds nor Pomeranians. Mirco approached the old man and asked him, "What kind of dogs are these?" And the old man, dry and proud, answered, "They're not dogs, they're jackals." (He spoke like a true, uneducated Southerner, then turned the corner with his pair.) Clizia loved droll animals. How amused she would have been to see them! thought Mirco. And from that day on he never read the name Modena without associating the city with his idea of Clizia and the two jackals. A strange, persistent idea. Could the two beasts have been sent by her, like an emanation? Were they an emblem, an occult signature, a *senhal*? Or were they only an hallucination, the premonitory signs of her fall, her end?

Similar things often happened; there were no more jackals, but other strange products from the grab-bag of life: poodles, monkeys, owls on a trestle, minstrels . . . And always, a healing balm entered the heart of the wound. One evening Mirco heard some lines in his head, took a pencil and a tram ticket (the only paper in his pocket) and wrote:

> *La speranza di pure rivederti*
> *m'abbandonava;*
>
> *e mi chiesi se questo che mi chiude*
> *ogni senso di te, schermo d'immagini*
> *ha i segni della morte o dal passato*
> *è in esso, ma distorto e fatto labile,*
> *un* tuo *barbaglio.*[4]

He stopped, erased the period, and substituted a colon because he sensed the need for an example that would also be a conclusion. And he ended:

4. The hope of even seeing you again / was leaving me; / and I asked myself if this which closes me off / from every sense of you, this screen of images / carries the signs of death or / from the past / there is within it, though distorted and diminished / a dazzle *of yours.*

(a Modena, fra i portici,
un servo gallonato trascinava
due sciacalli al guinzaglio).[5]

The parentheses were intended to isolate the example and suggest a different tone of voice, the jolt of an intimate and distant memory.

When the poems were published with others which were related and easier to understand, and which ought to have explained even their two least limpid sisters, great was the bafflement of the critics. And the objections of the detractors were totally out of line with the nature of the case. If the poet had perhaps abandoned himself too freely to his antecedent, his "situation," the critics demonstrated a very different, and more serious, mental torpor.

The first investigations concerned Cumerlotti and Anghébeni, which were mistaken for two characters essential to the understanding of the text. Anghébeni, Carneade, who was he? asked one critic, now a doctor, who we hope brings a better clinical eye to his new profession. And who, asked others, was "Cumerlotti's girl"? Were the jackals hers? And what did Modena have to do with it? Why Modena and not Parma or Voghera? And the man with the jackals? Was he a servant? A publicist? And the father? How did he die and where and why?

I have touched on one aspect (and only one) of the obscurity or apparent obscurity of certain contemporary art: that which is born of an intense concentration and of a confidence, perhaps excessive, in the material being treated. Faced with this, the critics act like the visitor at an art exhibition who looks at two pictures, a still life of mushrooms, for example, or a landscape with a man walking with an open umbrella, and asks himself: What do these mushrooms cost per pound? Were they picked by the artist or bought at the market? Where is that man going? What's his name? And is that umbrella real silk or synthetic? The obscurity of the classics, not only of Dante and Petrarch but also of Foscolo and Leopardi, has been partly unraveled by the commentary of whole

5. (in Modena, along the galleries / a servant in gold braid dragged / two jackals on a leash). *"Mottetti"* [6].

generations of scholars: and I don't doubt that those great writers would be flabbergasted by the exegeses of certain of their interpreters. And the obscurity of certain of the moderns will finally give way too, if there are still critics tomorrow. Then we shall all pass from darkness into light, too much light: the light the so-called aesthetic commentators cast on the mystery of poetry. There is a middle road between understanding nothing and understanding too much, a *juste milieu* which poets instinctively respect more than their critics; but on this side or that of the border there is no safety for either poetry or criticism. There is only a wasteland, too dark or too bright, where two poor jackals cannot live or cannot venture forth without being hunted down, seized, and shut behind the bars of a zoo.

Eugenio Montale:
An Interview

[*"Confessioni di scrittori (Interviste con se stessi),"* published in *Quaderni della Radio* (XI), E.R.I., Turin, 1951.]

Please tell us about your personal experience in recent years. How did a poet see and live the events that have tormented mankind through two World Wars? How do you feel you have rendered this acquired experience in your poetry?

The subject of my poetry (and I believe of all possible poetry) is the human condition considered in itself; not this or that historical event. This doesn't mean removing oneself from what happens in the world; it means simply having the awareness, and the will, not to exchange the transitory for the essential. I have not been indifferent to what has happened in the last thirty years; but I cannot say that if events had been otherwise my poetry too would have had a totally different appearance. An artist carries within him a particular attitude toward life and a certain formal stance in interpreting it according to rules of his own. External events are always more or less foreseen by the artist; but at the moment they occur they cease, in a certain sense, to be interesting. Among these events which I dare to call external, and preeminent for an Italian of my generation, was Fascism. I was not a Fascist and I did not sing the praises of Fascism; but neither have I written poems which seemed to oppose that pseudo-revolution. Certainly, it would have been impossible to publish poems hostile to the regime of those days; but the fact is that I would not have attempted it even if the

risk had been minimal or null. Since from birth I have felt a total disharmony with the reality that surrounded me, the material of my inspiration could only be *that* disharmony. I don't deny that first Fascism, then the war, and still later the civil war made me unhappy; still, I had reasons for unhappiness that went far above and beyond these phenomena. I believe it's a question of an inadaptability, a psychological and moral maladjustment which is part and parcel of every basically introspective personality, i.e., of every poetic personality. Those for whom art is a product of the artist's environmental and social situation may object: what's wrong is that you were estranged from your time; you should have opted for one side or the other in the conflict. In changing or improving society, individuals cure themselves as well; in the ideal society there will be no more decompensation or inadaptability and everyone will feel he is where he belongs; and the artist will be a man like any other with the gift of song besides, the disposition to discover and create beauty. I answer that I *did* choose as a man; but as a poet I soon realized that the battle was taking place on another front, where the great events that were then unfolding mattered little. The hypothesis of a future society that is better than the present one is nothing to sneer at, but it is an economic-political hypothesis which doesn't authorize deductions of an aesthetic nature except insofar as it becomes myth. Still, a myth cannot be obligatory. I'm inclined to work for a better world; I've always worked with this in mind; I even believe that to work with this in mind is the first duty of every man worthy of the name. But I also believe it is impossible to predict the role art will play in a society better than ours.

Plato banned poets from his Republic; certain countries we know have banned poets who are concerned with their own activities (i.e., poetry) instead of the collective activities of their society. In a world unified by technology (and by the prevalence of one ideology) I don't believe "individualist" poets could constitute a peril for the State or Superstate that harbors (or tolerates) them. It's possible to conceive of a world in which the well-being and normality of the many would allow free rein to the inadaptability and decompensation of the smallest minorities. In any case, this optimistic prospect allows for discord between the individual and

society. Yet it is just as possible an hypothesis that the discord will be resolved *manu militari*, by suppressing the inadaptable individual. What appears improbable and undemonstrable, however, is the automatic—or rapid—advent of a golden age (in the arts) as soon as the social structure is changed.

This explained, I can say, in answer to your question, that I have lived the events that have tormented mankind through two World Wars by sitting and watching them. There was nothing else for me to do. In my chapbook *Finisterre* (and the title alone is enough to prove it) the last great war in fact occupies the entire background, but only indirectly. Nevertheless my reaction was such that the book would have been unpublishable in Italy. I had it printed in Lugano in 1943. The opening epigraph alone would have been smoke in the eyes of the Fascist censors. It says, "*Les princes* (i.e., the dictators) *n'ont point d'yeux pour voir ces grandes merveilles; leurs mains ne servent qu'à nous persécuter. . . .*" These are the lines of a man who understood slaughter and struggle: Agrippa d'Aubigné.[1] In short, Fascism and war gave my isolation the alibi that perhaps I needed. My poetry in those days had no choice but to become more closed, more concentrated (I don't say more obscure). After the liberation I wrote poems of more immediate inspiration which in certain circles seemed like a return to the impressionism of *Ossi di seppia*, but filtered through a more careful stylistic control. References to contemporary things and events are not lacking. In any case it would be impossible to think they had been written ten years ago. And therefore, without considering their value, which I can't judge, I must conclude that I feel I am perfectly in tune with the so-called spirit of our time.

What in your opinion is the situation of contemporary Italian poetry in comparison with poetry abroad?

In Italy lyric poetry has remained classical. That is, it has not done away with the control of reason, but tries to overcome it by

1. Théodore Agrippa d'Aubigné (1552–1630). Protestant French poet and historian, author of *Les tragiques* (1577), from which Montale's epigraph to *Finisterre* is taken.

crossing onto another plane, which is none other than the alogical intuition of the lyric. In other countries it doesn't always happen this way, and there are poets in which the irrational element prevails; but in Italy, when all rational understanding fails, everyone—readers and critics—says he is stumped and the poets themselves are unhappy. Italy had futurism, which reacted against D'Annunzianism with very D'Annunzian weapons and was practically never divorced from reason; on the other hand, we never had surrealism or its derivatives. For our poets, the irrational is a necessary limit toward which they are tending, not the material itself of poetic inspiration. Here, poetry touches on the incomprehensible while remaining comprehensible at the same time. An impartially selected anthology of twentieth-century Italian poets could prove very surprising. Up until now it has been impossible to make: the very criterion of impartiality was neither possible nor desirable. Reasons of affiliation or intention had to take precedence. Those who hate the decadents should take heart: the Italy of today does not have truly decadent poets. It hasn't had a Valéry, a Benn, an Eliot, an Auden, a Char. It has no great orthopedists and experimenters. But it has had and has poets who I believe to be the equals of an Apollinaire, an Antonio Machado, or, if we want to go back in time, a Hopkins; poets in which the best of French symbolism (which was to poetry what impressionism was to painting) grafted onto Italian forms in very original ways. It is necessary to add, however, that recent Italian poetry is threatened with exhaustion. And it is specifically its classical aspect which seems in danger. There are recent words, modes, cadences that will not be usable for long; and a new language has not yet sprung up among the very young. If it does not, this will mean that Italy needs many years of prose—and possibly of real prose, not poetic prose.

What do you think of the activity of Italian criticism in relation to contemporary writers?

Literary criticism has virtually ceased to exist, in Italy and elsewhere. The newspapers concern themselves only with the arts organized (theater, cinema, visual arts) as professions. Writers

have other occupations and no one keeps an eye on their interests as writers. A bad play, a bad film, a bad exhibition always gets covered in the press; a book hardly ever does. Years ago, criticism had retreated into the little magazines; now publications of this sort hardly exist any more. Now there are only the big illustrated weeklies full of gossip, in which literary criticism gets scant space. The causes of the phenomenon are complex; but one has to admit that they are not all of an economic nature. It is natural for a commodity for which there is little demand to tend to disappear; but in this case one has the impression that a certain lack of energy in the offering corresponds to the lack of interest. The public asks for nothing because nothing is offered. If a literary panorama of the twentieth century, like the one Serra[2] published in 1914, were to appear today it would certainly sell like mad. But one could say that the critics have lost all confidence in their standards, their judgments. The crisis has infiltrated them more than the artists, the custodians need to be taken care of. For criticism to rise again, someone will have to appear with the courage to impose his personal taste as if it were objective truth; he will have to teach for years, earn credibility and imitators. In short, if the critics would reappear, the taste for criticism would spread again. An art dies without a parallel criticism. It's not true at all that the artist exists even if he is not understood. In the long run, the artist who is not understood ceases to exist, disappears from circulation. It may be that a new criticism is coming out of the universities, and nò longer from the literary sancta. Papers and theses on contemporary artists and writers are more and more frequent in academia. Years ago I would have deprecated this turn of events; today, due to the lack of avant-garde groups and schools, I would be more cautious in recommending the study of only constituted and official values in the universities. Somehow it is necessary to act so that written and printed criticism survives. What still remains, in fragmentary and oral form in the conversation of those who follow literary novelties, shows that good taste hasn't gone under, but that today it is hard to find someone who wants to tell the truth. The critics are human, they don't want to make too many enemies. Once it wasn't like this.

2. See Note 10 to "On the Poetry of Campana."

And why wasn't it? Here the economic motive I had tried to exclude rears its head again. Evidently it has become difficult today to write and judge writers. And unfortunately the word "crisis," which I had hoped to avoid, resurfaces. I have nothing else to add.

Introduction to
a Swedish Translation
of His Poems

[Preface to the volume *Eugenio Montale, Poesie*, translated by Gösta Andersson. Stockholm-Roma, Italica, 1960.]

The poems collected in this volume are drawn exclusively from my first book, *Ossi di seppia* (1925); it was followed—after a long interval—by two other collections, *Le occasioni* (1939) and *La bufera e altro* (1956). *Ossi di seppia* contains fifty poems written between 1920 and 1924, though one poem goes back to 1916 (when I was twenty). It ends with a stanza which I shall quote here because it sums up the tone of my early poetry: a state of mind of extreme desolation transposed into a landscape which would be called "existential" today, but which at that time was simply the landscape in which I lived:

> *E andando nel sole che abbaglia*
> *sentire con triste meraviglia*
> *com'è tutta la vita e il suo travaglio*
> *in questo seguitare una muraglia*
> *che ha in cima cocci aguzzi di bottiglia.¹*

1. And walking in the blinding sun / to feel with sad astonishment / how all of life and its trouble / is like following along a wall / topped with broken bottle necks. Last stanza of *Meriggiare pallido e assorto*.

Eastern Liguria—the region where I spent part of my youth—has this barren, rough, hallucinatory beauty. Instinctively, I was trying to write a line that would adhere to every fiber of that soil: and not without results, for a famous critic (Emilio Cecchi) soon noted that everything in my book transpired under a veil of hallucination. Later, in an "imaginary interview" of mine, I tried to give a philosophical explanation for this fact: "I seemed to be living under a bell jar, and yet I felt I was close to something essential. A subtle veil separated me from the definitive *quid*. Absolute expression would have meant breaking that veil: an explosion, the end of the illusion of the world as representation. But this remained an unreachable goal. And my wish to come close remained musical, instinctive, unprogrammatic. I wanted to wring the neck of the eloquence of our old aulic language, even at the risk of a countereloquence."

It was inevitable that when Fascism descended certain critics would think that the "bell jar" summed up symbolically the situation of a young generation sacrificed by a totalitarian regime; and it was said that my book could be read in another key, since my case was "both personal and generational." I was therefore considered an *engagé* poet in some ways; a comrade of Gobetti, who was my first publisher and who in those days was conducting a desperate campaign against triumphant Fascism in his reviews *La rivoluzione liberale* and *Il Baretti*.

Not all the poems selected by Gösta Andersson support such an interpretation. His anthology also contains poems which ideally —though not chronologically—precede the themes developed in *"Mediterraneo,"* and in some other poems which I consider particularly significant. I refer to poems such as *"I limoni,"* ["The Lemons"] *"Falsetto,"* and *"Riviere"* which above all are stylistically freer, but which also have a more experimental character. Naturally, the landscape in these poems does not change. I rediscovered the freedom of poems like these later on, in *La bufera e altro*: poems of war and love in which every inhibition, whether stylistic or psychological, seems to me to have given way once and for all.

But I must not ignore my second book, *Le occasioni*, poems written in Tuscany after I moved to Florence in 1927. While the success of *Ossi di seppia* had been slow (the book has now had

twelve printings), *Le occasioni* had an instantaneous reception from critics and public. Yet someone criticized me for having adopted Eliot's "objective correlative" method, which is to provide an object (the poem) in which the motive is included in the form of a suggestion, though not explained or commented upon in psychological terms. The fact is that I had translated three short poems of Eliot's in 1929 but knew nothing else about him, while many of my poems of the preceding years had already forced this route upon me. Certainly, in *Le occasioni* the need for objective expression grows and effusions of a romantic nature diminish. The interweaving of rhyme and assonance is more compact, and it is strange that no one has mentioned Gerard Manley Hopkins in this regard. In my own way, I was looking for my own "sprung rhythm." Still, the central theme did not change and the stylistic logic that the *Ossi di seppia* justified was carried to the most rigorous consequences. In that first book of mine there are many poems that are already ideally part of *Le occasioni*.

I lived in Florence (where I was head of a library which was important in the nineteenth century, the Gabinetto Vieusseux) until 1948; but by 1939 I had been dismissed from my post for evident political unfitness: I lacked the papers of an Italian citizen, i.e., the Fascist party card. In Milan, where I moved in 1948, I became an editor of the *Corriere della Sera*. My area of concern on the paper is literary criticism; for the afternoon edition, the *Corriere d'Informazione*, I write about music and opera.

My third book of poems, *La bufera e altro*, came out in 1956. It includes a chapbook, *Finisterre*, published at Lugano in 1943 in a semi-clandestine edition. *Finisterre* concludes *Le occasioni*, while the other poems in *La bufera* return to a more direct mode of expression and loosen the threads of a web that had become too tight. The play of images remains the same, "profoundly incorporated in the texture of the words: they are presented inside the language a little bit like knots in wood or rocks within stone; they are affective centers, emotion is concentrated around them" (A. Pieyre de Mandiargues, *Nouvelle Revue Française*, January 1960).

I consider *La bufera e altro* my best book, although one cannot penetrate it without repeating the whole previous itinerary. In *La bufera* the reflection of my historical condition, my life as a man

today, comes to life. Poems like *"La primavera hitleriana* ["Hitlerian Spring"], *"Il sogno del prigioniero"* ["The Prisoner's Dream"], *"Congedo provvisorio"* ["Provisionary Discharge"], *"La primavera del '48"* ["Spring of '48"], are the testimony of a writer who has always rejected the clericalism that afflicts Italy today in its two opposing forms ("black" and "red").

I have also published a book of prose halfway between the story and the *petit poeme en prose: Farfalla di Dinard* (1957). I have translated a great deal: five plays of Shakespeare (*Hamlet, The Winter's Tale, The Comedy of Errors, Timon of Athens,* and *Julius Caesar*); and Corneille's *Le Cid*; Marlowe's *Dr. Faustus*; Melville's *Billy Budd*; many *entremeses* and stories of Cervantes; a whole volume of poems from other languages (*Quaderno di traduzioni*), etc.

My thanks go to Gösta Andersson for his devoted labor and also to the publisher. I would be pleased indeed if through their efforts I could arouse, in Sweden too, the interest of a few fraternal spirits.

A Dialogue
with Montale on Poetry

[Published in *Quaderni Milanesi* (1), Milan, Autumn 1960.]

QUADERNI MILANESI : *You, Montale, have written lit-tle since the end of the war. The major part of your work comes to a stop in 1943. Up to that point you had exercised a determining influence on Italian letters: one can say that there was not a single young poet who didn't "steal" something from you. But precisely in the postwar years, i.e., just when the voices of those who had seen you as a master began to be heard, one had the impression that you had broken off the dialogue, as if closing yourself off inside your-self. What happened to your thought during those years? What kind of reflections did the rather tumultuous events in Italian liter-ature in that period provoke in you? Were there some changes in your way of thinking about the poet's work?*

What do you answer to those who contend that after the war you made no effort to look in a new direction in your poetry?

MONTALE : It's not true in fact: I wrote poems up until about 1954 or 1955. Not many, but with new accents. My book of 1956, *La bufera e altro*, doesn't repeat the one before it; the critics —even abroad—recognized this, though they were late in doing so. Don't forget that the successes of *Ossi di seppia* and *Le occasioni* were delayed reactions as well. I recognize that afterward I didn't make an *effort* to renew my voice and energies; but why should I have? I have never made an effort. There has been no "change in

my way of thinking about the poet's work." It has happened that in the face of the massive production of poems that has invaded our country, and not only ours, I have found the title of "poet" somewhat intolerable. I feel that those like myself who have written (a few) poems over thirty-five years need a breath of fresh air. I may begin again; or I may not. I will add that since 1948 I have been a journalist and I have absolutely no time for my own writing. I write for others. I don't exclude the possibility that I will one day write for myself again. But when?

Q. M.: *The most interesting postwar experiment in literature was certainly the* Politecnico *of Elio Vittorini,*[1] *who made himself the interpreter of a need for cultural renewal in every field, and therefore in poetry as well. You were not a regular contributor to the magazine, but you once published a poem in it. Can you tell us now how you regarded the experiment of* Il Politecnico? *And how you regard it now, fifteen years later? And why you didn't feel like taking an active part in it?*

M.: I read *Il Politecnico* when I was living in Florence: it was a magazine of youth in crisis. But I had had my crisis years before, and couldn't have much faith in a "renewal" which failed to take into consideration the actual conditions of our country. Apart from this, I was neither an ex-Fascist on the road to rehabilitation nor a Communist who was so independent as to be in danger of being expelled from the Party. For a while I was a member of the Partito d'Azione,[2] but I quit it in disgust, well aware that all the chatter would amount to nothing. I had hoped (naively) that after the fall of Fascism Italians would unite around a minimum program—

1. (1907–1966). Noted Communist novelist and intellectual, author of the celebrated *Conversazione in Sicilia* (1941) and *Diario in pubblico* (1957). He edited the Communist review *Il Politecnico* in Milan, 1945–1947. Starting in 1959, he and Italo Calvino edited *Il Menabò*.
2. Liberal political party espousing the ideas of Gobetti and Rosselli founded in 1942 by members of *Giustizia e Libertà* and Liberalsocialists. Influential in the first years after the fall of Mussolini, the party split after the failure of the Parri government in 1945, with left-wing members joining the socialists while the right wing allied themselves with the Italian Republican Party.

without a popular front—which would oppose the Fascists and the clerics. The power of the Communist Party prevented this, along with the clerics, who had an absolute need for a Communism that was strong but not too strong, in order to render impossible any democratic solution whatsoever.

Q. M.: *One of the subjects debated in* Il Politecnico *was that of committed art. You, at that time, did not have anything to say about this problem. Many years ago, in an "Imaginary Interview," you wrote that the poet must "concern himself" with politics. Did you mean to allude to an* engagement, *a need for "social involvement," on the part of those who write poems? In what sense, and within what limits?*

M.: The poet's *engagement* is total, and the poet, as an individual, may even belong to a political party (though he need not necessarily do so): but the poet is certainly not *obligated* to write "political" poems. He may do so, he may even have to, if his inspiration dictates them. But social *engagement* doesn't operate in only one narrow direction. Haven't there been revolutionary writers (or poets) who have believed they were professing reactionary ideas? (Baudelaire and Dostoevski, for example.) Art isn't made with opinions, though there are cases where opinions become one's lifeblood, and then they too enter into the realm of art. Very occasionally, this has also happened to me: in my *"Sogno del prigioniero"* ["The Prisoner's Dream]. My prisoner can be a political prisoner; but he can also be a prisoner of the existential condition. An ambiguity, *in this case*, which is necessary to the poem.

Q. M.: *There are typical, and unusual, characters in your poetry, like Arsenio and the Nestorian of "Iride," in whom it is possible to trace an existential background. And it is also possible to see in you a constant attempt to succeed in the creation of definite, well-delineated characters. Do you feel that this attempt, which is so evident in you, is an important part of a poet's work? What difference is there between the creation of a character in poetry and the creation of a character in narrative? We know that years*

ago, during the war, you announced the publication of a novel. We even read a few pages of it in Lettere d'oggi. *What happened to it? Why did you decide to write it? And why didn't you publish it?*

M.: I don't know what to say about characters in poetry, now that the character is disappearing even from the novel. Arsenio and the Nestorian are projections of myself. In any case, the character who appears in a poem will be much more synthetic than a character in a novel. Still, within certain limits, verse can narrate, too. I never thought about creating characters in poetry; rather, I have had occasion to meld different characters who were real for me, into one. I have never published pages from a novel: the things in *Lettere d'oggi* were short poems in prose: two of them were included in *La bufera*. It's true that I would have liked to write a novel, but I've never even begun one. It would take a great amount of free time, a great amount of thought, and also a lot of research (into the setting). The initial seed is in me, but it is still too hidden. Some approximations of pages of what a novel (never an anti-novel) of mine might be can be found in my *Farfalla di Dinard*, which Mondadori will soon be reprinting in an expanded edition.

Q. M.: *It seems to us that to recognize a certain degree of social involvement in poetry means to recognize implicitly a basis for the criticisms which have been directed at pure poetry for fifteen years in this respect. You are considered the most significant representative of pure poetry in Italian. But to what extent do you accept this label? What is your attitude toward theories of pure poetry?*

M.: Initially, I was not considered a pure poet at all; when it seemed that I was tending toward *poésie pure* in my second book I was repudiated by Gargiulo, who had praised the impure *Ossi di seppia*. And the labels "hermetic" and "hermeticism" developed late, too, to describe what by then were the tired and mannered products of imitators. If by pure poetry one means poetry of Mallarméan extraction, I do not belong to that strain. It's not that I reject it out of hand; I simply say that I am unconnected to it. There has been, however, starting from Baudelaire and some of

Browning, and now and then from where they come together, a strain of poetry which is neither realistic nor romantic nor decadent in the strict sense, but which very broadly speaking can be called metaphysical. I was born in this vein. Pancrazi realized this vaguely when he spoke of a physical and metaphysical Montale (though he rejected the latter); so did Giovanni Getto after him, who denied the existence of a "physical" Montale. All my most recent critics have gone in this same direction, using other terms but without altering the conditions. The question has been clarified in several essays (perhaps not all of them published) by P. Bonfiglioli. As it already had been, for that matter, in earlier essays, written many years ago now, by Gianfranco Contini.

It should be understood that I am not very fond of the metaphysical label, either, for the province of this poetry is extremely unclear. All art that doesn't reject reason but is born from the clash of reason with something which is not reason can also be called metaphysical. Religious poetry occupies a neighboring space: often the boundaries become confused. Certain forms of expressionism also share the metaphysical space. (Instead of calling it metaphysical, it would be better to speak—for one part of modern poetry—of a poetry which finds its own subject matter in itself. In reference to this—and also to the disappearance of the "work of art," I would like to call your attention to the fifth chapter of the recent book *L'esthétique contemporaine*, by Guido Morpurgo Tagliabue. The entire book deserves to be read.)

Q. M.: *You have written that poetry is more a way of knowing than of representation and you have specified that in speaking of poetry as knowing you are not thinking of a philosophical poetry, for what the poet needs is to search for a specific truth, not a general truth.*

It seems to us that your position is in line with those who hold that art is an individual rather than a universal way of knowing. Several months ago Lukács advanced the thesis that art is the point of encounter between the universal and the individual by way of a category which is proper to poetry, i.e., the particular. In speaking of a "specific" truth, are you perhaps alluding to something akin to

Lukács' "particular"? In what way can the concept of art as know-
ing be reconciled with the idea of pure poetry?

M.: Pure poetry, too, tends toward a kind of knowing. My
"specific" way of knowing can be reconciled with Lukács' "particu-
lar." Man himself is a universal made particular. In the phrase you
cited, I was distinguishing art from (theoretical) philosophy; but
there are poets who are more philosophical than the philosophers,
Dostoevski for instance. Today we are witnessing the collapse of
metaphysical philosophy; perhaps it will come to life again, but
when? Metaphysics has been replaced by art or by non-systematic
speculation.

Q. M.: *On the question of philosophical poetry, this is certainly*
an important strain: just think of the Eleatics, Lucretius, the En-
glish Metaphysicals. The latter even theorized their position and
said that they used ideas experimentally, as subject matter for
poetry like any other subject matter. Would you clarify your posi-
tion in relation to philosophical poetry? Probably, in explaining
why you claim to reject a philosophical poetry today you can
clarify another well-known assertion of yours, that one can only say
certain things in poetry today. What is it that limits the range of
what poetry can talk about?

M.: The Metaphysicals are not philosophical poets in the strict
sense. Philosophical poetry expresses ideas that would also be valid
if they were expressed in another form. In certain cases (such as
Lucretius) this poetry is true poetry. But the same cannot be said
for many of those who philosophize in verse. The poets of the
Dolce Stil Nuovo, Petrarch, Dante, Shakespeare in his sonnets, the
great Spanish, English, and German metaphysical (or religious)
poets, and more recently Hopkins, Valéry, Yeats, Benn, and others
have expressed ideas which are acceptable only in "that" form.
Hence poetry's scant translatability.

Poetry (in verse) demands a synthetic language which is
musically irreducible to the tone of common prose. The description
(in verse) of a factory or the parts of a motor would not be very

interesting today. In other times, everything that was "poetic" could, and even had to be said in verse; but prose had not yet achieved its present dignity. (It had another, which was certainly not inferior.) Today poetry and (artistic) prose have suffered the effects, the counterattack, of the other arts and are tending to become art. But for centuries painting and music survived by clinging to the back of poetry.

Q. M.: *Once again on the subject of pure poetry, which apparently has nothing in common with prose. Yet you have written that "the great seed-bed of every poetic invention lies in the field of prose." Are you trying to establish an interdependence between prose and poetry? In that case, can you clarify this concept, which at first glance seems like a contradiction in you?*

M.: Throughout the nineteenth century prose was worked "artistically" as never before (earlier it had been extremely worked, but in the direction of eloquence). Poetry, by contrast, has had to descend at least a tone and become less poetry-as-poetry and more poetry-as-truth. Poetic language always tends to become more prosaic; yet, if the differences are not simply visual (poetry is written in short lines, prose in long lines) a difference must still remain. When no more difference exists it is useless to maintain the appearance of verse. This is the situation of much contemporary pseudo-poetry. Since poetry (in verse) needs a language of its own, one hopes to replace the traditional "beauties" of poetic style with the beauties of an unheard-of prosaicism. In such cases true poetry would be prose; and in fact there are more poets today who write in prose than poets in verse. But all your questions are vitiated by the hypothesis that poetry is written in verse or that the use of verse is a condition, an especially favorable point of departure.

Q. M.: *Like many poets of our time, you have not escaped the accusation that you write prosaic poetry. The same is often said of Eliot, and the fear of prose is certainly a characteristic of an epoch which has witnessed the explosion of pure poetry. What is your answer to those who object that prosaic cadences are evident in your poetry?*

M.: There may be a musical dialectic between prose and poetry in my poetry: or rather, it was there in the beginning, later a tone more detached from the prosaic level prevailed. Tomorrow . . . I don't know. Poetry is a monster: it is music made out of words and even ideas: it comes as it comes, out of an initial intonation which cannot be predicted before the first line arrives. Very broadly speaking: poetry is less predictable than prose; perhaps the prose writer can imagine at the outset "what" his piece is "going to be"; the poet can do so to a much lesser degree. I think, however, that the prose writer cannot do so entirely either, if he is an artist (i.e., a poet). But, alas, where are you leading me? The distinction between art and poetry is obscure in De Sanctis, obscure in Croce, and worse than obscure outside Italy. All that can be said is that poetry is an art which has developed historically in a certain way and in certain specific directions. Yet there are other arts, other forms, other directions.

Q. M.: *The young who published their first efforts in poetry in the postwar years were likewise accused of being excessively prosaic. Do you share this objection to the poetry of the young? Or do you have other kinds of objections to the experiments, certainly still undeveloped, which were inspired by the Resistance and the early postwar period? Do you consider this a particularly interesting turning point for poetry, or do you feel contemporary writing is impulsive, incapable of achieving concrete results? And what do you think of the "sampler" of new poetry presented by Vittorini in* Il Menabò?

M.: I believe I have already partly answered this. I don't know that Vittorini would be terribly interested in what I mean here by poetry. But he has other interests. In publishing young poets in *Il Menabò* he may simply have been trying to be a gracious host, or maybe he actually found them interesting. Perhaps they are interesting. I can't be a good judge. What seems strange to me (and here I am not speaking of him) is the idea that at every change of season new, different, unpublished, unheard-of poets have to appear. Couldn't there be seasons entirely of poets and then seasons of artists (poets) who don't write verse? It takes years

and years to create new possibilities of style and language. And often when we look for them they "aren't there." He who can find them finds them, when the fruit is ripe. After Leopardi it was practically impossible to write verse for the whole rest of the century; at the beginning of the 1900s it became possible again. Today, I don't know: you who are young will know.

Q. M.: *The poetic experience you represent has been accompanied in an unusual way by a type of criticism which adhered to a, shall we say, philological examination of the poet's work, more or less confining itself to an immediate reading and posing problems which were predominantly problems of taste. Do you feel you were correctly read and interpreted by these critics? Do you think there is a need for a less unilateral literary school, i.e., one that is able to approach the poet's work with a broader investigative method?*

M.: The new critics who are appearing are also overly sensitive to ideologies and do not merit your reproof. My third book received criticism of a stupefying sensibility. But apart from those who display a concrete sensibility there are others, also intelligent, who under the guise of phenomenological inquiry reveal a total indifference as to what is and is not art. They are interested in research, in "poetics," in problems, not in results. In fact, the taste for research presupposes the impossibility of a result. "Woe to him who lingers" could be their motto. Your questions don't allow for the fact that today the avant-garde, too, is a big business; on the other hand, one can't put oneself in an *a priori* reactionary position without sensing he is worse than dead. We can't know whether there will be room for art, whether art will have meaning in a world of seven billion men, all of whom can read and all of whom are endowed with a "modern" sensibility. More than art itself, the concept of the "work of art" seems in crisis. And it seems that the anthropocentric sense of life without which the life of man has no meaning (for us men) is worse than in crisis.

Q. M.: *You have described well a situation as regards art and the shape of its relationship to the public, which seems to be changing. But it seems to us that consequentially criticism also betrays*

this uneasiness: i.e., criticism is doing nothing to stir the stagnant waters, it no longer fights any of those battles for a literary or artistic ideal which only a few years ago seemed to be the vital source of every cultural movement. It seems cold all over, professorial.

M.: Allow me, if you will, to make an observation about criticism and critics. Criticism is bound to disappear from the pages of the daily papers. What is left are the reviews, which few people read; and the illustrated magazines, where the critic is like a dog in church. There are doctoral theses and the "publish or perish" books, written to win a prize or procure a professorship. Nothing very attractive. How can an independent critic develop, where can he do his work, who can provide him with the means to survive and permit him to write and even not write? The only critic who can survive is the one who becomes a cog in the wheel of industrial culture, who "goes with the flow" and thinks by proxy, with the ideas of others—his friends, customers, colleagues. Such critics are legion, particularly in the (formerly) figurative arts, music, and the theater. But the authoritative, independent critic, the critic who is listened to, who is also a master, is becoming even a physical improbability. In today's world the artists (millions of artists) are the public and criticize themselves, they don't need to delegate this activity to anyone. The artists—by God—can proceed toward self-government: the first and only one in history with any serious probability of success.

Seven Questions
About Poetry
for Eugenio Montale

[Published in *Nuovi Argomenti* (55–56), Rome, March–June 1962.]

I. *There has been talk, even recently, of a "crisis in the novel." Can one speak of an analogous "crisis in poetry"? And if so, in what sense?*

Since poetry—like the novel, though on a reduced scale—is becoming an industrial product, it is clear that it too is subject to the oscillations caused by supply and demand, i.e., by the marketplace. Poetry is therefore in crisis no more or less than anything else: a product, if it is not kept current, even by becoming worse, loses its patronage.

But if we wish to consider poetry as a spiritual activity, then it is evident that all great poetry arises from a personal crisis of which the poet may not even be aware. But more than a crisis (the term is suspect nowadays) I would speak of a discontent, of an inner emptiness which the achieved expression temporarily fills. This, however, is the territory out of which every great work of art is born. Your question is vitiated by the hypothesis that the term poetry must refer to a particular literary genre; which is *also* true, but not absolutely so. One can imagine a great poetic period that produced nothing of what we ordinarily understand as poetry.

2. *The poetry of the postwar period has been characterized by an ideological "reaction" to hermeticism, among other things; what is the status today of this "reaction to hermeticism"? And what about hermeticism?*

I know very little about hermeticism. The term arose in Italy but did not catch on elsewhere. In Italy it was used in a sense that was not always negative: there was talk of a decadent experimentalism that also included so-called hermeticism, and which was supposed to have "deprovincialized" our literature. At present, if I am not mistaken, the negative use of the term is prevalent; although today the more serious critics are prone to exclude from the field the very poets who are supposed to have given rise to hermeticism. The "hermetics" are supposedly only their imitators and followers. But this is so with any school, assuming—and not conceding—that there was an hermetic school in Italy. Those who come first have certain advantages over those who follow. The opposite can also occur, though rarely: he who follows can gather the fruits of others' experiments that have been left hanging in mid-air. For the moment, this cannot be said of the so-called neo-hermetics. And yet it should be noted how many of the young poets who according to you are supposed to represent "an ideological reaction to hermeticism" are more obscure than their predecessors and are consequently deprived of a true means of communication. Today there are no poets who communicate in the sense that they are accessible to that abstraction known as "the people"; not even the dialect poets do so. In fact, the return to dialect is one of the surest signs of the "decadent" spirit (still assuming that decadence and hermeticism are labels to be taken seriously).

But then we are not speaking of the call "to an active intellectual awareness of the directions, etc., etc." *Who* is issuing the invitation? And to *whom*? Try to name some names and you'll see that it will be hard to keep from laughing. There has never been a period (in the production of so-called poetry) richer in active awareness in every direction, especially in Italy.

Ideological *engagement* is not a necessary and sufficient condition for the creation of a poetically vital work; nor is it, in itself, a

negative condition. Every true poet has been *engagé* in his own way and has not waited for it to be pointed out to him by barely identifiable regulators and guides of production. Naturally, professional poets have often paid tribute to their protectors, princes, and patrons; it is probable that those who are salaried as "poets" in Russia today must run on a prescribed track. These are extreme cases; but the history of poetry is also the history of great unfettered works. Poetry, whether or not it is *engagé* in the sense demanded by the moment, always finds its response. The error lies in believing that the response must be lightning-quick, immediate. There is a place in the world for Hölderlin and a place for Brecht. Another error is to believe that the response is measured statistically. Those with the most readers are the most valuable, respond best to the demand of the marketplace. Thus we come back to poetry understood as a commodity to be sold.

3. *Many claim that the task of contemporary poetry is to develop the new "content" and themes that our time suggests, which also involve new problems of communication. Poetry is being called to an active intellectual awareness of the directions in which history moves and is even being assigned a practical purpose of classification and animation, as has occurred in other eras, even long ago. What do you think of this?*

(See answer to question 2).

4. *Any poetry, or rather any concrete poetry, postulates, explicitly and implicitly, a problem of language, which involves a need for innovations and at the same time for a particular relationship with tradition, which is the point from which every poet "innovates." What do you think of the linguistic or stylistic experiments of recent poetry? What do you think of neo-experimentalism? Of the tendency of some currents to reabsorb attitudes and forms of the so-called European or American "avant-garde"? What do you think of dialect in recent poetry?*

There are no problems of language, experiments, transplants, or derivations from other literatures that have a normative value. Every poet creates the instrument he feels is necessary for himself. What we can see, in any case, is that today in all the arts, technique seems to be understood in the materialistic sense: the collage, the paint in a tube, the noise of the lowered shop shutter, the multilinguistic "cocktail" of words mixed in a shaker "before serving" substitute for the "mediated" expression proper to art. Let's be honest: at this point art is no longer interesting, nor is it in demand any more. Its failing is that it cannot be produced serially and planned. This does not mean there is no one who practices the profession of artist. The number of artists increases, in fact, in inverse proportion to the decrease in real and true artistic feeling. These supernumerary artists learn and apply the formulae: they can be guided, directed, and divided into "currents." If they did not exist, intellectual unemployment would create very serious problems. In fact, with their associates, patrons, and relatives, they make up a totality of economic interests of great significance.

5. *Can the irrational moment in poetry, any poetry, be defined? And if so, how can one differentiate the "irrational" in an "engagé" poet from the irrational in a "pure" poet? Does the notion of irrationality coincide with the notion of decadence to the point of a total identification, or is there an irrationality that is necessary, not decadent, i.e., not mythicized as the one possible mode of consciousness?*

Does something similar happen in poetry, too? Certainly, though to a much lesser extent, for poetry by its very nature circulates much more slowly. Yet there are beginning to be a considerable number of young poets who have read poets of all times and all kinds and believe they can avail themselves of a very extensive keyboard and try to play it in all directions. Here too they fall into the error of believing that the instrument (the means) is the poetry. I pass over other errors inherent in the fast pace of our time. He who believes he is endowed in terms of poetic technique looks

for speedy confirmation, i.e., success, whether within the circle of a small group or in a small review. If the instant consensus of the judges (who write poems themselves) is not forthcoming, the poet is prepared to change his manner and style; he believes in good faith that he is searching for himself, but in actuality he is only looking for the part that is most acceptable to others, the most salable.

There is a kind of charlatanism, a way of leading people on, which up until a few years ago seemed to be limited to the visual arts and to music: today it has also entered the field of letters and even that very restricted area of literary production which you understand as poetry. Poetry is becoming an art at the very time when art is being challenged and rejected in favor of other human products: the happening, the gesture, the figure, the easily used. cliché. There are no remedies: if the world changed, poetry would change, too; but poetry (or whatever is left of it) cannot change the world. Nor can the men of action change it, today; any regime, any social organization whatsoever must come to terms with the absolutely new conditions under which human life is being lived: conditions that are hardly favorable to artistic creation, but endlessly open to every sort of substitute. In this sense a great transformation is under way; and the intellectuals (many of whom are *engagés*) are ready to accept it with enthusiasm. And I don't deny that they must accept it: I only deny that they should claim to be free men.

6. *Poetry always seems to be determined by its special contact with prose. What do you think of the relationship between contemporary poetry and contemporary prose, both fiction and nonfiction?*

Someone once defined poetry as a dream dreamt in the presence of reason. It was true then, and it is still true today, after Blake, Mallarmé, and the Rilke of *The Sonnets to Orpheus* and the *Duino Elegies*. There will be a difference between the poet who eliminates some links in a chain of metaphors and the poet who wants to say everything, explain everything; but there will always

be the need for reason in these various activities. The use and abuse of reason is present even in those surrealists who claim to immerse themselves in the "Gulf Stream" of the subconscious.

But here, too, I am not in favor of restricting poetry to a certain type of writing in verse or pseudo-verse. I don't think Cervantes or Gogol were more rational than Baudelaire; nor do I think that one can distinguish between decadent rationalism and rationalism of another sort in the realm of poetry. One can, however, distinguish between the reason of silence and the reason of art: the mechanism may be the same but the intention is different.

The boundaries between prose and verse have been brought much closer: today verse is often an optical illusion. To a certain degree it has always been so; an error in typesetting can ruin a poem; Ungaretti's *Fiumi* [*Rivers*] are incomprehensible without the vertical dripping of their syllables. A large part of modern poetry can only be listened to by those who have *seen* it.

Verse is always born out of prose and tends to return to it (cf. the frequent "drops in tone" of poets). It is a question of tone and of expressive concentration. The art of the word has many gradations of nuance, many musical possibilities, and does not exhaust them all in one period of history. Certain ages have shown themselves to be more favorable to verse, others to prose. When the necessity for spoken discourse (which can be true poetry) is prevalent, we have a period of prose; when writers appear who are lifted to an intense musical concentration, poetry carries the day. I speak of periods that can be very brief; and of recent periods. In other eras even a long rational discourse in strictly observed metrical verse was possible (e.g., the *Divine Comedy*); but prose hardly existed then. Today the poem-as-summa, the poem-as-machine, is no longer possible in verse—and perhaps no more so in prose. Neither the *Cantos* nor *Ulysses* can repeat the miracle of Dante.

7. *Poetry, too, constitutes a social "value," whatever place one wishes to assign it in the hierarchy of values of our time. How does poetry in particular fit in with the other forms of expression in art today? What do you think of the place of poetry in our society?*

Whatever I have said demonstrates that poetry (in the sense you indicate) already "fits in" very well, too well in fact, with the arts of today. And what about the situation of the poet in contemporary society? In general it is not a happy situation: some are dying of hunger, some live less badly by doing other work, some go into exile, and some disappear without leaving a trace. Where did Babel and Mandelstam go? Or Blok and Mayakovsky, if not to kill themselves? And where did Dino Campana go but to the insane asylum? (I limit myself to the moderns: the list could be much longer.)

But these are illustrious examples in any event: they are the glory of modern poetry. Many others make understandable the discredit into which the modern poetic animal has fallen. And it is not only society's fault: to a large extent it is the fault of the poets.

Translator's Acknowledgments

———

Bibliography

———

Index

Translator's
Acknowledgments

I am grateful, first of all, to the late Eugenio Montale for his interest and cooperation in this project. Thanks are also due to the following publishers of Montale's work for permission to print the translations in this volume, several of which appear under new titles:

Il Saggiatore, S.p.A., for "*Stile e tradizione*," "*Augurio*", "*Il fascismo e la letteratura*", "*Tornare nella strada*," "*La solitudine dell' artista*," "*Le magnifiche sorti*," "*Il secondo mestiere*," "*L'uomo nel microsolco*," "*Sul filo del corrente*," and "*Le parole e la musica*" from *Auto da fe: cronache in due tempi*, © 1966 by Il Saggiatore, Milano;

Arnoldo Mondadori Editore, for "*Un poeta greco*," "*Le Cinque Terre*," "*Sulla scia di Stravinsky*", "*Malraux*", "*Visita a Brancusi*", "*La complice Marietta*," and "*Auric e Char*" from *Fuori di casa*, ©1975 by Arnoldo Mondadori Editore; "*Italo Svevo nel centenario della sua nascita*", "*Poesia e società*", and "*Ricordo di Roberto Bazlen*" from *Italo Svevo-Eugenio Montale: Carteggio, con gli scritti di Montale su Svevo*, © 1976 by Arnoldo Mondadori Editore; and "*E ancora possibile la poesia?*", "*Sulla poesia di Campana*," "*Esiste un decadentismo in Italia?*", "*La fortuna del Pascoli*," "*D'Annunzio per tutti*," "*L'estetica e la critica*," "*Dante ieri e oggi*," "*Pièces sur l'art di Paul Valéry*," "*Eliot e noi*," "*Invito a T. S. Eliot*," "*Il cammino della nuova poesia*," "*Il 'Nuovo Colombo' della poesia francese*," "*W. H. Auden*," "*Liriche cinesi*," "*Lo zio Ez*," "*Due artisti di ieri*," "*Ricordo di Sbarbaro*," "*La mia testimonianza. Ungaretti*," "*Esule voluntario in Italia*," "*Della poesia d'oggi*," "*Parliamo dell' ermetismo*", "*Intenzioni (Intervista immaginaria)*," "*Due sciacalli al guinzaglio*," "*Confessioni di scrittori (Interviste con se stessi)*," "*E.M., 'Poesie'*", "*Dialogo con Montale sulla poesia*," and "*7 domande sulla poesia a E.M.*" from *Sulla poesia*, © 1976 by Arnoldo Mondadori Editore, S.p.A., Milano.

Vanni Scheiwiller, All'Insegna del Pesce d'Oro, Milano, for "*L'intellettuale*" and "*Il poeta*" from *La Poesia non esiste*, © 1971 by Eugenio Montale, Milano;

"*Espresso sul cinema*" was first published in *Solaria* (II, 3), Firenze, May 1927.

"*Per Lina Saba*" appeared in the *Corriere d'informazione*, 1–2 December, 1956.

I would also like to thank the Ingram Merrill Foundation, for a generous

award which helped me to complete this project; the Columbia University Translation Center, for a Translation Grant in 1978; and my former colleagues at Houghton Mifflin Company, whose kind cooperation enabled me to take a leave of absence from my duties there to work on this book. I have also benefitted from reading other translations of some of the essays included in this volume by Joseph Cary, W. S. Di Piero, Arshi Pipa, Bernard Wall and others, and I am further indebted to W. S. Di Piero for his generosity in looking over early drafts of certain essays. Other friends and colleagues have contributed valuable advice, criticism, encouragement, and other kinds of assistance, among them James Atlas, Anne Barbernitz, Glauco Cambon, Maria Campbell, Giovanna Dalla Chiesa, Susan Dwyer, Anna Fels, Meredith Galassi, Peter Galassi, Daniel Halpern, Charlotte Holmes, Robert Kent, Galway Kinnell, Sydney Lea, David Paradis, Luciano Rebay, Mark Rudman, Jean Strouse, Brian Swann, William Weaver, Eliot Weinberger, Rebecca West, and Charles Wright. Copy editor John Anderson gave the manuscript a meticulous and sensitive reading.

I am especially grateful to Frank Bidart, who first suggested that I attempt a translation of Montale's *Xenia* more than seven years ago, thus initiating an intellectual adventure that has been one of the richest experiences of my life. Finally and most importantly, I thank my wife, Susan Grace, for her boundless care, support, and enthusiasm in the years it has taken for this project to come to fruition.

J.G.

Bibliography

Principal Works of Eugenio Montale

POETRY

Ossi di seppia [Cuttlefish Bones]. Torino: Gobetti, 1925. New editions in 1928, 1931, 1939, 1942; first Mondadori edition, 1948.

Le occasioni [The Occasions]. Torino: Einaudi, 1939. New edition, 1940; first Mondadori edition, 1949. *Le occasioni* contains the poems originally published in *La casa dei doganieri e altri versi* [The Customs House and Other Poems] (Firenze: Vallecchi, 1939).

Quaderno di traduzioni [Notebook of Translations]. Milano: Edizioni della Meridiana, 1948. First Mondadori edition, 1975.

La bufera e altro [The Tempest and Other Things]. Venezia: Neri Pozza, 1956. First Mondadori edition, 1957. *La bufera e altro* includes the poems published in *Finisterre* (Lugano: Collana di Lugano, 1943).

Satura [Miscellany]. Milano: Arnoldo Mondadori Editore, 1971.

Diario del '71 e del '72 [Diary of 1971 and 1972]. Milano: Arnoldo Mondadori Editore, 1973.

Quaderno di quattro anni [Notebook of Four Years]. Milano: Arnoldo Mondadori Editore, 1977.

Tutte le poesie [Complete Poems]. Milano: Arnoldo Mondadori Editore, 1977.

L'opera in versi [Poetical Works]. Complete bibliographically annotated edition, ed. Rosanna Bettarini and Gianfranco Contini. Torino: Einaudi, 1980.

Altri versi (e poesie disperse) [*Other* (and Uncollected) *Poems*], ed. Giorgio Zampa. Milan: Arnoldo Mondadori Editore, 1981. Contains the previously uncollected work first published in *L'opera in versi*.

PROSE

Farfalla di Dinard [Butterfly of Dinard]. Venezia: Neri Pozza, 1956. First Mondadori edition, 1960; new edition 1969. Autobiographical/fictional sketches.

Eugenio Montale / Italo Svevo: Lettere, con gli scritti di Montale su Svevo [The Montale-Svevo Letters, with Montale's writings on Svevo]. Bari: De Donato, 1966. Published by Mondadori as *Italo Svevo-Eugenio Montale: Carteggio* [Correspondence], ed. Giorgio Zampa, 1976.

Auto da Fé: Cronache in due tempi [Act of Faith: Chronicles from Two Periods]. Milano: Il Saggiatore, 1966. Cultural criticism drawn mainly from the pages of the *Corriere della Sera*. [ed. Giorgio Zampa.]

Fuori di casa [Away from Home]. Milano-Napoli: Ricciardi, 1969. First Mondadori edition, 1975. Travel writing and reportage.

La poesia non esiste [Poetry Doesn't Exist]. Milano: Scheiwiller, 1971. Cultural burlesques.

Nel nostro tempo [In Our Time], ed. Riccardo Campa. Milano: Rizzoli, 1972. Anthology of extracts from Montale's cultural criticism.

Sulla poesia [On Poetry], ed. Giorgio Zampa. Milano: Arnoldo Mondadori Editore, 1976. Collected critical writings on poetry and poets.

Prime alla Scala [Openings at La Scala], ed. Gianfranca Lavezzi. Milan: Arnoldo Mondadori Editore, 1981. Collected writings on music.

Notable English Translations of Montale's Work in the Order of their Publication

Sergio Pacifici, ed. and trans., *The Promised Land and Other Poems: An Anthology of Four Contemporary Italian Poets*. New York: S. F. Vanni, 1957.

Edwin Morgan, trans., *Poems from Eugenio Montale*. Reading, England: School of Art, University of Reading, 1959.

Robert Lowell, *Imitations*. New York: Farrar, Straus & Cudahy, 1961.

Quarterly Review of Literature (XI, 4), spring 1962. Montale issue, ed. Irma Brandeis. Annandale-on-Hudson, New York: Bard College.

Carlo Golino, ed. and trans., *Contemporary Italian Poetry: An Anthology*. Berkeley and Los Angeles: University of California Press, 1962.

George Kay, trans., *Eugenio Montale: Poems*. Edinburgh: University Press, 1964.

Glauco Cambon, ed., *Eugenio Montale: Selected Poems*. New York: New Directions, 1965. Various translators. Includes poems from *Ossi di seppia*, *Le occasioni*, and *La bufera e altro*.

Robin Fulton, trans., *An Italian Quartet: Saba, Ungaretti, Montale, Quasimodo*. London: London Magazine Editions, 1966.

George Kay, trans., *Selected Poems of Eugenio Montale*. London: Penguin Books, 1969.

G. Singh, trans., *The Butterfly of Dinard*. London: London Magazine Editions 1970.

Edith Farnsworth, trans., *Provisional Conclusions: A Selection of the Poetry of Eugenio Montale*. Chicago: Henry Regnery Company, 1970. Translations of the poems from Montale's first three books not included in the New Directions *Selected Poems*.

G. Singh, trans., *Xenia*. Los Angeles: Black Sparrow Press and New Directions, 1970.

Lawrence Kart, trans., *The Motets of Eugenio Montale*. San Francisco: Grabhorn-Hoyem Press, 1974.

Cid Corman, trans., poems in *The Gist of Origin: 1951–1971: an anthology*, ed. Cid Corman. New York: Grossman Publishers, 1975.

Jonathan Galassi, trans., *Xenia*, in *Ploughshares* (2/4), 1975. Cambridge, Mass. Reprinted in *The Pushcart Prize: Best of the Small Presses*, edited by Bill Henderson. Yonkers, New York: Pushcart Book Press, 1976.

G. Singh, trans., *New Poems: A Selection from* Satura *and* Diario del '71 e del '72. New York: New Directions, 1976. Contains F. R. Leavis' essay on *Xenia*.

Alastair Hamilton, trans., *Poet in Our Time*. New York: Urizen Books, 1976. Translation of *Nel nostro tempo*.

Pequod (II,2), Winter 1977. *Eugenio Montale: Poetry and Prose*, ed. Jonathan Galassi.

Charles Wright, trans., *The Storm and Other Poems. Field* Translation Series 1. Oberlin, Ohio: Oberlin College, 1977.

G. Singh, trans., *Selected Essays*. Manchester, England: Carcanet New Press Ltd., 1978.

G. Singh, trans., *It Depends: A Poet's Notebook*. New York: New Directions, 1980. Translation of *Quaderno di quattro anni*.

Allen Mandelbaum, *Mediterranean: Selected Poems of Eugenio Montale*. Berkeley and Los Angeles: University of California Press, forthcoming.

William Arrowsmith, trans., *Eugenio Montale: The Storm*. New York: Horizon Press, 1982.

Other Works

Laura Barile, *Bibliografia montaliana*. Milano: Arnoldo Mondadori Editore, 1977.

Joseph Brodsky, "The Art of Montale," *New York Review of Books*, June 9, 1977.

Glauco Cambon, *Eugenio Montale*. New York: Columbia University Press, 1972. Monograph in the Columbia Writers Series.

———. *Eugenio Montale's Poetry: A Dream in Reason's Presence*. Princeton: Princeton University Press, 1982.

———. "Summer Days with Eugenio Montale," *Canto* (2,1), Spring 1978.

Lanfranco Caretti, "Il Saba di Montale," *Nuovi Argomenti* (57 Nuova Serie), January–March 1978.

Joseph Cary, *Three Modern Italian Poets: Saba, Ungaretti, Montale*. New York: New York University Press, 1969. By far the best available critical introduction in English to the work of the last great triad of Italian poets.

Annalisa Cima, *Incontro Montale*. Milano: Scheiwiller, 1973. An interview which restates many of the ideas set forth in previous interviews and essays.

Annalisa Cima and Cesare Segre, eds., *Eugenio Montale: Profilo di un autore*.

Milano: Rizzoli, 1977. Short anthology of notable critical essays on some of the major works of the poet.

Marco Forti, ed., *Per conoscere Montale. Antologia corredata dei testi critici.* Milano: Arnoldo Mondadori Editore, 1976. Contains an extensive critical bibliography.

Clare Huffman, *"Occasions" and "Intentions"; Studies in Montale through "Finisterre".* Princeton: Princeton University Press, forthcoming.

F. R. Leavis, "Montale's *Xenia* and Impersonality." *The Listener*, London, December 16, 1971. Reprinted in *Ploughshares* (2/4), 1975, and in *New Poems* (New Directions, 1976).

Giulio Nascimbeni, *Montale.* Milano: Longanesi, 1969. 3rd edition 1975. The first biography.

Arshi Pipa, *Montale and Dante.* Minneapolis: University of Minnesota Press, 1968. An excellent study of Dante's deep and complex influence on Montale. Includes translations of several of Montale's major critical articles and stories.

Silvio Ramat, ed., *Omaggio a Montale.* Milano: Arnoldo Mondadori Editore, 1966. A collection of critical appreciations originally published as an issue of *Letteratura* (79/81), 1966.

G. Singh, *Eugenio Montale: A Critical Study of his Poetry, Prose, and Criticism.* New Haven, Connecticut: Yale University Press, 1973.

Dennis Mack Smith, *Italy: A Modern History.* Ann Arbor, Michigan: University of Michigan Press, 1959.

Sergio Solmi, "The Poetry of Montale," excerpted and translated by Irma Brandeis from an article in *Nuovi Argomenti*, May–June 1957. *Quarterly Review of Literature* Montale Issue (XI, 4), 1962.

Stephen Spender, "The Poetry of Montale," *New York Review of Books*, June 1, 1972.

Helen Vendler, "The Transcendent 'I'," in *Part of Nature, Part of Us: Modern American Poets.* Cambridge, Massachusetts: Harvard University Press, 1980.

Elio Vittorini, *Diario in pubblico: autobiografia di un militante della cultura.* Milano: Bompiani, 1957.

Rebecca West, *Eugenio Montale: Poet on the Edge.* Cambridge, Massachusetts: Harvard University Press, 1981.

Index